Anne Markham Schulz

The Sculpture of Bernardo Rossellino and his Workshop

PRINCETON UNIVERSITY PRESS, PRINCETON, NEW JERSEY

COPYRIGHT © 1977 BY PRINCETON UNIVERSITY PRESS
Published by Princeton University Press
Princeton, New Jersey
In the United Kingdom: Princeton University Press
Guildford, Surrey

Illustrations printed by The Meriden Gravure Company
Meriden, Connecticut
Text composed in Linotype Janson and printed
in the United States of America by Princeton
University Press at Princeton, New Jersey
Designed by Mahlon Lovett

Library of Congress Cataloging in Publication Data

Schulz, Anne Markham, 1938–
 The sculpture of Bernardo Rossellino and his workshop.

 Originally presented as the author's thesis
New York University, 1968.
 1. Rossellino, Bernardo, 1409–1464. I. Title.
NB623.R83S38 1976 730'.92'4 75-3473
ISBN 0-691-03886-4

For my MOTHER *and in memory of my* FATHER

Contents

List of Illustrations

Preface

THE importance of Bernardo Rossellino for the history of Renaissance sculpture does not need to be elaborated. For a short time he so dominated the field of Florentine sculpture that there is only one known commission for marble sculpture in Florence that he did not receive. Two of his tombs, new solutions to long-standing problems, were destined to transform the design of sepulchral monuments. He contributed more than any other sculptor to the formulation of the standard Quattrocento wall tabernacle. Yet few serious studies of his sculpture have been made. An article by Cornelius von Fabriczy over seventy years ago still serves as the fundamental work on the master, although it is filled with attributions long since superseded. Maryla Tyszkiewicz subsequently assembled all the secondary literature and carefully discussed the published documents, but her monograph, written in Polish and published privately, has proven practically inaccessible. Moreover, like Leo Planiscig's later book on Antonio and Bernardo Rossellino, it was addressed to an unsophisticated lay public. Articles on individual monuments, for the most part published long ago, rarely served to illuminate more than limited problems.

A corollary of the absence of any thorough study has been the lack of a corpus of photographs of Rossellino's sculpture. In spite of the sometimes arduous conditions imposed by the heights of Rossellino's sculptures, I have tried to fill that void with numerous detail photographs taken from every angle that scaffolding afforded. The photographs, most of which are reproduced in this book, and a lengthy examination of all works at first hand, put at my disposal a wealth of primary material previously unavailable. Measurements were taken and the condition of the works described. Documents newly discovered in the Florentine archives cast further light on the Rossellino family.

All this new information necessitated a fundamental reassessment of the sculpture, not only of Bernardo Rossellino, but also of his brothers and the assistants he employed in his shop. It has long been assumed that Bernardo, one of five brothers all of whom were *scarpellini*, was assisted in his shop by the other four, and indeed on several occasions documents record the existence of his workshop. This record of employment of assistants is borne out by the bewildering variety of styles in works associated through documents or reliable secondary sources with Bernardo. A major goal I set myself, therefore, was a classification according to hands of the individual portions of all the monuments and an identification of one of those hands with the master of the shop. But I possessed not a single point of reference: no work within the total oeuvre had any surer claim to Bernardo's authorship than any other. Without criteria, however arbitrary they might be, I could not proceed. It may help the reader to know what assumptions governed my attributions to Bernardo Rossellino. The first and most important of these was that the work of the master would have to be among the finest productions of his shop. This assumption I believed was justified by Bernardo's apparent reputation which brought him lucrative and prestigious commissions. Secondly, his style would have to be present in several if not

all of the works produced by the shop, in thematically or visually important places. Thirdly, while evidence of his hand might not be present in late works, it would have to appear in early works, that is, in works executed before Bernardo had attained that position which later permitted him to employ an army of assistants. Fourthly, the master's style would have to be consistent with that of a sculptor trained in Florence in the late 1420s and the early 1430s.

The limits of change and evolution of style through the length of Bernardo's artistic career could not be set beforehand. One might expect the artist's style to have developed more rapidly at one moment than another. Differences of purpose, theme, scale, material might account for other changes. Therefore, it seemed to me possible to countenance dissimilarities between certain works attributed to Bernardo so long as similarities to other works within the group were present. However, as a result of this, the reader must not expect a coherent view of Rossellino's style to emerge before all the works attributable to him have been analyzed.

A second goal of mine was an understanding of the functioning of the Quattrocento sculptor's workshop. Documents are useful to the extent that they reveal the names and numbers of assistants, their rate of pay and occasionally the monuments on which they were employed. But no account so far published describes the division of labor within the workshop. We have at our disposal only the works themselves, which, I am convinced, if scrutinized with sufficient care and discretion, will prove an exceptionally reliable guide to the division of labor. It is for this reason that I have analyzed the works so thoroughly, even at the risk of proving tedious. In addition, I was well aware of the ordinary art historian's prejudice against supposing that more than one artist worked on any given sculpture, or if more than one did participate in its execution, that it should be possible to discover their respective contributions, and I therefore realized that dogmatic assertions of authorship would hardly prove persuasive. Of course, ultimately all attribution is a question of opinion. In favor of my own I can only say that no attribution was made without long first-hand acquaintance with every part of every monument no matter how minute or inaccessible, even where that could be accomplished only from a scaffold, and that every attribution is the result of many years' reflection.

I believe that this thorough reassessment of the oeuvre of Bernardo Rossellino has rendered supererogatory an examination of attributions to Bernardo made previously which even the most cursory glance at photographs of his autograph work, available now for the first time, will suffice to disprove. I have included works unconnected in conception or execution to the art of Bernardo only where there was a likelihood that they nevertheless were produced in his shop.

It has been my intention to touch upon the architecture of Rossellino only in so far as his documented activity in that field is pertinent to his biography. I have not dealt with it more fully because the philological problems related to his architecture are of such complexity that they would require a book of their own for their proper explication. For instance, the Rucellai Palace, generally acknowledged as a work of Alberti's, is actually cited in the earliest secondary sources as a work of Rossellino's. While Manetti's contemporary biography of Pope Nicholas V calls Rossellino the Pope's chief architect and credits him with the planning and execution of the extensive restorations undertaken in Rome and the papal states, Julius Schlosser concluded from the many striking similarities between the plans for the rebuilding of Rome and Alberti's *De re aedificatoria* that the

design was, in fact, Alberti's. At Pienza one must reckon with the contribution of Pope Pius II who, as Ludwig Heydenreich has shown, was chiefly responsible for the appearance of the Cathedral. The degree to which his assistants transformed Bernardo's designs for the other buildings at Pienza, constructed during Bernardo's tenure as *capomaestro* of the Florentine Cathedral and during the long illness that preceded Bernardo's death, has yet to be explored. In the other architectural projects on which Bernardo was involved, documents suggest that he functioned primarily as contractor, overseer, purveyor of material or simple mason. In sum, art historical scholarship published thus far has not yet arrived at any clear perception of Rossellino's personality as an architect and so far from shedding any light on his sculpture, a definition of his architectural style must depend upon an understanding of his sculpture for its initial point of departure.

My debts are so many that there is not room to list them all. However, I do wish to express my gratitude to the people without whose aid this enterprise could never have been brought to completion. Above all, my thanks go to Professor H. W. Janson, in whose seminar at the Institute of Fine Arts I first grappled with the identity of Bernardo Rossellino and under whose guidance this study was presented as a dissertation at New York University in 1968. His concern, encouragement and criticism have been of inestimable value. I have found conversations with Professor Ulrich Middeldorf invariably stimulating, and signs of his judicious criticism are evident throughout this book. I am grateful to Professor Richard Krautheimer for his careful reading and beneficial suggestions. Without the magnanimous help of Mr. Edward Sanchez I would have been at an utter loss in the archives of Florence. Professor Peter Meller offered me unstintingly the fruits of his erudition. Professor Dante de Julisse, former superintendent of monuments at Arezzo, generously made it possible for me to study and photograph Bernardo's sculpture on the facade of the Palazzo della Fraternità. Professor Ugo Procacci, former superintendent of Florentine galleries, kindly facilitated my researches on the Tomb of Neri Capponi. My thanks go to Professor Anna Matteoli, who helped me decipher many of the documents; to Dr. Osanna Fantozzi-Micali, who executed my architectural drawings; to Dr. Berta Leggeri, who led me through the labyrinths of the Florentine Soprintendenza. Dr. Gino Corti kindly checked many of the documents in the appendix, and in doing so, found one that had never been published. Not the least recognition and gratitude are due the extraordinary skill and patience of my two photographers, Mr. Giorgio Laurati and Mr. Giancarlo Kaiser. To Mr. Walter Benelli, Mr. Howard Burns, Professor Enzo Carli, Dr. Marcia Hall, Professor Isabelle Hyman, Professor Julius Kirschner, Dr. Ulrich Krause, Father Stefano Orlandi, Countess Maryla Tyszkiewicz, I am much indebted. For his help in solving the innumerable problems that writing and publication pose, I am grateful to my husband, Juergen Schulz.

I wish, further, to express my gratitude to the Fulbright Commission and the American Association of University Women whose fellowships in 1961-62 and in 1966-67 enabled me to work so long in Florence. Funds from the Frick Art Reference Library in New York and the Institute of Fine Arts of New York University helped to defray the expense of photographs, and for this financial support I am greatly beholden.

Providence, R.I.
November 1972

Abbreviations

s.C.	*stile Circumcisionis*, i.e. the date as calculated according to the modern system in which the year begins on the feast day of the Circumcision, January 1. In the Renaissance, the Florentine year began on the feast day of the Annunciation, March 25
ASF	Archivio di Stato, Florence
BNCF	Biblioteca Nazionale Centrale, Florence

FREQUENTLY CITED JOURNALS

AB	*Art Bulletin*
Arch. stor.	*Archivio storico dell'arte*
BM	*Burlington Magazine*
GBA	*Gazette des beaux-arts*
JPK	*Jahrbuch der königlich preussischen Kunstsammlungen*
Mitt. d. ksth. Inst.	*Mitteilungen des kunsthistorischen Institutes in Florenz*
R. d'arte	*Rivista d'arte*
Rep. f. Kstw.	*Repertorium für Kunstwissenschaft*
WJ	*Journal of the Warburg and Courtauld Institutes*

FREQUENTLY CITED BOOKS AND ARTICLES

Baldinucci, *Notizie*	Filippo Baldinucci, *Notizie de' professori del disegno da Cimabue in qua*, Florence, ii, 1686; iii, 1728
Becherucci, "BR," *Enc. ital.*, xxx	Luisa Becherucci, "Bernardo Rossellino," *Enciclopedia italiana*, Rome, xxx, 1936, pp. 135-136
Billi	Antonio Billi, *Il libro di Antonio Billi*, ed. Carl Frey, Berlin, 1892
Bocchi	Francesco Bocchi, *Le bellezze della citta di Fiorenza*, Florence, 1591
Bocchi-Cinelli	*idem* and Giovanni Cinelli, *Le bellezze della città di Firenze*, Florence, 1677
Bode, *Denkmäler*	Wilhelm Bode, *Denkmäler der Renaissance-Sculptur toscanas*, Munich, 1892-1905
Burckhardt-Bode, *Cicerone*	Jacob Burckhardt, *Der Cicerone*, ed. Wilhelm Bode, Leipzig, various editions
Burger	Fritz Burger, *Geschichte des florentinischen Grabmals*, Strasbourg, 1904

Caspary, Hans Caspary, *Das Sakramentstabernakel in Italien bis*
 Sakramentstabernakel *zum Konzil von Trient, Gestalt, Ikonographie und*
 Symbolik, kultische Funktion, Dissertation, Ludwig-
 Maximilians-Universität, Munich, 1964

Fabriczy, *JPK*, 1900 Cornelius von Fabriczy, "Ein Jugendwerk Bernardo
 Rossellinos und spätere unbeachtete Schöpfungen seines
 Meissels," *Jahrbuch der königlich preussischen Kunst-*
 sammlungen, xxi, 1900, pp. 33-54, 99-113

Galassi Giuseppe Galassi, *La scultura fiorentina del Quattrocento*,
 Milan, 1949

Graves Dorothy B. Graves, *Bernardo and Antonio Rossellino*,
 M.A. Thesis (typescript), Smith College, Northampton,
 Mass., 1929

Hartt, Corti, Kennedy Frederick Hartt, Gino Corti, Clarence Kennedy, *The*
 Chapel of the Cardinal of Portugal, 1434-1459, at San
 Miniato in Florence, Philadelphia, 1964

Heydenreich and L. H. Heydenreich and F. Schottmüller, "Bernardo
 Schottmüller, "BR," Rossellino," *Allgemeines Lexikon der bildenden Künstler*,
 T-B, xxix ed. U. Thieme and F. Becker, Leipzig, xxix, 1935, pp.
 42-45

Janson, *Michelozzo* H. W. Janson, *The Sculptured Works of Michelozzo di*
 Bartolommeo, Ph.D. Thesis (typescript), Harvard
 University, Cambridge, Mass., 1941

Janson, *Dona.* *idem, The Sculpture of Donatello*, Princeton, N.J., 1957

Kennedy, *R. d'arte*, 1933 Clarence Kennedy, "Recensione di M. Tyszkiewicz,
 Bernardo Rossellino," *Rivista d'arte*, xv, 1933, pp. 115-
 127

Longhurst Margaret H. Longhurst, *Notes on Italian Monuments of*
 the 12th to 16th Centuries (photostat), London, Victoria
 and Albert Museum, 1962

Magl. *Il codice magliabechiano*, ed. Carl Frey, Berlin, 1892

Michel, *Histoire*, iv, 1 André Michel, *Histoire de l'art*, Paris, iv, 1, 1909

Paatz, *Kirchen* Walter and Elisabeth Paatz, *Die Kirchen von Florenz*,
 Frankfurt a.M., i, 1940; iii, 1952; iv, 1952; v, 1953

Planiscig, *BR* Leo Planiscig, *Bernardo und Antonio Rossellino*,
 Vienna, 1942

Pope-Hennessy, *Ital.* John Pope-Hennessy, *Italian Renaissance Sculpture*,
 Ren. Sc. London, 1958

Pope-Hennessy, *idem, Catalogue of Italian Sculpture in the Victoria and*
 V & A Cat. *Albert Museum*, London, 1964, i

Reymond, *Sculpture* Marcel Reymond, *La Sculpture florentine*, Florence,
 ii, 1898; iii, 1899

Richa Giuseppe Richa, *Notizie istoriche delle chiese fiorentine*,
 Florence, i, 1754; ii, 1755; iii, 1755; viii, 1759; ix, 1761

Schubring, *Plastik* Paul Schubring, *Die italienische Plastik des Quattrocento*,
 Berlin, 1919

Seymour, *Sculpture*	Charles Seymour, Jr., *Sculpture in Italy, 1400-1500*, Harmondsworth, 1966
Stegmann-Geymüller	Carl von Stegmann and Heinrich von Geymüller, *Die Architektur der Renaissance in Toscana*, Munich, iii, 1885-1907; vi, 1889-1907
Tysz, *BR*	Maryla Tyszkiewicz, *Bernardo Rossellino*, Florence, 1928
Vas-Mil	Giorgio Vasari, *Le vite de' più eccellenti pittori scultori ed architettori*, ed. Gaetano Milanesi, Florence, ii, 1878; iii, 1878
Vas-Ricci	*idem, Le vite de piu eccellenti architetti, pittori et scultori italiani*, ed. Corrado Ricci, Florence, 1927
Venturi, *Storia*	Adolfo Venturi, *Storia dell'arte italiana*, Milan, vi, 1908; viii, 1, 1923
Weinberger and Middeldorf, *Münch. Jahrb.*, 1928	Martin Weinberger and Ulrich Middeldorf, "Unbeachtete Werke der Brüder Rossellino," *Münchner Jahrbuch der bildenden Kunst*, n. F. v, 1928, pp. 85-94
Ybl	Ervin Ybl, *Toscana szobrászata a Quattrocentóban*, Budapest, 1930, ii

The Sculpture of
Bernardo Rossellino
and his Workshop

Introduction

BERNARDO ROSSELLINO was born in 1407 or 1409–10, probably in Settignano, the second of five brothers.[1] All his brothers, as well as his father, two uncles and a cousin, were stonemasons, as were many of the male inhabitants of Settignano, where quarrying was the major means of livelihood. His elder brother, Domenico, and the younger Giovanni and Tomaso also received occasional commissions for sculpture though no works can be attributed to them with certainty and no reputation ever crowned their efforts. But the youngest brother, Antonio, born in 1427 or 1428 and trained by Bernardo, achieved a technical virtuosity in marble carving the fame of which endured even when the sculpture of Bernardo was forgotten. Throughout Bernardo's life his brothers formed his closest associates: they shared a single shop and though they rarely received commissions jointly, they often executed them in concert.

If we do not accept at face value Bernardo's *curriculum vitae* submitted in 1457 in support of his petition to be exempted from the country tax,[2] we may imagine his arrival in Florence soon after 1420, at the moment of the installation of Nanni di Banco's Assumption of the Virgin on the Porta della Mandorla, of Donatello's Bearded and Beardless Prophets and Abraham and Isaac on the *campanile*, of Ghiberti's St. Matthew and Donatello's St. Louis at Or San Michele. Yet, for the most part, these works of revolutionary import in the history of art, did not attract Bernardo. Rather, it was the International Style, which reached its apogee in these years in the Bartolini Chapel, S. Trinita, with frescoes and an altarpiece by Lorenzo Monaco, in Gentile da Fabriano's Adoration of the Magi of 1423, in Ghiberti's North Baptistry Doors installed in 1424, that indelibly impressed Rossellino. Probably having already learned the rudiments of stonemasonry in Settignano from his father and uncles, he sought out a shop where, as he tells us in his petition, "he was put to work as a stonemason." It may have been in the shop of Brunelleschi that Bernardo served his first apprenticeship. Towards the end of the decade he probably entered the *bottega* that Donatello and Michelozzo ran jointly between 1425 and 1434, the only shop of any significance in Florence, before the debut of Luca della Robbia in 1431, in which marble sculpture was produced. In some peripheral capacity he may have participated in the production of the Coscia and Brancacci Tombs finished in 1428 (Figs. 161, 162), the Aragazzi Tomb begun in 1427 (Figs. 154–160), Lo Zuccone (1423–25) or Jeremiah (1427–35). In 1430, when Donatello went to Rome,[3] Bernardo probably entered the employ of Ghiberti[4] who had begun, only a year before, to model

[1] For the lives of Bernardo Rossellino and his brothers, see Chronology (App. 2).

[2] Doc. 10 (App. 3). The petition states that "Bernardo came to live in Florence at seven years of age when he was put to work as a stonemason." However, Bernardo was capable of exaggeration as well as outright lies, as other fallacious information in the petition shows.

[3] For the date of Donatello's trip, see Janson, *Dona.*, p. 101.

[4] The corroborating testimony of Bernardo's apprenticeship in Ghiberti's shop in *Magl.*, p. 73, unfortunately, is suspect on a number of counts. However, documents indicate that Ghiberti employed not only stonemasons and sculptors in stone but also painters. Among the painters were Paolo Uccello,

the earliest of the ten panels of the Gates of Paradise. During the period of Rossellino's hypothetical apprenticeship, work continued in Ghiberti's shop on the panels and began on the relief of the Resurrection of the Servant (1432–34) for the Shrine of St. Zenobius (Fig. 138). In spite of the different medium, it was Ghiberti's sculpture of this period that had the most profound effect on Rossellino's style.

The first notice of Bernardo's activity as an independent sculptor dates from April 24, 1433. On that day, he, along with three stonemasons from Settignano, was commissioned to give an architectural facing to the second story of the facade of the Palazzo della Fraternità, Arezzo (Fig. 1). There followed commissions for a relief of a Virgin of Mercy flanked by SS. Lorentinus and Pergentinus (Fig. 2) and two free-standing figures of SS. Gregory and Donatus (Figs. 17, 18) to be placed within that architectural setting. The commission for the tabernacle of the Badia of SS. Fiora e Lucilla at Arezzo, now lost, also dates from 1433. But Bernardo's success in Arezzo seems to have had no reverberation in Florence. In the decade following his return at the end of 1435 he received only one commission for a work of sculpture, and that, a relatively minor one: the tabernacle of the Florentine Badia made between 1436 and 1438 (Figs. 25, 26, 27). For the most part he worked as a stonemason, inserting doors and windows, constructing a chimney and a well between 1436 and 1438 at the monastery of the Badia and its dependent Chiostro alle Campora, supplying hewn stones for a new dormitory at S. Miniato al Monte in 1443 and building two hundred feet of the lower parapet and a gallery of the drum of the Duomo between 1442 and 1444.

In the second half of the 1440s Bernardo's fortunes underwent a complete transformation. An explanation is provided primarily by the careers of Rossellino's rivals. From 1436 on, when Cosimo de' Medici had engaged him to renovate the church and cloister of S. Marco, Michelozzo was fully occupied as architect. In 1441–43 Luca della Robbia had made his first successful experiment in the use of glazed terracotta in the Peretola Tabernacle (Fig. 200) and after that he rarely worked in any other medium. In 1443–44 Donatello had moved to Padua and remained in the north of Italy until 1453. The dearth of commissions to Buggiano after the death on April 15/16, 1446, of his adoptive father, Brunelleschi, suggests that it had been Brunelleschi's influence with Cosimo de' Medici and the *Opera del Duomo* that had previously won commissions for this mediocre sculptor. The absence of Donatello and the exclusion of Michelozzo, Luca and Buggiano from competition left a vacuum in the sphere of Florentine marble sculpture that was filled by Bernardo Rossellino. Between 1446 and his own departure for Rome at the end of 1451, Bernardo so dominated the field of Florentine sculpture, that, with one negligible exception,[5] he received all known commissions for marble sculpture in Florence. During those five years Bernardo was instrumental in establishing the canonical Renaissance form of tomb, tabernacle and portal. Bernardo's achievement may be explained by the particularly fortunate congruence of aptitude and task: in most of the commissions he received architecture was a significant, if not the dominant, component.

Benozzo Gozzoli and possibly Masolino (Richard Krautheimer, *Lorenzo Ghiberti*, Princeton, N.J., 1956, pp. 6, 108f). Three stonemasons are designated in the accounts of Ghiberti's shop (*ibid.*, p. 378, doc. 83; p. 382, docs. 90, 91; p. 383, docs. 98, 99; pp. 384f, doc. 102; pp. 165ff). Bernardo Ciuffagni and Donatello were employed on the North Doors (*ibid.*, p. 109) though the former never worked independently in bronze and the latter did not do so until nearly two decades later.

[5] Buggiano's Bust of Brunelleschi, Duomo, Florence, 1447.

The type of commission that Bernardo received and which was so favorable to the flowering of his artistic genius reflects a fundamental change in the function of sculpture at Florence which occurred at the end of the 1420s and the beginning of the 1430s. Starting with the resumption of the facade decoration of the Florentine Duomo in the late 1380s and 90s through the first quarter of the fifteenth century, sculpture served, almost exclusively, as the ornamentation of the exterior of ecclesiastical buildings. In accordance with this function, sculpture consisted primarily of single, free-standing figures, monumental in scale and frequently bound together by a comprehensive iconographic program. Figures or reliefs were invariably destined for a particular architectural setting: the latter for jambs, archivolts or doors; the former for niches, tabernacles or buttresses (though the relation between figure and setting was often so tenuous as to permit the installation of the figure in a setting very different from the one originally intended). In both type and function, the sculpture of this period represents a revival of the sculpture of the end of the thirteenth and the beginning of the fourteenth century when, under the influence of French Gothic architecture, Italian *capomaestri* (almost invariably sculptors of note themselves) had decreed vast sculptural programs for cathedral and other church facades. Indeed, many of the major Florentine projects at the end of the fourteenth and the beginning of the fifteenth century continued or completed projects commenced at the beginning of the fourteenth century but interrupted, first by the economic depression which began around 1340 and continued through the 1370s, then by the Black Death of 1348 and finally by the insurrection of the Ciompi in 1378 and its aftermath.[6] The statuary made by Arnolfo di Cambio before his death in 1302 for the cathedral facade was supplemented by figures by Piero di Giovanni Tedesco, Jacopo di Piero Guidi and Niccolò di Pietro Lamberti in the 1380s and 90s.[7] Between 1408 and 1415 Donatello, Nanni di Banco, Niccolò Lamberti and Bernardo Ciuffagni furnished the over life-size Evangelists for the first story. When these had been completed, two life-size figures by Ciuffagni and one by Giuliano di Giovanni were commissioned for the second story. Nanni di Banco's Isaiah (1408) and Donatello's David (1408–09) and colossal Joshua (1410) intended for the buttresses of a tribune partially realized a decorative scheme projected much earlier and already depicted by Andrea da Firenze in a fresco of 1365–67 in the Spanish Chapel of S. Maria Novella. Donatello's life-size prophets for the *campanile* (1415–36) completed the series for which Andrea Pisano had already furnished eight statues between 1337 and 1343. (It is an amusing commentary on the passion with which these projects of decoration were pursued that four of Donatello's eight prophets were virtually invisible when installed.) Ghiberti's two bronze Baptistry doors completed the set begun by Andrea Pisano in 1330–36. In 1339 each of the guilds had been assigned a niche in the exterior piers of Or San Michele and between 1339 and 1340 two tabernacles were erected and two statues installed.[8] Not until 1399 was another statue added, but by 1429 all fourteen niches had been filled.

Just as the type and function of early Renaissance sculpture was actually Gothic, so

[6] For the history of this period, see Gene A. Brucker, *Florentine Politics and Society, 1343-1378*, Princeton, N.J., 1962.

[7] The documents regarding the decoration of the Florentine Duomo were published by Giovanni Poggi, *Il Duomo di Firenze*, Berlin, 1909, pp. xviiff. See also

Martin Wackernagel, *Der Lebensraum des Künstlers in der florentinischen Renaissance*, Leipzig, 1938, pp. 24ff, and Paatz, *Kirchen*, iii, pp. 363ff.

[8] For the history of the decoration of Or San Michele, see *ibid.*, iv, pp. 491ff.

the manner in which it was commissioned followed earlier traditions. In 1391 the reliefs of the Porta della Mandorla were distributed in equal portions among four sculptors each of whom was obliged to follow a master plan—Niccolò Lamberti's deviation from the plan brought a fine of twenty-five florins and the obligation of rectifying it. Nearly twenty years later the four Evangelists of the cathedral facade likewise were commissioned from four different sculptors of very dissimilar talents. A comparison of the four figures reveals that the composition of each was strictly controlled by a single design. Apparently the patrons preferred a uniform design realized in different ways to a diversity of design unified by one style and quality. What counted therefore was not the style or quality of the work, and thus its author, but rather the concrete object and its ability to convey a certain conventional meaning.

A partial explanation for this exercise of patronage resides in the character of the late Gothic and early Renaissance patron. During the fourteenth and fifteenth centuries the construction and decoration of the churches and religious institutions were the responsibility of the four major guilds, the *Arte della Lana*, the *Arte della Seta*, the *Calimala* and the *Cambio*. Out of the guild membership a small number of men were chosen to oversee the work on the building for which their guild was responsible. The entrepreneurs of Florence's wool industry, from whose members the overseers of the cathedral were drawn, were accustomed to commissioning woolen cloth from a number of subcontractors and apparently followed the same procedure in commissioning works of sculpture. Moreover, it was probably easier for a group of men to agree on a design than on an artist, where partisan feelings might be involved. It is interesting to note that the original commission for the cathedral Evangelists contained the provision that the sculptor of the best of three should receive the commission for the fourth: one can easily imagine such incentives applied to the production of cloth.

But by the time the four Evangelists were completed in 1415 the attitude of the consuls of the *Arte della Lana* had changed. Two out of the six statues for the second story of the facade were entrusted to Bernardo Ciuffagni while five of the eight prophets for the *campanile* were commissioned from Donatello. An unforeseen result was that both projects took twenty years to complete. Although the pattern established by Andrea Pisano's earlier prophets apparently influenced Donatello's conception of his earliest beardless prophet, the sculptor clearly felt himself under no obligation thereafter to follow either his own or Andrea's model.

While this new valuation of style by sculptor and patron alike favored the cultivation of artistic individuality, it was probably stimulated in the first instance by the maturation between 1400 and 1410 of an extraordinarily large number of exceptionally talented and individualistic sculptors. In 1399 Brunelleschi made his sculptural debut; from 1401 date the first works by Ghiberti and Jacopo della Quercia; the earliest known work by Donatello dates from 1406; and in 1408 Nanni di Banco received his first commission.

In the first quarter of the fifteenth century commissions for sculpture were so numerous that even sculptors of second and third rank were kept busy with work of their own. Common to all the sculptural projects of the period is their ambitiousness, both in terms of labor and cost of material. Marble statues were generally life-size, often larger. In 1406 the city council of Florence gave the major guilds the right to install bronze rather than marble statues at Or San Michele. Ghiberti's bronze John the Baptist for Or San Michele (1412–16), the first free-standing life-size figure to be cast in Florence, initiated

a competitive drive among the guilds for still larger and more expensive bronze statues: in its contract with Ghiberti of 1419 the *Calimala* specified that its statue of St. Matthew was to be "at least the size of . . . the Baptist . . . or larger." This rivalry was climaxed in 1423 by the Parte Guelfa's over life-size gilt bronze statue of St. Louis. The munificence of the Florentines in the decoration of exteriors of communal churches has been explained by the patriotism and optimism engendered by republican Florence's heroic resistance to the expansion of the Milanese tyranny which proved effective when Giangaleazzo Visconti unexpectedly died on September 3, 1402.[9] Doubtless, Florence's fortitude in withstanding where others had yielded did much to buttress the citizens' pride in their city and may well have contributed to the burgeoning of artistic activity. But it is not the total explanation. For, in fact, the competition for what was to prove the costliest sculptural project of the century, the Baptistry doors, was announced during the winter of 1400–01,[10] precisely after the Milanese blockade of Florence's major roads and the conquest of her ports had begun to throttle her economy and after all her Tuscan allies had defected. Of course the competition may have been intended primarily as propaganda—contestants came not only from Florence but from the Tuscan cities of Siena and Arezzo, and the contract with Ghiberti was not actually signed until 1403. Nevertheless, the revival of sculpture precedes the surmounting of the Milanese threat by more than a decade.

After the death in 1414 of King Ladislaus of Naples, whose designs of Italian conquest from the south resembled Visconti's conquest of Italy from the north, there was unprecedented prosperity and peace in Florence. They came to an end, however, with the resumption of hostilities with Milan in the summer of 1423. Wars with Milan followed intermittently for more than a decade and a half. The disastrous Lucchese campaign of 1429–30 filled one of the rare intervals of peace with Milan. The support of mercenary armies was extremely costly and in spite of the institution of the *Monte dei doti* in 1425 and the attempt to equalize the weight of taxation by means of the *catasto* in 1427, Florence's deficits soared.[11] In 1431–32, the years of acutest financial crisis, liquid cash was so scarce that loans to the state regularly fetched an annual interest of over 33 percent. With financial depression, political factionalism became more intense. In 1433 the Albizzi succeeded in expelling Cosimo de' Medici and his adherents. The following year Cosimo returned and banished the Albizzi, the Strozzi and several other of Florence's wealthiest families. From then on, the internal government of Florence, manipulated behind the scenes by Cosimo, was stable, but lasting peace was not achieved until the decisive victory of Anghiari in 1440 and the advantageous treaty signed the following year with Milan.

The effect of the economic and political situation on the arts was felt within a couple of years.[12] Building projects such as S. Lorenzo, S. Spirito, the Cappella de' Pazzi, S. Maria

[9] H. W. Janson, "The Image of Man in Renaissance Art: From Donatello to Michelangelo," *The Renaissance Image of Man and the World*, Fourth Annual Conference on the Humanities, Ohio State University, 1961, ed. Bernard O'Kelly, n.p., 1966, p. 79. Cf. Frederick Hartt, "Art and Freedom in Quattrocento Florence," *Marsyas: Studies in the History of Art*, Suppl. I, *Essays in Memory of Karl Lehmann*, Institute of Fine Arts, New York University, New York, 1964, pp. 114ff. These writers developed the controversial thesis of Hans Baron according to which the Florentine-Milanese wars led directly to a new, self-

conscious republicanism and optimism among Florentine statesmen and citizens: Baron, *The Crisis of the Early Italian Renaissance*, Princeton, N.J., 1955, pp. 12ff.

[10] Krautheimer, *op. cit.*, pp. 33ff.

[11] For the economic history of the first third of the fifteenth century, see Anthony Molho, *Florentine Political Finance, 1400-1433*, Cambridge, Mass., 1971.

[12] See Ugo Procacci, "Sulla cronologia delle opere di Masaccio e di Masolino tra il 1425 e il 1428," *R. d'arte*, xxviii, 1953, pp. 12-35, and *idem*, "L'Uso dei documenti negli studi di storia dell'arte e le vi-

degli Angeli, the Sapienza, were interrupted because their patrons could no longer afford to contribute to them, or funds already designated for their construction were diverted to support the wars. The Brancacci Chapel was interrupted in March 1427 and was not finished until the 1480s. Major sculptural projects continued to be commissioned in Florence—the contract for Ghiberti's second pair of doors dates from 1425—but most of the largest were intended for clients outside the city; Donatello's and Michelozzo's Brancacci Tomb (1426–28) was sent to Naples; Michelozzo's Aragazzi Tomb (1427–38) to Montepulciano; Donatello's and Michelozzo's outdoor pulpit (1433–38) to Prato. Ghiberti's St. Stephen, commissioned for Or San Michele in 1425 by the *Arte della Lana* was considerably smaller and far more summarily chased than either his bronze John the Baptist or his bronze St. Matthew, and a new tabernacle originally planned, was dispensed with. Artists sought work in other cities: Nanni di Bartolo, Dello Delli, Paolo Uccello and Andrea del Castagno at Venice, Florence's closest ally throughout this period; Filippo Lippi and Niccolò Baroncelli followed Palla Strozzi to Padua where the goldsmith, Giuliano di Giovanni, was already employed by the Santo; Masolino went to Hungary and Masaccio to Pisa before they finally departed for Rome. At the Vatican Donatello made the Tabernacle of the Sacrament (1432–33) (Fig. 202), and Filarete, the bronze doors of St. Peter's (1433–45). Even Gentile da Fabriano, who had enjoyed unparalleled success at Florence in the early 1420s, left for Siena in 1425. It is no wonder therefore that Bernardo Rossellino made his debut in 1433 not in Florence but in Arezzo.

The momentum generated in the production of sculpture in the first quarter of the fifteenth century did not cease altogether in the second quarter. But the nature of sculptural commissions did change radically. With very few exceptions (and these exceptions, for the most part, belonged to series commenced long before) sculpture was no longer commissioned to ornament the exterior of churches. The decision of the Florentine *Opera del Duomo* of 1428 according to which no new statues were to be commissioned for the following three years is indicative. In fact, between the commissioning of the last of the *campanile* prophets in 1427 and Agostino di Duccio's giant Hercules of 1463 for a tribune buttress, no external decoration for the Duomo was undertaken at all, apart from the modest program of completing the *campanile* reliefs begun a century earlier by Andrea Pisano, with five reliefs by Luca della Robbia. Indeed, monumental free-standing figures, either as architectural decoration or independent statuary, were not commissioned again in significant numbers until the beginning of the sixteenth century.

In the second quarter of the fifteenth century most sculpture was commissioned for the interior of churches, as it had been during the sculptural depression of the 1350s and 60s.[13]

cende politiche ed economiche in Firenze durante il primo quattrocento nel loro rapporto con gli artisti," *Donatello e il suo tempo, Atti dell'VIII convegno internazionale di studi sul rinascimento*, Florence/Padua, 1966, Florence, 1968, pp. 37f.

[13] After 1340 no statues were added to the exterior of Or San Michele, and plans were abandoned for the one or two Baptistry doors for which Andrea Pisano had prepared drawings in 1338–39. The major works of mid-century were Andrea Orcagna's tabernacle for the interior of the loggia of Or San Michele (1352–60), Alberto Arnoldi's altarpiece for the loggia of the Bigallo (1359–64) and the silver antependium

for the high altar of the Baptistry begun by Leonardo di Ser Giovanni (commissioned in 1366). There are very few other pieces of Florentine sculpture that can be assigned to this period. The paucity of sculptural commissions in the 1350s and 60s cannot be attributed to want of money, for the endowments of churches and religious confraternities swelled through bequests realized in the wake of the Black Death. Indeed, the staggering cost of material and labor necessary to realize the complex designs of Orcagna's tabernacle and the silver antependium reflect the flourishing financial state of religious institutions after the Black Death and the scarcity of uses to which

Some of these works were purely decorative such as reliefs above doors, in pendentives, beneath arches, or the decoration of ceilings. For these works the medium of glazed terracotta invented by Luca was particularly appropriate. Not only did it provide a variety of color and a contrast of texture with the surrounding wall, but it was cheap: the material itself cost little and molds could be substituted for the executing hand of the sculptor. But most of the works of the period were utilitarian and fall within the category of ecclesiastical furniture. Certain genres of sculpture are represented with particular frequency. Tabernacles for the holy sacrament, of which there are very few examples in Florence prior to the second quarter of the fifteenth century, began to appear regularly after 1427 when Brunelleschi designed one, now lost, for S. Jacopo in Campo Corbellini.[14] Other genres included altars, pulpits, lavabos, holy-water fonts, shrines and tabernacles to house objects of particular veneration.[15]

The commissions of the Florentine Duomo during this period are illustrative. Between 1427 and 1431 no new works of sculpture were undertaken at all. By 1431 however, the dome of the cathedral, begun eleven years earlier, was nearing completion and it became necessary to make the choir ready for services. The cathedral was dedicated on March 25, 1436, when the dome had reached the level of the lantern. Meanwhile, in 1435 Brunelleschi and Ghiberti had been entrusted with the arrangement of the new chapels in the tribunes. In connection with this, two altars each were commissioned from Donatello and Luca della Robbia in 1439. In the same year the choir was provisionally erected in wood and Donatello was engaged to choose the marble from which it was to be constructed. From the 1430s and 40s date Luca's and Donatello's Cantorie (1431–38 and 1433–39 respectively), Ghiberti's reliquary shrine for the Chapel of St. Zenobius (1432–42), Buggiano's lost ciborium and Luca's candelabra-bearing angels for the Chapel of the Corpus Christi (commissioned in 1443, 1448–51 respectively). The sacristies were embellished with two washbasins by Buggiano (1432–40 and 1442–45) and two reliefs of the Resurrection and the Ascension made by Luca for the lunettes over the entrances (1442–45 and 1446–51 respectively). The contract for the bronze doors of the north sacristy which, along with the commission for the doors of the south sacristy, had been awarded first to Donatello in 1437, was signed by Luca, Michelozzo and Maso di Bartolommeo in 1446. The continuation of work in the Duomo throughout the 1430s was made possible by the government's traditional subvention of cathedral works with 1.5 percent of the gross income produced by all of the city's gabelles and a tax of twenty soldi which everyone was obliged to bequeath the Duomo.[16] It is indicative of the prestige that attached to the Duomo that even during the period of Florence's severest financial crisis these measures were not rescinded. Nevertheless, far less was spent on interior furnishings than had been spent a quarter of a century earlier on the ornamentation of the facade, tribune buttresses, *campanile* and Porta della Mandorla.

Since the board of overseers of the Duomo was the major artistic patron of the second quarter of the fifteenth century, the works it commissioned determine the general nature of Florentine sculpture of the period. Its commissions seem to have influenced

their money could be put. But in terms of patronage, an abundance of funds resulted primarily in the commissioning of large fresco cycles—the cheapest, most rapid and most didactic form of artistic decoration.

[14] See Caspary, *Sakramentstabernakel*, pp. 14ff.
[15] Wackernagel, *op. cit.*, pp. 85ff.
[16] I am grateful to Dr. Robert Hatfield for this information from Felice Brancacci's unpublished testaments of 1422 and 1430.

the pattern of patronage of the Medici, the one Florentine family sufficiently wealthy and solvent to be able to commission works of art on an extensive scale during this period. The only Medicean commissions for sculpture during the second quarter of the fifteenth century about which we are informed (although there may well have been others) are for ecclesiastical furniture and interior decoration: Ghiberti's Shrine of SS. Protus, Hyacinth and Nemesius for S. Maria degli Angeli (1426–28) (Fig. 165); Buggiano's and Donatello's work in the Old Sacristy (1432–ca. 1444) (Figs. 201, 212); the Tabernacle of the SS. Annunziata in the church of the Servi (1448); the Cappella del Crocifisso in S. Miniato al Monte (1448).[17]

The major effect of this change in the function of sculpture was that sculpture became more architectural. An important element in the decoration of the object was its frame, generally composed of architectural members. Other ornamentation was inevitably limited to relief, occasionally composed solely of abstract motifs, but even when figurative, generally not of a pictorial kind. Not infrequently figures carved in high relief fill the entire surface of the field, and even where they are smaller in scale or fewer in number, the setting is usually minimal. Large free-standing figures are rare. With the exception of Luca's candelabra-bearing angels and possibly Donatello's lost Dovizia in the Mercato Vecchio, all were private commissions, whose dating and patronage are obscure, or if public commissions, all concluded series begun long before. There are more commissions in terracotta and stucco, which was even cheaper, and fewer commissions in bronze; in public commissions bronze was used only when marble was entirely impracticable, as in doors, grills, candelabra and shrines.

One may surmise that commissions for "furniture" were not greeted with enthusiasm by Donatello. He did no more than possibly supply a wax model for one of the altars commissioned by the *Opera del Duomo* and he never began the doors for the sacristies although one pair continued to be reserved for him until his death. The expectation of undertaking an over life-size free-standing bronze equestrian monument—the kind of monument which, if it was commissioned in Florence at all, was executed in fresco—is therefore more than sufficient to explain his move to Padua,[18] and the subsequent commission for the high altar of the Santo, with its seven nearly life-size free-standing bronze figures and four pictorial reliefs, is sufficient to explain why, in spite of his dislike of the city, he remained in Padua for the five years or so that intervened between the completion of the Gattamelata and its erection.

In light of the reduced level of patronage in Florence as a whole and the monopoly of the patronage of the *Opera del Duomo* held by Donatello, Luca and Buggiano, it is not surprising that between 1435 and 1446 Bernardo Rossellino was forced to ply the trade of stonemason. But in June 1446, only two months after the death of Brunelleschi, Bernardo received the commission for the portal of the Sala del Concistoro in the Palazzo Pubblico, Siena (Fig. 28). It was probably at the end of 1446 that Bernardo was entrusted with the most prestigious commission of his sculptural career, the Tomb of Leonardo Bruni, the chancellor of the Florentine Republic (d. 1444), in S. Croce, Florence (Fig. 49). Because of its magnitude as well as the demands of several contemporary projects, work on it probably continued into 1451. The commission for the two figures of the

[17] For the patronage of the early Medici, see E. H. Gombrich, "The Early Medici as Patrons of Art: A Survey of Primary Sources," *Italian Renaissance*

Studies, ed. E. F. Jacob, London, 1960, pp. 279ff, with further bibliography on p. 281.
[18] See Janson, *Dona.*, pp. 150f.

Annunciation (Fig. 33) was given by the Compagnia della SS. Annunziata at nearby Empoli in August 1447. In 1450 Bernardo was paid for the tabernacle presently in S. Egidio (Fig. 91), although it, too, may have been commissioned a few years earlier. In July 1451 he was entrusted with the Tomb of the Beata Villana in S. Maria Novella, Florence (Fig. 96). Probably through Bernardo's mediation, his brother, Giovanni, and Pagno di Lapo Portigiani were asked to undertake the execution of the tabernacle of the baptismal font in the Duomo, Massa Marittima in 1447 (Figs. 135, 136).

From the end of 1446 or the beginning of 1447 Bernardo was in charge of a large and active workshop, for his numerous commissions could be executed within the time limits set only with the aid of great numbers of assistants at every level of proficiency. Conversely, Bernardo had little difficulty in attracting assistants since he was practically the only recipient in Florence of commissions for marble sculpture, and his was the only workshop for marble sculpture flourishing at the time. Antonio Rossellino's presence in the shop is proven by the figures he contributed to monuments commissioned from Bernardo, and we may assume that the other Rossellino brothers were similarly employed. Even Desiderio da Settignano, who must have found Bernardo's style antipathetic, enrolled as an apprentice. It has been suggested that Mino da Fiesole was also apprenticed to Bernardo.[19] Indeed, the dates of Mino's birth and the commencement of his activity as well as his dependence on Antonio Rossellino and Desiderio do make his training under Bernardo plausible, but there is no work from the Rossellino shop that even remotely resembles his in style. Perhaps he performed the menial tasks of a *garzone* of which no visual record has been preserved. Bernardo's hegemony of Florentine sculpture explains why the mature Buggiano, his pulpit in S. Maria Novella completed, joined the Rossellino workshop and why the only other mature marble sculptor of note remaining in the city, Bernardo Ciuffagni, left for Rimini in 1447 and did not return until 1450.

As master of the shop Bernardo oversaw its daily functioning, apportioned work, supervised assistants, provided material and tools and dealt with patrons. The design of the monument in general was also his responsibility although the design of individual figures within the whole might often be left to assistants. Where the entire work consisted of only two individual figures, as in the Empoli Annunciation (Fig. 33), Bernardo hardly intervened at the stage of design. Bernardo, himself, executed only a very small proportion of the figurative sculpture that issued from his shop, though if he contributed anything to a monument at all, he generally chose to do the most conspicuous or thematically important parts. A second principle regularly followed was the allotment of individual figures within a series to as many different sculptors, probably so that the entire member of the monument to which the series belonged could be executed at once. Apart from this, there seems to have been no visual logic to the division of labor in the execution of single figures or parts of monuments—no evidence of specialization of assistants in the carving, for instance, of faces, garments, hands. Two, or on one occasion, even more, artists frequently cooperated in the execution of a single figure which might be divided between them anyhow. This apparently arbitrary division of labor is best explained by the availability of particular assistants at moments when specific tasks were to be performed: certainly there is no evidence of the sixteenth-century sense of the uniqueness and inviolability of the artistic creation. The variety of styles evident in the monuments produced in the Rossel-

[19] Seymour, *Sculpture*, p. 140.

lino shop is due in part to the independence given to assistants, but even more to the fact that the shop did not function long enough or at a sufficient leisurely pace for the master to be able truly to undertake the training of his apprentices. In this respect Bernardo's shop represents an anomaly among the workshops of Quattrocento sculptors.

In 1451 Rossellino was called to Rome by Pope Nicholas V. He concluded unfinished sculptural projects in great haste, judging from the careless addition of the putti and *stemma* to the top of the Bruni Tomb (Fig. 49) and from the fact that the Tomb of the Beata Villana (Fig. 96) was left entirely to the execution of assistants, and by December of that year he was in Rome. He remained in the Pope's constant employ at least until the very end of 1453. The documents call him "ingegniere in palazo" and record payments for a hoisting machine and extensive work of reconstruction in the church of S. Stefano. The documents, however, are but a pale reflection of Bernardo's activity as chief architect for Nicholas V (1447–55) as it was recorded in Giannozzo Manetti's contemporary biography of the Pope.[20] According to Manetti, Rossellino was placed in charge of all the papal building projects inside and outside of Rome. Within Rome these included the reconstruction of the city walls with the addition of several towers and a new fortress outside the Castel S. Angelo; the restoration and rebuilding of the forty station churches; the restoration of the quarter between the Castel S. Angelo and the Vatican which was to house the whole of the Curia (the quarter was to be divided by three streets leading to St. Peter's lined with loggias for shops and dwellings above); the reconstruction and redecoration of the papal palace with the addition of a theatre for the coronation of the Pope, gardens, fountains, chapels, libraries and a separate conclave hall; the rebuilding of St. Peter's. Outside of Rome, Manetti tells us, Bernardo directed for the Pope the restoration of S. Benedetto in Gualdo and S. Francesco in Assisi; the construction or reconstruction of the fortresses at Narni, Orvieto and Spoleto; the reconstruction of a portion of the walls at Civitacastellana; the remodeling of the baths at Viterbo. Vasari adds that Bernardo enlarged and embellished the *piazza* and restored the church of S. Francesco at Viterbo.

From December 29, 1453, until February 15, 1457, Bernardo's name is absent from the documents. Perhaps some of this time was spent on the extra-Roman papal projects for which documents have not yet come to light. In any event, Bernardo is not likely to have left the Pope's employ before Nicholas's death on March 24/25, 1455. Surely, if Bernardo had returned to Florence immediately upon his disappearance from the Vatican documents, the commission of May 2, 1454, for the marble Tomb of Bishop Federighi presently in S. Trinita would have gone to him rather than to Luca della Robbia.

We do not know what happened to Bernardo's workshop in Florence when he went to Rome. The addition to the Tomb of the Beata Villana commissioned in January 1452 was never executed and there is no known work of any of the Rossellino brothers that can be assigned to this period. Moreover, in 1453 the commission for a portrait bust was given by Piero de' Medici to a newcomer to Florentine artistic circles, the twenty-four-year-old Mino da Fiesole. Perhaps Bernardo's brothers accompanied him to Rome and on his travels through the papal states. On the other hand, Antonio's name appears in a Florentine document of 1453 and the way in which he is described ("che sta a Proconsolo") suggests that he was occupying the shop in the Via del Proconsolo that Bernardo rented in the early 1460s.

[20] Reprinted by Torgil Magnuson, *Studies in Roman Quattrocento Architecture*, Stockholm, 1958, pp. 351ff.

Meanwhile the pattern of artistic patronage in Florence was undergoing another change. The peace with Milan and the political stability at home had ushered in another era of relative prosperity which once again permitted large expenditures for works of art and architecture. But patronage was no longer dispensed predominantly by the representatives of the guild charged with overseeing the construction and decoration of a particular church, and expenses were no longer met from the income from endowments to the church. Commissions proceeded now from individuals acting on their own behalf, and if the objects they commissioned were not destined for the home and the private delectation of the patron, then they were, by and large, tombs installed in public churches intended to propagate the fame of a particular family or individual.

Politically this change in patronage in the second quarter of the century can be linked to the gradual concentration of governmental power in the hands of a very few people.[21] At the beginning of the Quattrocento all decisions had been made in Florence by committees whose composition changed every few months, but by mid-century most important issues were decided by Cosimo de' Medici or his personal deputies. The goal and course of foreign diplomacy were no longer determined by the needs of the republic but by the personal relationships of the Medici. Economic activity was cautiously limited to a preservation of the *status quo* and vast amounts of money were spent on objects that produced no revenue but conferred prestige. In fact, it was an era of conspicuous consumption during which sumptuary laws were either repealed or not enforced. Socially there emerged an elitist impulse by which the patriciate hoped to define itself as a special caste. Both artistic patronage and classical learning were fundamental to the achievement of this goal.

One consequence of the concentration of patronage in the hands of individuals was the appearance of new genres of sculpture intended to appeal to a new type of Florentine patron—the collector. The first extant dated portrait bust in the Renaissance was made in 1453.[22] The independent bronze statuette became common only around 1460.[23] Though the Renaissance portrait bust was influenced by medieval reliquary busts and the traditional use of death masks, both types of sculpture represent a revival of antique genres. In content, too, the bronze statuette was often classical in nature. The appearance of both genres is one manifestation of that passion for the antique among the elite of Florence which expressed itself concurrently in the avid collection of antiquities. The popularity of the bronze statuette is also symptomatic of the predilection for the small, the precious, the highly worked, which accounts for the very considerable rise in the production of liturgical objects in silver in the later fifteenth century.

Reliefs of the Madonna and Child intended for domestic use also gained in popularity and stature. While in the first half of the century such reliefs were generally executed by assistants in stucco and glazed or unglazed terracotta, frequently from molds, now the reliefs are often executed in marble by the master of the shop himself. It is indicative that even Duke Francesco Sforza wanted to obtain from Desiderio da Settignano two gilded and painted stucco Madonnas. Thematically related and equally sentimental in content

[21] For an historical summary of this period, see Gene A. Brucker, *Renaissance Florence*, New York et al., 1969, pp. 256ff.

[22] For the development of the portrait bust, see John Pope-Hennessy, *The Portrait in the Renaissance*, New York, 1966, pp. 71ff; Irving Lavin, "On the Sources and Meaning of the Renaissance Portrait Bust," *Art Quarterly*, xxxiii, 1970, pp. 207ff.

[23] For the history of the bronze statuette, see Pope-Hennessy, *Ital. Ren. Sc.*, pp. 99ff.

are the contemporary busts or figures of an infant or child (Fig. 181), sometimes recognizable as the young St. John the Baptist or infant Christ—a genre of domestic sculpture that was virtually unknown in the first half of the fifteenth century.

A second characteristic of artistic patronage in the second half of the fifteenth century is its conformity. It is epitomized by the gargantuan palaces which very few members of the upper class needed or could afford but which nevertheless were built in considerable numbers[24] and whose similarity to one another contrasts with the variety of palace architecture of the preceding century. Portrait busts also became so numerous that they seem to have been a social requisite and they are so similar to one another that their design seems to have been standardized. Tombs commemorating private persons not only were commissioned in far greater numbers than in the preceding fifty years, but for the most part they belonged to a single type. That type, the arcosolium, was developed by Bernardo Rossellino upon his return to Florence in 1456–57 in the Tomb of Orlando de' Medici in SS. Annunziata (Fig. 106).

A corollary of the conformity of works of art was the specialization of artists. Even before mid-century, of course, Luca della Robbia had worked almost exclusively in glazed terracotta but his specialization is to be understood in terms of possession of a lucrative trade secret: in the 1450s and early 60s specialization exists even where no technical invention is involved. Thus very few free-standing figures were commissioned from anyone but Donatello, who in the 1450s executed the Mary Magdalene in the Baptistry, the Giovannino Martelli in the Bargello, the bronze St. John the Baptist for Siena and the group of Judith and Holofernes. Moreover, until Luca made the bronze doors of the Duomo sacristy between 1464 and 1469, Donatello had a virtual monopoly of all important commissions for bronze sculpture in Florence. The two bronze pulpits of S. Lorenzo (1460–70) became the training ground for a future generation of bronze sculptors, including Bellano and Bertoldo, as Ghiberti's doors had been before. Antonio Pollaiuolo worked in silver, executing for the Baptistry a silver cross (1457–59) and two candlesticks (1465), a reliquary for S. Pancrazio (1461) and silver ornaments for Cino Rinuccini (1461–62). He evidently received such a large proportion of the trade that in 1458 Verrocchio lamented that he was abandoning the trade of goldsmith because business was so poor. For marble portraits, Piero de' Medici (1453), Giovanni de' Medici, Alessio di Luca Mini (1456), Rinaldo della Luna (1461), and Diotisalvi Neroni (1464) sought Mino da Fiesole. Mino's reputation as a portraitist reached as far as Rome, where Niccolò Strozzi (1454) sat for him, and Naples, where he carved the likenesses of Astorgio Manfredi (1455) and Alfonso I of Aragon. Until the late 1460s only one other securely dated portrait bust was executed by a sculptor other than Mino—Antonio Rossellino's Bust of Giovanni Chellini (1456) (Figs. 218, 219). Moreover, not until the commission of 1464 for the Badia Altarpiece, is Mino known to have received in Florence any other type of work. In spite of two major ecclesiastical commissions and one monumental tomb, Desiderio seems to have concentrated on small scale domestic marble sculpture, primarily religious reliefs, which manifest a *ne plus ultra* of technical perfection. During this period the shop of Bernardo Rossellino produced three tombs, received the commission for a fourth and was contractually involved in a fifth—there is no record of any other sculptural

[24] Richard A. Goldthwaite, "The Florentine Palace as Domestic Architecture," *American Historical Re-* view, lxxvii, no. 4, October 1972, pp. 977ff.

commissions. Apparently only Antonio Rossellino, whose oeuvre in the 1450s and 60s included tombs, a portrait bust, Madonna reliefs, a holy-water font, escaped this specialization.

This specialization did not last past the mid-1460s. After 1464 Mino took on more varied commissions. The oeuvre of Benedetto da Maiano included portrait busts, tombs, altars, a doorway, a crucifix, free-standing figures, reliefs, and a lavabo, while the careers of Verrocchio and Antonio Pollaiuolo after about 1465 represent the acme of versatility. Perhaps the change was wrought by the deaths of Bernardo Rossellino and Desiderio da Settignano in 1464 and Donatello in 1466, which removed at a stroke Florence's three most prestigious sculptors.

In the third quarter of the fifteenth century foreign communal, ducal and papal patrons competed for the services of Florentine sculptors far more vigorously than they had a quarter of a century before. Donatello's Sienese commissions constitute a large proportion of the work he undertook to do during his last years: the bronze John the Baptist (1457), the abortive project for the bronze doors of the Cathedral (1457–59), and the marble statue of S. Bernardino for the Loggia dei Mercanti which was never executed. The Judith and Holofernes (1456–57) may also have begun as a Sienese commission. Mino da Fiesole, on the other hand, appears in Rome in 1463 at work on the Benediction Pulpit of Pope Pius II, while Bernardo's major architectural projects of the 1450s and 60s were executed under Popes Nicholas V and Pius II. In addition, the rulers of the numerous Italian duchies, having succeeded in large measure in consolidating their power during the first half of the fifteenth century, set about legitimizing their reigns and magnifying their glory by means of grandiose architectural and sculptural undertakings in which Florentines were frequently involved. Thus Agostino di Duccio, with a troop of assistants, was employed at Rimini by Sigismondo Malatesta from 1449 to 1454 to decorate his burial church of S. Francesco. Mino da Fiesole was brought to Naples between 1455 and 1456 by Alfonso I who, evidently without success, also sought the services of Donatello. Throughout most of the 1450s Lodovico Gonzaga urged Donatello to return to Mantua to finish the Arca of S. Anselmo. Filarete and Michelozzo worked as architects for Francesco Sforza of Milan, and Michele di Giovanni da Fiesole, called "Il Greco," was active at the Ducal Palace at Urbino.

The pressure of work and the call to Rome had prevented Bernardo from contributing more than the design to the Tomb of the Beata Villana (Fig. 96). Similarly, only the design of the Tomb of Orlando de' Medici is his. From the fact that from about 1450–51 on there is only one small portion of a figure that is attributable to Bernardo, we may assume that his interest in the practice of sculpture had waned or that architectural projects, some of them vast, completely occupied his time. During the reign of Calixtus III (1455–58), whose major efforts were focused on the organization of a new crusade against the Turks, Bernardo worked in Florence on projects which, though more remunerative, were not very different from those on which he had worked between 1435 and 1446: the marble steps leading to the choir of S. Miniato al Monte (1457) and the pavement and steps of the portico of the Spedale degli Innocenti (1457–59). In 1459, however, Bernardo was placed in charge of the rebuilding of Pienza by the new pope, Pius II (1458–64). The construction of the Cathedral and *campanile*, the *piazza* with the Palazzo Piccolomini, the Palazzo del Comune, the Palazzo Vescovile and the Palazzo dei Canonici occupied him fully until 1463. In 1461 Bernardo was named *capomaestro* of the Florentine Duomo. Dur-

ing his tenure, work proceeded on the lantern and probably the external exedrae. In 1462 Bernardo purveyed stone for the church of SS. Annunziata. In 1463 he provided the design for the *campanile* of S. Pietro at Perugia.

Meanwhile Bernardo continued to receive commissions for sculpture, in every instance, tombs. But the Tomb of Filippo Lazzari in S. Domenico, Pistoia, commissioned in 1462 (Fig. 221), was not even begun by him. Though both the Tomb of Neri Capponi (d. 1457) in S. Spirito, Florence (Fig. 120), and the Tomb of Giovanni Chellini (d. 1462) in S. Domenico, S. Miniato al Tedesco (Fig. 121), were probably produced in his shop, the extent to which Bernardo contributed even to their design is moot: only the head of the right-hand putto in the Capponi Tomb (Fig. 119) gives evidence of Bernardo's thought or hand. On the basis of a joint contract of December 1461 to Bernardo and Antonio for the Tomb of the Cardinal of Portugal in S. Miniato al Monte, and payments to Bernardo equal to one quarter of the total cost of its carving, it has been argued that Bernardo executed an equivalent amount of its sculpture;[25] but in fact neither the design nor the execution reveal any hand other than Antonio's or that of an assistant trained and closely supervised by him.

In February 1458 separate tax declarations were filed by Bernardo, on the one hand, and Domenico, Giovanni, Tomaso and Antonio, on the other. Although all five brothers rented a single shop, they employed different apprentices and possessed different material. The debtors listed in Bernardo's *catasto* do not reappear in the *catasto* of the four brothers and their income is considerably less than Bernardo's. It may be that Bernardo, who received the vast bulk of commissions to the Rossellino workshop, both for architecture and sculpture, had works of architecture executed under his own supervision while sculpture was designed and executed or supervised by Antonio with the assistance of his other brothers and apprentices. (Among Antonio's apprentices of the 1450s and early 60s, as we may infer from the style of their early works, were probably Andrea Verrocchio, Matteo Civitali and Benedetto da Maiano.) Although Antonio's marble furniture, such as the sarcophagus of the Tomb of the Cardinal of Portugal, or the throne opposite it, or the holy-water font from the chapel of the Spedale degli Innocenti of 1461, are as much architecture as they are sculpture, there is no evidence that after 1451 he worked on buildings, while his activity as a sculptor during the later 1450s is well documented. His Bust of Giovanni Chellini in the Victoria and Albert Museum dates from 1456 (Figs. 218, 219). The figure he contributed to the Tomb of Orlando de' Medici (Fig. 108) dates from this or the following year, and the undated Nori Madonna in S. Croce (Fig. 170) was probably executed towards the end of the decade.[26] The Tomb of Beato Marcolino da Forlì of 1458 in the Pinacoteca Comunale, Forlì, probably comes from Antonio's shop. Moreover, soon after Bernardo's death the Tomb of Filippo Lazzari (Fig. 221) was reallocated jointly to Antonio and Giovanni. Only the payments of 1460–61 made independently to Giovanni for the carving of the architectural members of the Chapel of the Cardinal of Portugal imply a different, looser arrangement within the Rossellino shop.

The biography of Bernardo Rossellino exemplifies the social mobility possible for artists in fifteenth-century Florence. Born in the *contado* in relatively humble circumstances (to which his brothers, Domenico, Giovanni and Tomaso, returned after his death, but

[25] Frederick Hartt, "New Light on the Rossellino Family," *BM*, ciii, 1961, pp. 387f, 392; Hartt, Corti, Kennedy, pp. 93ff.

[26] *Ibid.*, pp. 79f.

before Antonio's, in 1479), Bernardo eventually became the most popular sculptor in Tuscany, the major entrepreneur in Florence for work of construction, *capomaestro* of the Duomo and chief architect of two popes. The plots of land which Bernardo listed in his *catasto* of 1458 reveal a pattern of increasing prosperity in the 1450s: between 1448 and 1453 Bernardo purchased eleven *staiora*;[27] between 1450 and 1455, sixteen and a half *staiora*; and between 1452 and 1457, thirty-two *staiora* and a house. In the *catasto* of Bernardo's heirs of 1469 the plots listed are still more numerous; even if the absence of the date of purchase does not always allow us to specify whether the plots were acquired before or after Bernardo's demise, it is evident that he left a very large estate. It is in this light that one must read the petition of February 1457 of Bernardo and his brothers to the *Consiglio Maggiore* of Florence to be exempted from paying the *estimo*, the tax levied at frequent intervals on the residents of the countryside. Levied more frequently and at a higher rate than the tax paid by residents of the city, its burdens were gladly escaped by those who had sufficient influence to be able to exchange the *estimo* for the *catasto*. We know that Bernardo aspired to higher things for his sons than the profession of mason or sculptor.[28] Bernardo's son Giovanni Battista became a notary and Lector at the University of Pisa, and a grandson, Domenico, was Podestà of Vicchio in 1547.[29]

Bernardo died at the end of September 1464 after a long illness. None of his direct descendants practiced the art of sculpture and none of his distant relatives who did ever attained renown in the art. Even Bernardo was much better remembered as an architect. His reputation as a sculptor suffered, in part, from the brilliance of his brother, Antonio, and in part, from the importance of his architecture. It is curious to note that, as an architect, Bernardo was celebrated above all for his work for Nicholas V, of which nothing was completed and almost nothing remains, while his construction of the city of Pienza was virtually forgotten. The reason for this, undoubtedly, is that Vasari, on whom all later critics depended, knew Giannozzo Manetti's life of Nicholas V but not the *Commentaries* of Pius II.[30]

[27] In Florence, one *staiora* equaled 1009.152 square meters.

[28] In his petition of 1457 Bernardo explicitly stated that "he made his two sons study as he believed to be well known." See Doc. 10 (App. 3).

[29] Domenico Maria Manni, *Osservazioni istoriche sopra i sigilli antichi*, Florence, xvii, 1746, p. 152.

[30] The first mention of Bernardo occurs in a list of sculptors in Filarete's *Treatise on Architecture*, trans. and ed. John R. Spencer, New Haven/London, 1965, bk. vi, fol. 44v. But Cristoforo Landino, in "Fiorentini eccellenti nella pittura, et nella scultura," *Dante con l'espositione di Christoforo Landino*, Venice, 1564, n.p., wrote: "Restono parimente dell'opere [of sculpture] molto belle d'Antonio, cognominato Rosso, Et similmente di Bernardo suo fratello Architetto." Billi, pp. 46f, included Bernardo in the chapter on Antonio where he was designated architect although credited with the Tomb of Leonardo Bruni and the Nori Madonna in S. Croce. In *Magl.*, p. 93, Bernardo was called sculptor and architect. Vasari, Vas-Ricci, ii, p. 141, wrote deprecatingly: ". . . lasciando [Antonio] un' suo fratello architetto et scultore nominato Bernardo, . . . Costui del continuo attese alla architettura; ma per non essere stato eccellente quanto il fratello, non se ne fa memoria altrimenti." In his second edition, Vas-Mil, iii, pp. 97ff, he devoted considerable space to Bernardo whom he recorded as both sculptor and architect. But nothing of Bernardo's sculptural activity was said beyond mention of the Tomb of Leonardo Bruni. Almost the entire discussion of Bernardo's life was dedicated to the projects of Nicholas V as recorded by Manetti. Bernardo's name does not appear at all in Raffaello Borghini's *Il riposo* or Baldinucci's *Notizie*, although both books treat sculptors as well as painters. Antonio Francesco Rau and Modesto Rastrelli, in *Serie degli uomini i più illustri nella pittura, scultura, e architettura*, Florence, iii, 1770, p. 9, wrote: "Ebbe Antonio Rossellino un fratello, che morì dopo lui il quale fu valente Architetto, ma nella Scultura fu assai inferiore ad Antonio." Rau and Rastrelli's description of the projects designed for Nicholas V was derived from that of Vasari. Neither they, nor Francesco Milizia (*Le vite de' più celebri architetti d'ogni nazione e d'ogni tempo*, Rome, 1768, pp. 175f), knew of any other work by Bernardo Rossellino.

The Sculpture of the Facade of the Palazzo della Fraternità, Arezzo

THE Fraternità di S. Maria della Misericordia of Arezzo was founded at the beginning of the thirteenth century. From the fourteenth century onward its membership included all citizens of Arezzo. It was dedicated to works of charity such as distributing food to prisoners and to the poor, succoring widows and orphans, providing dowries for impoverished spinsters, burying the dead, and maintaining students at the University of Pisa. In 1363 the confraternity purchased from the Commune the site on which it constructed the palace[1] which served as its residence until, in 1786, it became the seat of the Aretine tribunal (Fig. 1).[2] The first story of the facade, exclusive of the aediculae, was built between 1375 and 1377 by the Florentines, Baldino di Cino and Niccolò di Francesco.[3] In 1395 Spinello Aretino painted the Pietà in the lunette above the door.[4] A bequest of Lazzaro di Giovanni di Feo, rector of the fraternity, who died on September 2, 1425, and in a will dated November 10, 1410 left his entire estate to the fraternity, provided the impetus for the completion of the facade.[5] In 1433 Domenico di Giovanni, called il Fattore, was paid for constructing the wall of the second story of the facade and roofing it over.[6] The aediculae of the first story, transitional in style, are probably his.

On April 24, 1433, Bernardo Rossellino, along with three masons from Settignano, was commissioned to execute the architectural facing of the second story of the facade. Payments to Bernardo alone for the central relief of the Madonna del Manto (Fig. 5) commenced on March 21, 1434. The relief was installed approximately three months later. Meanwhile SS. Donatus and Gregory (Figs. 17, 18) had been commissioned for the lateral niches on April 16, 1434, while SS. Lorentinus and Pergentinus flanking the Madonna del Manto (Figs. 15, 16) were commissioned on August 31, 1434. Bernardo was entrusted with the series of brackets and friezes at the top of the facade on July 22, 1435.[7]

The gallery was completed in 1460 under the direction of Giuliano di Bartolo and Algozzo da Settignano.[8] The clock tower, designed by Vasari, dates from 1552.[9]

The architecture of the second story of the facade (Fig. 1) juxtaposes a late Gothic mixtilineal arch with fluted Composite pilasters, applied in pairs as in Michelozzo's and Dona-

[1] Arezzo, Biblioteca della città di Arezzo, MS 12, Memorie aretine, n.d. (nineteenth century), foll. 46v, 71v.

[2] Oreste Brizi, *Sulla piissima Fraternità dei Laici di Arezzo*, Arezzo, 1853, p. 7.

[3] Ubaldo Pasqui, *Nuova guida di Arezzo e de' suoi dintorni*, Arezzo, 1882, p. 104. Cf. H. Stegmann in Stegmann-Geymüller, iii, "BR," p. 5.

[4] U. Pasqui, "Pittori aretini vissuti dalla metà del secolo XII al 1527," *R. d'arte*, x, 1917-18, p. 65.

[5] Arezzo, Fraternità dei Laici, Vincenzo Tenti,

Sette secoli di vita della Fraternità dei Laici di Arezzo (typescript), 1964, p. 41.

[6] Alessandro Del Vita, "Contributi per la storia dell'arte aretina," *Rassegna d'arte*, xiii, 1913, p. 188.

[7] See Catalogue (App. 1).

[8] Pasqui, *op. cit.*, p. 105; H. Stegmann in Stegmann-Geymüller, iii, "BR," p. 6.

[9] U. Pasqui and U. Viviani, *Guida illustrata storica artistica e commerciale di Arezzo e dintorni*, Arezzo, 1925, p. 198.

tello's Tomb of Cardinal Brancacci. The shell-crowned niches and the spirally fluted columns of the lateral tabernacles reflect Donatello's niche of 1423 for the Parte Guelfa at Or San Michele. The motif of the triangular gable with putti on either side probably derives from Ghiberti's tabernacle for St. Matthew, 1422, also at Or San Michele.

Bernardo's relief was only one of several images of the Madonna del Manto made for the confraternity.[10] In the Madonna del Manto the theme of the Madonna as the most powerful and compassionate mediatrix is combined with the mantle as the symbol of protection.[11] Thus the Virgin becomes defender of, and intercessor for, mankind before the righteous and impartial judgments of God the Father. The inclusion here of a pope and queen beneath her mantle (Figs. 11, 12) indicates that the Madonna is intended as protector of all humanity and not simply of the members of the fraternity. The pope can be identified as the contemporary Pope Eugene IV by a comparison with his portrait from Filarete's bronze doors of St. Peter's (Fig. 137). St. Donatus, to the Madonna's right (Fig. 18), was the patron saint of Arezzo, while the Aretine martyrs and brothers, Lorentinus and Pergentinus (Figs. 15, 16), were the patron saints of the fraternity. The papal saint Gregory on our right (Fig. 17) is Pope Gregory X who, though never canonized, and not beatified until the eighteenth century, was especially venerated in Arezzo. In Aretine painting and sculpture he is frequently paired with St. Donatus.

Both the documents and the appearance of the facade testify to the absence of unified planning and frequent changes of mind. The replacement of *il Fattore* with a young Florentine probably trained in the ateliers of Brunelleschi, Donatello and Ghiberti strongly suggests that the patrons of the palace envisaged the completion of its Gothic *pianterreno* with a Renaissance *piano nobile*. The initial commission to Bernardo of April 1433 concerned only the architectural facing of the facade, exclusive of the crowning series of brackets and friezes which were commissioned two years later. It was probably not until the facing was finished at the end of 1433 that Bernardo received the commission for the Madonna del Manto and only after its carving had begun that he was commissioned to execute SS. Donatus and Gregory. Moreover, an examination of the Madonna del Manto (Fig. 5) indicates that the relief was originally planned to fit a narrower pointed arch. The seams of the component blocks of the relief produce within the larger mixtilineal arch a smaller ogival arch of approximately the width of the lunette over the portal. This ogive is almost entirely filled by the Madonna's cloak and figures very compactly grouped. Indeed, the boundary of the relief of the Madonna del Manto proper produced by the apex of the Virgin's head, her cloak and the angel's arms, coincides exactly with the contour of the smaller arch. Perhaps the ogival arch which the relief was intended to fill formed part of

[10] Between the end of the fourteenth and the early sixteenth century there is record of four paintings: (1) Spinello Aretino, facade of SS. Lorentino e Pergentino, Arezzo, destroyed; (2) Parri Spinelli, Pinacoteca Comunale, Arezzo, 1435-37; (3) Parri Spinelli, fresco in the *Udienza nuova*, Palazzo della Fraternità, Arezzo, 1448; (4) Niccolò Soggi, *tondo* for a baldacchino, destroyed. In 1529 Rosso Fiorentino designed a painting of the Madonna del Manto which was never executed. The design is lost. A drawing for it, however, is preserved in the Louvre. Niccolò di Giovanni's shrine for the relics of SS. Lorentinus and Pergentinus, Pinacoteca Comunale, Arezzo, com-

missioned in 1498, also contains an image of the Madonna del Manto.

[11] For the iconography of the Madonna del Manto, see Vera Sussmann, "Maria mit dem Schutzmantel," *Marburger Jahrbuch für Kunstwissenschaft*, v, 1929, pp. 285ff; also Leon Silvy, "L'Origine de la 'Vierge de Miséricorde,'" *GBA*, xxxiv, 1905, pp. 401ff; Paul Perdrizet, *La Vierge de Miséricorde: étude d'un thème iconographique*, Paris, 1908; Paul Deschamps, "La Vierge au Manteau dans les peintures murales de la fin du moyen âge," *Scritti di storia dell'arte in onore di Mario Salmi*, Rome, 1962, ii, pp. 175ff.

the wall constructed by Domenico di Giovanni. Yet the documents give no reason to suppose that the Madonna ever stood on the facade of the fraternity within a pointed arch: apparently before the Madonna del Manto was installed, the decision to enlarge the field of the relief supervened. But when it was erected the mixtilineal arch appeared too empty, and two months later SS. Lorentinus and Pergentinus were reclaimed from the background of the relief (Fig. 2). In order to make room for the saints, Bernardo scooped out the background that then surrounded the Madonna del Manto, creating behind SS. Lorentinus and Pergentinus very shallow niches which conform to the lower curves of the arch. The cloak of the Madonna, which originally extended to the edges of the base which run perpendicular to the background, was cut back in an attempt to unify the groups (Figs. 11, 12). In spite of their thematic integration through glance, kneeling pose and suppliant gesture, the two flanking saints cannot but seem afterthoughts. The scale of the saints is neither that of the Madonna and Child nor that of the kneeling figures, but precisely what enables them to fill the height of the new oddly-shaped fields. Their legs are turned into the plane and implausibly extended in order to fill the corners of the arch. The unsuccessful attempt to fill too much space with too little form jars with the density of the central relief.

The fact that the mixtilineal arch, a decorative form characteristic of the International Style, and no longer current in Florentine architecture,[12] was introduced among otherwise classically orthodox architectural members also points to its use as a substitute measure. But the width and heaviness of the frame of the arch (Fig. 2), emphasized by deeply stepped moldings, which seems excessive for the size of the field it contains and overpowers the figures, is a mistake that Bernardo makes again in the S. Egidio Tabernacle (Fig. 91) and the arch of the Bruni Tomb (Fig. 49) where the moldings extend beyond the edges of the frieze.

Typical of Bernardo's figures are the tall and slender proportions of the Madonna produced by an elongation of her legs (Fig. 5). Her pose is an amalgam of Gothic sway and classical contrapposto. The bent left leg is visible beneath the drapery and the right hip is thrust out. But the axes of hips and shoulders scarcely diverge, the engaged leg and both feet are concealed, and the curving folds of the skirt describe the path of a sway. Both proportions and pose can be traced to Ghiberti's works of the early 1430s, the earlier panels for the Gates of Paradise which Ghiberti began to model in 1429 (Fig. 140) and the small reliefs for the shrine of St. Zenobius modeled between 1432 and 1434 (Fig. 138).[13] Though the material of the Madonna's gown is heavier than that of Ghiberti's figures and individual folds are broader and not always convex, her folds, like Ghiberti's, produce a fundamentally linear pattern that is continuous from waist to hem. Folds are long, frequently parallel and invariably curved. The long gown forms a ring of folds around her feet. The flourish in the hem of Rossellino's Madonna resembles that of Noah's cloak in the background of Ghiberti's relief with the story of Noah (Fig. 140).

The Madonna's face (Fig. 8), however, is remarkably similar to the head of Donatello's

[12] For the history of the mixtilineal arch, see Richard Krautheimer, *Lorenzo Ghiberti*, Princeton, N.J., 1956, p. 260; also Marcel Reymond, "L'Arc mixtiligne florentin," *R. d'arte*, ii, 1904, pp. 245ff; Georg Weise, "Gli archi mistilinei di provenienza islamica nell'architettura gotica italiana e spagnuola," *R. d'arte*, xxiii, 1941, pp. 1ff; Giuseppe Marchini, "Aggiunte a Miche-

lozzo," *La rinascita*, vii, 1944, pp. 33f; Angiola Maria Romanini, "Apporti veneziani in Lombardia: note su Jacobello e Pierpaolo dalle Masegne architetti," *Venezia e l'Europa, Atti del XVIII Congresso Internazionale di storia dell'arte*, Venice, 1956, pp. 176ff.

[13] For the date of these works, see Krautheimer, *op. cit.*, pp. 141ff, 164.

marble David of 1408/09–16 (Fig. 141). In both, there is an equal degree of generalization, a regularization of the individual features as well as the shape of the whole, a smoothing of the surface with the consequent elimination not only of the indentations of the flesh but also, to a certain extent, of the projection and recession of the features. The oval face is set on a cylindrical neck. The arched but hairless brows are extremely elevated. The eyes, set far apart, are open yet blank. The unmodulated cheeks are flat and recede rapidly from the nose. The mouth is very narrow and slightly opened. The lips end well before the corners of the mouth, which are made by two drill holes. The chin is very small and round and hardly protrudes.

The inferior quality of the Madonna's left arm betokens the participation of an assistant (Fig. 6). The folds of the sleeve lack a coherent design, the elbow is misplaced, the hand is broad and swollen and the morphology of the fingers contrasts with that of the figure's right hand. Characteristically, the fingers of the Madonna's right hand are long and are separated very slightly even at their commencement. All the fingers are bent at the first knuckle—the last two fingers somewhat more than the others. The knuckle consists of a projection as wide as the finger, scored with straight, transverse lines.

The degree of recession of the baby seated at the right of the Madonna (Figs. 10, 12) and the illusionistic devices by means of which its recession is translated into relief correspond to Ghiberti's figure on the left of the Miracle of the Servant from the Shrine of St. Zenobius (Fig. 138). Both figures are placed on a sloping stage which, by its gradual rise alone, produces an illusion of recession. In both, the rising axes of feet, knees, hands and shoulders accord with the point of sight established by the sloping stage. Both figures are represented in three-quarter view and divergent limbs increase the number of planes spanned by the body. In both, the height of the relief is consistently diminished from parts carved in the round, like the nearer knee of the baby, to parts, like his farther leg, whose flattened surface hardly protrudes from the background and whose contours are not undercut. The baby's drapery possesses Bernardo's typically long, curving folds whose evenly spaced lines parallel one another and, like lines of hatching which follow the form, correspond to the contours of the body. Like Ghiberti's reclining Eve from the frame of the Gates of Paradise (Fig. 139), the drapery produces a linear definition of the plastic form by the convergence and divergence, the rise and fall, of uniform, long, thin, transverse folds. The fact that the frame was not cast until 1445, probably not long after having been modeled, only proves that Bernardo's treatment of drapery was so similar to that of Ghiberti that he did not need an immediate model by the latter in order to arrive at a similar result.

The Christ Child is similar in pose to the seated baby but very different in quality (Figs. 3, 4, 6, 7). His glance and gesture, in which he blesses the kneeling suppliants below, are not coordinated. His body is bloated; his anatomy is inorganic; his inner arm is too long and his inner leg is unconvincingly attached to his body. The similarity of the Christ Child's drapery to the drapery of the Madonna's left arm warrants an attribution to the same assistant.

A like distinction can be made between the two angels that support the cloak of the Madonna (Figs. 13, 14). Both figures are turned towards the Madonna but the receding portion of the face, shoulder, upper arm and chest of the angel on the right lacks that foreshortening that lends credibility to the pose of the figure on the left. A comparison of the unmodulated and inorganic face and the cap of hair which turns the head into a sphere,

with the head of the Christ Child (Fig. 7), justifies an attribution of the right angel to the same assistant.

The superior quality of certain of the heads of the figures kneeling at the feet of the Madonna bespeaks the authorship of Bernardo (Figs. 11, 12). They are the lowest three heads reading from the left on the left side of the Madonna, and on the right, the four lowest heads, the two heads in the center of the second row and the head in the top row nearest the Madonna. With the exception of the last head, where foreshortening and the gradual reduction of the height of the relief produce an emphatic sense of plasticity, all the heads by Bernardo are carved in high relief. For the most part, three-quarter views are employed and unlike the other heads, packed so closely together that not half their number of bodies would fit beneath the cloak, they are separated by a sufficient amount of space. Indeed, on the right a semicircular arrangement in space is indicated by means of a gradual and consistent change of view, spacing and level of the three heads. In the figures on the left a similar semicircular arrangement was foiled by an assistant's introduction of an overlapped head in profile view in the position nearest the Virgin. The bodies of all the suppliants, with the exception of the babies, are by an assistant.

Although SS. Lorentinus and Pergentinus are too damaged to permit a final attribution (Figs. 15, 16), I suspect that the only portion of either saint by Bernardo is the head of the saint on the right. It is more convincingly tilted than the head of its mate and its eyes seem focused on the Madonna.

An image of Pope Gregory X, evidently based on a death mask, was easily accessible in the effigy from his tomb in the Aretine Duomo. Nevertheless, Bernardo modeled the head of St. Gregory (Figs. 21, 22) on Donatello's Beardless Prophet of 1416–18 from the *campanile* (Fig. 142). In spite of their ultimately Roman Republican cast,[14] St. Gregory's features betray the same hand as the face of the Madonna (Fig. 8). In both, high, arched brows crown eyes with long tear ducts, set far apart and hardly recessed. The lips, considerably narrower than the mouth, are slightly parted; the chin is small and the neck long. The right hand of the saint (Fig. 17) is identical in form to the right hand of the Madonna (Fig. 4). The gesture of St. Gregory's left arm and the gathering of folds over his elbow (Figs. 17, 20) resemble the left arm and drapery of the Resurrected Christ from Michelozzo's Aragazzi Tomb in Montepulciano (Fig. 158).[15] The massive torso of the saint is swathed

[14] Cf. the head of Donatello's Beardless Prophet with the Roman Republican Portrait, no. 25.063 in the Museum of Art, Rhode Island School of Design, Providence, R.I.

[15] The date of the Risen Christ, as of all the sculptures of the Aragazzi Tomb, is problematic. In Michelozzo's tax declaration of 1427, the tomb was mentioned among the various works then in progress in the joint workshop of Michelozzo and Donatello. At the time the tax return was filed, they had received 100 florins for procuring marble. Janson, *Michelozzo*, p. 131, therefore surmised that the commission had been received only a short time before. Michelozzo's tax declaration of 1430 states that "alchuna persona da montepulciano overo cholcomune detto" was in debt to the sculptor. Evidently a certain amount of work had been done on the tomb since 1427. Unfortunately, the sculptures, two of which were unfinished and two of which (possibly the same two) portrayed Aragazzi and his mother respectively, which Leonardo Bruni reported having seen carted to Montepulciano in his letter of 1430-31 to Poggio Bracciolini, are of little assistance in dating the various portions of the tomb since only the effigy of Aragazzi can be identified with any degree of probability. On September 30, 1437, Michelozzo agreed to finish and erect the tomb within six months. By this date little must have remained to be done. For the documents relevant to the dating of the Aragazzi Tomb, see Fabriczy, "Michelozzo di Bartolomeo," *JPK*, xxv, 1904, Beiheft, pp. 62ff, 67, 69, 78ff; Howard Saalman, "The Palazzo Comunale in Montepulciano, An Unknown Work by Michelozzo," *Zeitschrift für Kunstgeschichte*, xxviii, 1965, pp. 36f, docs. 1, 2. Cf. R. Mather, "New Documents on Michelozzo," *AB*, xxiv, 1942, pp. 226ff.

by a heavy chasuble whose catenary folds diagram the three-dimensional form of the stomach while the left forearm issues forth from the bulky drapery encircled by chains of folds.

Bernardo's participation on the statue ended at approximately the middle of the chasuble (Figs. 17, 19). The upper portion of the body contains no hint of the contrapposto which the assistant attempted, but failed, to introduce below. The bent knee is too low and, pointing inward, belies the turned-out foot. The opposite knee was inserted although it would not have been visible beneath the loose garments worn by the saint. The feet have scarcely more volume than a piece of cardboard and the drapery on the right foot recedes too far to allow for the existence of an ankle. At about the level of the last major fold of the chasuble, the pattern of the embroidery changes and its execution becomes coarser.

In the figure of St. Donatus the division of labor was reversed (Figs. 18, 23): Bernardo executed the portion of the figure to the right of the crosier and below the waist including the right hand, while an assistant was responsible for the rest. The elongated Roman letters of the inscription contrast with the ineptitude of the inscription below St. Gregory (Fig. 17). The contrapposto revealed by the slight projection of the bent right knee and the receding foot betrays knowledge of Donatello's St. Mark at Or San Michele (Fig. 145) though the long gown unclassically hides the feet of the statue and the curving folds of the skirt imply a sway. As in St. Mark, St. Donatus's right hand is placed precisely at the juncture of thigh and hip, and his book occupies approximately the same position as the Gospel of St. Mark. Like St. Mark, the drapery reveals the anatomy and movement of the free leg. Two folds converge at the juncture of hip and thigh while the vertical folds suggest the weight-bearing function of the engaged leg. The type of fold which Bernardo employed here reappears in the portions of the Bruni Tomb attributable to him. Folds are sailient or deeply excavated. Projecting folds are long and tubular, often more than semicircular in transverse section. The concave separation between them also conforms to a tube. Where crushed by a belt or book, the folds are flattened. Then widening slightly, their surfaces become very slightly concave until they regain their tubular form. Such folds appear in Michelozzo's figure of Faith (Fig. 159) and the two angels from the Aragazzi Tomb and his two angels in the Brancacci Tomb. But in spite of the plasticity of individual folds, the folds of St. Donatus's skirt form an essentially linear pattern. The curve of the folds which accelerates sharply near its termination, the acute angles formed by the sudden turning back of the folds near the hem, and the regular overlapping of flat, straight folds around the feet are a common feature of Bernardo's work: they recur in almost identical form in the left angel of the S. Egidio Tabernacle (Fig. 92).

The richness, plasticity and calligraphy of the folds on the right throw into relief the monotony, rigidity and planarity of the folds to the left of St. Donatus's crosier. The forceful gesture of the hand on the right, correctly articulated and plastically carved, contrasts with the ineffectual hand on the left. The shoulders are too narrow and the left forearm has not been foreshortened. The head of the saint (Fig. 24) derives from the second saint on the left in Nanni di Banco's Quattro Coronati from Or San Michele (Fig. 143). Its features, not soldered to any skeletal structure beneath, seem to float at disparate angles on the surface of the face.

The sequence of work indicated in the documents is confirmed by the development of Bernardo's style. A comparison of the Madonna (Fig. 5) and St. Donatus (Fig. 18) reveals slight ineptitudes in the former which can be attributed to lack of experience. The

divergence of the folds of the Madonna's skirt denotes too high a juncture of thigh and hip. Her contrapposto is less precisely elucidated than that of St. Donatus. Her projecting knee occurs too far to the side and is turned outward slightly too much. Folds are less deeply excavated and less consistently tubular and the pattern they make is a more tentative, less idiosyncratic, version of the pattern made by the drapery of St. Donatus.

Those parts of the sculptural decoration of the facade not by Bernardo may be by his elder brother, Domenico. As we shall see, the work of this assistant in the Rossellino workshop covers more than twenty years and therefore its author is more likely to have been a member of the family than an apprentice. Only Domenico and Giovanni would have been old enough to have participated in the work at Arezzo. The equality of the division of labor speaks in favor of the older brother. Moreover, the influence of Nanni, who died in 1421, is more comprehensible in the work of a sculptor born at the beginning of the fifteenth century than in that of one born a decade later. Unfortunately, the lack of certain works by either brother prevents final confirmation.

The Portal of the Sala del Concistoro
in the Palazzo Pubblico, Siena

THE wooden door of the Sala del Concistoro in the Palazzo Pubblico at Siena was commissioned by the Commune of Siena from Domenico di Niccolò dei Cori in 1414. On June 24, 1446, Bernardo received the commission for the marble framework surrounding it (Fig. 28). The contract specified, as part of the decoration of the door, four half-length marble Virtues which were to be finished by Christmas of 1446. The Virtues were never executed and Bernardo received only two-thirds of the stipulated recompense.[1]

The flying putti which adorn the frieze (Figs. 29, 30) are common to Roman sarcophagi, where the putti support an inscription or medallion containing an image of the defunct. The motif seems to have been revived by Giotto in his fresco of the Birth of the Virgin in the Arena Chapel.[2] In Florence it is found first in 1418 on the Tomb of Onofrio Strozzi, S. Trinita, by Pietro Lamberti (Fig. 211), in 1423 on Donatello's Tabernacle of the Parte Guelfa (Figs. 147, 148), and frequently thereafter.

As was true of the moldings around the central compartment of the facade of the Palazzo della Fraternità at Arezzo, the enframing portal of the Sala del Concistoro in the Siena town hall seems heavier than is warranted by the field it encloses—in this case, the doorway. The breadth of the portal is equal to the height of the opening. The engaged columns project considerably in front of the plane of the wall and carry a salient architrave. The columns lack less than half their circumference and the putti and shields are carved in high relief. The impression of weight is increased by the compact plastic decoration and moldings which cover every surface below the entablature and contrast with the sparse, filigreelike ornament of Domenico dei Cori's wooden door.

As in Ghiberti's frame of the north portal of the Baptistry (Fig. 146), what seems a wreath is actually independent bunches of leaves, fruit or flowers whose stems, bound by a ribbon, are plainly visible. As in Ghiberti's frame, there is a large ring in either corner through which a bouquet is threaded. Several of the same motifs—roses, beans, laurel, olives, lilies, poppies, pine, plums, millet—appear in both. But in spite of these similarities, the effect of the two borders is entirely different. Where Ghiberti's frame seems envisioned by a painter and executed by a goldsmith, Bernardo's frame is clearly the work of an architect. The birds and serpents which find perches in Ghiberti's foliage have been banished. Where Ghiberti's sprays of fruit and flowers are very loosely contained within the bunch and very freely occupy the width of the border, Bernardo's bunches are as rigidly composed as if they were essential to the structural stability of the portal. Individual bouquets are so

[1] See Catalogue (App. 1).
[2] See Marcel Reymond, "La Tomba di Onofrio Strozzi nella Chiesa della Trinita in Firenze," L'Arte, vi, 1903, pp. 11f, and Margrit Lisner, "Zur frühen

Bildhauerarchitektur Donatellos," Münchner Jahrbuch der bildenden Kunst, ix-x, 1958-59, p. 115, n. 160; Gunnar Berefelt, A Study on the Winged Angel: The Origin of a Motif, Stockholm, 1968, pp. 109f.

tightly bound that the flowers, fruit or leaves form a solid unperforated mass. The contours of the bunches are invariably closed. Stalks sometimes echo the accents of the neighboring flutes. Ribbons are relatively short and their flutterings, therefore, are limited. In spite of the variation in motif there is an extraordinary degree of uniformity. Bunches are identical in size and degree of projection. Each bunch is overlapped to the same degree and contours hardly differ. The massiveness of the individual motifs is ideally suited to the considerable recession of the border within the portal and corresponds to the rotundity of the columns. The density of the wreath is augmented in the lintel where no stalks are visible and the thickened bunches expand into the entire width of the frame. Here Bernardo concentrated the peaches, figs and plums, leaving the less massive berries, nuts and flowers for the jambs. Unlike Ghiberti's border, there is no attempt to show the various leaves or flowers in perspective or from the rear. Leaves or flowers invariably are represented in profile view and the constant reiteration of the most characteristic view of every species gives to the border of the door the aspect of a botanical handbook. Even the overlapping of individual leaves and flowers is minimized. Unlike Ghiberti's floral decoration where, in a single bouquet every stage in the life cycle of the plant might be represented, Bernardo rendered only one: the moment of maximum maturity.

Bernardo's putti in the frieze were apparently inspired by the relief below Donatello's niche of the Parte Guelfa at Or San Michele (Figs. 147, 148). In both, the putti are infants. In both, the impression of flight is enhanced by the ambience of empty space and the overlapping by the putti of the moldings of the cornice. In both, a margin below the putti insures that they will not be overlapped by the projecting member beneath them when viewed from below. In addition, Bernardo has shifted his figures left of center. It is a device he will use again to mitigate the symmetry of a monument and produce a subliminal impression of movement. However, in later works figures are shifted right of center in accordance with the normal path of movement of the eye.

The putti's pose is one customarily employed for this motif involving a graduated torsion from frontal leg to torso represented in three-quarter view and nearer shoulder twisted forward sharply. The recession suggested by the torsion of the body is accentuated by the gradation in the height of the relief and the absence of undercutting in contours of those portions of the body farthest from the eye. But comparison with Donatello's relief reveals how little Bernardo succeeded here in creating the illusion of depth. His relief is never *schiacciato*, overlapping is less extensive, the scale of the farther legs of the putti is not diminished, and the receding feet are not foreshortened.

Other differences, such as the continuity of the curve from stomach to elbow or the slight upward swing introduced into the upper legs can be explained by Bernardo's habitual attention to contour. Contrasting with these curves are the angles produced by joints: the farther elbow (hidden by Donatello), the perpendicular wrist, the V formed at the waist of the right angel.

Features in the putto on the right that at first sight seem due to an assistant are due rather to its incomplete state. The relief of the lower leg of the right putto, for instance, is very high and cubic in form. Grooves that mark the various muscles are deep and traverse the entire width of the leg. The contours of the leg do not serve to differentiate its component forms. The next stage of work, illustrated by the lower leg of the opposite putto, in which excess stone has been pared away, surfaces have been made to revolve, indentations have been moderated and contours have been refined, has not yet been

reached. Where the upper contour of the upper leg of the putto on the left revolves continuously until it meets the ground, the upper leg of his mate is still connected by a bridge of stone to the background.

Such observations, combined with later testimony on the technique of sculpture,[3] permit us to reconstruct Bernardo's procedure after squaring the block. The design was drawn on the block and surplus material was removed, first with a mallet and heavy, faceted punches held at an angle of ninety degrees to the block, then with claw tools. At this stage all layers of relief must have projected considerably from the background and must have been more or less cubic in form. On the projecting surfaces major forms were gouged or deeply incised with a punch. Then the surface of these crudely articulated forms was carved away with finer and finer claw tools and straight-edged chisels held at an acute angle to the form, reducing the height of the relief, and as a consequence, the conspicuousness of the indentations. Forms were made to revolve, with the result that all hint of a facet disappeared and limbs became thinner. To remove as much of the stone behind forms in high relief as was practicable, a small drill held at an angle of forty-five degrees to the background was used in preference to a punch which, requiring the blows of a mallet, might fracture the marble. A line of small drill holes still follows the contour of the calf and foot in the upper leg of the putto on the left. In the rest of the contour of the leg the marks of the drill have been smoothed away with a chisel. Indentations within forms were accentuated with drill holes of various sizes. Large holes are visible between the putti's fingers and the shield; smaller holes define the orifices of nostrils and ears (Figs. 31, 32). Finally the surface was polished with rasps, files and pumice stone. In some places, but particularly the lower leg of the putto on the right, Bernardo proceeded to polish with chisels, files and abrasives, without having removed what Cellini called the "penultima pelle."

From the fact that the parts which are most nearly completed are the parts in highest relief, namely the forward legs, while the least finished parts are those in lowest relief like the rear arms, we may deduce that the order of work depended on the height of the relief: those parts were finished first whose surfaces had to be carved away least. The fact that forms meant to recede most were worked on least and therefore sometimes left in high relief accounts, more than anything else, for Bernardo's apparent lack of interest in recession.

[3] Benvenuto Cellini, *The Treatises on Goldsmithing and Sculpture*, trans. and ed. C. R. Ashbee, London, 1888, "The Treatise on Sculpture," ch. 6, p. 136; Giorgio Vasari, *Vasari on Technique*, trans. Louisa S. Maclehose, ed. G. Baldwin Brown, London, 1907; "Of Architecture," ch. 9, pp. 48f; "Of Sculpture," ch. 50, pp. 152f. Cf. John White, "The Reliefs on the Facade of the Duomo at Orvieto," *WJ*, xxii, 1959, pp. 274ff.

The Annunciation in the Museum
of the Collegiata, Empoli

THE statues of the Virgin Annunciate and the Archangel Gabriel (Fig. 33) were commissioned by the company of SS. Annunziata for the altar of their oratory in the Eremite church of S. Stefano at Empoli. The contract was awarded to Bernardo on August 2, 1447. A deadline of four months was set for the carving of the two figures, each two-thirds lifesize. The figures were approved by Ghiberti but the company was still in debt to Bernardo in 1458.[1]

The difference between the Virgin Annunciate (Figs. 34, 35, 36, 37) and Bernardo's Madonna (Fig. 5) and St. Donatus at Arezzo (Fig. 18) allows us to reject the attribution to Bernardo of all but the face of the Virgin. Her relatively large head is set on a diminutive body. These proportions, traceable to Ghiberti's north doors (Fig. 150), make the figure seem a mere statuette. The Virgin's shoulders are contracted and no provision is made beneath the mantle for her upper arms and elbows. Her legs are rather too large for her body so that the juncture of thigh and hip seems to coincide with her abdomen. A similar dissociation characterizes her movement: her feet are poised as though she were stepping forward but her torso is rigidly upright. Folds are conceived on a small scale and their morphology constantly changes. The material is pulled taut or hangs loose, adheres or stands free, lies flat or twists over upon itself, reveals or conceals the body. The pattern made by folds seems to follow no organizing principle except one of *horror vacui*. Constant undercutting, indentations and projections serve only to rut the surface.

A few of these defects vanish when the statue is turned so that its head is in profile, and its body is in three-quarter view (Fig. 37). Then the flat side of the base faces the observer as, doubtless, it was intended to do. The anatomical pecularities of the left arm no longer are visible and the diagonal border of the cloak, which in front view seems to take no cognizance of the existence of the upper arm, actually enhances the foreshortening of the farther side of the torso.

Like Donatello's Cavalcanti Virgin Annunciate in S. Croce, Florence (Fig. 151), the Empoli Virgin, surprised at her reading, has just risen from her seat.[2] The open book pressed to her body, the position of her right arm and both legs, the turn and tilt of her head correspond to Donatello's figure. But the resemblance almost entirely disappears when the Empoli Virgin is seen from its proper point of sight.

Clearly, the lower portion of the Announcing Angel is by another sculptor altogether (Figs. 41, 42, 43, 44). Mannerisms of the author of the Annunciate Virgin—the drapery which adheres to the body in small, irregular patches and the narrow, bumpy ridges between them or the crimping of the border of the drapery—are absent here. That the author

[1] See Catalogue (App. 1).
[2] The similarity between the two works was first noticed by Gerald Davies, "A Sidelight on Donatello's Annunciation," *BM*, xiii, 1908, p. 222.

of the angel is not Bernardo either is proven by the lack of anatomical justification given the movement of the figure and the dissimilarity of the type and pattern of folds to the drapery of Bernardo's autograph figures. The angel's drapery with its long smooth curves generously spaced, its succession of catenaries along one side of the figure which make no allowance for the swelling of a thigh recall Ghiberti's Annunciate Angel from the north doors of the Baptistry (Fig. 150).

The lack of correspondence between the portion of the angel above the waist and the portion below signifies the work of a second sculptor. The scale of the upper part of the figure is noticeably larger than that of the lower part. Half of the folds beneath the right arm do not continue above it, while the brocade sash disappears below (Fig. 45). The inelasticity of the lower part of the body contrasts with the upper part which seems not only to have the capacity to move, but to be in the very act of moving.

As in the Virgin, certain defects are minimized when the statue is turned so that its head appears in three-quarter view and a flat side of the base faces the viewer (Fig. 43). The heel, much too short in proportion to the rest of the foot and inexplicably poised, and the disappearance of the folds of the lower part of the cloak above the farther arm cannot be perceived.

Though the Virgin's face (Figs. 38, 39, 40) has not been brought to that ultimate state of completion represented by the face of the angel (Figs. 46, 47, 48), both faces betray the hand of Bernardo Rossellino. Common to both are the low forehead and large tear ducts produced by a drill. The lower lids very gradually fade into the flat cheeks. The tops of both noses are quite flat and a hint of the facet which has not yet been abraded away in the Virgin's nose remains in the nose of the angel. In a profile view both noses appear straight except for the barely perceptible rise below the bridge of the nose. The tip is pointed and the small, flat nostrils flare around the openings made by a drill. The mouth is very small and the lips fade away considerably before the indented points at the corners of the mouth. The caret is barely marked and the center of the upper lip hardly descends over the lower. The lower lip has no definable contour. The chin is narrow, begins considerably below the mouth and creates the barest suggestion of a point in the lower contour of the face.

In front view it is evident that what would have been the farther side of both faces in the views intended for them recedes much less than the nearer side of the face. This distortion was probably motivated by the desire to preserve in a three-quarter view as much as possible of the farther perimeter of the face otherwise lost in a lateral view. Because the farther side of the face is pulled forward, the hair reappears as background for the silhouette of the face. At the same time, however, in the face of the Virgin, the farther eye has been shifted nearer the center of the face while the slope of the nose, the nostril and the half of the mouth on the farther side of the face are smaller than the corresponding parts on the nearer side. Consequently, a greater proportion of the eye, nostril and lips is overlapped by the projection of the nose and the center of the mouth. The net result of these devices is that while very little of the farther edge of the face is hidden by the revolution of the form, the effect of recession is actually increased. These devices were not unique to Bernardo: they were the stock-in-trade of Renaissance sculptors, northern as well as southern. But he used them with uncommon mastery.

In the angel, Bernardo reproduced the effects of aerial perspective invented by Donatello in the landscape of his relief of the Ascension of Christ and the Delivery of the Keys

to St. Peter: by a manipulation of form Bernardo subdued contrasts of light and shadow in the farther side of the angel's face. To a lesser extent this effect is also achieved in the head of the Virgin. The farther side of the face of the angel is not polished as much as the nearer side and therefore reflects less light. In the faces of angel and Virgin, forms on the farther side are more nearly confined to one plane: in the face of the angel, especially, deep indentations and salient projections are uniformly avoided and indentations are some-times replaced by incisions. Concurrently, the contrast of light and shadow is accentuated in the nearer side of the face. In both heads, the inner corner of the nearer eye seems sharply indented in contrast to the gradual revolution of form above the opposite eye. Where incisions demarcate the pupil and tear duct in the farther side of the angel's face, a groove and a drill hole are used respectively for pupil and tear duct in the nearer side. The lids on the nearer sides of both faces are very slightly undercut. The modulations of the nearer cheeks, mouths, and chins and the tousled, undercut locks contrast with the smooth expanse of the farther cheeks and chins and the uniform surfaces of hair.

A third set of distortions creates effective silhouettes for the intended views of the heads of angel and Virgin—respectively, three-quarter and profile views from below. (The figures were meant to stand above an altar probably raised on steps and therefore were located above the eye level of a spectator, although the steepness of the spectator's angle of vision would have depended on his distance from the statues.) In the angel the gradual arc of nose and right brow contrasts with the straight brow on the opposite side. In a three-quarter view from below, this arc, continuous from the tip of the nose through the end of the brow, is silhouetted against the farther side of the face. There is a bulge toward the outer corner of the farther eye which, in a three-quarter view from below, makes visible the projection of the brow. The sharp downward curve at the outside of the upper lid of the farther eye produces a line parallel to the silhouette of the brow. The diagonally descending contours of the lower lip and chin increase the speed at which the orthogonals of lip and chin seem to recede and thus accentuate the effects of a low point of sight. In its proper view the incision at the hairline does not appear to cut into the volume of the angel's head but rather emphasizes the relief of the headband.

In accordance with the profile view from below from which the Virgin's head was intended to be seen, Bernardo has pulled forward the central features of the face—in particular, the center of the mouth—in order to increase their extension in profile view. The septum of the nose is askew but in this way a curve at the turning of the nose was introduced into the silhouette of the face. The lower lip ends on the right precisely where it will create a sharp, straight line in a profile view, while a fine diagonal ridge across the center of the upper lip becomes its outline.

There is little outside of the small mouth and waving locks of hair parted at the center which links the face of the Virgin with the face of the Madonna from Arezzo (Fig. 8). The change in facial type may be due in part to the influence of Michelozzo whose Madonna from the Coscia Tomb (Fig. 152) seems to have inspired Bernardo's treatment of the downcast eyes of the Virgin. Michelozzo may have introduced Bernardo to antique statuary from which a number of other elements in the face of the Virgin and the face of the Coscia Madonna derive. Or he may have been the intermediary himself. Of ulti-mately classical origin are the arrangement of waving locks, the low forehead, the brows which are low and nearly straight and consist merely of the sharply projecting ridge made by the orbit of the eye. In both faces, the distance between nose and mouth is very short. Bernardo's Virgin possesses the typically classical nose with its wide bridge, flat

top and straight contours which merge with the line of the brows. The shortness of her face is typical of antique heads.

The virtuosity in the rendering of five different garments of five different stuffs warrants an attribution to Bernardo of the front of the angel from his shoulders through his arms and including the peplum beneath his left elbow (Fig. 45). The sense of suspended animation conveyed by the hands is produced by all Bernardo's figures; it is due to the fingers which are all slightly bent at the first knuckle and just avoid touching one another.

A view of the angel from the front (Fig. 44) reveals several differences between the two halves of the torso. The right shoulder is higher and slopes more rapidly yet more gradually than the left, while the right elbow is lower. The right side of the figure including the arm is narrower than the left. The right shoulder and arm recede less. The right side of the angel is treated like high relief while the left arm of the figure is carved in the round. The sleeve of the right upper arm is considerably less articulated than the sleeve of the left arm and the contours of the right arm are smoother and straighter.

By pulling forward the farther half of the torso and farther arm, Bernardo insured that the farther edge of the figure would remain visible in spite of the foreshortening and overlapping normally attendant upon a three-quarter view. But while the actual recession of the farther half of the body is reduced, illusionistic devices insure that it will not appear so. Thus the contraction of the farther half of the body accentuates the normal effect of diminution in the scale of receding objects. The straighter contour of the farther upper arm accords with the normal reduction in the curvature of the receding portions of objects. In a normal three-quarter view from below the farther shoulder will seem to slope more rapidly and the farther of two horizontally aligned elbows will seem lower than the nearer one; these effects Bernardo intensified by the actual distortion of form.

Other distortions may be explained as an attempt to manipulate line and chiaroscuro in order to approximate, and thus intensify, the effect of atmospheric perspective. With the normal loss of distinctness and variety in objects viewed from a great distance correspond the simple and generalized silhouette of the farther half of the torso and the relative lack of articulation in the sleeve of the upper arm. Here folds are fewer and follow no perceptible paths. Consequently the farther sleeve produces a much weaker impression of texture than does the nearer sleeve. The absence of undercutting and the tempered modulations of the surface lessen the contrast of light and shade in accordance with the uniform middle value of objects seen through intervening layers of atmosphere.

When the angel is seen in three-quarter view his contours create an abstract design of great beauty. The crudely executed second wing is hidden behind his head and the excessive tilt of his head and strange curvature of his neck lose their inorganic character. The contour of the figure from elbow to elbow is nearly a perfect arch. The upper contour of the wing mirrors the contour of head and neck, the farther silhouette of the face makes a V with the outline of the shoulder, and the line of the cloak corresponds to that of the sash.

The emotion expressed by the tilt of Gabriel's head, by the expression of his face, by the slight forward thrust of his torso, by the gesture of his hands, is one of such reverence that it seems that Gabriel dare not utter the angelic salutation. His gaze, transfixed by the majesty of the Virgin, declares him no messenger, but only a witness of the miracle of Christ's incarnation. It is unfortunate that an assistant's trivial interpretation of the Virgin, surprised by the entrance of the angel, bears no narrative or conceptual relationship to the sublimity of meaning conveyed by the angel.

The Tomb of Leonardo Bruni
in S. Croce, Florence

LEONARDO BRUNI was born in Arezzo in 1370. From 1405 to 1415 he was Apostolic Secretary to Innocent VII and his successors, although he held the post of Chancellor of Florence briefly in 1410–11. He became Chancellor again in 1427 and remained in that post until his death. The most important humanist of the early Renaissance, he was noted as a student and disseminator of ancient Greek philosophy and as a writer of Latin prose. His most famous work, the *Historiae Florentini populi*, traced the history of Florence from its foundation to 1404. Bruni died on March 9, 1444, and was buried in S. Croce on March 12, 1444.[1]

Bruni's funeral was described by several contemporary chroniclers.[2] Its expenses were defrayed by the Florentine Republic,[3] while the Commune of Arezzo contributed forty florins to it.[4] The funeral was attended by the leading political figures of Florence as well as members of the Curia, courtiers of Eugene IV then resident in Florence. The Gonfalonier, Giannozzo Manetti, gave the funeral oration.[5] The deceased, dressed in a garment of rust-colored silk, lay on a bier on a platform, his history of Florence on his chest. At the climax of his oration, Manetti crowned Bruni with a laurel wreath in recognition of the eloquence of his poetry.

We are informed of Bruni's own wishes concerning his tomb. In a testament dated

[1] Lorenzo Mehus, "Vita Ambrosii Traversarii Generalis Camaldulensium," in *Ambrosii Traversarii latinae epistolae a domno Pietro Canneto*, ed. Mehus, Florence, 1759, p. cclxi.

[2] The amplest descriptions occur in the life of Manetti by Vespasiano da Bisticci, *Vite di uomini illustri del secolo xv*, ed. Paolo d'Ancona and Erhard Aeschlimann, Milan, 1951, pp. 267f; *idem*, "Commentario della vita di Gianozo Manetti," *Miscellanea di opuscoli inediti o rari dei secoli xiv e xv*, Turin, 1862, ii, pp. 21f; Naldo Naldi, "Vita Jannottii Manetti," in L. A. Muratori, *Rerum italicarum scriptores*, Milan, xx, 1731, cols. 543f.

Both Vespasiano and Naldo Naldi refer to the revival of two antique customs, namely, the delivery of the funeral oration and the coronation with laurel. However, neither of these customs was newly revived in 1444. Ser Viviano di Neri de' Franchi had delivered an oration on the death of Bruni's predecessor, Coluccio Salutati, and Poggio Bracciolini had given the funeral oration on the death of Lorenzo di Giovanni di Bicci de' Medici, to cite just two examples. As for the laurel wreath, Bruni's coronation was preceded by that of Fra Pacifico, Bonatino da Padova, Alberto

Mussato, Petrarch, Zanobi da Strada, Fazio degli Uberti, Francesco Landino and Coluccio Salutati. In fact, in almost every respect the funeral of Salutati, which took place in 1406, provided a precedent for that of Bruni. (For Salutati's funeral, see Richa, ii, p. 42.)

[3] In the fifteenth century this was an honor accorded only those who died in public office. For the funerals of the Florentine humanists of the fifteenth century, see Lauro Martines, *The Social World of the Florentine Humanists, 1390-1460*, Princeton, N.J., 1963, pp. 239ff. For Bruni's funeral in particular, see Georg Voigt, *Die Wiederbelebung des classischen Alterthums oder das erste Jahrhundert des Humanismus*, Berlin, 1880, pp. 314f.

[4] Eugenio Gamurrini, *Istoria genealogica delle famiglie nobili toscane, et umbre*, Florence, i, 1668, p. 122.

[5] Manetti's oration is published in Bruni, *Epistolarum*, ed. Lorenzo Mehus, Florence, 1741, i, pp. lxxxix-cxiv. The oration by Poggio Bracciolini published in the same book (pp. cxv-cxxvi) was not actually delivered at Bruni's funeral but was written in June or July 1444 according to Voigt, *op. cit.*, p. 314, n. 1.

March 22, 1439, Bruni specified that if he should die in Arezzo or its environs, he wished to be interred in the Aretine Pieve of S. Maria.[6] If he should die in Florence, he wished to be buried in S. Croce, "in a place suitable to his station with a stone of pure marble, without pomp." The tomb slab was to contain no more than his name.[7]

In regard to the appearance of his tomb, Bruni's wishes were not respected. On February 7, 1445, the Council of Arezzo decided to appoint two citizens who, together with Bruni's son, Donato, should decide upon and commission a statue of Bruni.[8] It has been suggested that the tomb was commissioned by this committee. But in spite of the absence of documentary proof, it is more frequently assumed that the tomb was commissioned by the Signoria of Florence. The Signoria had previously decreed similar monuments to Florentine men of letters.[9] Yet in contrast to the Bruni Tomb, the memorials it commissioned were destined for the Duomo and none but frescoes were realized.[10]

The tomb (Fig. 49) is generally supposed to date from soon after Bruni's death. But all documents concerning the tomb are lacking and, while early sources almost unanimously ascribe the tomb to Bernardo Rossellino, none assigns it a date.[11] Proof of dating, therefore, must depend upon comparison with related monuments that are securely dated. In fact, certain details of the portal of S. Domenico, Urbino (Fig. 153), begun in 1449 by Maso di Bartolommeo and finished by October 15, 1454, by Pasquino da Montepulciano and Michele di Giovanni da Fiesole show a remarkable similarity to corresponding portions of the Bruni Tomb. The frieze is continuously ornamented in low relief with a vegetal pattern all'antica similar to that of the Bruni Tomb, however reduced in detail and quality. In both, the palmette is cut in half by the breaking of the entablature. Above the frieze is a dentil molding. The supporting members of the tomb and portal stand on low plinths carved with an almost identical pattern. A heavy garland bound by a ribbon embellishes the arch.

The appearance of these insignificant classicizing ornaments within so short a time of one another cannot be fortuitous. I consider it far likelier that the portal of S. Domenico was derived from the Bruni Tomb than that the Bruni Tomb was derived from the portal or that both depended on a common source. The poor quality and provincial location of the portal argue against the second possibility while the third is disproved by the fact that a plinth with a design and proportions similar to those of the tomb and portal was used on only five other occasions, three times in tombs which ultimately derive from the Bruni

[6] Published most recently by Vito R. Giustiniani, "Il testamento di Leonardo Bruni," Rinascimento, iv, 1964, pp. 260ff.

[7] It is the same repugnance to ostentatious display that prompted Bruni's ridicule of the Tomb of Bartolommeo Aragazzi and the vanity that depended on a marble tomb rather than good works and an honored name to preserve the memory of the man. See the letter to Poggio Bracciolini published in Bruni, op. cit., ii, bk. vi, pp. 45ff.

[8] Leonardo (Bruni) Aretino, Istoria fiorentina, trans. by Donato Acciajuoli, addition and corrections to the life of Bruni by G. Mancini, Florence, 1855, i, p. 42.

[9] On December 22, 1396, the Signoria decreed tombs in S. Maria del Fiore for Accorso, Dante, Petrarch,

Boccaccio and Zanobi da Strada (see Giovanni Gaye, Carteggio inedito d'artisti dei secoli xiv, xv, xvi, Florence, 1839, i, pp. 124f, n.). The monuments were not built and on February 1, 1430, the Signoria renewed its decision concerning the monuments of Dante and Petrarch though again nothing came of it (ibid., i, pp. 123f, doc. 40). According to Luca da Scarparia, "Chronico Domni," in Coluccio Salutati, Epistolarum, ed. Lorenzo Mehus, Florence, 1741, part i, p. lxxvif, the Signoria ordered a marble sepulchre for Coluccio Salutati to be erected over his grave in the Duomo, but it was not executed either.

[10] I.e. the monuments to Fra Luigi Marsili, and the condottieri, Niccolò da Tolentino, Pietro Farnese and Giovanni Acuto, all in the Duomo.

[11] See Catalogue (App. 1).

Tomb,[12] once in the Tomb of Giovanni Chellini from the Rossellino workshop (Fig. 121) and once in the Tabernacle of S. Maria di Monte Luce, Perugia, by the most faithful imitator of the Bruni Tomb, Francesco Ferrucci.

The dependence of the portal of S. Domenico on the Bruni Tomb permits us to postulate a *terminus ante quem* of late 1451 for the design, at least, of the tomb. From December 1451 until December 1453 Bernardo was recorded at Rome, constantly in the papal employ. To be sure, the portal was not completed until 1454.[13] But in view of Maso's claim to have finished two-thirds of the work ca. June 20, 1451, it is not likely that, at the beginning of 1454, when Bernardo presumably was free once again to work on the tomb if it was still not begun, the portal was far enough from completion to have permitted the insertions of plinths beneath the columns.

The date of commission of the Bruni Tomb is less certain. But given the state of Florentine patronage, Bernardo is not likely to have been entrusted with the prestigious commission before April 1446. The fact that the carving of the Portal of the Sala del Concistoro is autograph suggests that he had not received it by the summer of 1446 either. But the four half-length Virtues which were intended for the door and were to be finished by December 25, 1446, were never furnished, and one putto in the frieze was not completed. Moreover, Bernardo left to assistants most of the design and execution of the figures of the Empoli Annunciation commissioned in August 1447, as he probably would not have done had he had no other sculptural commissions. Circumstantial evidence, therefore, leads to a dating of the commission at the end of 1446. The execution of the Madonna's face by Desiderio da Settignano (Figs. 67, 68), born only in about 1430, suggests that work was still in progress in about 1449–50, while the hasty execution and installation of the putti and garland at the top of the tomb (Fig. 49) (the garland, for instance, is displaced 3.5 cm. to the right of the vertical axis of the tomb[14]) suggests that it was still not quite finished when Bernardo was called to Rome in 1451.

The tomb represents the most popular genre in Italian sculpture of the second half of the fifteenth century. Indeed, there is no period in the history of Florentine art of a comparable span during which so many tombs were made. Tombs were commissioned by people who might never have commissioned another work of art, but who evidently thought a tomb a legitimate expense. The fact that such a large proportion of tombs resulted from testamentary disposition rather than from the unsolicited generosity of grateful survivors, as the Bruni Tomb presumably did, testifies to a common desire to be remembered after death. This desire must have been nourished by the revival of antiquity whose texts and monuments revealed a belief in immortality which meant not so much life after death as the perpetuation of one's memory among the living.

Indeed, these two fundamental concepts of immortality—the Christian concept of resurrection to an immortal life in heaven and the pagan-humanist concept of immortality

[12] The Tombs of Carlo Marsuppini, Alessandro Tartagni and Antonio Roselli.

[13] Payments for the portal are recorded in BNCF, MS. Baldovinetti 70, Maso di Bartolommeo, *Libro di conti e ricordi*, foll. 1v, 9r, 25v, 139v, 140r. They were published by Gaetano Milanesi, "La porta della chiesa di S. Domenico in Urbino," *Il Raffaello*, vi, March 10, 1874, pp. 25f; Anselmo Anselmi, "Le maioliche dei della Robbia nella provincia di Pesaro-Urbino," *Arch.*

stor., viii, 1895, pp. 436ff; Charles Yriarte, *Livre de souvenirs de Maso di Bartolommeo dit Masaccio*, Paris, 1894, pp. 55ff. The published versions of the payments are not reliable.

[14] The fact that the garland containing the Bruni *stemma* is incorporated within the proportional system of the tomb indicates that the *stemma* and putti formed part of the original plan of the tomb. See Catalogue (App. 1).

through eternal fame—coexist in the iconography of the Bruni Tomb. The laurel wreath, connoting the poet's immortal fame, crowns the temples of the effigy (Fig. 53), as it crowned Bruni's own temples during his funeral.[15] A book lies on Bruni's chest as his History of Florence did at the funeral, but its meaning here is probably less historical than symbolic. Books were a common feature of tombs and tomb slabs[16] and by the later fifteenth century had come to symbolize the humanist's dedication to letters.[17] As an illustration of the theme of the epitaph, in which the Muses mourn the death of Bruni,[18] the book may also refer to the eternal renown conferred on Bruni by the eloquence of his writing: as symbols of this they occasionally appear as attributes of fame.[19]

Classical symbols of real immortality achieved through resurrection and apotheosis are provided by the eagles which support the bier (Fig. 51) and the lions' skins (Fig. 52) (not lions, as they are generally described[20]) which support the sarcophagus. The lion skin is the traditional attribute of Hercules which, according to Coluccio Salutati, enabled Hercules to oppose *luxuria*.[21] The inference, therefore, is that Bruni possessed the virtue of Hercules, and that, like Hercules who was apotheosized as a reward for his virtue, Bruni would be resurrected to eternal life in heaven.[22] In this respect the iconography of the Bruni Tomb approaches that of Roman sarcophagi where the deceased was often represented with the attributes of Hercules to signify that he would partake of the immortality of the hero.[23] Thus the motif of the lion, which originally had signified the guardian of the tomb,[24]

[15] See Manetti's funeral oration: Bruni, *Epistolarum*, i, p. cxiv.

[16] E.g. Tomb of Ligo Ammanati (d. 1359), Cappella dell'Ammanati, Camposanto, Pisa; Tomb slab of Leonardo Dati (d. 1424), S. Maria Novella, Florence, by Ghiberti; Tomb of Raffaelo Fulgosio, S. Antonio, Padua, 1429-31, by Pietro Lamberti.

[17] Henriette s'Jacob, *Idealism and Realism: A Study of Sepulchral Symbolism*, Leiden, 1954, p. 206. As a symbol of a life devoted to poetry, history, literature and philosophy, the book corresponds to the significance of the *volumen* in Roman sarcophagi of poets, philosophers and rhetoricians (see Henri-Irénée Marrou, *Musikos Aner, Etude sur les scènes de la vie intellectuelle figurant sur les monuments funéraires romains*, Grenoble, 1938, pp. 191f).

[18] In translation it reads: "After Leonardo departed from life, history is in mourning and eloquence is dumb, and it is said that the Muses, Greek and Latin alike, cannot restrain their tears" (from Pope-Hennessy, *Ital. Ren. Sc.*, pp. 297f).

[19] E.g. the medal of the jurist Andrea Barbazza by Sperandio cited by Guy de Tervarent, *Attributs et symboles dans l'art profane, 1450-1600*, Geneva, 1959, col. 250; illustrations to Petrarch's "Triumph of Fame" including Matteo de' Pasti, Triumph of Fame, Uffizi; school of Mantegna, Triumph of Fame, Kress collection, Art Museum, Denver, Col.; Modena, Biblioteca estense, MS Ital. 103, fol. 44v, Petrarch, *I Trionfi*, fifteenth century (for which, see Domenico Fava, *Catalogo della mostra permanente della R. Biblioteca estense*, Modena, 1925, p. 51, no. 105); and the woodcut illustrating the printed Triumph of Fame in Petrarch's *I Trionfi*, Florence, 1499, in the Biblioteca

Nazionale Vittorio Emanuele, Rome (for all of which, see Prince D'Essling and Eugène Müntz, *Pétrarque, ses études d'art, son influence sur les artistes, ses portraits et ceux de Laure, l'illustration de ses écrits*, Paris, 1902, pp. 119, 135ff, 270.

[20] I am grateful to Prof. Peter Meller for pointing this out to me.

[21] See Peter Meller, "Physiognomical Theory in Renaissance Heroic Portraits," *The Renaissance and Mannerism, Studies in Western Art, Acts of the Twentieth International Congress of the History of Art*, Princeton, N.J., 1963, ii, pp. 67f, esp. n. 48. Prof. Howard Saalman has also suggested to me that the Herculean attribute of the lion skin may also have been intended as a pun on the name Leonardo.

[22] In the first edition of *De laboribus Herculis*, ed. B. L. Ullman, Zurich, 1951, ii, bk. ii, pt. 56, p. 634, Salutati wrote: "Sed Hercules philosophus videns a celo inclinationem procedere virtute resistens celum tulit (unde illud: 'Sapiens dominabatur astris') docuitque non adeo celum mortalibus imminere quin ferri possit omnis eius impressio et ad arduum illum virtutum ascensum, si non cedere sed pugnare voluerimus, pervenire." See also bk. iii, ch. 5, pt. 3 (*ibid.*, i, pp. 176f) of the second edition.

[23] Jean Bayet, "Hercule funéraire," *Mélanges d'archéologie et d'histoire, Ecole française de Rome*, xxxix, 1922, pp. 219ff, esp. 244ff and xl, 1923, pp. 19ff. See also Franz Cumont, *Recherches sur le symbolisme funéraire des romains*, Paris, 1942, pp. 342, 408.

[24] Steier, "Löwe," *Paulys Real-Encyclopädie der classischen Altertumswissenschaft*, ed. G. Wissowa, Stuttgart, xiii, 1926-27, col. 983; Henriette s'Jacob, *Beschouwingen over Christelijke Grafkunst voor-*

but which had lost every vestige of this meaning long before the Renaissance and had come to be used as a purely decorative motif, was reinvested with a new literary and classical meaning. This suggests that the iconography of the tomb was invented by a humanist, perhaps Carlo Marsuppini, Bruni's successor as Chancellor of Florence and author of Bruni's epitaph and later honored with a companion tomb across the nave of S. Croce (Fig. 167).[25]

The eagles beneath the bier must also be interpreted in the light of humanist learning (Figs. 50, 51). As the means by which the soul was believed transported to heaven, the eagle carries on its outstretched wings a bust-length image of the defunct or a full-length figure seated sidesaddle on Roman sarcophagi.[26] That that is their meaning here too seems likely from their use as supports for the bier, replacing the lions of the Coscia Tomb (Fig. 161), and from their outstretched wings.[27] They recall the concluding passage of Manetti's oration: ". . . your soul, now free and crowned with that divine laurel, will fly from this tempestuous earthly sea to heaven, the eternal refuge of the Blessed Spirits."[28]

The association of the Madonna (Fig. 63) with funerary art goes back to the catacombs, where she was often painted on the back of the niche from which the tomb was hollowed. When figures were painted or carved in medieval tomb sculpture, she was almost always included. As the most powerful, yet accessible, intercessor, she could best insure the defunct's salvation.

The *Marzocco*, the emblem of the Commune of Florence, adorns the center of the base (Fig. 83). Whether it refers to Bruni's service to the Commune or the Commune's service

namelijk in Frankrijk en Italië, Leiden, 1950, pp. 57f; *idem, Idealism and Realism*, pp. 22f, with bibliography on pp. 244f.

[25] The epitaph is attributed to Carlo Marsuppini by Bartholomaeus Fontius, *Liber monumentorum Romanae urbis et aliorum locorum*, fol. 129v, Coll. Prof. Bernard Ashmole (published by Fritz Saxl, "The Classical Inscription in Renaissance Art and Politics," *WJ*, iv, 1940-41, p. 44); Paolo Giovio, "Leonardus Aretinus," *Elogia virorum literis illustrium*, Basel, 1577, p. 20; Paulus Freher, *Theatrum virorum eruditione clarorum*, Nuremberg, 1688, ii, p. 1426. John Sparrow, *Visible Words*, Cambridge, 1969, p. 18, traced the source of the inscription to an epitaph on Plautus preserved by Aulus Gellius. The motif of the mourning Muses probably derives from Petrarch's epitaph composed for, but never inscribed on, the Tomb of King Robert of Anjou, for which see Erwin Panofsky, *Tomb Sculpture*, ed. H. W. Janson, New York, 1964, p. 87. H. W. Janson, "The Image of Man in Renaissance Art: From Donatello to Michelangelo," *The Renaissance Image of Man and the World*, Fourth Annual Conference on the Humanities, Ohio State University, 1961, ed. Bernard O'Kelly, n.p., 1966, pp. 98f has noted the unique character of the epitaph, which does not relate the date of Bruni's death and, indeed, contains no more essential data concerning the defunct than his first name. For other epitaphs composed for Bruni's sepulchre, see Giam-

maria Mazzuchelli, *Gli scrittori d'Italia*, Brescia, 1763, ii, 4, pp. 2201f, n. 61, and Bruni, *Epistolarum*, i, p. il.

[26] See the Roman sarcophagus in S. Antonio in the Via Nomentana, Rome. For the function of the eagle in scenes of apotheosis, see Karl Sittl, "Der Adler und die Weltkugel als Attribute des Zeus in der griechischen und römischen Kunst," *Jahrbücher für classische Philologie*, xv, suppl. 1885, p. 38; Ludwig Deubner, "Die Apotheose des Antoninus Pius," *Mitteilungen des kaiserlich deutschen archaeologischen Instituts, Römische Abteilung*, xxvii, 1912, pp. 1ff; Franz Cumont, *Etudes syriennes*, Paris, 1917, pp. 39ff, for the eagle in Syrian tombs; pp. 72ff, for the eagle in scenes of the apotheosis of the emperor; pp. 85ff, for the eagle in Roman tombs, and *passim*; Otto Walter, "Eine Marmorstatuette römischer Zeit in Athen," *Jahreshefte des österreichischen archäologischen Institutes in Wien*, xliii, 1956-8, pp. 102ff; Hans Jucker, *Das Bildnis im Blätterkelch, Geschichte und Bedeutung einer römischen Porträtform*, Lausanne/Freiburg i. Br., 1961, pp. 138ff.

[27] For the same reason, plus the fact that there are two of them, a Christian interpretation of the eagle as a symbol, rather than as an instrument, of resurrection (for which, see Rudolf Wittkower, "Eagle and Serpent, a Study in the Migration of Symbols," *WJ*, ii, 1938-39, pp. 312f) would be unjustified.

[28] Bruni, *Epistolarum*, i, p. cxiv.

to him in erecting his tomb, as it probably does in Bicci di Lorenzo's frescoed Tomb of Fra Luigi Marsili in the Florentine Duomo, is unknown.[29]

Thus a thread of meaning runs through the various motifs of the tomb. Connected to the emblems of real immortality and apotheosis of the lions' skins and eagles are the motifs of laurel wreath and book which refer to a figurative immortality, an immortality acquired through lasting renown. That renown, as the epitaph tells us and the book and wreath confirm, was acquired, not through service to the church, but by the pursuit of the classical ideal of eloquence. Nevertheless, the Madonna and Child flanked by angels indicate that it is to a Christian immortality that Bruni will be resurrected, to spend his days, according to Manetti, "in everlasting praise and happiness with the other triumphant spirits of the Church."[30]

The Tomb of Leonardo Bruni (Fig. 49) is the first extant example of the type of funerary monument in which the sarcophagus, bier and effigy are contained within a niche framed on either side by pilasters standing on a base and supporting a semicircular arch. Its form has been traced to Michelozzo's Tomb of Bartolommeo Aragazzi in the Duomo, Montepulciano, dated ca. 1427–38, of which only individual pieces are preserved (Figs. 154–160). The reconstructions by Marcucci (1887), Burger (1904) and Janson (1941) closely resemble the Bruni Tomb in structure and differ from one another only in detail. All three show a niche tomb, framed on either side by pilasters which rest on the base of garlands and putti. The sarcophagus stands on low bases within the niche. On the face of the sarcophagus are the two reliefs of the Virgin and Child Enthroned with Members of the Aragazzi Family and Aragazzi Welcomed by His Family in Heaven separated by the inscribed bronze plaque in the center. The two free-standing figures of Faith and Fortitude stand on the base in front of the pilasters. The effigy of Aragazzi rests either directly or indirectly on the sarcophagus and above it, the figure of the Resurrected Christ is affixed to the rear wall of the niche.[31]

A number of objections, however, may be made to these reconstructions on the basis of style. If Christ were located over Aragazzi's effigy, his gaze and blessing would be focused on Aragazzi's feet. The two Virtues are too completely finished in back to have stood directly against a wall. Also their poses and compositions and the relation of the figures to their bases indicate that Faith was meant to stand on the left and Fortitude in the center and that the Virtue intended for the right, completing a group like that of the three Virtues on the Coscia Tomb (Fig. 161), must be missing. Indeed, I believe the information we have at present is too fragmentary to permit any reconstruction of the Aragazzi Tomb.

The Bruni Tomb, however, was preceded by a tomb which it resembles very closely, namely, the Tomb of Cardinal Matteo Acquasparta (d. 1302) in S. Maria in Aracoeli, Rome, by Giovanni di Cosma or a member of his school (Fig. 163).[32] Both tombs are set

[29] On the Marsili Tomb, the roundel containing the head of the lion is located in the center of the sarcophagus. The inscription below reads: FLORENTINA CIVITAS OBSINGVLAREM ELOQVENTIAM ET DOCTRINAM CLARISSIMI VIRI/MAGISTRI LVISII DEMARSILIIS SEPVLCRVM ET SVMPTV PVBLICO FACIENDVM STATVIT.

[30] Bruni, loc. cit.

[31] Emilio Marcucci in Ricordi di architettura, x,

1887, fasc. vi, pl. iv, p. 199; Burger, pp. 121ff; Janson, Michelozzo, pp. 147ff. See also Pope-Hennessy, Ital. Ren. Sc., p. 291 and idem, V & A Cat., i, pp. 102f.

[32] See Hilda Merz, Das monumentale Wandgrabmal um 1300 in Italien, Dissertation, Ludwig-Maximilians-Universität, Munich, 1965, pp. 42f, 100ff. Merz reconstructed the Acquasparta Tomb on the basis of the Tombs of Bishop Guglielmo Durando in S. Maria

on the ground. In both, the base beneath the columns or pilasters is doubled; only the upper one is marble. The supporting members which frame the tomb rest on low plinths located at the extremities of the upper base. In both tombs two parallelepiped stages elevate the effigy to a height somewhat below the middle of the interior of the tomb. In both, the role of the cloth on which the effigy lies, in each case brocade, is prominent in the decorative scheme. Although it hangs freely in the Bruni Tomb, it preserves the architectonic form given it by Acquasparta's sarcophagus.

Although the Tomb of Acquasparta is the only such tomb preserved, it was not an unique example of its type. The original form of the Tomb of Vanna Aldobrandeschi in S. Maria in Aracoeli, as we know it from a seventeenth-century engraving by Gualdo da Rimini, was almost identical.[33] The architectural arrangement of the Tomb of the Gaetani in the Duomo, Anagni, 1294, from the Cosmati school is precisely that of the Acquasparta Tomb though the effigy is lacking. Giovanni di Cosma's Tombs of Bishop Guglielmo Durando (d. 1296) in S. Maria sopra Minerva, Rome, and Cardinal Gonsalvo Rodrigo (d. 1299) in S. Maria Maggiore, Rome, are also close in type.

But unlike the Bruni Tomb which was excavated from the depth of the wall, the Acquasparta Tomb stands against the wall. Of secondary importance for the form of the Bruni Tomb, therefore, was the traditional use of niches to contain free-standing sarcophagi. Roman in origin, the tradition was adopted in the Christian catacombs and survived into the Gothic period. In proportions and shape, the niche, containing a reused Roman sarcophagus, of the probably slightly earlier Tomb of Giuliano Davanzati (d. 1444) in S. Trinita, Florence is almost identical. The series of niches containing sarcophagi destined for illustrious humanists along the flanks of Alberti's Tempio Malatestiano at Rimini are approximately contemporaneous with the Bruni Tomb.

For the articulation of the niche Bernardo was ultimately dependent on the Brancacci Tomb (Fig. 162) where, for the first time in funerary sculpture, an entablature broken forward over a Corinthian order had tied together the rear wall of the tomb and its projecting frame while dividing the semicircular lunette with its heavenly figures from the lower rectangle with the mortal remains and image of the dead Cardinal. The architecture frescoed around and within the niche of the Davanzati Tomb contains the same motif. But in the Bruni Tomb pilasters were substituted for the Brancacci columns, and unlike the Davanzati Tomb, the Bruni Tomb does not terminate at the semicircular arch of the lunette.

The motif of the bier comes from the Coscia Tomb (Fig. 161) where the effigy was placed on a bed of state for the first time in Florentine funerary monuments. In Florentine tombs of the fourteenth century, lions are commonly found as supports for the sarcophagus.

As in the Brancacci Tomb (Fig. 162), a half-length Madonna and Child in relief, flanked by two subsidiary figures, are located in the lunette. The inclusion of half-length angels

sopra Minerva, Rome, and Cardinal Gonsalvo Rodrigo in S. Maria Maggiore, Rome. However, there is no reason to assume that the original form of the tomb has been altered. Cf. Julian Gardner, "Arnolfo di Cambio and Roman Tomb Design," *BM*, cxv, 1973, p. 438.

[33] See Alfonso Ciacconio, *Vitae et res gestae*

pontificum romanorum et s. r. e. cardinalium, Rome, 1677, ii, cols. 251f. Allowance must be made for the substitution of Vanna Aldobrandeschi's effigy by that of her son, Honorius IV, transferred to her tomb from St. Peter's in 1545, and for the medals which Gualdo arbitrarily introduced above it.

in the corners and the treatment of the frames of the medallion and lunette may go back, however, to the mosaic lunette over the lateral portal of S. Maria in Aracoeli dated ca. 1300 (Fig. 164). In both, the inner frames of the medallion intersect the outer frame of the entire lunette while the outer frame of the medallion is carried around the inner corners of the lunette, thus circumscribing the fields of the angels.

The tripartite division of the back wall of the Bruni Tomb also derives from the Coscia Tomb (Fig. 161).[34] The red and black marble incrustation probably comes from the dadoes of Trecento frescoes.

The base with putti bearing garlands can be found in the Aragazzi Tomb (Fig. 154) while the front of the sarcophagus with genii and epitaph derives from Ghiberti's Shrine of SS. Protus, Hyacinth and Nemesius in the Bargello (Fig. 165). The putti and garland enclosing a coat of arms at the top of the tomb are traceable to the Tomb Slabs of Giovanni Crivelli by Donatello in S. Maria in Aracoeli and Martin V in S. Giovanni in Laterano.

Though various motifs are related to works of classical antiquity, Rossellino's sources, for the most part, were classicizing works of the fifteenth century. The eagles supporting the bier (Fig. 51) resemble the eagles on the keystones of triumphal arches. Putti supporting a wreath, the lion's head, flying genii garbed in chitons supporting the epitaph, come ultimately from Roman sarcophagi; from their covers come putti supporting garlands with fluttering *taeniae* filling the interstices; from their supports, the lions' paws beneath the sarcophagus. But no antique chlamys flutters from the shoulders of the putti at the top of the Bruni Tomb (Figs. 75, 78); the lion's head in the base (Fig. 83) occupies the position and frame of the portrait bust of the deceased in Roman sarcophagi; the flying genii on the sarcophagus cross their legs (Figs. 50, 60, 61). Only the carved ornament of the frieze (Fig. 49) can be traced to a specific classical Roman monument—the inner entablature of the upper story of the Basilica Aemilia at Rome (Fig. 166).[35] An antique plinth, very similar to the one beneath the pilasters of the Bruni Tomb (Fig. 49) reappears in a drawing in the Uffizi attributed to Bramante.[36]

The Roman sources of the Bruni Tomb indicate that by the later 1440s Bernardo was well acquainted with Roman monuments. Yet no trip to Rome prior to 1451 is recorded for him—the payments of 1433 to a "magistro Bernardo architectori" for work in the Vatican Palace probably do not refer to Rossellino. Nevertheless, it may be assumed that he traveled there, perhaps several times. Indeed, lacunae in the documents between February 1438 and the end of 1441 and between December 1443 and June 1446 leave time for two extended visits.

Thus the Bruni Tomb bears the imprint of a wide range of periods and styles. Though they sometimes differ from the antique originals in minor ways, the putti, wreath and garlands, the genii, epitaph, lion and eagles as well as the frieze are a legacy of ancient art.

[34] Burger, p. 305, traced the motif to the incrustation of Florentine Romanesque facades. Indeed, the attic story of the exterior of the Florentine Baptistry is articulated by groups of three rectangles similar in spacing and proportion to the panels of the Bruni Tomb. The same motif is found in the lower story of the facade of the Badia of Fiesole.

[35] Martin Gosebruch, "Florentinische Kapitelle von Brunelleschi bis zum Tempio Malatestiano und der Eigenstil der Frührenaissance," *Römisches Jahrbuch für Kunstgeschichte*, viii, 1958, p 156. A drawing of this frieze was made in the shop of Domenico Ghirlandaio (see Christian Hülsen and Adolf Michaelis, *Codex Escurialensis*, Vienna, 1905, fol. 59r, pp. 145f). It was also drawn by Giuliano da Sangallo (see Hülsen, *Il libro di Giuliano da Sangallo. Codice vaticano barberiniano latino 4424*, Leipzig, 1910, fol. 16v).

[36] Arch. 4097, illustrated in A. Bartoli, *I monumenti antichi di Roma nei disegni degli Uffizi di Firenze*, Florence, 1914-22, i, pl. xxii, fig. 45. I am grateful to Mr. Howard Burns for having called this drawing to my attention.

The classicizing architectural articulation of the frame is a contribution of the early Renaissance. The components and composition of the tomb derive from Cosmati Tombs at Rome, transitional between the Romanesque and Gothic periods, while the composition of the lunette probably derives from a mosaic of the same period and place. However, the lightening of the massive structure characteristic of the Cosmati tombs and the new alternation of light and shadow produced by the elevation of the sarcophagus on two narrow supports and the elevation of the effigy on a bier was a consequence of the Gothic development of the tomb where, in the vertical multiplication of stages, a dark empty area generally alternated with a light solid one. For the richness of figurative sculpture and the variation of color produced by the red and black marble incrustation, Bernardo was also indebted to Gothic tombs and frescoes.

Yet all these sources were synthesized in a tomb which, we may suppose, from the frequency with which it was imitated, was looked upon as standard. Nine tombs can be traced to it directly while countless others, via a dependency on Desiderio da Settignano's Tomb of Carlo Marsuppini in S. Croce (Fig. 167), indirectly owe their form to it.[37] Yet by far the greatest number of copies, both direct and indirect, were made outside of Florence: in Florence only the Marsuppini Tomb and Mino da Fiesole's Tombs of Bernardo Giugni and Count Hugo of Tuscany in the Badia ultimately derive from it. The explanation, I believe, lies in the peculiarly Florentine sense of propriety which required specific types of tombs for different social classes. The tombs of artists—even non-Florentine artists—typically contained a high-relief, bust-length frontal portrait of the deceased within a roundel derived from the *imago clipeata* of early Christian tombs.[38] For the most part, private Florentine citizens were buried in relatively modest tombs derived from the arcosolium of Orlando de' Medici (Fig. 106). The fact that eminent ecclesiastics were given tombs as elaborate as the Bruni Tomb but different in form suggests that the type invented in the Bruni Tomb was identified by Florentines with humanists. And in fact, the only other Florentine humanist of the fifteenth century to receive a monumental tomb —Carlo Marsuppini—was buried in one modeled on the Bruni Tomb.

It remains to be asked why the Bruni Tomb proved so influential. A number of factors must have contributed, not the least of which was the prestige of its occupant. Another must have been its architectural logic and simplicity. The tomb is dominated, contained and isolated from the rest of the church by a frame whose orthodox architectural members orthodoxly combined, produce the unit of an arcade. The use of the arch by Brunelleschi to frame vaulted openings in flat walls, as in the sacristy and chapels of S. Lorenzo and the altar room of the Pazzi Chapel, had given the motif currency in the architectural vocabulary of the early Renaissance and made its adaptation to the framing of a shallow barrel-vaulted niche inserted in a planar wall particularly appropriate. The arch encloses

[37] The direct descendants are: Tomb of Carlo Marsuppini, S. Croce, Florence, by Desiderio da Settignano; Tomb of Pietro Noceto, Duomo, Lucca, by Matteo Civitali; Tomb of Barbara Manfredi, S. Biagio, Forlì, by Francesco di Simone Ferrucci; Ferrucci's Tomb of Alessandro Tartagni, S. Domenico, Bologna, 1477; Ferrucci's Tombs of Gianfrancesco Oliva and Marsibilia Trinci, S. Francesco, Montefiorentino; Tomb of Abbot Simone Grati, Duomo, Borgo San Sepolcro; Tomb of Antonio Roselli, S. Antonio, Padua, 1467, by Pietro Lombardo; Tomb of Cristoforo Ricinense by Giovanni Minello, of which only a fragment now exists in the Museo Civico, Padua, but whose form is preserved in a drawing dated 1483, in the Archivio Notarile, Padua.

[38] Examples include the Tombs of Filippo Lippi (d. 1469) by Filippino Lippi, Duomo, Spoleto; Antonio (d. 1498) and Piero (d. 1496) Pollaiuolo, S. Pietro in Vincoli, Rome; Andrea Bregno (d. 1506), S. Maria sopra Minerva, Rome; Andrea Mantegna (d. 1506), S. Andrea, Mantua.

a space which, by virtue of its height and its recession, becomes a separate architectural environment within the church, ennobled by its coffered barrel vault, its lavish moldings, its rich incrustation of colored marbles and its gilding. Yet this room is no more than a setting for the sarcophagus, bier and effigy which fill its breadth and depth entirely.

Further, the tomb was adaptable to almost any site. Unlike the Coscia Tomb (Fig. 161), erected between two columns of the Florentine Baptistry and in part suspended from its entablature, the Bruni Tomb provided its own frame. Unlike the Brancacci Tomb (Fig. 162), it projected very little beyond the plane of the wall and therefore did not obstruct the flow of traffic in the aisles. Indeed, it required no special architectural features beyond a wall of sufficient thickness to permit the excavation of a very shallow niche.

The importance accorded the effigy (Fig. 49) also must have impressed favorably those whose sense of their own worth is demonstrated by their commission of a monumental tomb. Largest in scale and most plastically carved, the effigy dominates the other sculpture of the tomb. Its *raison d'être* is narrative or historical not decorative or functional like that of the *stemma*-bearing putti. Elevated on sarcophagus and bier, the effigy is located approximately in the middle of the tomb. It is set off against the plain dark background of red marble slabs. The scale of the effigy corresponds to, and possibly determined, the scale of the figures in the lunette, necessitating their representation in half-length.[39] Indeed, the effigy furnished Rossellino with the module of the Bruni Tomb determining the circumference of the outer rim of the medallion in the lunette (2 times), the height of the order (2 times), the height at which the effigy is placed (mid-point of the order) and the height of the entire tomb (4 times).[40]

The size of the frame of the Bruni Tomb, its degree of projection from the wall and the variety, concentration and plasticity of its decorative motifs endow the frame with a disproportionate weight. Typical of the architect's mentality is the strict ordering of the sculptural and decorative elements of the tomb according to its architectural scheme. The height of the bases of the pilasters determines the height at which the sarcophagus is set. The size and shape of the niche determine the plan, elevation and dimensions of the sarcophagus. The sculpture is never allowed to wander over the tomb according to the will of sculptor or decorator, but is strictly contained within frames whose dimensions and forms are determined by the architecture, and whose function echoes that of the pilasters and arch. A continuous frame surrounds the lunette, and another frame containing the Madonna and Child, is inserted within it (Fig. 63). The genii are contained within a frame which surrounds all four sides of the front of the sarcophagus (Fig. 50). Unlike its archetype in antique sarcophagi, the lion's head is circumscribed by a medallion (Fig. 83). Even the front faces of the plinths of the pilasters are framed (Fig. 49). Where there is no frame the sculpture itself seems to adopt the format of a frame, as in the eagles whose silhouettes, filling all four corners and defining all four sides, create a rectangle (Fig. 51). In spite of falling freely, the cloth of the bier forms a parallelepiped (Fig. 50). Even the shape of the supports of the sarcophagus approaches a rectangle (Fig. 52). Unlike Michelozzo's base for the Aragazzi Tomb (Fig. 154), carving does not obscure the straight profiles at the edges of the Bruni base (Fig. 49).

Straight vertical or horizontal lines prevail. Rossellino hardly tipped the effigy forward (Fig. 50), for a steep inclination would have undermined the composition's architectural

[39] H. W. Janson, "An Unpublished Florentine Early Renaissance Madonna," *Jahrbuch der Hamburger Kunstsammlungen*, xi, 1966, p. 32, n. 7.
[40] See Catalogue (App. 1).

stability. Supports are clearly visible and are more than sufficient to bear the weight they carry (Fig. 49). While the tomb is by no means flat, planes, frequently aligned, invariably parallel, predominate. The flatness of the face of the sarcophagus is hardly disturbed by the two small genii in low relief. The eagles are parallel to the back wall and are united in a continuous plane with the brocade which, in turn, occupies the same plane as the front of the sarcophagus. The plane of the frieze of the base is aligned with that of the shafts of the pilasters and the frieze of the entablature. The lowest base occupies the plane of the arch.

Yet deviations from this rigid architectural system, too slight even to pass the threshold of perception, endow the tomb with vitality. The epitaph is located 1.15 cm. to the right of center in accordance with the normal path of the observer's vision (Fig. 50). There is a margin below the epitaph but its upper edge overlaps the molding of the sarcophagus. Thus the tablet seems borne by the flying genii rather than immovably fixed to the surface of the *cassone*. This impression is reinforced by the shifting of the inscription up and to the right. Neither of these dislocations occurs in the Ghibertian prototype of the Bruni sarcophagus (Fig. 165).

The proportions of the effigy of Bruni (Fig. 53) are a normative seven heads. Bruni's elbows rest loosely against his sides, his legs are spread apart slightly and his feet rise almost perpendicularly, providing him with a vertical boundary. The central fold between his legs marks the central longitudinal axis of the effigy. In spite of the fact that it was never intended to be seen from above, Bernardo imposed upon the drapery, as well as on the figure, a nearly symmetrical composition, not less finished on the farther, than on the nearer, side.

Bruni's robe gives the impression of a soft, heavy wool. The drapery adheres to the legs, revealing their contours. In accordance with Bruni's supine pose, the drapery sinks on either side of his legs. Around his ankles play folds that the force of gravity would eliminate if the figure were standing up. Folds are generally tubular, sometimes more than semicircular in transverse section. Where folds are crushed by the book their surfaces are slightly concave, but the edges of these folds arch and dip under until the fold becomes hollow. In spite of their plasticity, the folds produce a linear pattern, one conditioned by the repetition or correspondence of folds. Apart from the legs proper, folds are regularly and closely spaced and are either parallel or mirror images of one another. Folds are long and continuous and for the most part, longitudinal. Throughout their extension they hardly vary in width or degree of projection. They change direction only near the hem, sometimes turning back upon themselves. The curvature of the folds—extremely subdued until close to the hem—is similar in St. Donatus's drapery (Fig. 18): the acceleration of the curve never causes the fold to begin an upward swing and reverse curves are systematically avoided.

A little further than midway down Bruni's right sleeve (Fig. 55) the style changes so radically that the robe seems made of another material. A comparison of this drapery with the drapery that falls over the right arm of the Nori Madonna in S. Croce (Fig. 169) suggests that the young Antonio Rossellino[41] was given this portion of the effigy to execute. The volume of the individual folds is reduced and folds overlap one another without any appreciable increase in the volume of the whole. The edges of the folds are

[41] For Antonio's biography, see Chronology (App. 2). Antonio was born in 1427 or 1428. The first docu- mentary notice of his activity dates from October 31, 1449.

extremely thin, indeed, sometimes no more than an incision. The drapery turns over upon itself innumerable times and each time it does there is a broken line, an angle, an indentation or a bump. The outline of the sleeve constantly oscillates, accommodating itself to unexpected hollows or sudden bulges. Instead of the long, continuous curves, there are short curves which abruptly break or change direction, or short, straight lines. Curves move rapidly, completing a semicircle or more within a narrow space. The outlines of folds quiver almost imperceptibly. The surface of the drapery is corrugated but indentations barely penetrate the surface of the stone and through gradations imperceptibly become bulges. Thus they differ from the deep and definite indentations around the elbow, and unlike that drapery, where the ridges between hollows produce an interweaving pattern, the relation of concavities to convexities is amorphous. This drapery gives the impression of a semifluid material that has assumed for the moment a certain configuration on its surface but that in another moment will surely have another.

The style of the opposite sleeve, the *foggia* and *becchetto* of Bruni's *cappuccio* down to the level of his knee and the folds on the effigy's chest reveal the intervention of the young Desiderio da Settignano (Figs. 53, 55).[42] Unlike the folds which curve around the nearer arm in a continuous line until they meet the body or book and disappear, the folds of the farther arm suddenly switch direction at the top of the arm in order to follow its contour. Thus they fail to provide a continuously receding path which would elucidate the volume of the arm. In just this way is the drapery on the shoulder of the Christ Child in the Louvre *tondo* of Christ and the Baptist (Fig. 171) treated. The volume of the farther arm is considerably less than that of the nearer arm and its surface is much flatter: folds hardly project and hollows are systematically avoided. Instead of cutting back and into the stone so that forms might appear to revolve and recede, Desiderio clings to the pristine surface of the block much as he does in the Pietà from his tabernacle in S. Lorenzo (Fig. 174), where, in spite of the considerable depth of the relief, the surface is hardly less flat than *schiacciato* relief. The adherence of folds to a uniform plane is especially obvious in the *becchetto* where all folds project to an equally small degree and the hollows between the folds fail to penetrate the entire depth of the strip, as though the *becchetto* consisted of two layers of different materials. The surfaces of folds are almost perfectly flat or irregularly pitted. Their edges are neatly sliced, forming perpendicular walls, or else are defined by mere incisions that belie the heaviness of the material. Instead of the gentle curves of the

[42] Desiderio was born in 1428-29 (see the *catasto* of March 27-28, 1458: Clarence Kennedy, "Documenti inediti su Desiderio da Settignano e la sua famiglia," *R. d'arte*, xii, 1930, pp. 270ff, doc. 11) or in 1431 (see the *catasto* of December 20, 1459: *ibid.*, pp. 272ff, doc. 13). A *catasto* of 1451 calls Desiderio, as well as his father, Meo and his brothers, Francesco and Geri, "scharpellatori" (*ibid.*, pp. 263f, doc. 4). On June 20, 1453, Desiderio matriculated in the *Arte dei Maestri di Pietra e Legname* (*ibid.*, pp. 265f, doc. 6). On August 1, 1461, Desiderio's Tabernacle of the Holy Sacrament was immured in S. Lorenzo (Domenico Moreni, *Continuazione delle memorie istoriche dell'ambrosiana imperial basilica di S. Lorenzo di Firenze*, Florence, i, 1816, p. 15, n. 1). Desiderio was paid for a design for the Cappella della Madonna della Tavola in the Duomo, Orvieto, in 1461 (Kennedy, op. cit., *R. d'arte*, 1930, pp. 274f, doc. 15). On October 7, 1462, he received two florins for a head of the Cardinal of Portugal made in connection with his tomb (Hartt, Corti, Kennedy, p. 144, doc. 8; M. C. Mendes Atanásio, *A capela do Cardeal de Portugal em Florença à luz de novos documentos*, Milan, 1961, p. 33, doc. 32). Desiderio was buried on January 16, 1464 (Kennedy, op. cit., *R. d'arte*, 1930, p. 275, docs. 16, 17). For other documents concerning Desiderio, see the article by Kennedy cited above; Gino Corti and Frederick Hartt, "New Documents concerning Donatello, Luca and Andrea della Robbia, Desiderio, Mino, Uccello, Pollaiuolo, Filippo Lippi, Baldovinetti and Others," *AB*, xliv, 1962, pp. 163ff, docs. 13, 14, 15, 17, 19, 21; John R. Spencer, "Francesco Sforza and Desiderio da Settignano: Two New Documents," *Arte lombarda*, xiii, 1968, pp. 131ff.

right sleeve (Fig. 54) which operate in depth as well as on the surface, there are long, straight diagonal folds, which, like the fold which traverses the chest of the infant in the Mellon collection in Washington (Fig. 181), streak across the surface of the body, seeking the most direct route to the outer edge of the figure. These strip folds would be absolutely straight if it were not for the slightly irregular quiver of their outline. On the *becchetto* sharp ridges arise between arbitrary identations, and a long strip fold forks off, zigzagging across the surface like the fold on the torso of the candelabra-bearing angel on the right of Desiderio's S. Lorenzo Tabernacle (Fig. 176).

Bernardo's face of Bruni (Figs. 57, 58, 59), based on a death mask, reveals the effect of a terrible illness, perhaps of a stroke, which paralyzed one side of his face. While the flesh and features of the right side of the face are contracted and taut, the left side of the face is relaxed, the mouth is askew and the right eyeball is sunk into the orbit of the eye. Other features, like the accentuation of the orbit of the eye by the undercutting of the brow, the disappearance of the upper lip and the absence of a contour in the lower lip, either reproduce the effects of death on the physiognomy or are typical aspects of death masks. Indeed, the hair of the brows is flattened down and the lashes are stuck together as though imbedded in a soft and humid substance. The shape of the ear is so very odd that it must be a faithful imitation of Bruni's ear, for no Quattrocento artist would have evolved as his schema a form so abnormal.

The right side of Bruni's face is not as highly polished as the left even though an ordinary spectator would have seen more of the right than the left side. It may be that Rossellino wished to counteract artificially the effect of light reflected upward and onto the right side of Bruni's face by the highly polished cushion below Bruni's head: to preserve the shadows that would normally gather there.

Bernardo's hand is evident also in portions of the genius on the right of the sarcophagus (Fig. 60): in the entire skirt of the chiton, the right two-thirds of the peplum and the drapery around the angel's right shoulder. The contours of the leg beneath the skirt are revealed by means of the divergence of folds at the thigh and their disappearance over the thigh and knee. Folds are long, continuous, tubular. A linear pattern is created by the alternation of narrow, projecting folds and wider flattened hollows. The pattern of folds in the skirt was made as regular as a sudden flurry of the garment permitted: the ripple of the drapery does not cause the folds to switch their lanes and the twisting of the material occurs in every fold at the same small distance from the hem.

Like the flurry of the skirt, the upward swing of the peplum beneath the wing announces the genius's flight. But at approximately the line of the crotch, the peplum ceases to respond to the figure's movement. The excessive indentation and straight contours of the folds above the arm make no concession to the volume of the chest. Here broad, flat folds with steep sides replace Bernardo's fine, cordlike folds. While the upper contour of the arm is organically persuasive, the lower contour is uncertain, lacks an elbow and belies the solidity hinted at by the muscular biceps. With the exception of the expertly foreshortened farther foot, the remainder of the genius, its wing, farther shoulder and face, is of the same low quality.

The similarity of the drapery in the lower half of Bruni's left sleeve (Fig. 55) and in the peplum of the genius on the left of the sarcophagus (Fig. 61) warrants an attribution of the figure to Antonio Rossellino. Here, as in the lower half of the genius's skirt, the cloth twists over on itself, causing folds abruptly to change direction and velocity. The surface

of the drapery is constantly, if hardly, indented and outlines must take account of sudden bulges and indentations. The outlines of folds are irregular and agitated and may break off unexpectedly. The hook folds near the border of the peplum reappear in Antonio's portion of Bruni's sleeve and the drapery of the Nori Madonna (Fig. 169). As there, all the folds of the peplum, regardless of position, inhabit a single plane and share one degree of projection. The small patches of shadow created by the scattered drilling at the bottom of the genius's skirt also dapple the Madonna and Child (Fig. 182) and the palm-bearing angel from the Tomb of the Cardinal of Portugal (Fig. 184).

The drapery covers a robust body but only in the chest is the anatomy revealed. Antonio does not mark the juncture of hip and thigh by the confluence of two folds, or the crotch by the disappearance of folds. Nor does Antonio indicate the recession of forms in space: the hips are not foreshortened and the diminution in the height of the relief does not accord as consistently with the recession of the form as it does in Bernardo's genius.

The face of the genius (Fig. 62) resembles most closely the face of St. Sebastian in the Museum of the Collegiata at Empoli (Fig. 187). Both have wide-open eyes and heavy lower lids. The corners of the mouth are drilled. The lips are parted slightly. The thin upper lip with its emphatic curves disappears well before the corners of the mouth. The contour of the lower lip is indented in the center. The chin, which begins considerably below the lower lip, is very broad and prominent. The turning of the head creases the neck.

As in Bernardo's face of the Empoli Virgin (Fig. 40), the farther side of the face has been pulled forward: the farther nostril and eye and the farther side of the mouth do not recede at all. Concurrently, the slope of the nose on the farther side of the face has been reduced and the eye is moved closer to the nose. Thus the farther perimeter of the face remains in view while the illusion of recession is maintained by the accentuated overlapping of the inner portions of the farther eye and cheek.

The bungling of an assistant has marred the forward arm and leg of this genius, as well as the wings and clouds. The slit in the skirt is placed considerably above the knee and is closed below although the purpose of such slits was to remove all impediment of drapery from around the knee. Moreover, the slit has been made in a piece of drapery already parted to the thigh, and the button, which would have justified the star-shaped configuration of tiny wrinkles, has been omitted.

Like the effigy of Bruni, three different sculptors carved the Christ Child in the lunette (Figs. 64, 65). The design and major portion of its execution are Bernardo's; the right leg of the figure was carved by Desiderio; the folds between the fingers of the Madonna's right hand were carved by the assistant responsible for her hand. Typical of Bernardo is the pose of the figure—an orthodox contrapposto deployed within a single plane. But where Bernardo would have turned the knee of the free leg to the right, causing the leg to be seen in three-quarter view, the knee is turned forward, instead, and the leg is seen from the front. Thus the silhouette, from right armpit to ankle, is kept within the bounds of a vertical line. Precisely this treatment of the free leg characterizes the contrapposto of Desiderio's Christ Child in his tabernacle in S. Lorenzo (Fig. 180). In both, this modification of an orthodox contrapposto creates the impression that some of the body's weight rests on the right leg, as though the figure were about to take a step forward or had just finished doing so.

Where the movement of the figure corresponds to Bernardo's other works, the drapery

does too. As in his genius on the sarcophagus, the drapery is of a soft and malleable stuff which adheres to the body, disclosing the anatomy. As in the woman seen from behind in Ghiberti's panel of Jacob and Esau from the Gates of Paradise (Fig. 188), folds diagram the movement of the figure. From the raised right shoulder where all the folds are gathered, the drapery falls, curving left and up, signaling the thrust of weight-bearing hip. On the left hip the folds are gathered up a second time, creating a climax at the climax of movement. From the hip, folds flow across the leg in the opposite direction, leading the eye towards what was, no doubt, intended to be the outward thrust of the right knee. Here, the movement of folds as well as the movement of the body is interrupted.

On the torso of the Christ Child there are the long cordlike folds which merge imperceptibly into the hollows between them. Of approximately equal length, evenly spaced and parallel to one another, they curve only near their termination. On the left leg is the projecting strip with rounded edges and concave surface that appears in the effigy of Bruni (Fig. 53). Between the fingers of the Madonna an assistant carved three repetitious folds which truncate rather than overlap the folds executed by Bernardo. The folds are separated from one another by a mere incision, and the straight outlines of the folds shift after the interruption of the fingers as though the folds were discontinuous. At the contour of the right leg the pattern also changes. Either the folds disappear completely and a new fold arises out of what, on the left leg, was a hollow or a change in the direction of the fold produces an angle. The left leg is traversed by Desiderio's habitual strip fold with its very slightly quivering outline. Beneath the knee the fold forks like the fold on the torso of the candelabra-bearing angel on the right of Desiderio's tabernacle (Fig. 175). In both the angel and the Christ Child fine folds flash across the lower part of the leg, and where the contour of the leg is not disturbed, the drapery seems to vanish. A hiatus in the pattern of folds at the juncture of hip and thigh throws an uncomfortable emphasis on the point at which the movement of the figure breaks, an emphasis which also characterizes the movement of the candelabra-bearing angel (Fig. 176). The top of the thigh is sliced off flatly and forms an angle with the facet of the inside of the thigh.

The locks brushed forward and the rectangular hairline of the Christ Child (Figs. 69, 70) are identical to the hair of the left-hand angel in the Aretine relief of the Madonna del Manto (Fig. 13). But it is the face of the Virgin Annunciate from Empoli (Fig. 40) that the face of the Christ Child resembles most. In both faces the brow consists of the sharp edge created by the juncture of the orbit of the eye and the forehead which projects very slightly to meet it. The brows are hairless and the brow itself practically disappears midway over the eye. The upper lid of the eye is lowered to give the impression of a downward glance. The upper contour of the lid is clearly marked by a sharp incision. A second, weaker and parallel incision is found directly beneath it. The lower contour of the upper lid is straight. The upper and lower contours of the upper lid do not meet at the corners of the eye. The obtruding eyeball seems squeezed between the lids. The rounded tip of the nose descends below the slightly flaring nostrils. The distance from nose to mouth is short. The mouth is small and the lips—especially the upper lip—are short and narrow. Because the caret is only faintly indicated, the center of the upper lip barely descends over the lower lip. The edges of the mouth curve up very slightly, ending in small, shallow, circular indentations from which oblique indentations run outward and downward. The lower lip lacks a precise contour. The chin, barely pointed, is very small and projects very little. The same distortions appear in both faces. The farther side of the face recedes less

than the nearer side. The farther eye and swelling of the farther cheek are located nearer the nose. The slope of the nose and nostril on the farther side of the face and the farther half of the mouth are smaller than the corresponding parts on the nearer side of the face. The gradual arching of the farther brow, accentuated for the sake of a decisive silhouette, produces a continuous line connecting nose and brow.

The face of the Madonna (Figs. 67, 68) which bears no resemblance to the Virgin Annunciate, can be attributed to Desiderio da Settignano. A comparison of the face of the Madonna with the Madonna from Desiderio's Panciatichi relief in the Bargello (Fig. 189) reveals a similarity of proportion. In both, the heads are long while the features occupy less than the lower half of the head. The extreme height of the spherical forehead is increased by the location of the hairline beyond the curve of the skull. The eyebrows, raised high above the lids, describe perfect arcs. Barely indicated, they protrude hardly at all from the surface of the face. The eyes are not recessed and lowered lids preserve the integrity of the surface. The sharp cutting of the lid back to the flat, recessed surface of the eyeball produces the customary outline of shadow. The nose is very narrow. The nostrils, too, are narrow and do not curve. Almost equivalent to Desiderio's signature is the open and deeply undercut mouth. One senses the tongue inside the mouth of the Madonna as one does in the figures of the Pietà from the S. Lorenzo Tabernacle (Fig. 172). As in the Christ and St. John in the *Tondo* Arconati in the Louvre (Fig. 171), the lips are very thin and narrow. The prominent caret influences the lower contour of the upper lip. The upper lip is clearly defined by a salient line along its border and by the indentation of the lip itself. The semicircular corners of the mouth have been drilled. The surrounding form makes so few concessions to these indentations that the skin, stretched taut, seems punctured by the corners of the mouth. As in the Panciatichi Madonna there is a slight depression directly beneath the lower lip which is succeeded by the round, blunt chin.

The hair of the Madonna is closest to the hair of the youthful Baptist in the relief in the Bargello (Fig. 192). There we find locks of the same thickness, with faceted and slanting sides, separated by incisions. The rapid rippling of the locks indicates extremely wavy hair—a plausible excuse for the tousled locks that Desiderio prefers.

The similarity of Desiderio's facial type to that of Domenico Veneziano, especially as it appears in the Madonna in the Berenson collection (Fig. 190), indicates that Desiderio was strongly influenced by Domenico. Common to both is the egg-shaped face with its extremely high, broad and spherical forehead, relatively narrow jaws and blunt, round, chin. The geometrically perfect brows arch high above the eyes. In both, the brow is a mere line, unaccompanied by any projection of the form. The eyes barely penetrate the surface of the face while the downward glance draws down the upper lid, canceling the recession of the eyeball. The lower contour of the upper lid dips down almost imperceptibly; the upper contour of the lower lid curves down just slightly more. The tear ducts are very large and wide, tilted downward slightly and continuously curved. Immediately below the lower lid there is the barest indentation. The cheeks hardly protrude.

With the exception of the face carved by Desiderio, the Madonna is the most disappointing portion of the tomb (Fig. 66). The proportions of the figure are appropriately grandiose, but the large body does not accord with the rather small face and the hands are too large for the body. The rigid body tilted backwards slightly and the upright neck are not organically connected with the turned and downward tilted head. The right hand is unaccountably twisted and the protruding knuckles seem made of dough. The left arm

has no independent plasticity. Vertically, its surface is flat, but it curves horizontally, accommodating itself to the protrusion of the stomach. The right shoulder which ought to have ended at the border of the headdress, continues nearly to the head of the Christ Child. The contours of the Madonna are smooth and closed, creating a sort of broad-based triangle which enhances the effect of majesty and concentrates the spectator's attention on the figure's head. But the tedious design of the folds, derived from the drapery of Michelozzo's Madonna in the lunette of the Coscia Tomb (Fig. 161), destroy this effect. Though there is much movement back and forth in the surface of the relief, the gradation in its height is not related to the recession of the form.

The treatment of the marble in the veil of the Madonna is almost identical to that in the skirt of the Annunciate Virgin from Empoli (Fig. 35). In both there is the same confusion in the pattern, the same multiplicity of nearly vertical lines, the same rutted surface. In both, the surface is dappled by numerous small, irregular patches where the drapery adheres to the surface. Rising suddenly from the edges of these patches are narrow ridges whose width constantly contracts and expands and which writhe according to no perceptible design. The contours of these ridges are slightly undercut by a string of drill holes. The crimping of the border of the veil at the forehead and temples of the Madonna appears on a larger scale in the hem of the cloak over the left foot of the Virgin Annunciate. The border of the headdress on the left side of the Madonna's chest, with its slightly quivering hem which turns over on itself and at the turning is drilled, resembles the hem of the Virgin's cloak above her left knee. The bodice and belt are treated identically in both. The small dark patches in the cloak of the Empoli Virgin which manifest the improvident use of the drill are visible here, too, where the cloak envelops the Madonna's left elbow.

But the Madonna differs from the Virgin in its proportions, frontality, lack of movement, simplicity and symmetry of design. These differences are fundamental enough to suggest that while both figures were executed by one person, one was designed by another. Judging from the drapery pattern of the two figures—a pattern characterized by a plethora of small folds heterogeneous in form and confused in arrangement—I conclude that the executant of the two figures is not likely to have designed the grandiose Bruni Madonna. In all likelihood its designer was Bernardo although its style has been so altered by its execution that the attribution cannot be proved.

The gesture of the arms of the angel in the right of the lunette (Fig. 72), the tilt of its head, the movement of its left leg, betray a certain energy. The pattern made by the folds of the peplum is pleasing and the loop of the opening of the cloak harmoniously corresponds to, without repeating, the contour of the nearer arm. Nevertheless, these felicities of composition do not make up for the absence of foreshortening in the farther elbow, the misplacement of the nearer shoulder, the peculiar disappearance of the cloak at the waist of the figure and the moronic expression of the face. The head of the angel (Fig. 74), particularly its jaws and mouth, is related to the head of St. Donatus from the Palazzo della Fraternità at Arezzo (Fig. 24) by that assistant hypothetically identified with Domenico Rossellino. It is likely that this angel is his as well.

The angel on the other side of the lunette (Fig. 71) is by another sculptor. This sculptor lacked Domenico's energy as well as his ambition to suggest a spatial ambience through which the angel moves. The angel is seen very nearly from the front which makes the absence of one wing particularly disturbing. While appearing to stand perfectly upright,

the angel tilts inward slightly, as though his movement were determined by the shape of the field he inhabits. As a consequence, he more nearly fills the corner of the lunette than the angel on the right and his outlines more pedantically follow the outline of the arch. Nevertheless, this assistant avoided the mistakes in foreshortening and the handling of relief that Domenico committed. Where he was not able to make the elbow turn properly, he concealed it beneath a voluminous sleeve.

In style, this angel is related to works by Antonio Rossellino. The cloak fastened rather low on the chest, pulled by the elbow into taut diagonal folds, presages the design of the Nori Madonna (Fig. 170) and the Madonna from the Tomb of the Cardinal of Portugal (Fig. 182). The angel's face is similar to the face of Antonio's later palm-bearing angel on the right of the Tomb of the Cardinal of Portugal as well as to its faithful copy in the crown-bearing angel on the left (Fig. 183). Yet its quality does not justify an attribution to Antonio.

The putti above the arch are by Buggiano (Figs. 75, 78).[43] The head of the putto on the left (Figs. 76, 77) is closest to the head of the putto on the right of Buggiano's lavabo in the north sacristy of the Duomo, Florence (Fig. 194). Common to both are the square face which recedes only at its perimeter, the hemispherical cheeks with deep, round dimples immediately beneath them, the broad nose with its tiny nostrils, the small, flat dimpled chin. The arched strip of the upper lid and the much larger and fleshier lower lid, which project as though to accommodate an excessively protuberant eyeball, are typical of Buggiano. Above the outer half of the eye there is a bulge which is succeeded at the corner by a pronounced indentation. The thick, everted lips are of identical length and the contour of the upper lip resembles a Cupid's bow. The locks of hair flow downward in accentuated waves from the central part, forming plastic borders of corkscrew curls on either side of the face. Many of these peculiar features can be explained by Buggiano's attempt to portray an expression of glee: they appear in the infantile revelers on antique scarcophagi and were adopted to portray childish mirth by Luca della Robbia in his Cantoria and by Donatello in his putti in the Baptismal Font in Siena and the Cantoria and in the "Atys-Amorino" in the Bargello.

Both the smiling putto from the Bruni Tomb and the laughing putto from the lavabo of the north sacristy have serious mates (Figs. 79, 80, and 193) whose faces are extremely

[43] Andrea di Lazzaro Cavalcanti, known as il Buggiano from his birthplace in Borgo a Buggiano, was born in 1412-13. At the age of five he went to live with Brunelleschi, remaining with him until the latter's death and inheriting his estate. (See Buggiano's *catasti* of 1433, 1442, 1447, 1451, 1458: C. von Fabriczy, *Filippo Brunelleschi*, Stuttgart, 1892, pp. 522ff.) Buggiano died on February 21, 1462 (Vas-Mil, ii, p. 384, n. †). Extant works secured to him through documents are: the Tomb of Giovanni d'Averardo de' Medici and his wife, Piccarda de' Bueri in the Old Sacristy, S. Lorenzo and the marble altar there inscribed with the date, 1432 (Fabriczy, *op. cit.*, pp. 518f, doc. 3; p. 522, doc. 1); the lavabo in the north sacristy of the Florentine Duomo, probably 1432-40 (Fabriczy, "Brunelleschiana, Urkunden und Forschungen zur Biographie des Meisters," *JPK*, xxviii, 1907, Beiheft, pp. 35, 39; G. Castellucci, "I lavabo del Buggiano nelle Sagrestie di S. Maria del Fiore," *L'Illustratore fiorentino*, 1911, pp. 133f); the lavabo in the south sacristy of the Florentine Duomo, probably 1442-45 (*ibid.*, p. 134); the pulpit in S. Maria Novella, 1443-48 (Giovanni Poggi, "Andrea di Lazzaro Cavalcanti e il pulpito di S. Maria Novella," *R. d'arte*, iii, 1905, pp. 79ff; Fabriczy, *op cit.*, *JPK*, 1907, Beiheft, pp. 11ff; Kennedy, *op. cit.*, *R. d'arte*, 1930, pp. 264f, doc. 5); the Bust of Brunelleschi in the Florentine Duomo, 1447 (Cesare Guasti, *La cupola di S. Maria del Fiore*, Florence, 1857, pp. 55ff, docs. 119, 120, 121; G. Poggi, "La 'maschera' di Filippo Brunelleschi nel Museo dell'Opera del Duomo," *R. d'arte*, xii, 1930, p. 538). On the basis of its style and its location near the birthplace of the artist, the Cardini Chapel in S. Francesco, Pescia, dated by inscription to 1451, is invariably included among the works of Buggiano.

similar to one another. In addition to the features mentioned above, there is the nose which looks as though it had been broken. Noticeably contracted at the bridge, squashed until the tip, it curves around to the left so that one nostril is considerably higher than the other. The cheeks are fullest opposite the mouth and chin. The dimpled chin is bounded by oblique indentations.

But the face closest to that of the putto on the right is the face of the cherub in the left spandrel from the entrance to the Cardini Chapel in S. Francesco, Pescia, of 1451 (Fig. 191). The similarity of these two heads encourages a dating for the upper portion of the Bruni Tomb as close as possible to 1451, a date supported by the evident haste with which the putti were installed.

The anatomy of the putti from the arch (Figs. 75, 78) is comparable to that of the figures from the lavabo in the south sacristy of the Duomo (Figs. 195, 196). In all four figures the torso is exceptionally long, the legs are short, the head is large and the neck is almost nonexistent. The hemisphere of the stomach is encircled by a continuous indentation; another indentation runs from clavicle to navel. The navel occurs very high on the stomach—indeed, just below the waist. The rounded shoulders give way too soon to the biceps of the arm. A second indentation occurs approximately in the middle of the upper arm. Opposite the elbow there are two linear indentations. Above the wrist the flesh swells, surrounding the arm with two tires, the upper one less prominent than the lower one. Characteristic of Buggiano are the inflated thighs, the egg-shaped protrusions at the knees, the double tires encircling the legs just above the feet and the sharp separation of ankle and foot which makes the putti seem to be wearing tightly fitting leggings. The strip of drapery which traverses the leg of the putto on the right of the arch with its long, thin, parallel, curving folds and occasional fine hairpin-shaped indentations is identical to the swathes of drapery behind the putti of the lavabo.

A number of Buggiano's idiosyncrasies in the description of anatomy are encountered in the second putto from the right on the base of the Bruni Tomb (Fig. 82). The long torso, high, circular navel, short legs, nonexistent neck and large head are typical. Indentations designate the waist and rib cage high beneath the prominent breasts and encircle the tumescent stomach. The knee is an egg-shaped protrusion where the surface of the leg contracts and wrist and ankle are surrounded by a tube of fat. The weight-bearing foot is identical to the corresponding foot of the putto on the right of the Bruni arch: the heel, delimited by a diagonal indentation, is much too small; the arch, cut back too far towards the heel, is very high and above it, the foot is swollen.

Buggiano's putto, including facial type and to a certain extent, relief technique, derives from its mate, the second putto from the left on the base of the Bruni Tomb (Fig. 81). Indeed, where the other putti reverse the poses of their opposite number on the other side of the base, the pose of Buggiano's putto is identical to that of the second putto on the left. By far the best putto of the frieze, it is attributable to Desiderio. Anatomical mistakes are negligible. Unlike Buggiano's putto, movement is convincingly interpreted in terms of the ponderation of the body, and the foreshortening of the torso makes its twist in space entirely credible. Desiderio's characteristic treatment of relief is visible here, especially in the nearer arm and hand and farther leg (Fig. 85). As in his Pietà from the S. Lorenzo Tabernacle (Fig. 174), the relief is very flat: the edges of the forms do not recede and there is only the slightest modulation of the surface. But unlike Donatello's equally *schiacciato* relief, the flattened limbs stand away from the background to a considerable extent.

The edges of the forms, which in ordinary relief would recede gradually to the plane of the background, are undercut: forms are connected to the background by a continuous, smooth facet which slants inward and meets the background at an angle of forty-five degrees. The juncture of this facet causes a line of shadow to circumscribe the figure, visually detaching it from the ground.

The straight outlines of the figure which collide with one another at the joints produce the same lines and sharp angles that a transverse section of the relief would make. The contours of the nearer arm of the putto are sliced off as though by a paper cutter and the straight line of the shin of the forward leg, which continues uninterrupted into the knee, makes a right angle at its juncture with the upper leg. Equivalent lines and angles abound in the figures and drapery of the S. Lorenze Pietà (Fig. 174). Like the hand of John the Baptist in the *tondo* in the Louvre (Fig. 171) and the lowered hand of Christ in the Pietà, the contours of the back of the putto's hand define a rectangle while the straight fingers are attached along a straight line perpendicular to the edges of the hand.

The face of the putto (Fig. 84) is reminiscent of the putto on the left of the Marsuppini Tomb (Fig. 168). The shape of both faces typically approaches a square. The projection of the features is reduced to a minimum, while all but the merest recessions are eliminated. Thus the features uniformly inhabit the frontal, relief-like plane of the face and the silhouette of the face makes a straight line. The forehead is wide and flat; the eyes are set far apart. The corners of the mouth end in indented points. The hair of the putto from the Bruni Tomb resembles the hair on the back of the skull of the Marsuppini putto.

The foreshortening of the face of the putto, unique among the putti of the base of the Bruni Tomb, reappears in the Christ Child from the Panciatichi relief (Fig. 189). As much of the skull is included as would be visible in a profile view but the features are represented in three-quarter view. Thus the nearer eye is hardly foreshortened, and a portion of the farther half of the mouth and the entire farther eye remain visible. To compensate for the diminution in the effect of recession which this causes, the farther eye is shifted close to the nose.

The correspondence of design of opposite putti on the Bruni base is not matched by correspondences of style: the remaining four putti (Figs. 87, 88, 89, 90) are evidently due to four different sculptors. The locks of the lion's mane in the center of the base (Fig. 83) are so similar to the hair of the cherub from the left spandrel of the Cardini Chapel that I am tempted to assign the medallion to Buggiano. Very likely he was also responsible for the lion in Bruni's coat of arms (Fig. 86).

The Tabernacle of the Sacrament in S. Egidio (S. Maria Nuova), Hospital of S. Maria Nuova, Florence

EXTANT payments for the Tabernacle of the Sacrament (Fig. 91) commence on February 11, 1450. The marble portions of the ciborium were completed by April 22, 1450. The bronze *sportello* was made over the following months in Ghiberti's shop.[1] The tabernacle was intended for the chapel of S. Maria Nuova in the women's ward of the Florentine Hospital of S. Maria Nuova. The Baroque console probably dates from the time of the transfer of the tabernacle to the main church of the hospital, S. Egidio.

In form, the S. Egidio Tabernacle is very similar to Buggiano's earlier tabernacle in S. Ambrogio, Florence (Fig. 197).[2] In both, the base, in the form of an entablature, supports fluted Corinthian pilasters. Above the upper entablature is a triangular pediment with a bust-length figure of God the Father who blesses with his right hand and holds a globe with his left. The central portion of the tabernacle is enclosed by an arch tangential to the pilasters and architrave. In both, secondary moldings circumscribe the spandrels. Above the rectangular *sportello* is a figurated lunette carved in low relief. Because of the Brunelleschian arches formed by continuous moldings, it has been suggested that both tabernacles derive from the tabernacle commissioned by Fra Giuliano Benini in 1426-27 for S. Jacopo in Campo Corbolini for which Brunelleschi probably supplied the design and oversaw the execution.[3] But the tabernacle no longer exists and there is no record of its appearance.

The architectural form of Buggiano's and Rossellino's tabernacles can, however, be traced to the Romanesque tabernacles produced in the Cosmati workshop during the thirteenth century. There, as in the tabernacle in SS. Cosmas and Damian, Rome (Fig.

[1] See Catalogue (App. 1).

[2] See Ursula Schlegel, "Ein Sakramentstabernakel der Frührenaissance in S. Ambrogio in Florenz," *Zeitschrift für Kunstgeschichte*, xxiii, 1960, pp. 167ff. Schlegel dated the tabernacle to the first half of the 1430s on the basis of its style. Caspary, *Sakramentstabernakel*, p. 17, suggested that the tabernacle of S. Ambrogio might be identical with Buggiano's lost tabernacle made between 1443 and 1447 for the Florentine Duomo. The documents make clear, however, that this was a free-standing ciborium and not a wall tabernacle. Indeed, it was apparently the first one of this type, preceding Desiderio's ciborium for S. Pier Maggiore by several years. See Giovanni Poggi, *Il Duomo di Firenze*, Berlin, 1909, pp. 218ff, docs. 1089, 1090, 1092, 1093, 1096 and esp. 1094 and 1098.

[3] Schlegel, op. cit., *Zeitschrift für Kunstgeschichte*,

1960, pp. 170f. For Brunelleschi's tabernacle, see Fabriczy, *Brunelleschi*, Stuttgart, 1892, pp. 23f and Carlo Carnesecchi, *Ricordi di una cena nuziale*, Florence, 1899, pp. 6f. To be sure, arches formed by moldings which do not break at the springing but continue to the base were used by Brunelleschi to frame niches or entrances to chapels or openings in every one of his constructions. But the same motif, used, as here, to bind together aedicule and round-arched niche, occurred prior to Buggiano's tabernacle in the bishop's staff of Donatello's St. Louis, 1423-25; the niches enframing the Virtues of the Coscia Tomb, 1425-27; the tabernacle of the Baptismal Font in the Sienese Baptistry, 1427-30. This is not to say, however, that Brunelleschi could not have influenced the form of Buggiano's tabernacle.

198),[4] columns resting on a narrow, oblong base and supporting a lintel and a triangular pediment enframe the central rectangular area containing the *sportello*.[5] The Romanesque source of Buggiano's tabernacle speaks in favor of Brunelleschi's influence on its design, for it corresponds to Brunelleschi's own dependence on that architecture which he often mistook for Roman. That this form proved congenial to Bernardo indicates on his part too a basic sympathy for Romanesque architectural forms already demonstrated by the sources of the Bruni Tomb.

Nevertheless the S. Egidio Tabernacle did incorporate motifs evolved by its Gothic predecessors. If Bernardo's tabernacle had a triangular console similar to the one which presently exists, its source was in the tabernacles of the late fourteenth and early fifteenth centuries.[6] The carved lunette above the Renaissance *sportello* was a consequence of the substitution of Gothic arches for the Romanesque grid of post and lintel which left a space above the door for sculpture.[7] The Renaissance *sportello*, smaller and narrower than its Romanesque ancestor, originated as a response to the exigencies of a Gothic superabundance of architectural motifs which left much less room for a door. The embellishment of the tabernacle with figurative sculpture was also a bequest of the Gothic tabernacle. A blessing half-length figure of God the Father is sometimes found in the gable of Gothic tabernacles.[8] Bernardo's adoring angels were borrowed from a work of the International Style: in the tabernacle in the crypt of the Duomo at Fiesole (Fig. 199) two angels similarly garbed and posed and identical in type and scale flank the *sportello*.[9]

The relatively steep pediment and the moldings, including closely spaced channels, of the S. Egidio Tabernacle may derive from Luca della Robbia's Peretola Tabernacle (Fig. 200). In both, the spandrels are filled and the bases have the same proportions. The unorthodox ornamentation of the frieze of the S. Egidio Tabernacle comes from the frame of Donatello's bronze doors in the Old Sacristy of S. Lorenzo (Fig. 201), while its application to the frieze of the aedicule may have been inspired by Donatello's tabernacle in St. Peter's (Fig. 202).

The architecture surrounding the *sportello* is generally described as a barrel-vaulted hall. But the perspective construction in which the foreshortening of the angels—particularly the angel on the left—and the gradual tilt of the ground plane indicate a point of sight midway up the height of the *sportello*, while each pair of orthogonals of the vault establishes its own vanishing-point at the top of the *sportello*, does not define a room whose lateral walls are perpendicular to its rear wall. Moreover, the extreme shallowness of the

[4] Other examples include the tabernacles in Rome in S. Crisogono, S. Maria Egiziana (the Temple of Fortuna Virile), S. Sabina, S. Maria in Trastevere and the tabernacle in S. Francesco, Viterbo. The tabernacle in S. Cecilia, Rome, by Vassalletto is now missing its upper and lower parts but originally, no doubt, was identical in form.

[5] The form of the Cosmati tabernacles is closely related to the windows of the incrustation style as they appear in Romanesque church facades in Tuscany, e.g. the Florentine Baptistry, S. Miniato al Monte, and undoubtedly had its source in the architecture of Roman antiquity.

[6] See the tabernacles in S. Vittore, Feltre; the Tolentino collection, Florence; the crypt of the Duomo, Fiesole.

[7] See the tabernacles in the Tolentino collection, Florence; SS. Felice e Fortunato, Vicenza, early fifteenth century; Museo Civico, Vicenza, 1427; Collegiata, Castiglione d'Olona; S. Vito, Treviso; S. Eugenio, Villa di Monastero, Siena.

[8] See the tabernacles in S. Eugenio, Villa di Monastero, Siena, and S. Simone, Florence (contained within a terracotta frame of the Della Robbia school).

[9] See Odoardo H. Giglioli, *Catalogo delle cose d'arte e di antichità d'Italia*, Fiesole, Rome, 1933, p. 121. The tabernacle is undated but the coat of arms on the console seems to be that of Roberto Folchi, Bishop of Fiesole from 1481 to 1504. Nevertheless, as Caspary, *Sakramentstabernakel*, pp. 15, 125, n. 30 observed, its (Gothic) style renders such a dating impossible.

structure, whose openings hardly suffice to accommodate the angels, is difficult to reconcile with a barrel-vaulted hall which, as Desiderio's tabernacle in S. Lorenzo shows (Fig. 173), could be vastly extended by slight manipulations of scale.

The apparent errors in perspective, however, are justified if the lateral walls and barrel vault are intended to be splayed. Splaying accounts for the relatively slow diminution in the scale of the coffers and the fact that the height of the foreshortened equilateral coffers exceeds their width by very little. If the walls and vault are splayed then Bernardo must have intended to reproduce the porch of a Renaissance church and not a hall. The splayed walls of the portal of S. Agostino, Montepulciano, by Michelozzo (Fig. 203), for example, are proportionately no wider than those of the S. Egidio Tabernacle while the door is flanked by equally ample jambs. The portal of S. Maria degli Angeli, Siena, is enclosed within an aedicule like the tabernacle's. The reproduction of an exterior may also account for the absence of a tiled pavement. The adoption of the motif of the porch in Rossellino's tabernacle must have been mediated by a similarity of form—a rectangular door crowned by a semicircular lunette containing sculpture—but even more, by an identity of function: to confer on recessed portal or *sportello* the symbolic honor of a baldacchino and the real protection of a hood.

Precedents for the idea of porch as frame for the *sportello* exist in three Sienese tabernacles, one in the sacristy of the Duomo dated shortly after 1400 (Fig. 204), and the other two, dating from the fourteenth century and preserved only in casts, in the church of S. Eugenio in the Villa di Monastero in the periphery of that city (Figs. 205, 206).[10] But Bernardo reduced their three-bay facades to the portal proper and for their Gothic forms he substituted Brunelleschian arches and octagonal coffers with rosettes like those in the vault of Michelozzo's Cappella del Crocifisso of 1448 in S. Miniato al Monte.

The logic of Bernardo's architecture is compromised, however, by his angels who issue from openings in the splayed walls of the portal. Yet their location here conforms to an entrenched pictorial tradition. The central panels of painted tabernacles of the fourteenth and early fifteenth centuries were often recessed within narrow splayed embrasures to which shutters were attached. Acknowledging the subservience of the embrasure to the central field, painters like Fra Angelico in his Linaiuoli Triptych (Fig. 207), ornamented the embrasures with music-making angels who, by their action and expression, direct the attention of the spectator toward the center of the altarpiece and celebrate the holiness of the image conserved there. In his tabernacle, Bernardo integrated the splayed embrasure and the central area by means of an illusionistic setting and unified the scale of adoring angels and central Deity.

While the idea of angels issuing from the openings in the lateral walls of a perspectively foreshortened vaulted enclosure whose rear wall is the *sportello* was decisive for the form of Italian wall tabernacles until the end of the fifteenth century, the motif of the splayed portal had little resonance. One may surmise that the spatial illusion provided by a shallow portal was too weak to satisfy the Renaissance passion for the deceptions of linear perspective. In any event, it was Desiderio who, fusing these elements from Bernardo's tabernacle with the barrel-vaulted interior of Masaccio's Trinity, provided the archetype for the architectural setting depicted in fifteenth-century wall tabernacles (Fig. 173).[11]

[10] Since no other Trecento Sienese tabernacles are known, we may tentatively consider the imitation of the church facade customary for Gothic tabernacles in Siena. See Caspary, *Sakramentstabernakel*, pp. 15f.

[11] Ursula Schlegel, "Observations on Masaccio's Trinity Fresco in Santa Maria Novella," *AB*, xlv, 1963, p. 31.

The architectural members of the frame of the tabernacle (Fig. 91), executed with particular ineptitude, are by an assistant. Nevertheless, the weight of the frame and the variety and density of its ornament point to a design by Bernardo. The succession of leaf-and-dart and cable moldings in the architrave recur in the architrave of Rossellino's tabernacle in the Badia at Florence (Fig. 25). Inspired perhaps by Donatello, Bernardo treated the architectural framework with atypical license. The architrave is not divided into three fasciae. As in Donatello's Cantoria, the motives of the moldings are extremely large in relation to the size of the whole tabernacle.

Though the two angels (Figs. 92, 93) conform to a single pattern, the pose, proportions and drapery style differ from one to the other. Hair, faces and wings are made according to different formulae. The figure on the left lacks those anatomical and technical errors which mar the right angel: the consummate mastery of its execution warrants its attribution to the master of the shop.

The angel is thin and tall; his legs are long. His small head rests on a long neck. His hands, perhaps as the focus of the figure and the key to its meaning are disproportionately large.

The figure stands in a contrapposto pose: apart from the gesture of prayer, nothing in the pose alters its meaning of potentially mobile repose. With the exception of the engaged leg, every part of the body moves either forward or back, in or out, thus creating an equilibrium of counteracting movements. Even the angel's head is thrust forward and his mouth is open as though reciting a prayer. The angel seems not to feel the effect of gravity for his elbows do not depend upon the support of his hips, his hands barely touch and the foot of his free leg does not exert any pressure on the ground. The hip over the engaged leg is slightly drawn in and the muscles of the stomach are contracted, as when a dancer, in preparation for a leap, concentrates the center of gravity of his body high in his upper torso. The angel's hair and the drapery around his legs and hips fly back as though in response to a sudden movement forward. The folds between his legs have not yet had time to fall into place.

The effect of the angel's recession in space is produced by every possible device. The angel is represented in three-quarter view, requiring the foreshortening of chest, inner shoulder and arm. Like orthogonals, the various borders of the garment and the axes of the limbs ascend or descend, to a greater or lesser degree, according to their distance above or below a point of sight located in the middle of the *sportello*. To be sure, the obliquity of some axes is occasioned by the pose, but comparison with the angel's mate reveals their accentuation here. In addition, there is a progressive overlapping of forms, like cards held in the hand of a player. The rate of overlapping varies, accelerating toward the edges of the figure, decelerating where the figure most projects, as in the folds of the peplum over the hip. Gradation in the height of the relief accords precisely with the degree of recession: at one end of the scale is the projecting elbow carved practically in the round; at the other, is the farther upper arm in *schiacciato* relief. To the gradation in the height of the relief corresponds the diminution in the degree of modulation of the surface by means of which the effects of aerial perspective are simulated. As in the face of the Empoli Angel (Fig. 48), forms closer to the observer are salient or deeply excavated; forms toward the rear are more likely to be smooth, preserving intact the uniform plane of the *schiacciato* relief. The transition from fold to fold on the farther side of the body is indicated by incisions rather than the alternation of convexity and concavity, as on the nearer side. Thus strong contrasts of light and shadow are gradually replaced by a uniform tonality of middle value.

With the loss of *chiaroscuro* accords the reduced differentiation of texture: where the nearer sleeve seems made of a crisp silk, the farther sleeve does not simulate cloth at all. Where the deeply incised contour of the nearer arm and change of texture from wing to sleeve make its boundary one of the most conspicuous portions of the figure, the identity of surface and plane of farther sleeve and background architecture de-emphasizes the outline of the farther arm and causes it to coalesce with the background.

For Bernardo, drapery served many artistic ends which, up to then, only Ghiberti had succeeded in reconciling. By the pattern of its folds or its adherence to the body, drapery reveals the anatomy of the figure, particularly the legs and feet. Folds also diagram the mechanics of the figure's pose. The peplum drops suddenly over the angel's lowered hip. Two folds collide at the bent knee. The straight folds of the skirt imitate the verticality of the engaged leg. Over the engaged foot the drapery has settled into essentially horizontal folds. Concurrently, however, the pattern of folds is endowed with a decorative value of its own. Because folds are thin and nearly always narrower than the hollows between them, the pattern created is a linear one. Folds are predominantly vertical, occasionally oblique but never horizontal. When a fold breaks off, there is always another fold or the contour of a limb to provide an uninterrupted path for the eye. Folds follow a gentle curve, the smallest section of a circle, rarely a reverse curve. The curve generally accelerates very slightly towards its termination. Near the hem, folds break very suddenly, making acute angles as they turn back upon themselves, forming a ring of folds about the angel's feet like Rebecca's drapery in Ghiberti's panel of Jacob and Esau. Folds tend to be parallel and of approximately the same width and length. The pattern of folds therefore is conditioned primarily by repetition, though not to the exclusion of an occasional forking fold or random indentations. But in spite of the linearity of the pattern, the plasticity of the individual folds—cords that merge imperceptibly with hollows—is never compromised.

The pattern created by the angel, to which the folds so conspicuously contribute, is so obvious and clear as to seem preordained by some external necessity. Every part follows naturally upon the preceding part: folds repeat one another, as where the two folds on either thigh form a calyx at the knee, or where the puffing sleeve forms a V at the elbow. The folds around the waist move up or down at an identical angle. The angel's arms make two parallelograms and the contour of the wing is the mirror image of the contour of the angel's neck and shoulder.

Of the angel's two companions, the head of one is identical to the head of the putto on the left of the portal in the town hall at Siena (Fig. 31). The angel on the left of the lunette above the *sportello* (Fig. 95) is also by Bernardo. The forward thrust of the head and the upper torso suggests the same mobility as the pose of the larger angel on the left, intensified, as there, by the movement of hair and folds. The further arm, just barely indicated, the progressive overlapping of folds, and the foreshortening of the wing convince us of the recession of the figure. The fine, linear folds have the same curvature, the hand, the same proportions, and the locks, the same waves as in the angel below.

The full-length angel on the opposite side of the tabernacle (Fig. 93) is, I believe, the earliest extant work by Desiderio da Settignano. The robust proportions which contrast with the tall and slender angel by Bernardo reappear in the angels in relief from Desiderio's S. Lorenzo Tabernacle (Figs. 178, 179). As there, the shoulders are broad and massive,

the waist is high, the stomach, prominent. As in the Pietà (Fig. 174) as well, the cubic head is very large; its size is increased by its mass of curls.

Features which distinguish the pose of the angel on the right from its companion recur in the angels in the back row of the central relief in the S. Lorenzo Tabernacle (Figs. 178, 179). The angel's head is tilted down, his elbows are pressed close to his hips and his hands are held higher than the hands of Bernardo's angel, producing a more acute angle at the elbows and a more steeply rising diagonal in the arms. The upper torso of the angel is upright while the hips and stomach are thrust forward. As in the free-standing angel at the right of the S. Lorenzo Tabernacle (Fig. 175) the differentiation of the weight-bearing function of the legs has not prevented the awkward alignment of the knees. The ungainly juncture of the S. Egidio angel's engaged leg and foot also characterizes the S. Lorenzo angel's free leg and occurs again in the Christ Child of the Panciatichi Madonna (Fig. 189), where the foot, instead of resting flat, has been turned forward at an angle of forty-five degrees.

The pattern of folds in the skirt of the angel is comparable to that of the free-standing angel on the right of the S. Lorenzo Tabernacle (Fig. 175). In both, the drapery clings to the legs, at times leaving them so free of folds that they seem to be bare. Between the legs and along their outer contours there fall several long, straight folds which overlap one another densely. Because their overlapping edges are invariably separated by a furrow and none is ever shown to be continuous with the next, they seem independent strips of cloth. Their edges quiver as their width constantly expands and contracts. Similarly their surface manifests very slight depressions which barely penetrate the surface of the stone. In the S. Egidio angel a straight fold conceals the forward contour of the inner leg in much the way that it conceals the silhouette of the right leg of the free-standing angel (Fig. 176). In neither angel do the folds over the bent thigh meet at the juncture of hip and thigh. Thus an empty space is left at the top of the leg and nothing prepares the eye for the sudden horizontal of peplum or sash. As a result, the spectator's attention is focused here, at the weakest point of the figure, at that part of the body which neither supports nor is supported, where the line of movement breaks. In both, the confusion of folds surrounding the feet contrasts with the clarity of Bernardo's pattern. Folds crisscross the feet, changing direction with great rapidity, breaking, sometimes adhering to the foot, sometimes standing clear. Oblong depressions with sharp ridges that flash into existence and as suddenly disappear traverse the ankle.

The angel's drapery seems to have been inspired by Donatello's Virgin from the Cavalcanti Annunciation in S. Croce (Fig. 151). In both, the inner contour of the nearer leg is set against, and only partially overlaps, a curving fold which continues from peplum to ankle. In both, the farther thigh is overlapped, not by the fold which eventually falls into the hollow between the legs, as in the angel on the left and as would naturally occur, but by a straight fold on the outside of the leg. The harsh accents produced by the deep incisions and denting of the surface of the legs, by the long diagonals, by the not quite straight strip folds, by the confusion of folds at the ankles, indicate that it was Donatello's means that Desiderio adopted in the evolution of his acerbic drapery style.

In the face of the angel Desiderio expressed his preference for the plane. Like the face of the Christ Child from the Panciatichi Madonna (Fig. 189), the silhouette of the face is almost perfectly straight: the foreheads of both rise very nearly to the top of the head

where they meet the skull at a sharp angle. The conjunction of rectangular hairline and wide jaws produces in both a square face. Features hardly project while the eyes are brought forward to the plane of the brow. The normally convex center of the forehead is leveled while the edges bulge. In flattening out the forehead, Desiderio deprived the temples of hair, which in the S. Lorenzo angel (Fig. 177), creates an effect of incipient baldness.

Numerous anatomical mistakes in the S. Egidio angel reveal Desiderio's immaturity. The upper part of the outside arm is too long; the elbow is misplaced; the nearer forearm is not properly foreshortened and the juncture of hands and arms is inorganic. The notches in the farther forearm and the penetration of the mass of the nearer upper arm suggest that Desiderio was not entirely accustomed to the tools of his craft. Though the relief of his angel is much flatter than that of the angel on the left, the relief technique is not that of Desiderio's later works in which *schiacciato* forms are deeply undercut.

The same mistaken rendering of the elbow, the same rectangular fold at the border of the blouse and the same relative deficiency in the indication of recession suggest that the author of the angel on the right of the tabernacle was also responsible for the right angel in the lunette (Fig. 95).

The difference between the S. Egidio angel and the other works executed by Desiderio in the Rossellino shop, in particular, the effigy of the Beata Villana dated 1451 (Fig. 96), suggests that more than a single year, as the documents lead us to believe, separates the two works. Though there exist four payments to Bernardo for the tabernacle from the first half of 1450, the date of its commission is not known. Under pressure of contemporaneous projects like the Bruni Tomb, work on the tabernacle may not have proceeded systematically. Desiderio's evident inexperience warrants a dating of his angel to ca. 1448, to which year I therefore incline to date the commission.

The bust-length figure of God the Father in the pediment (Fig. 95) does not bear comparison with either angel. It is evidently by an assistant who derived the figure's face from Michelozzo's Resurrected Christ at Montepulciano (Fig. 158).

The Tomb of the Beata Villana in S. Maria Novella, Florence

THE Beata Villana was the daughter of Andrea di Lapo delle Botti, a prosperous merchant.[1] As a child, Villana was very pious. But after her marriage to Rosso di Piero Benintendi, which probably took place in 1351, her religious fervor yielded to mundane interests. She was accustomed to dress elegantly, and one day, looking into a mirror, she descried the image of a devil in place of her own. Thus was Villana reconverted to a religious life, characterized from that day on by visions, vigils and acts of penitence and charity. Villana died on January 29, 1361, when still young and was buried in S. Maria Novella, the scene of her religious devotions. She was beatified by Pope Leo XII in 1824.

The first tomb of the Beata Villana consisted of a slab with her effigy in low relief. Above it, the crucifix before which she had worshipped, was affixed to the wall. On July 12, 1451, Fra Sebastiano Benintendi, the grandson of the Beata Villana and procurator of the convent of the church, commissioned a new tomb from Bernardo Rossellino (Fig. 96). It was to be finished by the end of the year. A supplement to the contract, of January 27, 1452, provided for a tabernacle for the crucifix.[2] Apparently the tabernacle was never made, but the crucifix was installed above the tomb.

Rossellino's tomb was influenced by the Tomb of Doge Tommaso Mocenigo of 1423 by Pietro Lamberti and Giovanni di Martino da Fiesole in SS. Giovanni e Paolo, Venice (Fig. 208), which Bernardo might have known first hand (though no trip to Venice is recorded) or through drawings. In both tombs the effigy lies on a slab or mattress placed directly on the sarcophagus. Behind the effigy the large expanse of curtain, whose shallow folds curve downward and outward, functions as backdrop, while at either side the densely gathered folds with zigzagging border provide a decorative frame. In both, the advance of the curtain at either side and its circular closing beneath a massive finial create a sufficient effect of three-dimensionality to preserve the iconographical significance of the baldacchino as honorific covering. Angels slightly smaller in scale than the effigy and nearly identical to one another stand inside the tent at the head and feet of, and slightly behind, the effigy. They are posed frontally with their outer arms raised to support the curtains. In both cases they wear a chiton over a long-sleeved undergarment.

The canopy of the Tomb of the Beata Villana, however, is much squatter than that of the Mocenigo Tomb. Doubtless the reduction of its height and flattening of its contour were a concession to the inclusion of the crucifix over the tomb: the resemblance of its profile to the curtain of the Tomb of Bishop Ranieri Ubertini of 1360 in S. Francesco, Cortona, is probably fortuitous. The tent pole used to support the canopy of the Mocenigo Tomb was replaced by Rossellino with a ring derived from the Coscia Tomb (Fig. 161).

[1] For bibliography on the Beata Villana, see Stefano Orlandi, O.P. *La Beata Villana, terziaria domenicana* *fiorentina del secolo xiv*, Florence, 1955, pp. 91ff.

[2] See Catalogue (App. 1).

Unlike Bernardo's other tombs, that of the Beata Villana had very little influence on subsequent funerary sculpture, probably because no tombs commemorating saints or *beati* were erected in Florence in the second half of the fifteenth century. Its only echo occurs in a copy of it—Vincenzo Danti's Tomb of Beato Giovanni Salernitano, the founder of the convent of S. Maria Novella, which, upon its completion in 1571, was erected directly across the nave from its prototype,[3] like the matching Bruni and Marsuppini Tombs in S. Croce.

The effigy wears monastic dress though the Beata Villana did not take vows or even belong to the third order of the Dominicans. However, burial in the garb of a favorite order was not uncommon and probably conforms to her express desire.[4] The treatment of her face (Figs. 98, 99, 100) is characteristic of portraits derived from death masks but the influence of her death mask may be only at second hand, via the effigy from her tomb slab.[5] The crown (Fig. 103) is a symbol of heavenly majesty.

Without benefit of architectural members, the Tomb of the Beata Villana (Fig. 96) possesses the regularity and monumentality of a piece of architecture. In spite of the fact that the tomb is actually a continuous relief, the densely gathered and projecting folds of the border of the heavy canopy provide a niche for the figures and enframe half the perimeter of the tomb. The proportions and straightened vertical and horizontal edges of the canopy echo the oblong shape of the red slab beneath the effigy. The frontal upright angels located at either end of the tomb and filling the entire height of the canopy function visually, if not physically, as caryatids. Within a composition of very low proportions Bernardo created an impression of elevation by means of the rising movement of the angels, the rays emerging from the crown and the upward sweep of the folds of the curtain into the apex of the finial. The lower outline of the scroll reflects the contour of the effigy's nearer leg while the upper outline of the scroll repeats the curves of the borders of the curtain. The crown forms a transition from the horizontal scroll to the apex of the curtain, and the diverging rays above balance the diverging folds below while creating a focus in the crown.

The attribution of the effigy to Desiderio da Settignano vindicates the older critics who, unacquainted with the documents, from ca. 1530 to 1755 consistently assigned the tomb to him.[6] Although the depth of the figure would have sufficed for a portrayal of fully rounded forms, Desiderio clings to the surface of the block, shrinking convexities until the surface of the figure approximates low relief. Major crevices and protrusions are suppressed. The void between the legs is filled with as much drapery as will make, in conjunction with the legs, a fairly smooth plane. The upper contour of the figure (Fig. 97) barely makes a

[3] ASF, MS 812, *Sepoltuario di S. Maria Novella*, 1617, fol. 49; Richa, iii, pp. 50f; Florence, Biblioteca Riccardiana, MS Codice Riccardiana 1935, *Sepolcrario* 1729, fol. 31v; Florence, Archivio di S. Maria Novella, Vincenzo Borghigiani, O.P., *Cronica annalistica del convento di S. Maria Novella*, 1757-60, iii, p. 398.

[4] The earliest biography of the Beata Villana, written between 1420 and 1422 by Fra Girolamo di Giovanni, states that she requested burial in the Dominican habit. See Orlandi, *op. cit.*, p. 85.

[5] Vas-Mil, iii, p. 108: "e lei [Beata Villana] vi ritrasse [Desiderio] di naturale, che non par morta, ma che dorma."

A second portrait of the Beata Villana can be identified in the Dominican nun in the lower right of Andrea da Firenze's fresco of the Militant and Triumphant Church, Cappella degli Spagnuoli, S. Maria Novella, 1365-67 (Giuseppe Benelli, *Firenze nei monumenti domenicani*, Florence, 1913, p. 63). She appears once again in the Lamentation over the Dead Christ by Fra Angelico in the Museo di S. Marco. This painting was commissioned in 1436 by Fra Sebastiano for the altar of the Oratory of the Compagnia del Tempio.

[6] See Catalogue (App. 1).

concession to the volume of the arms, and the rising of the fold on the inside of the inner leg eliminates a hollow. The inner arm of the effigy is flush with the rest of its body and the hands are so thin that, even double, they have no effect upon the level of the surface. At the same time, the side of the effigy is leveled off and an edge is formed with the upper surface of the figure, recalling the original corner of the block. Though the surface is in constant motion, folds never project or recede very far. And though folds constantly break or disappear, they tend to be continuous where the form underneath the drapery changes level—the left forearm, for instance—thus concealing it and insuring a continuity of plane.

Like Desiderio's Christ Child in the Louvre *tondo* (Fig. 171), his bust of Julius Caesar also in the Louvre (Fig. 209) and his three infants in Washington (Fig. 181) and Vienna, the material of the effigy's drapery seems paper-thin because it clings so readily to the body and because folds are so fine that they sometimes have no plasticity at all. Like paper, the material is very stiff: folds are very often straight and when they change direction they almost invariably break. The garment of the effigy (Fig. 99) repeats the veil and wimple of the Virgin in the Pietà from the S. Lorenzo Tabernacle (Fig. 172). In both, the material below the chin is slashed in the same apparently haphazard manner. The smooth drapery reveals upper arms conceived as rectangular blocks and the juncture of the long facet of the arm and the receding facet of the shoulder is equally prominent in both. From the lower part of the arms of both hang the same flat, diagonal folds that in the effigy of Bruni (Fig. 53), too, streak diagonally across the figure to its outer edge. The contours of these straight folds quiver slightly and their surfaces vibrate. Folds are frequently separated from one another by deep, sharp incisions—never by graduated hollows. Like the free-standing angel on the right of the S. Lorenzo Tabernacle (Fig. 175), the drapery clings to the forward leg of the Beata Villana. At rare intervals tiny folds flash across its surface, barely disturbing its smooth contours. In both figures the drapery is wound so tightly about the ankle (Fig. 102) that movement would be impossible. The frenetic zigzagging of folds across the other ankle recalls the S. Egidio angel (Fig. 93).

The face of the Beata Villana (Figs. 98, 99, 100) is carved with a spareness of form and a constant reduction of volume that replaces the cheek with a cavity, restricts the lips to a mere suggestion, refines the bony structure and retains only the outermost layer of skin. Like the relief of Julius Caesar (Fig. 209), the proportions of the head are very long and from profile to occiput, very narrow. The width of eye, nose and mouth is so diminished that one has the impression of less than a profile view. A comparison of the silhouettes (Fig. 100) reveals the same high bridge of the long nose and the swelling beneath it. The wing of the nostril flares. Its crescent shape recurs in the nostril of the figures from the Pietà (Fig. 172). The distance between lip and nose is extremely long. Apart from its caret, the upper lip does not exist. A hollow immediately succeeds a thicker, yet still very narrow, lower lip. The lock of hair which escapes from the wimple possesses Desiderio's characteristic ripple. Common to both the Christ Child from the *tondo* in Paris (Fig. 171) and the effigy of Villana (Fig. 97) is the peculiar relation of head and shoulder in which the shoulder appears to tilt down because not properly foreshortened.

All accidental features, such as wrinkles or the hair of brows or lashes, have been eliminated from the face of the Beata Villana. There are no signs of age or sickness. To judge from the delicate nose with just a trace of the prized aquiline hump, the geometrically arched brow, the firm chin, the features, too, were idealized. Forms flow into one another

with such subtlety that the smoothness of the surface is never compromised and the only boundaries are openings: the partings of the lips and lids, the orifices of the nostrils. The stone is so highly polished that its surface seems translucent. The result is the kind of idealized portraiture that we are accustomed to identify with Francesco Laurana. But where Laurana's goal was the rendering of a youthful, aristocratic beauty, Desiderio sought the image of agelessness, insensibility and transcendency of a medieval ascetic.

In their stubby proportions and paralytically rigid extension, the hands of Desiderio's figures (Figs. 171, 174, 189) eschew an easily achieved elegance. The rectangular fingers of the Beata Villana (Fig. 101) are separated from one another by drill holes which penetrate the stone nearly at right angles. As is generally the case in Desiderio's work, the index and middle fingers are spread apart while the middle and ring fingers touch. The contraction of the circumference of the fingers at their boundary with the palm and the horizontal line formed by the knuckles, accentuate the square shape of the hand. The ends of the fingers and fingernails are straight. Even the elongated and tapering thumbs pursue a straight diagonal path.

Certain details of the design, such as the preference for acute angles and the use of the V-shape that appears in the left arm of the Beata, recur constantly in the work of Desiderio. One need only observe the interlocking V's made by the drapery of Julius Caesar (Fig. 209), or the angles made by the arms and legs of St. Jerome in the relief in Washington (Fig. 210), to realize the extent to which they were congenial to Desiderio's sense of design. In spite of the fact that the larger design of the effigy has no precise parallel in the work of Desiderio, its intent and effect contain the essence of Desiderio's style. For in Desiderio's work the harmony and proportionality by which Alberti defined beauty is a standard no longer applicable and the "grazia e leggiadria" with which Vasari described Desiderio's style, takes into account only a very selected group of works. The malproportions of the figures in the Pietà from the S. Lorenzo Tabernacle (Fig. 174), the strident diagonals, the disruptive angles, the tortured expressions of the faces, combine to form something far more moving than pleasurable. In the linear pattern in the Louvre *tondo* (Fig. 171) there is a similar refusal to admit the patently pleasant, to construct parallel lines, or to continue a linear motif despite a change in object. The odd contortions in the pose of the angel on the right of the S. Lorenzo Tabernacle (Fig. 175) produce the impression that its movement is caused by the delirium which its face expresses. Similarly, in its complexity and subtlety, the effigy of the Beata Villana (Fig. 96) abjures the simple harmonies and tectonic organization that would have appealed to a taste formed in the early part of the fifteenth century. The moderate proportions which Alberti advocated and Bernardo used for his effigy of Bruni (Fig. 53) have given way to pronounced elongation. Bruni's robust forms have atrophied. The hands of the Beata Villana are placed high on her chest, revealing the full extent of her attenuated limbs. Her foot is stretched out, and the longitudinal lines of her drapery propel us with great force along the surface of her leg. Instead of an equitable distribution of forms and shapes as in Bernardo's figures, there is a concentration of forms in the upper half of the Beata Villana, a distension of form in the lower. Instead of the symmetry of the effigy of Bruni, the pattern of drapery on one side of the figure differs completely from that on the other. The regularity and grace of Bernardo's folds are superseded by a discordant juxtaposition of smooth and pitted areas; their easy flow has been replaced by folds stretched taut, which rend the figure of Villana with long, diagonal gashes. Lines are broken, crisscrossed. Angles are

made as acute as possible and the drapery surrounds the feet with convulsive zigzags. The surface is despoiled of its smoothness by ridges that serve neither to define the stuff of which the drapery is made, nor the pattern of folds into which it falls. For the author of the effigy of the Beata Villana, beauty no longer consists in the harmony of all the parts, in justness of proportion, in regularity or balance as it did for Bernardo Rossellino.

It is above all, the style of the effigy of the Beata Villana that explains, if it does not justify, the tradition of Desiderio's apprenticeship in the *bottega* of Donatello,[7] for the figure clearly manifests the influence of Donatello's Tomb Slab of Giovanni Pecci from the Cathedral of Siena (Fig. 214). Both figures are elongated. The less usual crossing of the hands high on the breast serves to accentuate the length of limb and creates a sharp angle at the elbow. The drapery of both figures consists of a thin and extremely brittle stuff: Donatello's folds also are straight and break instead of curving, while the edges of folds are defined by mere incisions. In the effigy of Pecci, as in the effigy of Villana, the garment adheres to the legs, revealing contours in some detail and creating narrow, angular, broken ridges where the stuff is free. From the forearms of Donatello's figure issue the long, narrow, diagonal folds that we already have encountered in Desiderio's portion of the effigy of Bruni and the Beata Villana—Desiderio's customary strip folds. In none of the three figures do these folds make a concession to the inevitable difference in plane of arm and body.

Of the two hands which hold the crown (Fig. 103), the right is evidently the superior. The incisiveness of the angular folds of the sleeve and the combined *schiacciato* relief and undercutting of the hand, are evidence of Desiderio's work.

To judge by the similarity of the folds in the sleeve of the hand on the left and the bodice of the angel on the right (Fig. 105), the same assistant was responsible for both. The brittle stuff of the angel's drapery which forms long, straight, diagonal folds, shows this sculptor to have been influenced by Desiderio. While the quality of the angel on the left (Fig. 104) is not superior to that of its mate, differences in proportions, anatomy, movement, drapery and facial type testify to another hand. This sculptor made the curious mistake of rendering the angel's garment as though sleeves and skirt, made of the same clinging stuff, constituted a dress while the upper part of the chiton, whose folds indicate a heavier material, looks like a vest worn over it.

[7] Vas-Ricci, ii, p. 144: "Fu costui (Desiderio) imitatore della maniera di Donato, . . ." In his edition of 1568 (Vas-Mil, ii, pp. 423f) Vasari added: "Le cose dell'arte lasciò a suoi discepoli: i quali furono . . . Disiderio. . . ." Baldinucci, *Notizie*, iii, p. 41: ". . . ebbe nella sua prima età da Donato i principj dell'arte, e dopo la morte di lui, datosi, come era costume suo, a studiare a tutto suo potere le opere del defunto maestro, in breve si portò ad un altissimo grado di perfezione." Vasari (Vas-Ricci, *loc. cit.*; Vas-Mil, iii, p. 108) followed by Baldinucci (*loc.*

cit.), described a base made by the young Desiderio for Donatello's bronze David. For a discussion of the vicissitudes of the base, now lost, see Janson, *Dona.*, pp. 79f. A letter from Baccio Bandinelli is unique among the early sources in its departure from this tradition: ". . . quando gli [Ghiberti] furono allogate le porte, per suo aiuto prese giovani con ottimo disegno, . . . l'altro fu Disiderio," (Giovanni Bottari, *Raccolta di lettere sulla pittura, scultura ed architettura*, Milan, i, 1822, p. 105, letter 45).

The Tomb of Orlando de' Medici
in SS. Annunziata, Florence

ORLANDO di Guccio de' Medici was born in 1380.[1] He was among the zealous supporters of Cosimo de' Medici, and with the latter's arrest and banishment in 1433, he was exiled to Ancona. There he prospered, receiving the post of *Tesoriere della Marca*. Upon his return to Florence, Orlando was entrusted with several ambassadorial missions. At Ferrara in 1452 he welcomed Emperor Frederick III, who later conferred on him the order of *cavaliere* in a ceremony in the Florentine Duomo. Orlando died on December 10, 1455,[2] and was buried the following day in SS. Annunziata.[3]

In his testament of December 6, 1455, Orlando designated 100 florins to be spent by his heirs, his two sons, Piero and Gianfrancesco, on a marble tomb for his chapel dedicated to Mary Magdalene in SS. Annunziata. The record of money owed by Orlando's heirs in Bernardo's tax declaration indicates that the tomb (Fig. 106) was commissioned from Bernardo and that it was at least under way, if not actually completed, by the beginning of 1458.

As has long been recognized, the Tomb of Orlando de' Medici is based on the Tomb of Onofrio Strozzi of 1418 by Pietro Lamberti in the sacristy of S. Trinita (Fig. 211).[4] In both, the free-standing sarcophagus almost entirely fills the semicircular lunette situated high on the wall. The moldings of the sarcophagus produce an accentuated profile. The high, sloping cover is slightly concave. Both sarcophagi rest on castors. Lions' heads ornament the ends of both *cassoni*. In both, there is a coat of arms but no image of the defunct. In neither is there any Christian reference, either visual or literary. However, where the Strozzi Tomb is double-sided because the rooms on either side of the wall containing the tomb were Strozzi appropriations, the Medici Tomb, opening onto the unitary Medici Chapel, is not.

To the lunette of the Strozzi Tomb Bernardo added a base which served to connect the niche with the ground by means of an architectonic foundation. The foundation of the Medici Tomb may be related to the base, now lost, of Luca della Robbia's chronologically

[1] For the biography of Orlando de' Medici, see Pompeo Litta, *Famiglie celebri italiane*, series 1, Milan, 1813-49, iii, "Medici," pl. iv.

[2] See the note in the margin of Orlando's testament: doc. 21 (App. 3).

[3] Fabriczy, *JPK*, 1900, p. 48, n. 1.

[4] For the dating of the tomb see Margrit Lisner, "Zur frühen Bildhauerarchitektur Donatellos," *Münchner Jahrbuch der bildenden Kunst*, ix/x, 1958-59, pp. 94f, 99f. The problems of attribution pointed to by Dr. Lisner, I think, have not yet been solved. The source of the Strozzi Tomb cannot be the Tomb of Maso degli Albizzi from S. Pier Maggiore, of which

only fragments remain, as Lisner, *ibid.*, pp. 93f, following Walter Paatz, "Ein frühes Donatellianisches Lünettengrabmal vom Jahre 1417," *Mitt. d. ksth. Inst.*, iii, 1932, pp. 539f, suggested, for Maso's tomb was evidently of the type of Verrocchio's Tomb of Piero and Giovanni de' Medici in the Old Sacristy, S. Lorenzo. Nor can the source be the Tomb of Taddeo Pepoli in S. Domenico, Bologna, postulated by Burger, pp. 182f, and with reservations, by Lisner, op. cit., *Münchner Jahrbuch der bildenden Kunst*, 1958-59, p. 113, n. 158, which was still not finished in 1551 (I. B. Supino, *L'arte nelle chiese di Bologna, secoli viii-xiv*, Bologna, 1932, pp. 191ff).

overlapping Tomb of Bishop Federighi in S. Trinita, but, while a document mentions its four pilasters, three red marble slabs and cornice, there is no record of its original composition.[5] The motif of the coat of arms encircled by a wreath occurs in the similar sarcophagus of Giovanni and Piccarda de' Medici by Buggiano in the Old Sacristy, S. Lorenzo (Fig. 212). The motif and poses of the putti holding the epitaph derive from the sarcophagus of the Coscia Tomb (Fig. 161).

Very likely the lions' heads (Figs. 112, 113)[6] and the garland of oak leaves (Fig. 106)[7] are intended as purely decorative motifs though both could signify fortitude while the former could also represent the Florentine *Marzocco*. The red balls which support the sarcophagus are the Medici *palle*; the balls used as castors in the Strozzi Tomb are gilded, and in derivations of the Medici Tomb the red balls are invariably replaced by emblems of the family of the deceased.[8]

The Tomb of Orlando de' Medici was extremely influential. Four, possibly five, Florentine tombs erected within a span of fifty years, are dependent on it. Another tomb in nearby Prato is based on it, while a tomb in Faenza is more distantly related.[9] The tomb in Faenza was dedicated to a saint, but all the Florentine and Pratese tombs commemorate only prominent and wealthy citizens. This is true, as well, of the Strozzi Tomb from which the others ultimately derive. The Medici, Capponi and two Sassetti Tombs were commissioned by their occupants, either directly or indirectly through testamentary disposition. The others, with the exception of the Tomb of S. Savino, are likely to have been as well. It is interesting to note that during the same period, Florentine humanists and important ecclesiastics were commemorated by different and more elaborate monuments,[10] while only five tombs of Florentine citizens departed from the type, and only one from the reticence of the arcosolium.[11] On the other hand, no citizens outside of Florence (except Filippo Inghirami), not even banished Florentines, ever used the arcosolium.

From this we may deduce that the arcosolium represented a standard of good taste to the citizens of the upper class in Florence in the second half of the fifteenth century, much as the palace type evolved in the Palazzo Medici did for the same period of time. Why this type came to be identified with the private citizen in Florence may be explained by

[5] Hannelore Glasser and Gino Corti, "The Litigation concerning Luca della Robbia's Federighi Tomb," *Mitt. d. ksth. Inst.*, xiv, June 1969, pp. 7f, 30, doc. 10. For the dating of the tomb between May 2, 1454, and the beginning of 1457, see *ibid.*, pp. 2ff.

[6] The decorative use of a pair of lions' heads occurs frequently in Roman sarcophagi. One such was adapted for the Tomb of Giuliano Davanzati (d. 1444), S. Trinita, Florence.

[7] See Guy de Tervarent, *Attributs et symboles dans l'art profane, 1450-1600*, Geneva, 1959, col. 91, "chêne." Though the oak has no specific connection with the Medici family, it does appear conspicuously on certain Medici commissions such as the lavabo and balustrade in front of the altar in the Old Sacristy, S. Lorenzo, and in Michelozzo's Cappella del Crocifisso in S. Miniato al Monte.

[8] The Pandolfini sarcophagus is supported by dolphins; the Inghirami sarcophagus, by pomegranates; and the Castellani sarcophagus, by reliefs of castles.

[9] Copies of the Medici Tomb are: the Tombs of Gianozzo Pandolfini (d. 1456) in the Badia, Florence;

Filippo Inghirami (d. 1480) in the Duomo, Prato; Francesco and Nera Sassetti, both in S. Trinita, Florence, 1485-91, attributed to Giuliano da Sangallo; Francesco Castellani (d. 1505) and his wife, Helena Alemanna, S. Croce, Florence; possibly also Neri Capponi (d. 1457), S. Spirito, Florence; and more distantly, the Arca of S. Savino, Duomo, Faenza, 1468-70.

[10] E.g. Tombs of Leonardo Bruni and Carlo Marsuppini, S. Croce; Tombs of Bishop Federighi, S. Trinita, and Bishop Salutati, Duomo, Fiesole.

[11] In Benedetto da Maiano's Tomb of Filippo Strozzi, S. Maria Novella, and Verrocchio's Tomb of Piero and Giovanni de' Medici, Old Sacristy, S. Lorenzo, the sarcophagus is contained within a full-length arch but in neither is there an image of the deceased. Nor is there any in the Tombs in S. Lorenzo of Niccolò Martelli or Cosimo de' Medici. Mino da Fiesole's Tomb of Bernardo Giugni in the Badia, Florence, based on the Bruni Tomb, contains two images of the deceased.

its combination of reserve and austerity, on the one hand, and imposing size and costly materials, on the other. In the arcosolium, sculptural motifs were few and generally subordinate to a design which relied almost entirely on the decorative use of architectural members. The sarcophagus was recessed within a niche no larger than necessary and generally located above the eye level of the spectator. As was traditional already in Trecento tombs of Florentine citizens who had no claim to ecclesiastical or scholarly distinction, the identity of the defunct was revealed only to his peers—those who could read the Latin epitaph or were acquainted with his coat of arms. (Exceptions are the portrait of Capponi and the miniatures of the Sassetti Tombs.) The location of the focus of the tomb in the inscription and the classicizing putti and wreath lent an aura of humanistic learning to the tombs of those for whom such learning had social connotations. Surprisingly, no reference at all is made to the religion of the defunct. But burial within a church, in proximity to an altar, doubtless constituted by itself a profession of the Christian faith.

The garland which entirely surrounds the lunette of the tomb, the double pilasters at either end of the base and the moldings of the sarcophagus which enclose all four sides of its face manifest that desire to enclose and enframe which we have already encountered in the Tomb of Leonardo Bruni (Fig. 49). The wreath and garlands of the tomb share with the garland that surrounds the portal in the Palazzo Pubblico in Siena (Fig. 28) the qualities of heaviness and density. In both door and tomb, garlands fill the entire available space and only by virtue of being tightly bound are they contained within the limits set by the moldings. Both garlands are continuous and uniform in width, outline, design and degree of projection, which in both is very high. On the cover of the sarcophagus one species of fruit succeeds another with precise regularity, creating even stripes of identical outline. Fruit is invariably ripe, and flowers full-blown.

The absence of an entablature in the Tomb of Orlando de' Medici has been criticized. Indeed, the subsequent Tombs of Giannozzo Pandolfini (Fig. 215) and Filippo Inghirami, in which the entablature replaces part of the continuous garland of the Medici Tomb, reveal a far greater integration of niche and base. There, while the entablature is visually a part of the base, it functions as one side of the lunette containing the sarcophagus. By the inclusion of an entablature, and even more by the heightening of the base, the architecture of the tomb was made to approach that single component of an arcade that we are accustomed to perceive as a unit. In contrast, the continuous garland of the Medici lunette severs base from niche: the base seems a mere appendage to the niche, a filling-in of the wall underneath the niche. This impression is augmented by the proportions of the base—too high to be construed as an ordinary base and too low to be construed as the area between the supports of an arch. The duality of the Medici Tomb may be understood in terms of its place in the middle of the development of the Renaissance arcosolium, which began with a niche alone in the Strozzi Tomb and ended with the fusion of base and niche.

The central axis of the Medici Tomb is marked with great discretion and restraint by several unobtrusive accents. To indicate the centers of the garlands, Bernardo did not add new elements but rather varied the use he made of elements already present. The symmetry of the tomb is tempered by the continuous movement in one direction of the ribbon binding the garland. The epitaph is placed 1.4 cm. to the right of center while the inscription is also shifted slightly along the normal path of vision.

A comparison of the head of the putto on the right (Figs. 109, 110) with the putti from the Tomb of the Cardinal of Portugal (Figs. 185, 186) warrants an attribution of

the former to Antonio Rossellino. In all three heads the upper part of the forehead is protuberant. Towards the outside of the brows there are indentations which give the temples greater prominence. The brows are nearly straight and immediately below them, towards the outer corner of the eyes, there is a bulge which continues to the upper lid and is followed by an indentation which prolongs the corner of the eye. The eyes are heavily rimmed, and the brows, accommodating the wide bridge of the nose, are set far apart. But for its rounded tip and small nostrils, the nose is amorphous. The cheeks of the putti bulge most opposite the mouth. The thin upper lip with its pronounced caret projects in front of the lower lip. The thicker lower lip is contracted in the center. Immediately beneath the lower lip is the indentation which defines the upper border of the chin. The chin is small, round and quite prominent. The putto has a double chin and a very short neck. The skull of the putto is full and rounded. Although Antonio has not yet acquired the technical skill which will allow him to render the texture and movement of the individual strands, the hair of the putto of the Medici Tomb is similar in type to the hair of the later putti. Immediately above the center of the forehead is a large, high tuft of hair. The hairline recedes above the temples, then descends vertically. The short locks leave the ear exposed. All the locks are brushed forward.

The distortions in the features of the right putto have been encountered already in Antonio's genius on the left of the Bruni sarcophagus (Fig. 62). While the nearer side of the face recedes normally, the farther side of the face is pulled forward, receding as little as it would do in a frontal view. Yet the farther brow, eye and cheek are brought close to the center of the face so that little room remains for the slope of the nose. The farther nostril is tiny, and the size of the farther half of the mouth and chin has been greatly reduced.

As in the figures of the Christ Child from the roundel of the Tomb of the Cardinal of Portugal (Fig. 182) and the Nori Madonna (Fig. 170), the carriage of Antonio's putto (Fig. 108) is erect: his back is straight and his head is drawn back on his neck, justifying his double chin. All his limbs are bent and his legs are retracted. Thus, as in the Nori Christ Child especially, the mass of the figure is compressed into a relatively small area, presaging the density of form in the figural compositions of the High Renaissance.

A comparison of the putto with the putto on the opposite side of the sarcophagus (Fig. 107) reveals to what extent Antonio consciously organized his design. A central vertical axis runs through the center of the ear of the putto, his shoulder and his buttock precisely where it is planted on the base. The right forearm of the putto is parallel to the silhouette of his face. A line drawn through the top of his nearer wing would continue in the diagonal of the upper contour of his leg. The elbow of his nearer arm is placed directly over his knee and from this point of near contact the contours of the limbs diverge with radial symmetry. The line of the top of the wing continues into the top of the putto's shoulder and the creases that form beneath the chin. The figure is so well centralized within the available space that the lower tip of its wing is no farther from the right edge of the relief than its inner elbow is from the right edge of the inscription. Indeed, Antonio has almost as consciously composed the voids as the solids. With this regular and immobile system of corresponding lines and calculated voids, contrasts the unsystematic pattern of feathers of diverse shapes and sizes, whose own decorative beauty is due to less obvious means.

The face of the putto on the left (Fig. 111) recalls the face of Domenico Rossellino's (?) angel on the right of the lunette of the Bruni Tomb (Fig. 74). The extremely thin and

faceted strip of the upper lip with its broad, shallow, central dip and the very narrow, trapezoidal, everted lower lip produce the same pouting expression in both. In both, the bulging brow presses down on the outer half of the eyes. In both figures (Figs. 72, 107), the farther shoulder seems swiveled forward because inadequately foreshortened, while the nearer shoulder is much too long.

Many of the putto's defects also mar the Christ Child from the relief of the Madonna del Manto at Arezzo (Fig. 6) which I attributed to Bernardo's elder brother. In neither figure is the farther shoulder overlapped. The upper half of the forward leg is too long. A front view of the Christ Child (Fig. 3) reveals the same immense distance from neck to edge of shoulder. The upper chest seems inflated while the lower backs of both are excessively full and rounded. Both show an idiosyncratic rendering of the wrist as a flat, narrow band defined by straight, parallel incisions. The heads of both are unusually large, even for infants. In both, the facial features sit on the surface of what would be a cube if its edges were not so rounded, creating a straight silhouette from chin to forehead. The eyes are barely recessed within their sockets. Just as Domenico increased the scale and breadth of the angel supporting the cloak of the Madonna in Arezzo (Fig. 14), so he increased the scale and breadth of the putto on the left of the Tomb of Orlando de' Medici: it was partly because he had to fit so large a figure within the low *cassone* that he curved the figure's spine so unanatomically.

The Tomb of Neri Capponi
in S. Spirito, Florence

NERI DI GINO CAPPONI was born on July 3, 1388.[1] Although his birth and connections disposed him to take the part of the Albizzi against Cosimo de' Medici, Neri held himself aloof from either faction and by the force of his influence prevented either one from usurping the government. Author of historical works and member of the Florentine government for some forty years, Neri devoted himself primarily to military matters. He was commissar of the Florentines in the siege of Lucca in 1429 and 1430. In 1436 he was elected to the commission which oversaw the construction of the new church of S. Spirito.[2] Neri died on November 22, 1457.

In a testament dated December 10, 1450, Neri requested burial in S. Spirito in the grave of his father.[3] A tomb, paid for out of his estate, was to be newly erected. Its cost, location and form were to be decided by his heirs, his brothers, Agostino and Lorenzo, his son, Gino, and their descendants. The style of the profile portrait on the tomb (Fig. 115) permits the assumption that the tomb was commissioned and executed soon after Neri's death.

The only extant document regarding the Capponi Tomb (Figs. 114, 120) is dated September 12, 1488.[4] In it permission was granted the sons of Gino di Neri Capponi (who had died the previous year) to break the wall of their chapel and install a bronze or brass grating in order to make Neri's sarcophagus visible. The chapel, the seventh in the right transept, was dedicated to the Visitation.[5] Unfortunately, the document does not say whether the tomb was then standing invisible behind the wall of the Capponi Chapel or whether the installation of the tomb was to accompany the installation of the grating. Certainly the tomb could not have been installed before 1459 when Gino di Neri Capponi acquired his chapel in the new church.[6] Indeed, the fitful progress of construction of the new church of S. Spirito would have made installation of the tomb there impossible before

[1] For the biography of Neri Capponi, see Bartolomeo Platina, "Vita clarissimi viri Nerii Capponii," in Lodovico Antonio Muratori, *Rerum italicarum scriptores*, Milan, xx, 1731, cols. 479ff; Giulio Negri, *Istoria degli scrittori fiorentini*, Ferrara, 1722, p. 419; *Elogi degli uomini illustri toscani*, Lucca, i, 1771, pp. cccl ff; Pompeo Litta, *Famiglie celebri d'Italia*, Milan, series 2, 1847-99, ii, "Capponi di Firenze," pl. xi.

[2] Carlo Botto, "L'edificazione della chiesa di Santo Spirito in Firenze," *R. d'arte*, xiii, 1931, p. 493.

[3] Published in Giovanni Cavalcanti, *Istorie fiorentine*, ed. F. Polidori, Florence, 1839, ii, pp. 434ff.

[4] Doc. 22 (App. 3). I am grateful to Mrs. Anne Fuller for having called this document to my attention.

[5] On its altar was the painting of the Visitation with SS. Nicholas and Anthony Abbot of ca. 1490 by Piero di Cosimo now in the Kress Collection, National Gallery, Washington. See Fern Rusk Shapley, *Paintings from the Samuel H. Kress Collection. Italian Schools, XV-XVI Century*, London, 1968, p. 118, K 1086; Stephanie J. Craven, "Three Dates for Piero di Cosimo," *BM*, cxvii, 1975, p. 572.

[6] *Serie di ritratti d'uomini illustri toscani*, Florence, ii, 1768, p. 47v, repeated in *Elogi*, i, pp. ccclv f, cites a document according to which the chapel was acquired only in 1464. The Capponi were fortunate in acquiring one of the twelve (out of a sum total of thirty-eight) chapels at the projecting corners of the arms of the transepts in which a niche could be constructed.

the early 1480s.[7] In 1472, 1473 and 1475, columns and capitals were still being executed. The side aisles were vaulted and the last crossing pier and arch were erected only in 1477. Not until 1479-82 was the cupola placed over the crossing.

Nevertheless, the delay in construction need not have prevented the author of the tomb from adapting its design to its eventual site, especially since the walls of the chapels had begun to rise even before Brunelleschi's death.[8] The elaborate carving of Neri's sarcophagus indicates that the tomb cannot originally have been intended to stand hidden behind the chapel wall. But the defects of the arrangement devised in 1488 suggest that the arched opening and grating allowing a glimpse of the tomb were not originally intended either. Enveloped in the shadows of the niche, the tomb is far less visible than its elaborate carving warrants. The entrance to the niche, as wide as the shallow chapel permits, nevertheless conceals a certain amount of figurative and decorative sculpture as well as the boundaries of the sarcophagus. Although the sarcophagus is shoved as far to the left as the curvature of the semicircular chapel allows, the sarcophagus is not centered within the arch. Indeed, the niche was too small to accommodate the entire sarcophagus, and its left rear corner had to be broken off.

However, if the Capponi sarcophagus cannot have been intended to stand within a niche recessed behind the chapel wall, neither can it have been intended to stand within the chapel proper. The plain and partially unfinished rear indicates that it was not free-standing and its length and straight back would have prevented it from being set against the curving wall. Indeed, the small semicircular chapels designed by Brunelleschi are so inhospitable to tombs that the only sepulchral monuments erected in the church, outside of the Capponi Tomb, are epitaphs embedded in the wall, sometimes with a portrait bust or relief.

Since the Capponi Tomb could not have been destined for any church other than S. Spirito, it must have been intended for the pre-Brunelleschian church[9] in which the Capponi had a chapel dedicated to St. Nicholas of Bari.[10] In spite of the initiation of construction of the new church in 1436 a good deal of the old church was still standing at Capponi's death. A considerable portion of it must still have been intact and the new church, still far from completion when, after the fire of March 22, 1471, the old church

[7] The building history of S. Spirito is only imperfectly known, in part because of a lacuna in the building accounts for the years 1461 to 1471. For the building history of the church, see C. von Fabriczy, *Filippo Brunelleschi*, Stuttgart, 1892, pp. 198ff; Botto, op. cit., *R. d'arte*, 1931, pp. 489ff; Paatz, *Kirchen*, v, pp. 119ff; Howard Saalman, "Filippo Brunelleschi: Capital Studies," *AB*, xl, 1958, pp. 129ff. The documents are assembled by Eugenio Luporini, *Brunelleschi, forma e ragione*, Milan, 1964, pp. 230ff.

The tomb could not have been installed, either, prior to the enclosure of the curved chapel walls, which Brunelleschi had intended to determine the form of the exterior of the church, by the rectilinear wall that presently bounds the church and conceals the niche of the Capponi Tomb. But the construction of the rectilinear wall is not mentioned in any document. Its absence leads Saalman, op. cit., *AB*, 1958, pp. 132f, to date the change of plan to the period for which all documentation is missing. The only in-

disputable evidence for a dating of the rectilinear wall exists in the famous "Map with a Chain" which repeats a lost engraving of Florence by Francesco Rosselli made in 1482 or just before (for which see K. H. Busse, "Der Pitti-Palast, seine Erbauung 1458-1466 und seine Darstellung in den ältesten Stadtansichten von Florenz (1469)," *JPK*, li, 1930, pp. 120ff and L. D. Ettlinger, "A Fifteenth-century View of Florence," *BM*, xciv, 1952, pp. 160ff.

[8] Alessandro Chiappelli, "Della vita di Filippo Brunelleschi attribuita ad Antonio Manetti," *Archivio storico italiano*, series 5, xvii, 1896, p. 278.

[9] Tysz, *BR*, p. 48, and Paatz, *Kirchen*, v, p. 188, n. 156, also remarked that originally the tomb must have been installed in the old church.

[10] ASF, Manoscritti 622, *Sepoltuario di tutto il quartiere di Santo Spirito*, n.d. (seventeenth century), fol. 18r. Mentioned under the rubric "Cappelle e Sepulture della Chiesa Vecchia di Santo Spirito."

was restored. Indeed, Mass continued to be said in the old church until 1481. The decision to raze the last remnant of the old church in order to make room for a new sacristy dates only from June 27, 1488. On the very day that Giuliano da Sangallo was commissioned to prepare a model of the sacristy, permission was granted the Capponi heirs to open the wall of their chapel of the Visitation in order to make Neri's tomb visible. It is therefore very likely that the earlier Capponi Chapel of St. Nicholas, with the grave of Neri's father and Neri's own new tomb, was situated in this last remnant of the old church and that Neri's tomb remained there until demolition of the chapel impended.

If the present arrangement of the Capponi Tomb is not original, what did the original tomb look like? The epitaph probably did not form part of the original tomb.[11] In contrast to the epitaph from the Tomb of Orlando de' Medici (Fig. 106), dating from ca. 1456–57, the inscription is well centered and there is no crowding of the letters on the right. The individual letters resemble the classical script of the sixteenth century: they are more regular and less vertical than those of the Medici epitaph. The spacing of letters is ampler; that between words, less so. As a result, the rhythm of the individual letters is more uniform. No abbreviated endings appear above the line of the script. Therefore I think the epitaph likely to date from the reinstallation of 1488.

From the plain but worked rear face of the sarcophagus and the bosses on its ends, we may assume that the sarcophagus stood flush against a wall in such a way that the ends of the sarcophagus were at least partially visible. Three possible arrangements meet this requirement. The sarcophagus might have been raised on consoles, now presumably lost, like the Tomb of the Beato Angelo Mazzinghi (d. 1438) in the Carmine, Florence (Fig. 213). As in the vast majority of console tombs, the original inscription, probably higher and narrower than the present one, would have been embedded in the wall between the brackets. Or the tomb might have been framed by a niche like the one enclosing the sarcophagus of Filippo Strozzi by Benedetto da Maiano in S. Maria Novella (Fig. 216). The sarcophagus, with its present supports, would then have been set upon an inscribed base like the base of the Tomb of Piero and Giovanni de' Medici by Verrocchio in the Old Sacristy, S. Lorenzo (Fig. 217). Or the tomb might originally have been an arcosolium. In favor of this possibility is the shape of the Capponi sarcophagus, nearly identical to the sarcophagi of the arcosolium Tombs of Onofrio Strozzi (Fig. 211), Orlando de' Medici (Fig. 106), Giannozzo Pandolfini (Fig. 215) and Filippo Inghirami. The ornamentation of the cover with the defunct's coat of arms encircled by a wreath reappears in the Medici, Pandolfini and Inghirami Tombs. The ends of the Medici and Strozzi sarcophagi are carved with lions' heads. Flying putti ornament the face of the Strozzi sarcophagus too. Strange supports are a common feature of all arcosoli and the sarcophagus from the Tomb of St. Savinus in the Duomo, Faenza, is even raised on imitation consoles. However, in every example of the arcosolium, the inscription occurs on the sarcophagus—never on a separate slab or on the base, as it would have had to in the Capponi Tomb.

The Tomb of Neri Capponi is the first Renaissance tomb to contain a portrait medallion (Fig. 115). On Roman sarcophagi flying putti frequently support a central portrait medallion of the defunct but the sitter is invariably represented in bust-length from the front, often with one hand resting on his breast. The profile, bust-length portrait of Capponi in which the face is seen from the left, comes from antique coins and their derivatives.

[11] See Giovanni Mardersteig, "Leon Battista Alberti e la rinascita del carattere lapidario romano nel Quat- trocento," *Italia medioevale e umanistica*, Padua, ii, p. 304.

Among early Renaissance medals there are examples in which a death mask was used for a profile relief portrait[12] as it apparently was in the portrait of Capponi. The putti (Figs. 116, 117) derive from Bernardo's portal in the Palazzo Pubblico at Siena (Figs. 29, 30). The rope grill (Fig. 120) is identical to the grill in the balustrade in Antonio and Piero Pollaiuolo's Altarpiece of SS. Vincent, James and Eustace from the Chapel of the Cardinal of Portugal, 1467–68.

The attribution of the Capponi Tomb to Bernardo Rossellino does not rest on the testimony of documents or early secondary sources. Indeed, the design of the sarcophagus (Fig. 114) cannot be his. A comparison of the garland on the cover of the sarcophagus with the garland on the Tomb of Orlando de' Medici (Fig. 106) reveals a less regular and uniform design and a less plastic execution. The leaves of the wreath encircling the coat of arms are homomorphic and schematic: they do not correspond to any plant in nature. The cover is less densely filled and the background is nearly as assertive as the carving. The moldings of the *cassone* lack the variety of those of the Medici Tomb. Instead of reflecting light and casting shadows, they produce the linear effect of musical staves. In the Capponi Tomb no distinction is made between the moldings of the cover and the moldings of the sarcophagus, with the result that cover and sarcophagus merge. The duplication of the *tondo* of the cover in the *cassone*, and the repetition of the line of the garlands in the movement of the flying putti result in a monotony of design that Bernardo would have found antipathetic.

Nevertheless, the tomb does come from Rossellino's shop. The putti faithfully imitate the putti from the portal in Siena. And the portrait of Capponi (Fig. 115), identical in style to the Bust of Giovanni Chellini (1456) in the Victoria and Albert Museum (Figs. 218, 219), was evidently carved by Antonio Rossellino not long after the bust and therefore during the period of association with his brother. Both portraits depend on masks, the bust of Giovanni Chellini on a life mask, the bust of Neri Capponi on a death mask. In evidence of this is Capponi's sunken eye and cheek, his drawn mouth and the disappearance of his lips. The folding of the ear is due to the *cappuccio*, worn with the thick *mazzocchio* pulled down on the juncture of auricle and cranium. As in the ears of Giovanni Chellini, Antonio preferred not to correct a defect. Each head presents the same density of detail. In both there is a constant denting of the surface—on a minute scale in the area of chin and jaws, on a larger scale in the nose and forehead—that leaves no patch of flesh entirely smooth. Veins which consist of slightly raised, flat bands that ripple evenly, have the same configuration in both. Wrinkles that possess the spontaneous wavy quality of an etched line, in contrast, for instance, to the engraved wrinkles of Benedetto da Maiano's Pietro Mellini, are loosely but regularly spaced in both and of equal length. The contour of the skulls and the heads of hair are identical, for here the sculptor was not restricted by a mask. In both, the crumpled undergarment of a muslinlike material emerges above the collar of the heavy robe.

The bust of Neri Capponi is as carefully composed as the putto from the Tomb of Orlando de' Medici (Fig. 108). The ear occurs on the central vertical axis and the line from the tip of the nose to the point at which the skull begins defines the central hori-

[12] I.e. Antonio Marescotti, Medal of S. Bernardino, ca. 1444 (for which, see George Francis Hill, *A Corpus of Italian Medals of the Renaissance before Cellini*, London, 1930, no. 84); *idem*, Medal of Beato Giovanni Tavelli da Tossignano, Bishop of Ferrara, 1446 (*ibid.*, no. 79); Pisanello, Medal of Vittorino da Feltre, ca. 1446 (*ibid.*, no. 38).

zontal axis. The forward outline of the neck is parallel to the outline of the back, and the outline of the lower part of the skull is parallel to the contour of the chest. Around the tip of the nose, along the central axis, the profile forms an obtuse V.

The bust occupies a medallion whose edge curves forward nearly to the foremost plane of the relief as defined by the projecting ear. The head is carved in *schiacciato* relief: the change in the height of the relief is not determined by the gradual revolution of the form at its perimeter but only by the sudden dramatic recession of the eyeball, cheek and ear. The silhouette of the head consists of a minute perpendicular facet which shrinks to a mere incision where the background of the relief advances, at the top and bottom of the bust. There is no undercutting.

In spite of the fact that the ear projects more than the shoulder, one reads the forms with perfect comprehension. For the shoulder is foreshortened in such a way as to make it seem no less deep than it was in actuality. A short oblique seam indicates the distance from sleeve to collar. Very little of the chest is shown, and the folds of the robe become progressively thinner and gradually rise as they recede. The collar, as well as the lower outline of the bust itself, curves up.

This upward curve at the bottom of the bust, a device drawn from portraits on coins and medals, gives a termination to the bust much more emphatic than the incidental one which the limits of the field alone would otherwise produce. It nullifies the impression that the figure continues below, that it is seen through a window frame which accidentally cuts it off at the level of the shoulders, and signifies the frank acceptance of the image *qua* image. And yet the features, based on a death mask, are as close a record of reality as it was possible to make in the Renaissance.

Signs of age are apparent in the sunken features and flaccid forms, the wrinkles around the eye, nose and ear, the jutting veins in the forehead, the fold of thinnest parchment skin in the jowl, the accentuation of the bony structure because of the withering of the flesh. Even the carriage of the figure proclaims decrepitude, for the spinal cord no longer serves to hold the figure erect. As the chest sinks, and the head falls forward, a crease is formed in the nape above the humping of the back. Among these signs of age, the boldly staring eye is anomalous. This eye is Antonio's invention, for a death mask always showed the eyelids closed. The stare, however, vivifies the sitter and suggests the force of will for which Capponi was renowned.

The two putti (Figs. 116, 117) are unfinished: surfaces were polished although the final stage of carving was by-passed. The anatomy of the putto on the left, superior to that of its mate, suggests the presence of a more accomplished master. But the head of the putto on the right (Fig. 119) is much the better of the two (Fig. 118). Though but a sketch, it is of a quality worthy of Bernardo Rossellino. The slight turning of its head to the right is justified by the focus of its eyes. The impression of a rightward stare is due to the turning of the eyes slightly to the right of the axis of the face, as though the eyes were seen more laterally than the face itself. Thus the right corners of the two eyes are more sharply indented than the left corners; the right halves of the eyeballs curve more rapidly than the left, and the right halves of upper and lower lids are foreshortened. The mode of foreshortening used in the portrait of Leonardo Bruni (Fig. 59) is used here, too: the axis of the chin is shifted to the right of center and its contour is tilted sharply upward forcing a compression of the lower part of the right side of the face. The narrow mouth and particularly contracted upper lip which hardly extends beyond the caret recall Ber-

nardo's Christ Child from the Bruni Tomb (Figs. 69, 70). In both, the brows do not extend beyond the middle of the eyes. The sequence of convexity and hollow above the outer corners of the eyes and in the temples and the protuberance in the center of the forehead which spreads to the hairline are identical in both. Had the hair been realized, it would not have proven unlike the hair of the putto on the right from the Siena portal (Fig. 32).

The Tomb of Giovanni Chellini in S. Domenico, S. Miniato al Tedesco

GIOVANNI CHELLINI, known also as Giovanni Samminiati after his native town, was born at S. Miniato al Tedesco, probably in 1373.[1] In 1401 he was elected to the post of lecturer at the University of Florence. As a doctor, merchant, and moneylender he amassed a fortune which he invested in properties in S. Miniato and Florence. Upon the death of his only remaining son in 1458, Chellini designated his brother's son, Bartlommeo di Barto-lommeo, as his heir. Chellini died in Florence on February 4, 1462 (s.C.), at the age of ninety and was provisionally buried in the Duomo. His body was later transferred to its final resting place in S. Miniato al Tedesco.

In June 1455, Chellini provided for the construction of a chapel dedicated to the patron saints of physicians, SS. Cosmas and Damian, in the right transept of S. Domenico (formerly SS. Jacopo e Lucia).[2] Its construction was completed on April 8, 1456.[3] Very likely Chellini intended this chapel from its foundation as his place of burial. In a will dated February 20, 1460 (s.C.), he ordered that he be interred in the church of S. Jacopo in S. Miniato "in tumulo pro eius ordinato in eius cappella."[4] Thus the commission and perhaps also the commencement of the tomb (Fig. 121) preceded his death. That it was completed only afterwards, at the instigation of his nephew, is disclosed by the content of the inscription, the use of death masks for the carving of face and hands (Figs. 131, 134) and Chellini's provisional burial in Florence. The severe damage to the base of the tomb may have been inflicted by Napoleon's cavalry quartered in the convent of S. Domenico on May 18, 1799.[5]

The present form of the tomb is not original.[6] The broken pediment and stucco deco-

[1] For the biography of Giovanni Chellini, see Mario Battistini, "Giovanni Chellini, medico di S. Miniato," *Rivista di storia delle scienze mediche e naturali*, xviii, 1927, pp. 106ff; Alessandro Gherardi, *Statuti della Università e studio fiorentino*, Florence, 1881, pp. 181f, doc. 85; 375ff, doc. 113.

[2] S. Miniato al Tedesco, Biblioteca Comunale, MS U. 2, Prior Fra Gerolamo Rosati, *Cronache del convento di S. Jacopo di S. Miniato*, 1595, i, fol. 39r. This volume is presently missing from the library. The chapel was constructed during the priorate of Fra Pietro Francesco di ser Michele di ser Francesco Grifoni, from 1452 to 1470.

[3] *Ibid.*, i, fol. 39v f, anno 1456. Chellini endowed the chapel with plots of land at Ribaldinga, Fontevivo, Reggiana and Nocicchio.

The patronage of the chapel passed to the Pazzi family in 1762 and was subsequently transferred to the Settimanni. See R. W. Lightbown, "Giovanni Chellini, Donatello and Antonio Rossellino," *BM*, civ, 1962, p. 102.

[4] Battistini, op. cit., *Rivista di storia delle scienze mediche e naturali*, 1927, p. 112, n. 5.

[5] Anne Markham Schulz, "The Tomb of Giovanni Chellini at San Miniato al Tedesco," *AB*, li, 1969, p. 318.

[6] There has been much discussion and disagreement about what portion of the tomb is original. See H. von Geymüller, Stegmann-Geymüller, vi, "Pagnio di Lapo di Portigiani," p. 1; Wilhelm Bode, "Donatello als Architekt und Dekorator," *JPK*, xxii, 1901, p. 27, n. 1; Hans Mackowsky, "San Miniato al Tedesco," *Zeitschrift für bildende Kunst*, xiv, 1903, p. 216; C. von Fabriczy, "Pagno di Lapo Portigiani," *JPK*, xxiv, 1903, Beiheft, p. 123; idem, "Michelozzo di Bartolomeo," *JPK*, xxv, 1904, Beiheft, p. 43; Burger, p. 130; Guido Carocci, *Il Valdarno da Firenze al mare*, Bergamo, 1906, pp. 93f; Weinberger and Middeldorf,

rations are probably eighteenth-century additions. The remaining portions of the tomb date from the fifteenth century but belong to two separate campaigns. According to a reconstruction of the first state of the tomb which I published in 1969 (Fig. 122),[7] the effigy lay on a sarcophagus, now lost, supported by the two consoles that are presently located above the capitals of the pilasters. The two consoles flanked the epitaph located directly beneath the sarcophagus. The present pilasters rose from the head and feet of the effigy (Fig. 125) to support a semicircular lunette bounded below by an unbroken entablature whose uppermost cornice presently crowns the base of the tomb. On the face of the sarcophagus was a relief, perhaps a Man of Sorrows. Very likely a half-length Madonna and Child, either carved or frescoed, adorned the lunette, while a fresco, perhaps the Resurrection of Christ, was intended for, but never executed on, the rear wall of the niche.

With discrepancies of never as much as one percent, the extant measurements of the Chellini Tomb are simple fractions or multiples of the *braccio* (58.4 cm.). The width of the pilasters is ⅓ of a *braccio*. The interval between them is ten times as large, or 3⅓ *braccia*, making the total width of the monument 4 *braccia*. The height of the pilasters, including the capitals but excluding the floreated plinths is 3⅓ *braccia*. Thus the rear wall of the niche formed a square. The total height of the order, from the base beneath the plinth through the capital, is ten times the height of the capital, or 3½ *braccia*.[8]

On the basis of these measurements the proportions of the whole tomb can be reconstructed. Since the inside of the niche conforms to a square, it is probable that the outside did too. This would allow 28.2 cm. for the height of the entablature. Since the uppermost cornice is 9 cm. high, the architrave and frieze would have measured 19.2 cm., i.e. ⅓ *braccio*. The height of the interior of the lunette must have measured half the distance between the pilasters, i.e. 96.5 cm., and the archivolt around the lunette would probably have been as wide as the pilasters. The distance from the top of the entablature to the apex of the tomb would thus have equaled 8 mm. less than 2 *braccia*. If the lower portion of the tomb was equal in size to the upper and if the epitaph was contiguous to the sarcophagus, then the sarcophagus must have measured 87.6 cm., i.e. 1½ *braccia*—almost exactly the height of the sarcophagus in the Bruni Tomb. Thus the central square of 16 square *braccia* would have been bounded above and below by a rectangle of 8 square *braccia* and the tomb would have been exactly twice as high as it was wide.

The type of tomb to which the original Tomb of Giovanni Chellini belonged, in which consoles support a carved sarcophagus on which rest two vertical supports crowned by a pediment, is fairly frequent in the fourteenth century. The Tomb of Tommaso Pellegrini (d. 1392) in S. Anastasia, Verona (Fig. 220) is an example of the type.[9] But it is

Münch. Jahrb., 1928, pp. 85ff; Heydenreich and Schottmüller, "BR," T-B, xxix, p. 44; Anna Matteoli, "Il monumento sepolcrale di Giovanni Chellini nella Chiesa Sanminiatese di S. Domenico," *Bollettino della Accademia degli Euteleti della città di San Miniato*, xiv, 1948-49, pp. 17, 21; H. W. Janson, "Giovanni Chellini's *Libro* and Donatello," *Studien zur toskanischen Kunst, Festschrift für Ludwig Heinrich Heydenreich*, Munich, 1964, p. 137.

[7] For a detailed argumentation for the following reconstruction of the tomb, see Schulz, op. cit., *AB*, 1969, pp. 318ff.

[8] Smaller measurements also were calculated ac-

cording to the *braccio* though generally they manifest larger percentages of error than the larger measurements do. The capitals are approximately ⅓ by ½ *braccio*. The width of the corbels is closer to ⅓ *braccio*. The floreated plinths measure ⅛ by approximately ½ *braccio*. The rectangle of the inscription is almost exactly 2 *braccia* long.

[9] Others are the Tomb of Fra Ildebrandino Cavalcanti di Firenze, Bishop of Orvieto (d. 1279), S. Maria Novella, Florence (if its present arrangement is, or follows, the original); Tomb of Ranieri degli Uberti, Bishop of Volterra (d. 1290/96), S. Domenico, Arezzo (the corbels are missing); the Monument of

anomalous in Tuscan Quattrocento funerary sculpture. Tombs placed on the ground were much more popular than console tombs throughout the century, but especially after the Bruni Tomb. Though console tombs were not rare, by and large they followed the type of either the Coscia Monument or Mino da Fiesole's Tomb of Bishop Salutati in the Duomo, Fiesole. Indeed, in the fifteenth century there is only one tomb comparable to the Chellini Tomb: Antonio and Giovanni Rossellino's Tomb of Filippo Lazzari (d. 1412) in S. Domenico, Pistoia, 1464–67 (Fig. 221), as reconstructed by Bruno Bruni (Fig. 223).[10] There, consoles support a sarcophagus on which the effigy lies. Supports located at either end of the sarcophagus are surmounted by an unbroken entablature crowned by a semicircular lunette containing a painted Madonna.[11] The angels which presently spread apart the curtains originally stood on either end of the cornice. The relief was located above the effigy in the rear wall of the niche. The dimensions of the tomb as stipulated in the contracts are those of the Chellini Tomb: "Que sepultura est altitudinis brachiorum otto et latitudinis brachiorum quatuor."[12]

In other respects, too, the Chellini Tomb represents a return to the Trecento. In the Quattrocento the epitaph was moved from below the sarcophagus to a place of honor on its face, while the effigy was made the focus of the tomb by being elevated on a bier, located in the center of the tomb, and set off by simple marble slabs. A concomitant of the exaltation of the defunct was the gradual secularization of the monument with the result that religious imagery was confined to the Madonna and Child flanked by angels in the lunette. In the Chellini Tomb both these trends were reversed: evidently the religious imagery was meant to take precedence over the defunct. For this reason it seems likely that the tomb was, in large part, the product of Chellini's desires and that it reflected the tastes and attitudes of someone educated at the end of the Trecento and not those of a Renaissance artist, or even of Chellini's nephew, Bartolommeo, born in 1438. Interestingly, the only fifteenth-century tomb that resembles Chellini's and for which a specific fourteenth-century model was designated by its patron, the Tomb of Lazzari, was also commissioned by a man born considerably before the end of the fifteenth century and very old when he made provision for the tomb.[13]

At a later date, probably towards the end of the fifteenth century, the epitaph was removed from beneath the sarcophagus and incorporated within a base added on below

the Cerchi family, S. Francesco, Assisi, lower church, fourteenth century, from the Cosmati workshop; the Tomb of Cino di Sinibaldi, 1337-38, Duomo, Pistoia; the Tomb of Ligo Ammanati (d. 1359), Camposanto, Pisa; the Arca of S. Margherita, S. Margherita, Cortona, 1369; the Tomb of Guidone da Montechiaro (d. before 1380), S. Anastasia, Verona.

[10] "Per il monumento sepolcrale di Filippo Lazzari," *Chiesa monumentale di S. Domenico*, supplement to *Voce di S. Domenico*, Pistoia, October 16, 1932, pp. 43f. The tomb, as reconstructed, approaches much more closely the Tomb of Cino di Sinibaldi of 1337-38 (s.C.) in the Duomo, Pistoia, which Filippo's father, Sinibaldo, had designated in his testament as a model for the scene of the teacher and his pupils in the tomb of his son (Stefano Orlandi, O.P., *Il Beato Lorenzo da Ripafratta, campione della riforma domenicana del sec. xv*, Florence, 1956, pp. 8off, doc. 9).

[11] Payments for the Madonna were reported by Peleo Bacci, "Una celebre opera d'arte fiorentina," *Il messaggero toscano*, Pisa, December 27, 1916, reprinted in *Il popolo pistoiese*, Pistoia, January 6, 1917.

[12] Gaetano Milanesi, *Nuovi documenti per la storia dell'arte toscana dal xii al xv secolo*, Florence, 1901, pp. 112ff, docs. 133, 135.

[13] The tomb was commissioned by Filippo's father who survived his son by thirty-five years (Orlandi, *Il Beato Lorenzo*, p. 44, n. 12). So high a proportion of these tombs commemorate professors (Cino di Sinibaldo, Ligo Ammanati, Lazzari, Chellini) that one is led to wonder whether the type may have been identified with the profession, at least in Tuscany. On the other hand, people distinguished in other ways were also buried in tombs of this type while professors were sometimes buried in other kinds of tombs.

the tomb (Fig. 123). The proportions and ornamentation of the base (Fig. 124), diametrically opposed to the upper portion of the tomb, point to the involvement of a different workshop. The new base was not substantially different from the base that presently exists. Very likely a green marble strip 5 cm. high appeared above the inscription to match the strips above and below the red marble slab. The consoles projected 3.5 cm. more than they do at present, and a molding 5 cm. high below them provided a transition between the divergent planes of volute and lesene. At the top of the base was a narrow cornice between 15 and 20 cm. high.

There appears to have been no motive behind the addition of the base beyond the modernization of what must have seemed a very old-fashioned monument. The type of tomb the Chellini Tomb came to resemble by the addition of the base was preëminently Roman and was probably invented by Andrea Bregno after 1480. An example is the Tomb of Bishop Didaco Valdes (d. 1506) in S. Maria di Monserrato, Rome.[14] Like the second state of the Chellini Tomb, these tombs are combination ground and corbel tombs. Into the type of niche invented in the Bruni Tomb was inserted a platform treated like a cornice, supported by consoles and supporting a sarcophagus with projecting legs. The platform surmounted a base approximately the height of the Chellini base in which two upright rectangles flanked a broader rectangle. In front view, if not in profile, the combination resembled the sequence of lesenes flanking the red marble slab, corbels supporting a low cornice, further corbels and sarcophagus in the Chellini Tomb. Indeed, the tomb whose base most nearly approaches that of the Chellini Tomb, the Tomb of Filippo Decio by Stagio Stagi in the Camposanto, Pisa (Fig. 225), belongs to this type even though its niche is missing. However, since the sarcophagus of the Chellini Tomb extended the full width of the tomb and supported the architectural framework above, the tomb required a wider base than those of the Roman corbel-ground tombs. For the proportions of the whole base and its components, the author of the Chellini base found numerous models in Roman niche tombs of the late fifteenth century such as the Tomb of Ludovico Lebretto (d. 1465) in S. Maria in Aracoeli.

In the final restoration of the tomb, the moldings between the lower corbels and the lesenes and the strip of marble over the inscription, the cornice which crowned the base, the original corbels and the sarcophagus were removed. To provide a transition between the lower corbels and the slab on which the effigy lies, the restorer utilized the uppermost cornice of the entablature of the original tomb. The lower consoles which hardly extend in back, were pulled back slightly, anchored more firmly within the base and thus enabled to support the burden of the effigy. For this reason, the small projecting moldings beneath the consoles were no longer needed. The brackets which originally supported the sarcophagus were moved above the capitals, necessitating the construction of a new pediment which would project to the same degree. The new pediment was embellished with a stucco relief.

We are provided with a *terminus ante quem* for the restoration of the tomb by a draw-

[14] Others include the Tomb of Cristoforo della Rovere (d. 1479), S. Maria del Popolo, by Andrea Bregno and Mino da Fiesole; the Tomb of Giorgio Costa (d. 1508), S. Maria del Popolo; the Tomb of Pietro Rocca, Bishop of Salerno (d. 1482), S. Maria del Popolo; the Tomb of Benedetto Sopranzi, Bishop of Nicosia (d. 1495), S. Maria sopra Minerva. There is even a variation of this type in which the sarcophagus rests directly on corbels. Examples include the Tomb of Nerone Diotisalvi (d. 1482), S. Maria sopra Minerva, Rome, and the Tomb of Ferdinando di Cordoba (d. 1486), S. Maria di Monserrato, Rome.

ing of the tomb in its present state in Giovanni di Poggio Baldovinetti's *Sepoltuario* (Fig. 224).[15] The manuscript is not dated. However, an examination reveals that the author began compiling material for it in 1722. The latest drawing is dated 1766, while a majority of the dated drawings are from the fourth decade of the eighteenth century. The drawing of the Chellini Tomb can be dated with a fair degree of certainty to 1737, for one of the other two drawings made in S. Miniato al Tedesco is dated then.[16] In any event, the drawing was made before the chapel in which the tomb is found passed to the Pazzi (1762), for Baldovinetti's label implies that tomb and chapel belonged to the same family.

The style of the upper part of the tomb suggests that its restoration cannot date much before 1737. Motifs comparable to the broken, triangular cornice, wedged in the corners, whose raking and straight cornices do not coincide, and corbels supporting doubled cornices finely divided by numerous moldings occur in Filippo Juvarra's facade of S. Cristina, Turin, 1715–28 and Stupinigi Castle, 1729–33 respectively. White stucco decoration is a hallmark of the Rococo style and even in the monumental facade of S. Cristina there is a festoon similar to ours.

Neither documents nor secondary sources support an attribution of the Chellini Tomb to Bernardo Rossellino. Yet the formal resemblance of the Chellini Tomb to the Lazzari Tomb (Fig. 223) and to that tomb alone among fifteenth-century funerary monuments bespeaks a provenance in the Rossellino shop, and the date of the tomb coincides with the period during which Bernardo was its head. The consoles that supported the Chellini sarcophagus are identical to those which support the Lazzari sarcophagus (Fig. 221), and the effigy of Lazzari (Fig. 222) is copied from Chellini. Nevertheless, it must be admitted that such formal resemblances constitute an inferior sort of proof of authorship and therefore, until further evidence is uncovered, the origin of the Chellini Tomb in the shop of Bernardo Rossellino must be considered only probable.

Bernardo, himself, cannot have designed the Chellini Tomb (Fig. 121). In contrast to the alternation of void and solid in the Medici and Bruni Tombs (Figs. 106, 49), which served to emphasize the three-dimensionality of every form, solids are concentrated here, given a unitary geometric outline which causes them to coalesce, and then set off against a vast amount of empty space. The continuity of plane produced by the conjunction of the effigy and the bases of the pilasters characterizes the entire tomb. The flat entablature and the narrow effigy are indices of the shallowness of the tomb which, despite a niche framed by fully three dimensional members, is comparable to the relief tomb of the Beata Villana (Fig. 96). With the tomb's lack of depth accords its lack of weight. Long and slender pilasters support a light entablature. The sarcophagus rests on relatively short and narrow consoles. The elongation of the epitaph is increased by the unorthodox extension of the *alae*. Bernardo's dense and plastic ornament contrasts with fine cordlike tendrils so loosely dispersed over the surface of the shaft of the pilasters (Fig. 125) that the integrity of the plane is not disturbed. The uniformity and architectural stability of Bernardo's garlands contrast with the variety of motifs and the frequency of curves. The moldings are extremely fine and closely spaced and serve to narrow still further the proportions of the shaft.

These characteristics are shared by the effigy of Chellini (Fig. 129) whose long and narrow proportions are opposed to the normal proportions of the effigy of Bruni (Fig.

[15] Florence, Biblioteca Riccardiana, Codice Moreni [16] *Ibid.*, fol. 19r.
339, fol. 42r.

53). The straight, long, longitudinal lines of Chellini's folds increase the impression of elongation, as do the hands crossed low on the torso and the pointed toes. Even the book has become narrower and longer.

The deathlike rigidity of Chellini's pose is totally unlike the relaxation of Bruni's limbs, suggestive of a sleeping man. Where Bruni's legs are turned outward and spread apart, Chellini's legs touch one another. Chellini's arms, crushed against his body, are hardly bent and his head is held far back on his neck, so that, unlike the head of Bruni, it conforms to the longitudinal axis of the figure. The drapery partakes of the same rigidity. Instead of drooping around the limbs and falling into the hollow, it stiffly skims the surface of the figure, forming a brittle crust around the outside of the form.

A comparison of the profile views of the two figures (Figs. 50, 126) reveals how much the substance of the effigy of Chellini has been reduced, how flat the upper contour is, how neither arms nor feet are permitted to interrupt the horizontal outline of the figure, which, indeed, is reinforced by the repetition of longitudinal folds. In contrast to the ebb and flow of projecting and receding forms, the surface of the effigy of Chellini is uniform, and neither limbs nor drapery is permitted to expand to either side. Individual folds are squashed, crushed on top of one another; folds never recede gradually into rounded hollows. The material itself, to judge by the fine-edged folds and thin hems, is very much lighter than Bruni's heavy cloak. Even the book is hardly more than half as thick.

The tension of Chellini's pose is reflected in the design of the folds. Unlike the long and gently swinging curves of Bruni's folds, the folds of Chellini's *tabarro* follow a predominantly longitudinal course. Yet the outlines of folds are never straight, for their width is subject to constant expansion and contraction. To this corresponds the very subtle, yet constant denting of the tinny surface of folds. Combined with these folds are a minority of curving folds which, unlike those of the effigy of Bruni and of all Bernardo's figures, do not resolve themselves, but merely end or are rudely truncated by an overlapping fold.

In addition to the long folds which carry the eye from neck to feet, the surface of the effigy is strewn with tiny folds, complete in themselves and preëminently decorative in effect. Minute folds cover the entire surface of the *becchetto* (Fig. 127). Trivia which would not have detained Bernardo, such as the buttons of Chellini's shirt, the rings on his fingers, the ornament of his pillow, are treated with obsessive care (Figs. 128, 130).

Similarly, a comparison of the heads of the two effigies (Figs. 57, 58, 59, 132, 133, 134) reveals a greater degree of generalization in the head of Bruni—larger, smoother planes which merge gradually with one another. The features of Bruni's face are far from regular, yet the relative simplicity of surface allows us to seize more easily the face's structural framework.

In the narrowness of the effigy, the flattening of the surface, the elongation of proportions, the rigidity of pose and the long, straight folds, the effigy of Chellini is similar to Desiderio's effigy of the Beata Villana (Fig. 96). Yet the two effigies are not sufficiently alike to warrant attribution to the same master. The aberrant design of the Beata Villana contrasts with the conventionality of the design of the effigy of Chellini. In the latter, the drapery is arranged almost symmetrically and the lower edge of Chellini's book divides the effigy in half. While the total surface of the figure may be flatter and more regular, individual forms, such as the arms and hands and folds are less squashed, and differences in planes are not elided. Where folds are separated from one another by a mere incision

in the effigy of the Beata Villana, in the figure of Chellini the edges of overlapping folds have a palpable thickness and are sometimes undercut. The rendering of Chellini's face and hands, both drawn from death masks, lacks Desiderio's refinement: the author of the effigy of Chellini intensified the reality of his image by probing every wrinkle and disfigurement produced by age.

Nor can the effigy belong to Antonio Rossellino. The importance he attributed to plastic form would not have allowed so flat a figure. The uniform surface produced by the repetition of crushed, straight folds is opposed to the gouged and irregular surface he created by the massive bunching of cloth. The imprisonment of the effigy within the architectural frame contravenes the independence he bestowed upon the single figure in the Tomb of the Cardinal of Portugal. The treatment of the face of Antonio's Portrait of Chellini (Figs. 218, 219) in which not a single detail of the form is lost, contrasts with the aggressive, almost improvident, excavation of the surface of the visage of the effigy.

I must confess that a thorough search has not enabled me to find another work of sculpture, either within or outside the Rossellino workshop, precisely comparable in style to the effigy of Giovanni Chellini. This fact is all the more remarkable in view of the quality of the figure, which, while perhaps not such as to warrant an attribution to Bernardo Rossellino or his peers, is certainly far higher than the usual run of shop work. The drapery style seems related to that of the followers of Donatello, such as Giovanni da Pisa in his altarpiece in the Eremitani, Padua. The rigidity of the pose and the explicit reference to death in the face and hands is reminiscent of Vecchietta's effigy of Mariano Sozzini in the Bargello. To these clues I think we are justified in adding that of the architecture, undoubtedly designed and executed by the author of the effigy (Fig. 121). Both effigy and tomb share elongation of proportions, planarity and shallowness, minuteness of scale and linearity, produced in the one case by the very fine and even undercutting of almost volumeless folds and in the other by the application of thin tendrils to the surface of the pilasters.

Conclusion

An investigation of the sculpture of Bernardo Rossellino is invaluable for the light it sheds on the structure and practice of the sculptor's workshop in fifteenth-century Florence. The existence of Bernardo's workshop is frequently attested in the documents.[1] Though none of the assistants mentioned in the documents, nor any of the brothers, with the exception of Antonio and possibly Domenico, can be linked securely with a particular work or part of a work executed in the Rossellino shop, stylistic analysis has revealed the participation of perhaps as many as a dozen assistants. Buggiano entered Rossellino's shop as an accomplished master. His unassisted execution of the upper portion of the Bruni Tomb suggests a high degree of independence within the shop. Among the young apprentices were Antonio and Desiderio. Desiderio's talent was soon recognized by Bernardo who entrusted to him figures at least as important as those he executed himself. For Desiderio's first work, the S. Egidio angel, Bernardo provided a model in his own angel or a preparatory study for it. Desiderio's sculpture for the Tomb of Leonardo Bruni also probably was guided by the master's design. But the effigy of the Beata Villana, Desiderio's last work in the Rossellino shop, was designed and executed without Bernardo's intervention. Though older, Antonio was given less to do during the busiest period of the Rossellino shop. Possibly his development was less precocious than Desiderio's. Or his employment outside the shop, at S. Lorenzo and S. Miniato, left him little time. Domenico, if it is really he, worked at Arezzo as Bernardo's equal. But neither the documents nor the works attributable to him reveal that he retained this significance for long. Least accomplished technically were the *garzoni*. For the most part, these boys, or sometimes men, were given the simpler and more tedious tasks to do: hewing the block of marble, blocking out the forms to the master's design, polishing the figure when it was carved.

Documents reveal that employment in Bernardo's shop did not preclude acceptance of commissions from outside. To be sure, Tomaso and Giovanni Rossellino were matriculated members of the sculptors' guild; probably Domenico was too. But Antonio was employed on outside work before he matriculated in the guild in 1451. Conditions of employment for the Rossellino brothers, however, may have been less stringent than those applied

[1] At the Florentine Badia between 1436 and 1437 Bernardo was paid four times for the work of his *garzone*, once for the work of his brother, Giovanni, and once for the work of a brother whose name was not specified. The phrases, "Bernardo Mathej delborra et sociis" and "Bernardo Mathej del borra et fratribus," appear in the documents of 1443 and 1444 regarding the parapet of the drum of the Florentine Duomo. In the supplement to the commission for the Tomb of the Beata Villana of January 27, 1452, we read: ". . . ognaltra spesa dogni minima chosa toccha al detto bernardo e compagnj." According to the tax declarations of 1458, Bernardo and his four brothers rented a single shop in Via del Proconsolo. Five apprentices were specifically designated as Bernardo's *garzoni*, while six *garzoni* were named in the *catasto* of the other four Rossellino brothers. One of Bernardo's apprentices, Puccio di Paolo, was also recorded in connection with the Campanile of the Duomo of Pienza and the Campanile of S. Pietro, Perugia. The commission for the Tomb of the Cardinal of Portugal of December 23, 1461, went to Bernardo and Antonio jointly, while Giovanni was paid for carving the architectural members of the chapel.

to ordinary assistants and apprentices. There is no evidence that Desiderio executed any independent commissions during the period of his apprenticeship, and Buggiano's employment in the shop can be dated between his completion of the Bust of Brunelleschi and lost ciborium in the Duomo (1447) and the pulpit of S. Maria Novella (1448), and the commencement of the Cardini Chapel in Pescia (1451).

The degree to which Bernardo was responsible for the design of the monuments that issued from his shop follows no consistent rule. Every element of the portal at Siena, down to the garlands and moldings, seems to have been supervised if not actually carved by Bernardo. The architecture of the Bruni Tomb, the S. Egidio Tabernacle and the Tomb of Orlando de' Medici bear the stamp of his personality. In the design of the Tomb of the Beata Villana he probably realized specific intentions of the donor. Apart from the head of the putto on the right, the sarcophagus of the Tomb of Neri Capponi gives no evidence of the master's intervention. On the Tomb of Giovanni Chellini, Bernardo did not work at all. No rule holds either for the figurative sculpture produced in Rossellino's shop. Doubtless, the identity, position and scale, on occasion possibly the pose, of particular figures, were included in the overall design of any monument. When a figure executed by an assistant constituted the mate to a figure executed by Bernardo, the model that Bernardo had made in preparation for his own work, or the figure itself, served as guide. Beyond this, Bernardo seems to have left the executants of the work entirely to their own devices. This is true even when part of the figure was executed by Bernardo himself, like the angel at Empoli, where neither scale, nor costume, nor movement above the waist of the figure corresponds below; or like the effigy of Bruni, where the sleeve completed by Antonio does not seem to belong to the garment begun by Bernardo.

If the master worked on a monument at all, he generally, but not always, did the most important part. For the sculpture of the facade at Arezzo, work was divided equally not only according to its quantity, but also according to its importance. Where Bernardo carved most of the Madonna, Domenico (?) carved the Christ Child. Nor was one side of the facade considered the exclusive domain of one artist: both artists worked equally on two sides, each carving one upper and one lower part of a saint at either side. In the Annunciation from Empoli, on the other hand, Bernardo executed only the faces and the upper part of the front of the angel. In the Bruni Tomb, Bernardo was largely responsible for the effigy. He probably worked on the less significant figure of the genius because it was located at the observer's eye level. But he allotted to Antonio the portrait of Neri Capponi, reserving to himself only the face of a putto.

An entire figure, unless it was very small, was rarely executed by a single person. Indeed, three sculptors carved the effigy of Bruni. A figure could be divided anywhere: horizontally at the knees (St. Gregory) or waist (Empoli angel); diagonally (St. Donatus); or into nude and clothed parts (right-hand genius from the Bruni tomb), though it was most common to separate the execution of the face from the remainder of the figure. If the design of a monument required the repetition of a single motif either once, as in the relief at Arezzo, the S. Egidio Tabernacle, the Bruni, Villana, Medici or Capponi tombs, or several times, as in the Bruni base, one sculptor did not do more than a single figure. (The putti at Siena constitute the one exception.) (It is interesting to note that this way of apportioning figures corresponds to the division of commissions at the end of the fourteenth and the beginning of the fifteenth centuries.) By means of this extensive division of labor the various parts of a single figure or all the figures belonging

to a single unit could be executed simultaneously. Since a normal workshop would not have been large enough to permit the dispersal of all the component pieces of a monument, let alone of the several monuments commissioned contemporaneously, in such a way that all could be worked upon at once, the assignment of several sculptors to a single piece permitted the most rapid execution of a work.

The fact that sculptors worked on separate parts of a single figure simultaneously, that one part could not be checked against another part more nearly finished, partially accounts for the discrepancies in scale and pose and even costume in figures jointly executed. That Rossellino would allow an inferior assistant to work on a figure begun by him indicates that he did not consider himself the genius that the master became with Michelangelo and has remained ever since, but rather the most competent among trained craftsmen. No doubt it was important both to him and to the patron that the monument should be designed by him, but what mattered even more was to get the job done quickly with the smallest possible expense.

The *bottega* of Bernardo Rossellino cannot be accepted as the model of a Quattrocento workshop in all respects, for unlike the activity of most shops spread evenly over several decades, the great bulk of the sculptural activity of the Rossellino shop was concentrated within five years. As a result, Rossellino's workshop functioned on a far larger scale than was generally the case.

The concentration of sculptural commissions explains the unusually low proportion of work executed by the master. Indeed, the degree of Rossellino's personal intervention declined with every monument after the Siena portal. After 1451, architectural projects claimed nearly the whole of his attention.

Another extraordinary feature of the Rossellino shop is the number of assistants. The number I have identified in the works produced in Rossellino's shop during a period of several years may not seem unusually large; but in other shops the majority of assistants would have performed only rudimentary tasks of which no visual record—the only basis for a reconstruction of anonymous personalities—is preserved. For every assistant in the Rossellino shop who carved a figure and whose style is therefore identifiable, there must have been many others who functioned as *garzoni*. Moreover, inferior sculptors not infrequently were entrusted with the design and execution of the most conspicuous or iconographically significant portions of a monument. Clearly, Rossellino was in desperate need of *manodopera*, a need even Florence could not entirely fill with sculptors of proven talent. With the possible exception of architectural details, sculptors do not seem to have specialized in the carving of one particular class of objects.

The concentration of work within a very short period also accounts for the diversity of style of the assistants, for the fact that Bernardo did not succeed in imposing a style immediately recognizable as his on any of his assistants, let alone on them all, as did Antonio, Desiderio, Mino da Fiesole, Verrocchio. The uniformity of style of all the members of a shop is the result of intensive training of young apprentices over a period of many years. But Bernardo probably did not employ his assistants for more than five years. Moreover, he must have sought experienced assistants capable of assuming a degree of responsibility which in less prosperous shops devolved upon the master alone. All Bernardo's assistants were probably hired more or less at once so that there was no time to train them individually or to entrust the training of one disciple to another whose style

had been modeled on the master's. Finally, there existed very few examples of the master's style: Bernardo's major works, of which there are not many, were created alongside those of his assistants. Thus not a single sculptor actually became his follower, and his own assistants were more indebted to Desiderio and Antonio than they were to the master of the shop.

Bernardo's function in the workshop must have been primarily that of an entrepreneur. He possessed the reputation which brought him the most outstanding and lucrative commissions. He had the shop, the tools and sufficient capital to purchase material and assistance before being paid. He designed the monuments, assigned the work and oversaw its execution. Therefore it was he who signed the contracts and received the payments, even when he personally contributed very little to the project. He even played a role in the contract between Giovanni Rossellino and Pagno di Lapo Portigiani and the Duomo of Massa Marittima though it did not concern his shop directly. And it was probably as financial guarantor of the work that he signed the contract for the Tomb of the Cardinal of Portugal.

In view of the extensive use made of assistance, documents of commission and payment for sculpture cannot be interpreted, as is generally the case, as an infallible indication of the designer and executant of the work in question. Indeed, the presence of the clause which states that if a work is not finished by the artist from whom it was commissioned, it must be finished by a second artist at the expense of the first,[2] occasionally casts doubt upon even the artistic origin of the monument. (It is important to note that in such a case only the first artist would have been paid by the patron.)

One class of evidence that has proven itself more useful than is usually allowed is the critical literature of the fifteenth and sixteenth centuries with its lists of artists' works. The Tomb of the Beata Villana, attributed to Desiderio da Settignano from its first appearance in the secondary literature until the discovery of the commission to Rossellino in the eighteenth century, is a case in point. The Tomb of the Cardinal of Portugal is certainly another. From the earliest notices of it at the end of the fifteenth century until the publication of the bulk of the documents in 1964, the tomb was invariably published as Antonio Rossellino's.[3] The discovery of the documents revealed Bernardo's signature on the second of two contracts for the tomb and payments to him amounting to nearly a quarter of all the money disbursed for it. But the tomb itself contains no evidence of his hand.[4]

[2] See the contract of December 23, 1461, for the Tomb of the Cardinal of Portugal (Hartt, Corti, Kennedy, p. 141, doc. 6): "E al chaxo ch'e sopra detti Antonio e Bernardo non facièssino detto lavorio, vogli(o)no e sono chontenti lo possino fare fare a chi loro paressi o piacessi e a lloro spese."

[3] The early sources are: Luca Landucci, *Diario fiorentino dal 1450 al 1516*, ed. Jodoco Del Badia, Florence, 1883, p. 3; Billi, p. 46; Magl., p. 93; Vas-Ricci, ii, pp. 139f; Vas-Mil, iii, pp. 94f; Raffaello Borghini, *Il riposo*, Florence 1584, pp. 337f; "Ricordi antichi d'arte fiorentina," ed. Paolo Galletti, *Rivista fiorentina*, i, October 1908, pp. 19, 27; Paolo Mini, *Discorso della nobilità di Firenze, e de fiorentini*, Florence, 1593, p. 109.

[4] In a *compagnia* formed between two or more artists, contracts and payments invariably were joint even when the work was done by only one. For the *compagnia*, see Ugo Procacci, "L'Uso dei documenti negli studi di storia dell'arte e le vicende politiche ed economiche in Firenze durante il primo quattrocento nel loro rapporto con gli artisti," *Donatello e il suo tempo, Atti dell'VIII convegno internazionale di studi sul rinascimento*, Florence/Padua, 1966, Florence, 1968, pp. 24ff. For the purpose of production of the Tomb of the Cardinal of Portugal, Bernardo and Antonio might have formed a similar association.

Bernardo Rossellino's major contribution to the sculpture of the Renaissance lies in the standard forms that he helped develop for tomb, tabernacle and portal. In the Tomb of Leonardo Bruni, Bernardo established the type of lavish tomb employed in Florence for major humanists and elsewhere in Italy for anyone with social or humanist pretensions. The more austere and reticent Tomb of Orlando de' Medici set the standard for funeral monuments of prosperous Florentine citizens of the second half of the fifteenth and the beginning of the sixteenth centuries. In the S. Egidio Tabernacle, Bernardo introduced the motif of adoring angels framed by the lateral openings of an enclosure whose rear wall was the *sportello*. Its fifteenth-century progeny are too numerous to list. Although the portal at Siena had less impact, its influence can also be traced.

The success of Bernardo's inventions may be explained by the sculptor's architectural bias. The frame was often as much the focus of attention as the object framed. It was invariably decisive for the ordering of the sculptural components of the work. For the sculpture, the architecture provided both the frame and the field. Therefore the scale of sculpture was predetermined and sculpture was generally limited to relief. The symmetry of the architecture demanded a symmetrical disposition of figures. Sometimes the iconography was suggested by the architectural divisions of the monument. In the relief of the Madonna del Manto the original ogive arch determined even the shape of the composition.

Bernardo's architectural style, as it reveals itself in works of sculpture, is characterized by frames which not only surround as completely as the monument permits but provide a total spatial ambience like the boxlike setting in a certain type of relief: the sculptural components of a work are set inside a niche, even if its lateral walls consist merely of a succession of moldings or the gathered folds of a heavy curtain. The walls of the niche are never penetrated to give the impression of a loggia, like Michelozzo's Brancacci Tomb, for instance. Within the niche, the sarcophagus or bier is carved in the round and is free-standing on all sides but the rear. Even in the relief in Arezzo the heads of Bernardo's supplicants are distinguished from the rest by their unabridged volume and their independence from the background. For his frames Bernardo generally utilized orthodox architectural motifs in orthodox combinations. His frames are heavy, plastic, richly embellished. Even when decorative motifs are not strictly architectural, they possess the regularity and uniformity of a molding.

Bernardo's figure style belongs to the linear, decorative trend of Florentine art exemplified by Ghiberti in sculpture, by Lorenzo Monaco, Fra Angelico, Fra Filippo Lippi in painting. To the pattern on the surface made by lines, to the symmetry or correspondence of part to part, the contours, the design of folds, the linear rhythms made by the movement of the body, Bernardo devoted much consideration. The pattern that results is inevitably rational, precise, simple without being bare, regular without being repetitive. There is never any disequilibrium or imbalance. Curves invariably resolve themselves—are never merely truncated. Straight lines, angles and indented surfaces are just sufficient to add tartness to a composition based on curves.

The linearity of Bernardo's style implies a visual rather than a tactile approach to sculpture. Indeed, Bernardo never conceived a statue fully in the round, nor even a statue intended to be seen from more than a single point of view. To enhance that view Bernardo utilized the purely visual devices of foreshortening and linear and aerial perspective. He manipulated light through form and degree of polish with a mastery that contradicts Leonardo's assertion of the superiority of painting because it carries its own light within

it. His differentiation of textures is comparable to the effects of brush and pigments and, along with the finely delineated detail, demands a careful scanning from close range.

And yet this visual approach was not of such pervasiveness that it caused Bernardo to repudiate the three-dimensionality of sculpture, as it did Desiderio, for instance. The volume of such figures as the effigy of Leonardo Bruni and St. Gregory is, if anything, slightly exaggerated, and their three-dimensionality is explicated by the movement of their folds. Bernardo never employed the technique of *schiacciato* relief and the surfaces of his figures are never flat. The linear pattern of the drapery paradoxically, is produced by plastic folds, and garments sometimes seem made of very heavy stuffs.

No traces of works remain other than those carved in stone. Though it is conceivable that Bernardo worked in wood, I do not think it likely that he ever worked independently in bronze. For Bernardo, unlike Antonio, would not have appreciated the liberty offered by the technique of modeling. Figures always retain that fundamental three-dimensionality endowed them by the block of stone and their thick, cubic bases, carved from the same block as the statues, recall the original shape of the blocks, their atavistic stability and weight. The movements of the figures are always restrained, generally vertical, hardly asymmetrical and therefore do not produce those apparent disequilibria that can be made to balance out only in bronze. Figures do not twist about in space but retain that directionality imposed upon them by the quadratic block of stone. Limbs remain close to the body and where not contiguous are almost invariably connected by means of drapery. Thus the block is never perforated, and outlines are inevitably closed, smooth and continuous. Surfaces, while not uniform, do not manifest sudden jumps in plane, and projections are either very limited or very gradual. Despite their plasticity, folds inevitably remain attached to the mass of the figure and diagram its surface rather than giving it a new and more complex three-dimensional configuration.

Despite his classification among exponents of the decorative trend of Florentine art, Rossellino was not ignorant of scientific innovations. He learned what Donatello had to teach him about the effect of movement on anatomy. In a most sophisticated way he applied the laws of perspective to the foreshortening of the individual figure and explored the effects of aerial perspective more widely than even Donatello had done. His appreciation of the beauty of abstract pattern never induced him to produce unnatural effects. He avoided inconsistencies in the anatomy, the poses, the drapery of his figures. Movement, anatomy, recession were made as explicit as if they were part of a scientific demonstration. How a garment is sewn, the way it is worn, the stuff of which it is made were scrupulously recounted. But for Rossellino, science had relevance only in so far as it bore upon the technique of sculpture.

In his figures Rossellino avoided portraying strong emotions. Gestures are tranquil. Poses barely hint at feelings: the violent poses demonstrative of uncontrolled passion that Donatello derived from antique sarcophagi were uncongenial to Bernardo. Expressions are muted and reveal, above all, a shyness about disclosing the subject's inner self.

Bernardo was extremely dependent on his teachers. From Ghiberti come the elongated proportions of his figures, their moderated sways and a relief technique in which the height of the relief is precisely keyed to the recession of the form. Like the folds of Ghiberti's draperies, his long, thin, cordlike folds separated by wider hollows produce a pattern composed of curving, parallel lines, evenly spaced, which diagrams the figures' movement and anatomy. From Donatello come the contrapposto of Bernardo's figures and the various devices which cumulatively produce the effect of aerial perspective. The faces

of the Virgin and St. Gregory at Arezzo were imitated from works of his. Sculptures by Michelozzo inspired the classicistic face of the Virgin at Empoli as well as Bernardo's characteristic long, tubular folds. Yet what Bernardo learned from Ghiberti, Donatello and Michelozzo, he assimilated, transformed and made his own.

For want of commissions, what Bernardo had learned in the late 1420s and early 1430s could not be put to use until the second half of the 1440s. But by that time, the grace of Bernardo's figures, the linearity of his patterns, the calligraphy of his drapery, the restraint of the movement of his figures, the subdued emotional states were all slightly old-fashioned, and Desiderio and Antonio, born a generation after Bernardo, found little in his style worthy of imitation. Neither owes his facial type to Bernardo. In his London Bust of Giovanni Chellini Antonio surpassed his teacher by rendering formally purely visual details. The arbitrariness, the deliberate irregularity, the squashed and indented surface of Antonio's drapery defy the calligraphy of Bernardo's folds, while the strip folds and discordant angularities of Desiderio's drapery owe far more to Donatello's style of the late 1420s and early 1430s than to Bernardo's harmonious patterns. For the expression of simple humility with which the Empoli Virgin acknowledges the message of Gabriel, Desiderio substituted a trancelike state in his Madonna from the Bruni Tomb. The awkward movement which Desiderio introduced into the mellifluous pose of the Christ Child hints at a strange emotional state like that of Donatello's John the Baptist in the Frari. In the head of his putto from the base of the Bruni Tomb, Desiderio exaggerated the foreshortening of the heads of Bernardo's figures. In place of Rossellino's Ghibertian relief, Desiderio combined flattened surfaces and sharply undercut contours, a relief technique probably derived from a certain kind of antique cameo and used, perhaps not long afterward, in the classicizing *tondi* of the *cortile* of the Medici-Riccardi Palace.

Nevertheless, Bernardo Rossellino did have an inheritance to bestow upon the sculptors who followed him, for he brought to the technique of carving a refinement and precision for which the first generation of inventors had not had time or thought. Thus, though Bernardo's particular style was carried forward by no one, what he had to teach about the handling of marble was learned by all Florentine sculptors of the second half of the fifteenth century. Without the infinite care Bernardo took with works tiny in scale, Antonio might never have carved so meticulously the base of the Tomb of the Cardinal of Portugal. The elaborate and decorative drapery style of Antonio's flying angel on the left of the cardinal's tomb is predicated upon Bernardo's conscious consideration of the placement, the configuration and the relation of every fold to every other. Between Michelozzo's heads of the effigies of Cardinal Brancacci and Bartolommeo Aragazzi and Antonio's Bust of Giovanni Chellini, the precision and particularity of treatment of the head of Leonardo Bruni is an intermediate step. Devices of foreshortening of faces and the virtuoso depiction of a range of textures were lessons Bernardo taught his brother. To Desiderio Bernardo bequeathed an ability to control effects of light through the sensitive manipulation of surface forms. The expressive countenance of Bernardo's Empoli angel presages the Leonardesque smile of Desiderio's left-hand putto from the Marsuppini Tomb. In Verrocchio's Portrait of a Lady in the Bargello, the curls composed of myriad single strands, the graceful hands that exert no pressure, the material of the silken bodice gathered round the neck to produce a hundred fleeting folds are indebted to the sublime refinement of Bernardo's Gabriel and reveal that the influence of Rossellino's works endured long after he had died.

Catalogue

In the catalogue the following topics are considered in sequence:

1. Location of object within the building (where pertinent). Right and left refer to spectator's right and left. Within a church right and left designate spectator's right and left when facing the high altar. Bays are counted from the main entrance of the church.

2. Description.

3. Material and polychromy.

4. Condition, including elements missing or replaced.

5. Measurements. Dimensions are metric. Height precedes width; width precedes depth.

6. Inscriptions.

7. Bibliography. Items are arranged in chronological order. Unpublished manuscripts have been omitted. Raised Arabic numerals preceding the date of publication indicate edition.

1. The Sculpture of the Facade of the Palazzo della Fraternità, Arezzo

The statuary and relief with their architectural framework span the second story of the facade.

The upper story of the facade is divided by paired Composite pilasters into three sections which correspond to the three bays of the ground floor. In the center a mixtilineal arch contains the relief of the Madonna del Manto with the Christ Child in her arms. The Madonna's cloak is held open by two angels. Beneath it kneel fourteen figures on the left and thirteen on the right including a pope, a monk, a nun, a queen, a soldier, infants, youths and old people, men and women. The Madonna del Manto is flanked by SS. Lorentinus and Pergentinus, who cannot be distinguished from one another. The kneeling saints hold martyrs' palms and the insignia of the fraternity, the cruciform monogram, M[iseri-cordi]a, in a circular shield. To either side are shell-topped niches framed by classical aediculae and crowned by pediments and putti holding garlands. St. Donatus, in bishops' dress and holding a crosier and book, occupies the left niche. On the right St. Gregory, in papal garb, blesses and holds a book.

Pietra bigia, a variety of *arenaria macigno*.

The lower portions of the Madonna's cloak have been hacked off. The surface of the sculptures and architectural details is extremely friable and in the past few years has been crumbling at an accelerated rate.

Entire facade (to roof): 1560 cm. x 1000 cm.; pilasters of second story: 287 cm. high;

entablature: 110 cm. high; area between cornice and balcony: 120 cm.; columns of lateral tabernacles: 196 cm. high; lunette: 350 cm. wide; SS. Lorentinus and Pergentinus: 167 cm. high. (From Tysz, *BR*, p. 140.)

Inscribed on the base of St. Donatus: S̄ DONATVS. Inscribed on the base of St. Gregory: S̄. G EGO IVS. ᴙ ᴙ

Bibliography: Vas-Ricci, i, pp. 240f; Vas-Mil, ii, p. 136; Baldinucci, *Notizie*, ii, p. 107; Giovanni Rondinelli, *Relazione sopra lo stato antico e moderno della città di Arezzo al serenissimo Granduca Francesco I. l'anno MDLXXXIII*, Arezzo, 1755, p. 83; Antonio Francesco Rau and Modesto Rastrelli, *Serie degli uomini i più illustri nella pittura, scultura e architettura*, Florence, i, 1769, p. 70; Leopoldo Cicognara, *Storia della scultura dal suo risorgimento in Italia*, Venice, i, 1813, p. 401; Giulio Anastasio Angelucci, *Memorie istoriche per servire di guida al forestiero in Arezzo*, Florence, 1819, p. 104; Emanuele Repetti, *Dizionario geografico fisico storico della Toscana*, Florence, i, 1833, p. 114; N.O. Brizi, *Nuova guida per la città di Arezzo*, Arezzo, 1838, p. 86; G. B. Sezanne, *Arezzo illustrata, memorie istoriche, letterarie e artistiche*, Florence, 1858, p. 197; Charles C. Perkins, *Les Sculpteurs italiens*, Paris, n.d., i, p. 156, n. 3; Jacob Burckhardt, *Der Cicerone*, ed. A. von Zahn, Leipzig, ³1874, ii, p. 627; Ubaldo Pasqui, *Nuova guida di Arezzo e de' suoi dintorni*, Arezzo, 1882, p. 105; Burckhardt-Bode, *Cicerone*, ⁵1884, ii, 2, p. 345d; Adolfo Venturi, "Sperandio da Mantova (appendice)," *Arch. stor.*, ii, 1889, p. 233; Eugène Müntz, *Histoire de l'art pendant la renaissance*, Paris, 1889, i, p. 471; Burckhardt-Bode, *Cicerone*, ⁶1893, ii, 2, p. 382a; Reymond, *Sculpture*, ii, p. 179; iii, pp. 23f; Fabriczy, *JPK*, 1900, pp. 34ff, 99f, 106ff; Stegmann-Geymüller, iii, "BR," pp. 5ff; Bode, *Denkmäler*, p. 98; Fabriczy, "Ancora del tabernacolo col gruppo del Verrocchio in Or San Michele," *L'arte*, v, 1902, p. 337; Burger, p. 302; Paul Perdrizet, *La Vierge de Miséricorde: étude d'un thème iconographique*, Paris, 1908, p. 82, no. 21; Venturi, *Storia*, vi, p. 606; viii, 1, pp. 491ff; Michel, *Histoire*, iv, 1, p. 97; Giannina Franciosi, *Arezzo*, Bergamo, 1909, pp. 128ff; Alessandro Del Vita, "Contributi per la storia dell'arte aretina," *Rassegna d'arte*, xiii, 1913, p. 188; Mario Salmi, "Passeggiate nell'Aretino," *Pagine d'arte*, iii, Nov. 30, 1915, p. 151; Schubring, *Plastik*, p. 117; A. Del Vita, *Guida di Arezzo*, Arezzo, 1923, p. 55; Massimiliano Falciai, *Arezzo, la sua storia e i suoi monumenti*, Arezzo, 1925, pp. 76f; Ubaldo Pasqui and Ugo Viviani, *Guida illustrata storica, artistica e commerciale di Arezzo e dintorni*, Arezzo, 1925, pp. 177, 198; Tysz, *BR*, pp. 13ff, 100f, 140; Vera Sussmann, "Maria mit dem Schutzmantel," *Marburger Jahrbuch für Kunstwissenschaft*, v, 1929, p. 332; Ybl, ii, pp. 316f; Kennedy, *R. d'arte*, 1933, pp. 115ff; Heydenreich and Schottmüller, "BR," T-B, xxix, pp. 43f; Becherucci, "BR," *Enc. ital.*, xxx, p. 135; Janson, *Michelozzo*, pp. 264f; Planiscig, *BR*, pp. 9f, 48; Janson, *Dona.*, p. 52; Pope-Hennessy, *Ital. Ren. Sc.*, pp. 34, 296; Galassi, p. 159; Luciano Berti, *Il Museo di Arezzo*, Rome, 1961, p. 21; Seymour, *Sculpture*, p. 121.

On April 24, 1433, Bernardo Rossellino, Giovanni di Piero di Ciori da Settignano,[1] Ciechino di Giagio da Settignano[2] and Giuliano di Nanni da Settignano were commissioned

[1] In 1435 Giovanni di Piero di Ciori was working on the Tomb slab of Bishop Ubertino degli Albizzi at Pistoia. From Giovanni's *catasto* of 1451 we learn that he was born in 1400 and that he farmed as well as carved. The accounts of the sculptors' guild record the date of his death as 1465. See Hartt, Corti, Kennedy, p. 88.

[2] Ciechino di Giagio was commissioned to make 100 *braccia* of what was probably the lowest parapet of the Florentine Duomo on September 12, 1442 (C. von

to "do the work of the fraternity," i.e. provide the architectural facing through the cornice of the second story of the facade.[3] A time limit was set at October 31, 1433, but on October 16, 1433, it was postponed until the end of the following November. On July 23, 1434, the final payment of 802 lire, 8 soldi, was made. On August 1, 1434, Bernardo, Giuliano, Ciechino and Giovanni confirmed having received 810 lire, 2 soldi, on different occasions.

On March 21, 1434, Bernardo received 10, out of a salary of 90,[4] florins for the figure of the Madonna del Manto or Virgin of Mercy, at the center of the second-story facade. On June 17, 1434, it was decided that the 50 florins which were to be realized from the sale of grain were to be paid to Bernardo for the Madonna. The Madonna was installed above the portal of the palace by June 30, 1434, amidst great celebration and feasting. Bernardo's final payment of 30 florins dates from July 16, 1434.

Apparently the rectors were dissatisfied with the appearance of the Madonna when they saw the relief installed. On August 31, 1434, the figures of SS. Lorentinus and Pergentinus flanking the Madonna were commissioned from Bernardo. They were to be carved in "meço rilievo," according to a preestablished design, at a cost of 6 florins. They were to be executed and carted at the sculptor's expense and finished by October 31, 1434.

Previously, on May 27, 1434, two workmen had been paid for having carted the stone for the statues of SS. Donatus and Gregory intended for the niches at the sides of the facade. On June 21, 1435, Bernardo received a partial payment of 40 grossi for the two completed saints which had been entrusted to him on April 16, evidently of the preceding year. On August 20, 1435, Bernardo received 4 lire, 13 soldi, for the statues which he had carved "some time ago."

On July 22, 1435, Bernardo was commissioned to do the "work that must be done or else friezes, etc., that must be made above the facade" for a price not to exceed 65 florins. On August 20, 1435, the rectors specifically commissioned a series of brackets with friezes to be completed within a year at a cost of 50 florins. All expenses, except those for iron and lead, were to be borne by the artist. Bernardo was to follow the design he had already submitted though he could omit the heads—possibly those which appear in the frieze over the brackets—if he wished. On August 26, 1436, Bernardo released the fraternity from any debt incurred for the work he had done for them.

Fabriczy, "Brunelleschiana. Urkunden und Forschungen zur Biographie des Meisters," JPK, xxviii, 1907, Beiheft, p. 24). On the same day an identical commission to Bernardo was witnessed by Ciechino. Ciechino served as witness again on September 15, 1442 (Tysz, BR, pp. 104f, doc. 7). On December 1, 1442, Ciechino and Papo di Maso were commissioned to make 40 braccia of the gallery in the nave of the Duomo. In July 1446, Ciechino and his companions were advanced 200 lire for the shafts of six columns for the nave of S. Lorenzo which they agreed to furnish completely carved (Margaret Kremers, The Sculptured Friezes in the Nave of San Lorenzo (typescript), M. A. Thesis, Smith College, Northampton, Mass., 1933, p. 20). In 1449 Ciechino figured among the scalpellini executing the capitals of S. Lorenzo (Leandro Ozzòlo, "La Basilica di S. Lorenzo in Firenze," La rassegna nazionale, Florence, cxxxiii,

1903, p. 242; idem, "Lavori dei Rossellino e di altri in San Lorenzo a Firenze," Bollettino d'arte, vii, 1927-28, p. 233).

[3] With the exception of the payment of June 21, 1435, for SS. Donatus and Gregory, all the relevant documents were published by Fabriczy, JPK, 1900, pp. 106ff, doc. 1. This payment, along with certain others, appeared first in Alessandro Del Vita, "Contributi per la storia dell'arte aretina," Rassegna d'arte, xiii, 1913, p. 188, and was included in the selection of documents in Tysz, BR, pp. 100f, doc. 2. See Doc. 15 (App. 3).

[4] This is the precise sum to which the payments published by Fabriczy add up. One is tempted, therefore, to question the existence or accuracy of transcription of a payment of 42 grossi, 10 soldi for the Madonna dated June 30, 1434, recorded only by Del Vita, op. cit., Rassegna d'arte, 1913, p. 188.

A small terracotta relief of the Madonna del Manto from the fraternity and now in the Pinacoteca, Arezzo (Fig. 144), has been identified frequently as Rossellino's model for the center of the lunette.[5] That the relief was copied, instead, from the Madonna of the facade is proven by the fact that those elements from the facade which are largest in scale and therefore visible from the street below, such as the Madonna and Child, correspond very well to the terracotta relief, while others which, on account of the foreshortening from below, were probably all but invisible, do not correspond at all.

According to Vasari, the facade was begun in the Gothic style and completed in 1383 by Niccolò Lamberti assisted by masons from Settignano.[6] This account was repeated into the nineteenth century[7] until Pasqui's paraphrase of some of the relevant documents in his guide to Arezzo of 1882.[8] Bode took note of this new information in his revisions to successive editions of Burckhardt's *Cicerone*,[9] as did Venturi.[10] Müntz, however, continued to cite the name of Niccolò d'Arezzo[11] while Reymond vacillated between attributions of the lunette to Bernardo (with a dating of ca. 1425) and to a master whose style recalled that of Giovanni d'Ambrogio (with a dating of ca. 1420).[12] The publication of the documents by Fabriczy in 1900 prevented the recurrence of such errors.[13]

[5] Fabriczy, *JPK*, 1900, pp. 37f; Bode, *Denkmäler*, p. 98; Michel, *Histoire*, iv, 1, p. 97; Schubring, *Plastik*, p. 117; Massimiliano Falciai, *Arezzo, la sua storia e i suoi monumenti*, Arezzo, 1925, p. 147; Ubaldo Pasqui and Ugo Viviani, *Guida illustrata storica, artistica e commerciale di Arezzo e dintorni*, Arezzo, 1925, p. 177; Tysz, *BR*, p. 16; Ybl, ii, p. 316; Luciano Berti, *Il Museo di Arezzo*, Rome, 1961, p. 21. Mario Salmi, "Passeggiate nell'Aretino," *Pagine d'arte*, iii, November 30, 1915, p. 151, identified the relief as the model without attributing it. In his commentary to Burckhardt's *Cicerone*, [4]1879, ii, 2, p. 327g, Bode also claimed the terracotta as the model, attributing it (along with the relief) to Niccolò d'Arezzo and dating it 1403. In the fifth edition, 1884, ii, 2, p. 345d, the terracotta was no longer attributed although the date of 1403 was retained.

[6] Vas-Ricci, i, pp. 240f; Vas-Mil, ii, p. 136. Vasari identified Niccolò di Piero Lamberti with Niccolò di Luca Spinelli. For the explanation of this confusion of identity, see Ugo Procacci, "Niccolò di Pietro Lamberti, detto il Pela di Firenze e Niccolò di Luca Spinelli d'Arezzo," *Il Vasari*, i, 1927-28, pp. 300ff.

[7] Baldinucci, *Notizie*, ii, p. 107; Giovanni Rondinelli, *Relazione sopra lo stato antico e moderno della città di Arezzo al serenissimo Granduca Francesco I. l'anno MDLXXXIII*, Arezzo, 1755, p. 83; Antonio Francesco Rau and Modesto Rastrelli, *Serie degli uomini i più illustri nella pittura, scultura e architettura*, Florence, i, 1769, p. 70; Leopoldo Cicognara, *Storia della scultura dal suo risorgimento in Italia*, Venice, i, 1813, p. 401; Giulio Anastasio Angelucci, *Memorie istoriche per servire di guida al forestiero in Arezzo*, Florence, 1819, p. 104; Emanuele Repetti, *Dizionario geografico fisico storico della Toscana*, Florence, i, 1833, p. 114; N. O. Brizi, *Nuova guida per la città di Arezzo*, Arezzo, 1838, p. 86; G. B. Sezanne, *Arezzo illustrata, memorie istoriche, letterarie e artistiche*, Florence, 1858, p. 197; Charles C. Perkins, *Les Sculpteurs italiens*, Paris, n.d., i, p. 156, n. 3; Jacob Burckhardt, *Der Cicerone*, ed. A. von Zahn, Leipzig, [3]1874, ii, pp. 627f.

[8] *Nuova guida di Arezzo e de' suoi dintorni*, Arezzo, 1882, p. 105. Around the turn of the century, Hans Stegmann in Stegmann-Geymüller, iii, "BR," pp. 5f, published a version of the building history of the first story of the facade which differed slightly from that of Pasqui. Twentieth-century guidebooks to Arezzo invariably follow the reading of Pasqui.

[9] [5]1884, ii, 2, p. 345d; [6]1893, ii, 2, p. 382a. In the fifth edition Bode continued to assign the sculpture to Niccolò d'Arezzo but noted that the lunette had been traced back to sculptors from Settignano. By the sixth edition the free-standing sculptures as well as the relief had assumed their rightful place in the biography of Bernardo Rossellino.

[10] "Sperandio da Mantova (appendice)," *Arch. stor.*, ii, 1889, p. 233.

[11] *Histoire de l'art pendant la renaissance*, Paris, 1889, i, p. 471. Although Müntz was unaware of Pasqui's paraphrase of the documents, he thought that the date of 1383 applied only to the first story.

[12] *Sculpture*, ii, p. 179; *ibid.*, iii, pp. 23f. Where he attributed the lunette to an anonymous master, Reymond ascribed the architecture of the second story to Rossellino and dated it ca. 1440.

[13] *JPK*, 1900, pp. 106ff. However, Del Vita, op. cit., *Rassegna d'arte*, 1913, p. 188, suggested that Domenico di Giovanni, of whose work at the fraternity Del Vita had discovered documentary notice, designed the middle portion of the facade and that its sculptures had been executed by others.

2. The Tabernacle of the Sacrament in the Badia, Florence

The architrave is immured in the fifth bay of the ground floor of the east loggia of the Chiostro degli Aranci; the console is immured in the fourth bay of the ground floor of the south loggia of the Chiostro degli Aranci. The *sportello* is incorporated into the sixteenth-century tabernacle to the left of the altar in the Cappella di S. Mauro in the Badia.

The console consists of an eagle with outstretched wings whose claws rest on a book. The frieze of the entablature is ornamented with festoons. The *sportello* is incised with the Man of Sorrows supporting a cross. Blood gushes from the wound in his side.

White marble. *Sportello* of gilded copper.

Pediment and central rectangular portion of the tabernacle are missing. The Host and chalice originally incised in the *sportello* have been obliterated.

Console: 32 cm. x 64.1 cm.; entablature: 18 cm. x 77.5 cm.; *sportello*: 25.2 cm. x 12.8 cm.

Bibliography: Vas-Mil, iii, 1878, p. 102, n. 1; Fabriczy, *JPK*, 1900, pp. 45f, 100, 108ff; *idem*, "Ancora del tabernacolo col gruppo del Verrocchio in Or San Michele," *L'Arte*, v, 1902, p. 337; Giovanni Poggi, "Il ciborio di Bernardo Rossellino nella chiesa di S. Egidio (1449–1450)," *Miscellanea d'arte*, i, 1903, p. 107; Fabriczy, "Ein unbekanntes Jugendwerk Andrea Sansovinos," *JPK*, xxvii, 1906, p. 80, n. 1; Venturi, *Storia*, vi, p. 606; Schubring, *Plastik*, p. 117; Weinberger and Middeldorf; *Münch. Jahrb.*, 1928, p. 94; Tysz, *BR*, p. 26; Ybl, ii, p. 317; London, Victoria and Albert Museum. Department of Architecture and Sculpture, *Catalogue of Italian Sculpture*, by Eric Maclagan and Margaret Longhurst, London, 1932, p. 36; Kennedy, *R. d'arte*, 1933, p. 118; Heydenreich and Schottmüller, "BR," *T-B*, xxix, p. 44; Becherucci, "BR," *Enc. ital.*, xxx, p. 135; Martin Wackernagel, *Der Lebensraum des Künstlers in der florentinischen Renaissance*, Leipzig, 1938, p. 88; Paatz, *Kirchen*, i, pp. 284, 287, 290, 309, n. 101, 313f, n. 137; Piero Sanpaolesi, "Costruzioni del primo quattrocento nella Badia Fiorentina," *R. d'arte*, xxiv, 1942, pp. 166ff; Planiscig, *BR*, pp. 11, 49; Ulrich Middeldorf, "Un rame inciso del Quattrocento," *Scritti di storia dell'arte in onore di Mario Salmi*, Rome, 1962, ii, pp. 287ff; Pope-Hennessy, *V & A Cat.*, i, p. 128; Caspary, *Sakramentstabernakel*, p. 17; *idem*, "Ancora sui tabernacoli eucaristici del quattrocento," *Antichità viva*, iii, July 1964, p. 27.

The commission for the tabernacle of the Florentine Badia has been lost, but six payments to Bernardo are recorded.[1] On September 22, 1436, the sculptor received 1 florin; on October 31, 1436, he was paid 6 lire, 15 soldi; on November 10, 12 lire; on January 15, 1437, 4 lire; on January 31, 1438, 4 lire and on February 3 of the same year, 4 lire. On March 28, 1439, a locksmith was paid for the lock of the *sportello*, and the following day the goldsmith, Niccolò degli Uriuoli, was paid for gilding it.[2] On April 4, 1439, payment

[1] The first four payments were published by Fabriczy, *JPK*, 1900, p. 109; Tysz, *BR*, pp. 103f, and Piero Sanpaolesi, "Costruzioni del primo quattrocento nella Badia Fiorentina," *R. d'arte*, xxiv, 1942, pp. 166ff. The last two payments were first published by Sanpaolesi, *loc. cit.* See Doc. 16 (App. 3).

[2] The three payments relating to the *sportello* were published by Ulrich Middeldorf, "Un rame inciso del Quattrocento," *Scritti di storia dell'arte in onore di Mario Salmi*, Rome, 1962, ii, p. 288, n. 49. The fourth is published for the first time along with the others in Doc. 16 (App. 3).

was made for its hinges. On May 15, 1439 the goldsmith, Agnolo di Niccolò and "compagni" were paid 3 florins, 19 soldi for making the *sportello*. As a result of the misreading of the documents, the original location of the tabernacle is almost invariably identified as the sacristy of the church. In fact, its original location within the church is not known.[3]

Measurements of the extant fragments of the tabernacle reveal the use of a proportional system: the console (Fig. 26) is twice as long as it is high; the *sportello* is twice as high as it is wide (Fig. 27).

The eagle on the console (Fig. 26) is the symbol of St. John the Evangelist, whose Gospel is found beneath the eagle's claws. Book and eagle refer to the phrase from the Gospel of St. John, "Et verbum caro factum est" (1, 14), which designates the antetype of the transubstantiation: the incarnation of Christ.[4]

The first mention of Bernardo's tabernacle occurred in a note by Milanesi to Vasari's life of Antonio Rossellino.[5] Evidently he was acquainted with one or more of the payments of 1436 though he did not mention them. In 1900 Fabriczy published the major part of the payments to Bernardo and identified the documented tabernacle with the tabernacle from S. Chiara, Florence, in the Victoria and Albert Museum.[6] This identification was accepted by Venturi[7] and Schubring[8] and, with reserve, by Poggi,[9] in spite of Bode's attribution of the London tabernacle to Antonio Rossellino and his dating of it ca. 1468 in the interim.[10] In 1928 Weinberger and Middeldorf,[11] and independently, Tyszkiewicz,[12] identified the console and entablature in the Chiostro degli Aranci as fragments of Ber-

[3] Almost all the payments include the word "sagrestia" in such a phrase as this from a payment of October 31, 1436: "Alla sagrestia Ll., sej ss XV per luj a bernardo dj matteo lastraiuolo porto edetto contt[ant]j per parte del tabernacholo." The use of the word "alla" rather than "per" or "andò alla," the position of the phrase "alla sagrestia" at the beginning of the sentence and the phrase "per luj," which follows the sum of money indicate that the "sacristy" was receiving money and that the word "sagrestia" therefore connoted the person who administered the funds dedicated by the convent to the embellishment of the church. (Apparently the *sagrestia* did not administer the masonry work of the convent.) That person very likely had his seat in the sacristy and possibly was the sacristan himself. That the *sagrestia* was indeed an administrative organ is confirmed by the appearance of the word in two documents which have nothing to do with work, *a fortiori*, work destined for the sacristy. One (September 22, 1436) concerns payments of Bernardo's tax. The second (November 24, 1438) refers to Bernardo's rent and reads: "Vuolsi porre debitore Bernardo di Mateo lastraiolo a Portinari di lire 5½ i quali ci promete p. Salvestro di Filippo Rinieri [Bernardo's landlord] e così echontento lo pongniamo debitore e poi si vuole porre creditore Salvestro di Rinieri e porgli dipoi achonto della sagrestia." Therefore it is not to be wondered at that in the 1441 *Inventario delle masserizie botteghe etc. di Badia e delle chiese dipendenti* (mentioned by Giovanni Poggi, "Il ciborio di Bernardo Rossellino nella chiesa di S. Egidio [1449-1450]," *Miscellanea d'arte*, i, 1903, p. 107), which contains an extensive list of objects in the sacristy, Bernardo's tabernacle does not appear.

[4] This phrase is inscribed on a tabernacle in the catacombs of S. Sebastiano, Rome, second half of the fifteenth century and a tabernacle in S. Brigida all'Opaco near Pontessieve. The eagle as console reappears in the tabernacle from S. Chiara, Florence, in the Victoria and Albert Museum, London; in the tabernacle on the left wall of the choir in S. Maria Maggiore, Florence, and in the tabernacle from the workshop of Benedetto da Maiano in the Badia, Arezzo.

[5] Vas-Mil, iii, p. 102, n. 1.

[6] *JPK*, 1900, pp. 45, 100, 108ff. Reaffirmed in his "Ancora del tabernacolo col gruppo del Verrocchio in Or San Michele," *L'Arte*, v, 1902, p. 337 and *idem*, "Ein unbekanntes Jugendwerk Andrea Sansovinos," *JPK*, xxvii, 1906, p. 80, n. 1.

[7] *Storia*, vi, p. 606.

[8] *Plastik*, p. 117, repudiating his earlier attribution of the London tabernacle to Antonio Rossellino (*Urbano da Cortona*, Strasbourg, 1903, p. 57).

[9] Op. cit., *Miscellanea d'arte*, 1903, p. 107.

[10] *Denkmäler*, p. 101. For the London tabernacle see Pope-Hennessy, *V & A Cat.*, i, pp. 128f, with bibliography, and Hans Caspary, "Tabernacoli quattrocenteschi meno noti," *Antichità viva*, ii, September 1963, p. 42, and *idem*, "Ancora sui tabernacoli eucaristici del quattrocento," *Antichità viva*, iii, July 1964, p. 27.

[11] *Münch. Jahrb.*, 1928, p. 94.

[12] *BR*, p. 26.

nardo's tabernacle. With one insignificant exception,[13] this identification has been accepted in all subsequent literature.[14]

Caspary considered the two fragments the work of Rossellino's shop.[15] In fact, the poorly foreshortened leg and claw of the eagle and the schematic feathers, too sparse for flight, do indicate the hand of an assistant. The ornament of the architrave lacks Bernardo's usual plasticity and compactness.

Paatz was the first to suggest that the *sportello* presently incorporated into the tabernacle in the Cappella di S. Mauro in the Badia belonged to Bernardo's tabernacle (Fig. 27), though he dated the *sportello* to the third quarter of the fifteenth century.[16] Middeldorf, on the other hand, connected it with the payments of 1439 for the gilding, lock and hinges of the *sportello* which he published for the first time.[17] He observed correctly that the incised figure of Christ is not Bernardo's.[18] Indeed, a newly discovered document proves its author to be the otherwise unknown goldsmith, Agnolo di Niccolò.

Kennedy reconstructed Bernardo's tabernacle using as his model the tabernacle in S. Maria Maggiore, Florence, now immured in the left wall of the choir.[19] The derivation of the S. Maria Maggiore tabernacle from the Badia tabernacle was seconded by Paatz,[20] and with reservations, by Caspary who nevertheless observed that the angels flanking the *sportello* in the S. Maria Maggiore tabernacle were preceded by those in the tabernacle in the crypt of the Duomo at Fiesole.[21] Until more evidence is uncovered, any attempt at reconstruction is bound to prove fruitless.

3. The Portal of the Sala del Concistoro in the Palazzo Pubblico, Siena

Door frame consisting of an entablature supported by engaged Corinthian columns. In the frieze two putti bear the *stemma* of the Commune of Siena, the black and white *balzana*. At either end is the *stemma* of the *Popolo* of Siena, a rampant lion on a red ground. In the frame surrounding the door, from the lower left corner: *pan di serpe*, palm, hazelnut, bean, artichoke, pine, pomegranate, oak, poppy, grape, quince, medlar, peach, fig, plum, laurel, rose, berry, flower, strawberry, olive, zucchini blossoms, oak, pine, asparagus, millet.

White marble, with the exception of the black marble field in the *balzana*. The grounds of the *stemma* of the *Popolo* of Siena are painted red. Recent gilding in the hair and

[13] Martin Wackernagel, *Der Lebensraum des Künstlers in der florentinischen Renaissance*, Leipzig, 1938, p. 88.

[14] Ybl, ii, p. 317; London, Victoria and Albert Museum. Department of Architecture and Sculpture, *Catalogue of Italian Sculpture*, by Eric Maclagan and Margaret Longhurst, London, 1932, p. 36; Kennedy, *R. d'arte*, 1933, p. 118; Heydenreich and Schottmüller, "BR," T-B, xxix, p. 44; Becherucci, "BR," *Enc. ital.*, xxx, p. 135; Paatz, *Kirchen*, i, pp. 287, 290; Planiscig, *BR*, pp. 11, 49; Pope-Hennessy, *V & A Cat.*, i, p. 128; Caspary, *Sakramentstabernakel*, p. 17; idem, op. cit., *Antichità viva*, July 1964, p. 27.

[15] *Ibid.*, p. 27.

[16] *Kirchen*, i, pp. 284, 290, 309, n. 101.

[17] Op. cit., *Scritti . . . Salmi*, ii, pp. 287ff, accepted by Caspary, *Sakramentstabernakel*, p. 17.

[18] For the contrapposto of Christ, see the tax collector at the right edge of Masaccio's Tribute Money, Brancacci Chapel, S. Maria del Carmine, Florence. For the anatomy of his right leg, see John the Baptist in SS. John the Baptist and Jerome, variously attributed to Masaccio, Masolino or both, in the National Gallery, London.

[19] *R. d'arte*, 1933, p. 118.

[20] *Kirchen*, i, p. 314, n. 137.

[21] *Sakramentstabernakel*, p. 17.

wings of the putti, the crown and claws of the lions, the moldings of the entablature, the rosettes of the capitals, the ribbons that bind the sprays of leaves and flowers, and the rings that support the garlands in the two corners of the frame.

Portal: 295.5 cm. x 221.5 cm.; opening: 220.5 cm. x 110.3 cm.; double plinth: 13.2 cm. high; columns: 226.6 cm. x 18.5 cm. (measured at shaft); capitals: 18.5 cm. x 22.5 cm.; abacus: 4 cm. high; distance between columns: 153.7 cm.; inner frame on either side of door: 21.7 cm.; inner frame above door: 23.5 cm.; entablature: 51.5 cm. high; frieze: 18.5 cm. high.

Bibliography: Giorgio Vasari, *Le vite de' più eccellenti pittori, scultori e architetti*, Florence, iv, 1848, p. 220, n. 2; Gaetano Milanesi, *Documenti per la storia dell'arte senese*, Siena, 1854, ii, pp. 235f; Vas-Mil, iii, p. 97, n. 2; E. A. Brigidi, *La nuova guida di Siena*, Siena, 1879, p. 68 and ²1885, p. 50; [Everardo Micheli], *Guida artistica della città e contorni di Siena*, Siena, 1883, p. 100; Bode, *Denkmäler*, p. 99; Fabriczy, *JPK*, 1900, pp. 48, 100; Eugène Müntz, *Florence et la Toscane*, Paris, 1901, p. 124; Burckhardt-Bode, *Cicerone*, ⁸1901, ii, p. 180b; Corrado Ricci, *Il Palazzo Pubblico di Siena e la mostra d'antica arte senese*, Bergamo, 1904, p. 17; Tysz, *BR*, pp. 29f, 108f; Graves, pp. 29f; Heydenreich and Schottmüller, "BR," T-B, xxix, p. 44; Becherucci, *Enc. ital.*, xxx, p. 135; Planiscig, *BR*, pp. 13, 49; Pope-Hennessy, *Ital. Ren. Sc.*, p. 296; Gunther and Christel Thiem, *Toskanische Fassaden-Dekoration in Sgraffito und Fresko, 14. bis 17. Jahrhundert*, Munich, 1964, pp. 63f, no. 14.

The double-leafed wooden door of the Sala del Concistoro was commissioned by the Commune of Siena from Domenico di Niccolò dei Cori on June 16, 1414.[1] For it, the commune commissioned on June 24, 1446, a polished Carrara marble framework from Bernardo Rossellino.[2] According to the contract, the blocks of marble were to be large enough to be carved in one piece. There were to be four half-length figures one *braccio* high and also of Carrara marble of the Cardinal Virtues, whose attributes were to be those recorded in a design previously submitted. The portal was to be finished up to the level of the figures by August 15, and inclusive of the figures by Christmas 1446. Bernardo's fee does not appear in the commission but an entry under the date of 1446 in the *Libro di entrata ed uscita* records the stipulated recompense as 500 lire. Of this, Bernardo received only 326 lire, 7 soldi, apparently because he failed to furnish the Virtues.[3]

The opening of Domenico dei Cori's door is twice as high as it is wide.[4] Bernardo adapted the width of his frame to the height of the opening. The height of the entablature is one third the distance between the columns. The width of the capitals equals the height of capital plus abacus. The width of the shaft is identical to the heights of the capital and frieze.

The Portal of the Sala del Concistoro entered the literature in 1848 in a note in the

[1] The document was published by Gaetano Milanesi, *Documenti per la storia dell'arte senese*, Siena, 1854, ii, p. 239.

[2] The documents were published in *ibid.*, ii, pp. 235f, no. 174 and Tysz, *BR*, pp. 108f, doc. 8. See Doc. 17 (App. 3).

[3] A note in the margin of the commission explains that the price was omitted because Bernardo "did not

do what he was supposed to do."

[4] Cf. the rules on the proportions of doors in Leon Battista Alberti, *L'Architettura*, trans. by Giovanni Orlandi, intro. and notes by Paolo Portoghesi, bk. i, ch. 12 (i, pp. 82ff) and bk. vii, ch. 12 (ii, p. 618) and Filarete's *Treatise on Architecture*, trans. and ed. John R. Spencer, New Haven/London, 1965, bk. viii, fol. 60r (i, p. 103).

Le Monnier edition of Vasari's *Lives*. Misinterpreting the documents, the author of the note attributed to Bernardo the commission for the portal but not its execution.[5] Milanesi's publication of all the pertinent documents followed in 1854.[6] A more careful reading of the documents and a precise analysis of the portal's style led Fabriczy to restore the portal to Bernardo.[7] Graves derived the frame from the border of the north portal of the Florentine Baptistry;[8] Planiscig discerned the influence of Michelozzo as well as Brunelleschi and noted the similarity of the wreath to comparable works by Luca della Robbia and Ghiberti.[9]

In connection with Rossellino's portal at Siena Fabriczy cited the doorway between the first and second cloisters of S. Croce, Florence, probably of 1452, with the coat of arms of Tommaso Spinelli (Fig. 149).[10] Though the crowning of the portal at S. Croce derives from Donatello's Cavalcanti Annunciation inside the church, the undeniable similarity between the doors is sufficient to have induced several art historians to attribute the portal at S. Croce to Bernardo.[11] Though its author is not Rossellino, its design doubtlessly derives from the portal of the Sala del Concistoro, the first Renaissance portal of this type. Not until Benedetto da Rovezzano's entrance to the Florentine Badia in the first decade of the sixteenth century is there a third one of similar design.

4. The Annunciation in the Museum of the Collegiata, Empoli

The Virgin Annunciate and Archangel Gabriel are free-standing statues. Bases and figures are carved from single blocks. Both figures are standing. The Virgin turns back to look over her right shoulder. Her right arm is raised in a gesture of surprise. Her left hand presses a book to her hip. The arms of the angel are crossed on its breast.

White marble. Traces of gilding in the angel's curls, on his headband and on his forward wing. A large patch of recently applied gold paint on the rear of the hump of the angel's farther wing. Orange stains in the Virgin's hair may also be remnants of gilding.

The backs of the figures are not entirely finished. The wings of the angel, carved from separate pieces of stone, are badly cracked.

Virgin: 115.5 cm. high; Virgin's base: 15.5 cm. x 31 cm. x 31 cm.; angel: 110.5 cm. high; angel's base: 12 cm. x 26.8 cm. x 20.8 cm.

Bibliography: Giovanni Gaye, *Carteggio inedito d'artisti dei secoli xiv, xv, xvi*, Florence, 1839, i, p. 188; Eugène Müntz, *Les Archives des arts, Recueil de documents inédits ou peu connus*, Paris, 1890, pp. 28f; Bode, *Denkmäler*, p. 99; Fabriczy, *JPK*, 1900, pp. 40, 101; Giovanni Poggi, "Il ciborio di Bernardo Rossellino nella chiesa di S. Egidio (1449–1450)," *Miscellanea d'arte*, i, 1903, p. 105; Paul Schubring, "Die 'Verkündigung' in der roman-

[5] *Le vite de' più eccellenti pittori, scultori e architetti*, Florence, iv, 1848, p. 220, n. 2, taken over in Vas-Mil, iii, p. 97, n. 2. E. A. Brigidi, *La nuova guida di Siena*, Siena, 1879, p. 68, gave the portal to Jacopo della Quercia. This attribution found its way into Eugène Müntz, *Florence et la Toscane*, Paris, 1901, p. 124.

[6] *Op. cit.*, ii, pp. 235ff.

[7] *JPK*, 1900, p. 48.

[8] Graves, pp. 29f.

[9] *BR*, p. 13.

[10] *JPK*, 1900, p. 48. For the date of the portal, see Paatz, *Kirchen*, i, p. 625, n. 108.

[11] For the attribution and bibliography of the portal, see Gunther and Christel Thiem, *Toskanische Fassaden-Dekoration in Sgraffito und Fresko, 14. bis 17. Jahrhundert*, Munich, 1964, pp. 63f, no. 14.

ischen Kunst," *Preussische Jahrbücher*, cxx, April-June 1905, p. 465; Odoardo H. Giglioli, *Empoli artistica*, Florence, 1906, pp. 160ff; Gerald Davies, "A Sidelight on Donatello's Annunciation," *BM*, xiii, 1908, p. 222; Venturi, *Storia*, vi, pp. 606ff; G. Bucchi, *Guida di Empoli, illustrata*, Florence, 1916, p. 105; Schubring, *Plastik*, p. 117; Bode, *Die italienische Plastik, Handbücher der staatlichen Museen zu Berlin*, Berlin/Leipzig, 1922, p. 99; Vittorio Fabiani and Emilio Mancini, *Empoli, granaio della Repubblica fiorentina*, Milan, 1925, p. 6; Weinberger and Middeldorf, *Münch. Jahrb.*, 1928, p. 90; Tysz, *BR*, pp. 31f, 109f, 134; Ybl, ii, p. 317; Kennedy, *R. d'arte*, 1933, p. 120; Eric Maclagan, *Italian Sculpture of the Renaissance*, Cambridge, Mass., 1935, pp. 134f; Heydenreich and Schottmüller, "BR," T-B, xxix, p. 44; Becherucci, "BR," *Enc. ital.*, xxx, p. 135; Janson, *Michelozzo*, p. 268; Planiscig, *BR*, pp. 12, 48f; M. Tyszkiewicz, "Appunti d'archivio, il Chiostro degli Aranci della Badia fiorentina," *R. d'arte*, xxvii, 1952, p. 207; Umberto Baldini, *Itinerario del Museo della Collegiata*, Florence, 1956, p. 12; Pope-Hennessy, *Ital. Ren. Sc.*, pp. 38, 296; Galassi, p. 159; Baldini, *Guida alla visita del Museo della Collegiata di Empoli*, Empoli, 1964, p. 35, no. 93; Seymour, *Sculpture*, p. 121; Pope-Hennessy, "The Altman Madonna by Antonio Rossellino," *Metropolitan Museum Journal*, iii, 1970, p. 144.

Included among the "Debitori" in Bernardo Rossellino's tax declaration of February 1458 is the "conpangnìa della Nu[n]ziata da Enpoli" which owed the sculptor 8 lire.[1] Most likely this debt was incurred for Bernardo's figures of the Virgin Annunciate and Archangel Gabriel intended for the altar of the oratory of the company of the SS. Annunziata of Empoli in S. Stefano. Late sixteenth-century memoirs of the company inform us that its syndic commissioned the group from Bernardo on August 2, 1447.[2] A deadline of four months was set. The figures were to be two *braccia* high[3] and of white marble with gilded ornaments. They were to be brought to the oratory at Empoli at the expense of the artist. Upon their completion they were approved by Ghiberti and Bernardo was paid 36 florins. Some of this information is contradicted by an undated copy of a notice found in the *Libro di ricordi* of Messer Antonio di Giovanni Malepa, which states that the figures were made in 1444 and that a field belonging to the company was sold to Malepa in order to pay the sculptor. Of these two documents, the former, far more detailed and evidently a summary of the original commission, is probably the more reliable.

The two statues stood on the altar of the oratory in the late sixteenth century[4] and were still there in 1925,[5] in spite of the suppression of the company in 1786 and the transfer of the oratory in the nineteenth century, first to the Compagnia della Morte, then to the Confraternity of the Misericordia.[6] In 1906 the statues were to be seen above the altar in

[1] Hartt, Corti, Kennedy, p. 181. Unacquainted with the commission of the Annunciation, Giovanni Gaye, *Carteggio inedito d'artisti dei secoli xiv, xv, xvi*, Florence, 1839, i, p. 188, n., thought that the debt referred to Antonio Rossellino's St. Sebastian in the Museum of the Collegiata, Empoli.

[2] The memoirs were begun in 1576. The relevant notice was written in a late sixteenth-century hand. It was incompletely published by Eugène Müntz, *Les Archives des arts, Recueil de documents inédits ou peu connus*, Paris, 1890, pp. 28f. This and the following document received their first complete publication by Odoardo H. Giglioli, *Empoli artistica*, Flor-

ence, 1906, pp. 160ff. The documents were republished by Tysz, *BR*, pp. 109f, doc. 9. See Doc. 18 (App. 3).

[3] At 58.4 cm. to the *braccio*, the Virgin (without base) is only 1.3 cm. shorter than this. The angel is 6.3 cm. shorter.

[4] Giglioli, *op. cit.*, p. 161. The oratory, founded in 1374, is contiguous to the sacristy of the church.

[5] Vittorio Fabiani and Emilio Mancini, *Empoli, granaio della Repubblica fiorentina*, Milan, 1925, p. 6.

[6] For the history of the company, see Giglioli, *op. cit.*, pp. 153ff, and G. Bucchi, *Guida di Empoli, illustrata*, Florence, 1916, pp. 105f.

a niche, in the upper part of which was a stucco relief of God the Father surrounded by clouds and angels (Fig. 33).[7] There was also a damask curtain which probably was, or replaced, the one commissioned on April 16, 1596.[8] It is very likely that the relief was also made at this time—the contorted pose of the angel on the right, the elongated proportions of God the Father and the planar composition are typical of late Mannerist art.[9] The Annunciation was removed to the Pinacoteca of the Collegiata when, after the second World War, the museum was rebuilt.[10] The empty niche with its stucco relief is still to be found above the altar of the abandoned oratory.

As the most visible of Bernardo's works, the Annunciation has elicited much stylistic criticism. Giglioli emphasized the classical influence on the group, but especially in the Virgin.[11] Davies,[12] contradicted by Planiscig,[13] pointed to similarities between the Virgin and the Madonna from Donatello's Cavalcanti Annunciation in S. Croce. Tyszkiewicz noted the diversity in style between the Donatellesque Madonna and the Ghibertian angel,[14] where Gothic and Renaissance ideals confronted one another.[15] Janson compared the angel to Michelozzo's angels from the Aragazzi Tomb in the Victoria and Albert Museum and the Virgin to Michelozzo's Madonnas in the Bargello and SS. Annunziata, Florence.[16] Seymour stressed the influence of Ghiberti and observed a difference in execution between the two figures which, he wrote, "may be the result of a collaboration with another sculptor or assistant, or possibly simply the result of an interim of several years separating the finishing of the one and the completion of its companion."[17] Pope-Hennessy attributed the Virgin to Bernardo and the angel to an assistant, perhaps Giovanni Rossellino.[18]

5. The Tomb of Leonardo Bruni in S. Croce, Florence

The tomb is located on the left of the sixth bay of the right aisle.

The tomb is contained within a niche, rectangular in plan and framed by fluted Corinthian pilasters supporting a broken entablature and a semicircular arch. Two steps form the base. In the upper base six putti bearing garlands flank the head of a lion in a medallion. The sarcophagus rests on two feet composed of lions' paws and skins. On the front face of the sarcophagus two flying genii bear the epitaph; at either end of the sarcophagus is a Maltese cross. Two eagles support the bier on which the effigy lies. Bruni wears an *oppelanda di gala*, gloves and *pianelle*. His *cappuccio* lies on the cushion. In the lunette is a half-length Madonna with the Christ Child in a medallion flanked by two half-length angels. Above the arch two putti support a garland of oak leaves containing Bruni's coat of arms: a crowned rampant lion on a shield of red and gold lozenges.

[7] Giglioli, *op. cit.*, p. 162.

[8] *Ibid.*, pp. 165f, mentioned in the late sixteenth-century memoirs of the company.

[9] Paul Schubring, "Die 'Verkündigung' in der romanischen Kunst," *Preussische Jahrbücher*, cxx, April-June 1905, p. 465, thought that the relief was original and by Rossellino, himself.

[10] Umberto Baldini, *Itinerario del Museo della Collegiata*, Florence, 1956, p. 6.

[11] *Op. cit.*, p. 163.

[12] "A Sidelight on Donatello's Annunciation," *BM*, xiii, 1908, p. 222.

[13] *BR*, p. 12. [14] *BR*, pp. 31f.

[15] "Appunti d'archivio, il Chiostro degli Aranci della Badia fiorentina," *R. d'arte*, xxvii, 1952, p. 207.

[16] *Michelozzo*, p. 268. [17] *Sculpture*, p. 121.

[18] "The Altman Madonna by Antonio Rossellino," *Metropolitan Museum Journal*, iii, 1970, p. 144.

White marble with the following exceptions: red marble slabs behind the effigy and beneath the sarcophagus; black marble slabs in the lateral walls of the niche; sandstone base at bottom of tomb. Traces of original gilding as follows: narrow gold strip on upper border of the drapery of the Christ Child; circles on the Madonna's bodice; pseudo-Arabic lettering on the border of the Madonna's *façolo*; stripes on her belt; pattern on her cuff; gilding in background behind angels; in wings, hair and border of dress of right angel; in hair and border of left sleeve of left angel; in hem, edge of sleeves and belt of chiton, face, hair and wings of right genius; in stippled parts, dots and fringe of brocade covering bier; in feathers of both eagles; in upper moldings of sarcophagus. Recent gilding in moldings of frieze, intrados of arch and capitals. Pupils of right angel are painted black. Traces of umber paint on the upper part of Bruni's cloak and on his neck. Sandstone base painted red. Lozenges in Bruni's coat of arms painted red and gold.

Part of the upper arm and shoulder of the right angel above the arch has broken off. There is damage along the seam between the *tondo* and the left corner of the lunette. A crack begins in the lower part of the left side of the intrados and continues into the frieze of the entablature. The drapery along the inner edge of the effigy has been hacked off in order to accommodate the projecting frames around the red marble slabs. The inner left corner of the slab on which the effigy lies has been broken off.

Tomb: 7.150 m. high; sandstone base: .374 m. x 3.162 m.; marble base: .609 m. x 2.906 m. (measured at frieze); distance between pilasters: 2.250 m.; plinths below pilasters: .117 m. x .383 m.; pilasters: 2.878 m. high; necking: .193 m. high; shafts: 2.307 m. x .289 m.; capitals: .378 m. high; feet of sarcophagus: .317 m. high; sarcophagus: .860 m. x 2.250 m.; bier: .663 m. x 2.020 m.; effigy: 1.795 m. long; entablature: .581 m. high; architrave: .188 m. high; frieze: .205 m. high; cornice: .188 m. high; interior of lunette: 1.100 m. x 2.247 m.; archivolt: .416 m.; garland: .107 m. x .106 m.

Epitaph: POSTQVAM LEONARDVS EVITA MIGRAVIT
 HISTORIA LVGET · ELOQVENTIA MVTA EST ·
 FERTVRQVE MVSAS TVM GRAECAS TVM
 LATINAS LACRIMAS TENERE N̄O POTVISSE ·

Bibliography: Coll. Bernard Ashmole, Bartholomaeus Fontius, *Liber monumentorum Romanae urbis et aliorum locorum*, fol. 129v, published by Fritz Saxl, "The Classical Inscription in Renaissance Art and Politics," *WJ*, iv, 1940–41, p. 44; Luca Landucci, *Diario fiorentino dal 1450 al 1516*, ed. Jodoco Del Badia, Florence, 1883, p. 3; Billi, p. 47; Antonio Petrei, "Memoriale di curiosità artistiche in Firenze," in Billi, pp. 56f; *Magl.*, p. 93; Vas-Ricci, ii, pp. 141, 173; Vas-Mil, iii, pp. 97, 360f; Tobias Fendt (engraver), *Monumenta sepulcrorum eum epigraphis ingenio et doctrina excellentium virorum*, Breslau, 1574, pl. 23; Raffaello Borghini, *Il riposo*, Florence, 1584, bk. 3, p. 354; "Ricordi antichi d'arte fiorentina," ed. Paolo Galletti, *Rivista fiorentina*, i, Oct. 1908, p. 20; Bocchi, p. 153; Bocchi-Cinelli, p. 316; Richa, i, p. 91; Antonio Francesco Rau and Modesto Rastrelli, *Serie degli uomini i più illustri nella pittura, scultura, e architettura*, Florence, ii, 1770, p. 76; [Cambiagi], *Guida al forestiero per osservare con metodo le rarità e bellezze della città di Firenze*, Florence, [5]1790, p. 124; [Follini], *Firenze antica, e moderna*, Florence, v, 1794, p. 48; Leopoldo Cicognara, *Storia della scultura dal suo risorgimento in Italia*, Venice, ii,

1816, pp. 71, 125; Giuseppe Gonnelli, *Monumenti sepolcrali della Toscana*, Florence, 1819, p. 7; Nicolò Bettoni, *Le tombe ed i monumenti illustri d'Italia*, Milan, ii, 1823, pl. ix; Federigo Fantozzi, *Nuova guida ovvero descrizione storico-artistico-critica della città e contorni di Firenze*, Florence, 1842, p. 201; F. Moisè, *Santa Croce di Firenze*, Florence, 1845, p. 218; Bode, "Die italienischen Skulpturen der Renaissance in den königlichen Museen," II, *JPK*, iii, 1882, p. 252, n. 1; C. Perkins, *Historical Handbook of Italian Sculpture*, London, 1883, p. 121; Stegmann-Geymüller, iii, "Nachtrag zur Monographie Albertis," p. 8, and "BR," pp. 2, 8f; Bode, *Denkmäler*, p. 99; Reymond, *Sculpture*, iii, pp. 18ff, 64ff; Fabriczy, *JPK*, 1900, pp. 34, n. 1, 100; Jacques Mesnil, "Arte retrospettiva: le tombe del rinascimento a Firenze," *Emporium*, xvi, 1902, pp. 368ff; Burger, pp. 100, 137ff, 302f, 399, Excursus xii; Paul Schubring, *Das italienische Grabmal der Frührenaissance*, Berlin, 1904, pp. 8f; Vasari, *Die Lebensbeschreibungen der berühmtesten Architekten, Bildhauer und Maler*, trans. and ed. Adolf Gottschewski, Strasbourg, iii, 1906, p. 274, n. 15; Venturi, *Storia*, vi, pp. 509, 606, 727; viii, 1, pp. 410ff, 508ff; Michel, *Histoire*, iv, 1, pp. 96ff; Robert Corwegh, "Farbige Wandgräber der Renaissance," *Mitt. d. ksth. Inst.*, i, 1910, pp. 169ff; Schubring, *Plastik*, pp. 117f; Egidio Lorenzini, *Guida storico-artistica del monumentale tempio di S. Croce in Firenze dei Frati Minori Conventuali*, Padua, 1926, pp. 35f; Tysz, *BR*, pp. 9, 49ff, 135; Graves, pp. 6f, 27f; Saturnino Mencherini, O.F.M., *Santa Croce di Firenze (Memorie e documenti)*, Florence, 1929, pp. 40f; Ybl, ii, pp. 318ff; Kennedy, *R. d'arte*, 1933, pp. 120ff; Heydenreich and Schottmüller, "BR," T-B, xxix, p. 44; Becherucci, "BR," *Enc. ital.*, xxx, p. 135; Mary Pittaluga, *La scultura italiana del Quattrocento*, Florence, 1938, pp. 42f; Ulrich Middeldorf, "Frühwerke des Andrea Verrocchio," *Mitt. d. ksth. Inst.*, v, 1939, p. 209; *idem*, "Two Florentine Sculptures at Toledo," *Art in America*, xxviii, 1940, p. 23; Paatz, *Kirchen*, i, pp. 552, 642f, n. 257; Janson, *Michelozzo*, pp. 266ff; Planiscig, *BR*, pp. 15ff, 49f; Henriette s'Jacob, *Beschouwingen over Christelijke Grafkunst voornamelijk in Frankrijk en Italië*, Leiden, 1950, p. 156; André Chastel, "La Glorification humaniste dans les monuments funéraires de la Renaissance," *Umanesimo e scienza politica. Atti del Congresso internazionale di studi umanistici*, Rome, Florence, 1949, ed. E. Castelli, Milan, 1951, pp. 479ff; Walter Paatz, *Die Kunst der Renaissance in Italien*, Stuttgart, 1953, p. 81; Luigi Grassi, *L'arte del Quattrocento a Firenze e a Siena*, Rome, 1957, p. 34; Pope-Hennessy, *Ital. Ren. Sc.*, pp. 43f, 297f; Martin Gosebruch, "Florentinische Kapitelle von Brunelleschi bis zum Tempio Malatestiano und der Eigenstil der Frührenaissance," *Römisches Jahrbuch für Kunstgeschichte*, viii, 1958, p. 156; Chastel, *Art et humanisme à Florence au temps de Laurent le Magnifique*, Paris, 1959, pp. 39f; Galassi, p. 158; Peter Murray, *An Index of Attributions Made in Tuscan Sources before Vasari*, Florence, 1959, p. 140; Millard Meiss, "Toward a More Comprehensive Renaissance Palaeography," *AB*, xlii, 1960, pp. 99f; Longhurst, P. 1; Ferdinando Rossi, *Arte italiana in Santa Croce*, Florence, 1962, p. 116; Anne Markham, "Desiderio da Settignano and the Workshop of Bernardo Rossellino," *AB*, xlv, 1963, pp. 43ff; Erwin Panofsky, *Tomb Sculpture*, ed. H. W. Janson, New York, 1964, pp. 74, 76f; H. W. Janson, "The Image of Man in Renaissance Art: From Donatello to Michelangelo," *The Renaissance Image of Man and the World*, Fourth Annual Conference on the Humanities, Ohio State University, 1961, ed. Bernard O'Kelly, n.p., 1966, pp. 97ff; Seymour, *Sculpture*, pp. 13, 121f; John Sparrow, *Visible Words*, Cambridge, 1969, pp. 17f, 90; G. Passavant, *Verrocchio, Sculptures, Painting and Drawings*, London, 1969, p.

204, App. 7; Pope-Hennessy, "The Altman Madonna by Antonio Rossellino," *Metropolitan Museum Journal*, iii, 1970, pp. 142, n. 7, 144; Gianni Carlo Sciolla, *La scultura di Mino da Fiesole*, Turin, 1970, p. 18, n. 25.

No documents concerning the tomb have been preserved. The attribution of the tomb to Bernardo Rossellino rests on the testimony of early secondary sources. (See below).

The measurements of the Bruni Tomb reveal a proportional system of which the key is the length of the life-size effigy: 1.795 m. (= 4.3 cm. more than 3 *braccia* and therefore probably Bruni's actual height). Twice its length equals the circumference of the outer rim of the medallion in the lunette (3.566 m.) and the height of the order from plinth through entablature (3.576 m.). Since the height of the sarcophagus plus bier equals 1.794 m., the effigy is located at the mid-point of the order: precisely the place it would reach if it were standing on the base of the tomb. The total height of the tomb is four times the length of the effigy (7.150 m.).[1]

The first record of the Bruni Tomb occurred in a watercolor painting in the *Zibaldone* of Buonaccorso di Vittorio Ghiberti, dated ca. 1472–83, which departs from the original in several respects.[2] Bartholomaeus Fontius included the Bruni epitaph in his collection of inscriptions compiled at the end of the fifteenth century.[3] An engraving by Tobias Fendt, after a drawing by Siegfried Rybisch in Fendt's *Monumenta sepulcrorum eum epigraphis ingenio et doctrina excellentium virorum* (1574), is hardly more faithful than Ghiberti's painting.[4]

The first mention of the Bruni Tomb, with an attribution to Donatello, occurred under the date of 1458 in Luca Landucci's Florentine diary of 1516.[5] Billi[6] and the *Codice magliabechiano*[7] assigned the tomb to Bernardo. So did Vasari in the first edition of his life of Antonio Rossellino.[8] But in his life of Verrocchio he gave the Madonna and Child above the tomb of "M. Carlo Bruni Aretino" to Verrocchio.[9] In the 1568 edition of his life of Verrocchio Vasari corrected "Carlo Bruni" to Leonardo Bruni[10] while retaining his attribution of all but the Madonna and Child to Bernardo.[11] Vasari's second account was

[1] Other proportional relationships include the height of the shaft of the pilaster, which is eight times the width of the pilasters; the height of the lunette plus archivolt, which is four times the height of the capitals; the architrave, which is exactly as high as the cornice.

Evidence of the use of the *braccio* (1 *braccio* equals 58.4 cm.) exists in the total height of the tomb (12¼ *braccia*) as well as in its parts. The entablature is 1 *braccio* high; the pilaster is ½ *braccio* wide. The moldings at the foot of the pilaster, the architrave, frieze and cornice are all very nearly ⅓ *braccio* high.

[2] BNCF, MS B.R. 228, fol. 63r. For the drawing of the Bruni Tomb in the *Zibaldone*, see Burger, p. 399; Robert Corwegh, "Farbige Wandgräber der Renaissance," *Mitt. d. ksth. Inst.*, i, 1910, p. 172; Gustina Scaglia, *Studies in the "Zibaldone" of Buonaccorso Ghiberti* (typescript), Ph.D. Dissertation, Institute of Fine Arts, New York University, New York, 1960, i, p. 103; ii, p. 272.

[3] *Liber monumentorum Romanae urbis et aliorum locorum*, fol. 129v in the collection of Bernard Ashmole published by Fritz Saxl, "The Classical Inscrip-

tion in Renaissance Art and Politics," *WJ*, iv, 1940-41, p. 44.

[4] Breslau, 1574, pl. 23. The same engraving reappears in the several editions of this book: Fendt, *Monumenta illustrium per Italiam, Galliam, Germaniam, Hispanias*, Frankfurt a. M., 1585, pl. 23; idem, *Monumenta clarorum doctrina precipue*, Frankfort a. M., 1589, pl. 23; Marcus Zuerius Boxhorn, *Monumenta illustrium virorum et elogia*, Amsterdam, 1638, pl. 47; idem, *Monumenta illustrium virorum et elogia*, Utrecht, 1671, pl. 47.

[5] *Diario fiorentino dal 1450 al 1516*, ed. Jodoco Del Badia, Florence, 1883, p. 3.

[6] Billi, p. 47. [7] *Magl.*, p. 93.

[8] Vas-Ricci, ii, p. 141.

[9] *Ibid.*, ii, p. 173. Tysz, *BR*, pp. 52f, pointed out that this statement resulted from a misunderstanding of the attribution in the *Codice magliabechiano* (p. 89) to Verrocchio of "Nostra Donna di marmo sopra il sepolcro di messer Carlo d'arezzo," i.e. Carlo Marsuppini.

[10] Vas-Mil, iii, pp. 360f.

[11] *Ibid.*, iii, pp. 97, 361.

repeated again and again,[12] appearing in guidebooks as late as 1929.[13] However, at the turn of the century Bode remarked that Verrocchio was only ten years old when the Bruni Tomb was made,[14] after which the name of Verrocchio disappeared from the serious literature on the tomb. Only Petrei, among the early writers on the tomb, attributed the monument to Antonio Rossellino.[15]

The quality of the Bruni Tomb led Geymüller to claim its design for Alberti.[16] His attribution found almost no support and the Bruni Tomb does not appear in the literature on Alberti. Michel found the stylistic arguments in favor of Alberti inconclusive.[17] Tyszkiewicz[18] and Pope-Hennessy[19] rejected the attribution outright. Gosebruch, on the other hand, considered the classicizing frieze evidence of the influence of Alberti on the design of the tomb,[20] while Janson supported the hypothesis of Alberti's intervention with an unconvincing derivation of the framework of the Bruni Tomb from the doorway of the Pantheon.[21]

Modern criticism of the Bruni Tomb has been concerned largely with the participation of assistants in its sculpture, in particular, with the role of Antonio Rossellino. The attribution of the effigy to Antonio was championed by Hans Stegmann[22] and Venturi[23] and explicitly rejected by Schubring,[24] Tyszkiewicz,[25] Heydenreich and Schottmüller[26] and Pope-Hennessy.[27] Passavant assigned to Antonio the Madonna and Child in the tondo.[28] Venturi[29] and Tyszkiewicz[30] claimed the participation of Antonio in various portions of the architectural ornament; Heydenreich and Schottmüller considered it only possible.[31] Stegmann,[32] contradicted by Burger,[33] thought that the coat of arms was not originally intended for the place it now inhabits. Graves attributed the putti at the top of the tomb to Buggiano.[34] In 1963 I attributed the face of the Madonna to Desiderio da Settignano.[35]

[12] "Ricordi antichi d'arte fiorentina," end of the sixteenth century, ed. Paolo Galletti, *Rivista fiorentina*, i, October 1908, p. 20; Bocchi, p. 153; Bocchi-Cinelli, p. 316; Richa, i, p. 91; Antonio Francesco Rau and Modesto Rastrelli, *Serie degli uomini i più illustri nella pittura, scultura, e architettura*, Florence, ii, 1770, p. 76; Leopoldo Cicognara, *Storia della scultura dal suo risorgimento in Italia*, Venice, ii, 1816, p. 125; Giuseppe Gonnelli, *Monumenti sepolcrali della Toscana*, Florence, 1819, p. 7.

[13] [Cambiagi], *Guida al forestiero per osservare con metodo le rarità e bellezze della città di Firenze*, Florence, ⁵1790, p. 124; [Follini], *Firenze antica, e moderna*, Florence, v, 1794, p. 48; Federigo Fantozzi, *Nuova guida ovvero descrizione storico-artistico-critica della città e contorni di Firenze*, Florence, 1842, p. 201; F. Moisè, *Santa Croce di Firenze*, Florence, 1845, p. 218; Egidio Lorenzini, *Guida storico-artistica del monumentale tempio di S. Croce in Firenze dei Frati Minori Conventuali*, Padua, 1926, p. 36; Saturnino Mencherini, O.F.M., *Santa Croce di Firenze (Memorie e documenti)*, Florence, 1929, pp. 40f.

[14] *Denkmäler*, p. 99.

[15] "Memoriale di curiosità artistiche in Firenze," in Billi, p. 56.

[16] Stegmann-Geymüller, iii, "Nachtrag zur Monographie Albertis," p. 8.

[17] *Histoire*, iv, 1, p. 96.

[18] *BR*, p. 51.

[19] *Ital. Ren. Sc.*, p. 298.

[20] "Florentinische Kapitelle von Brunelleschi bis zum Tempio Malatestiano und der Eigenstil der Frührenaissance," *Römisches Jahrbuch für Kunstgeschichte*, viii, 1958, p. 156.

[21] "The Image of Man in Renaissance Art: From Donatello to Michelangelo," *The Renaissance Image of Man and the World*, Fourth Annual Conference on the Humanities, Ohio State University, 1961, ed. Bernard O'Kelly, n.p., 1966, pp. 97ff.

[22] Stegmann-Geymüller, iii, "BR," p. 9, n. 1.

[23] *Storia*, viii, 1, pp. 510f.

[24] *Das italienische Grabmal der Frührenaissance*, Berlin, 1904, p. 9.

[25] *BR*, p. 52.

[26] "BR," T-B, xxix, p. 44.

[27] *Ital. Ren. Sc.*, p. 298.

[28] G. Passavant, *Verrocchio, Sculptures, Paintings and Drawings*, London, 1969, p. 204, App. 7.

[29] *Storia*, viii, 1, p. 510. [30] *BR*, p. 51.

[31] "BR," T-B, xxix, p. 44.

[32] Stegmann-Geymüller, iii, "BR," p. 8, n. 3.

[33] Burger, p. 139, n. 3. [34] Graves, pp. 27f.

[35] "Desiderio da Settignano and the Workshop of Bernardo Rossellino," *AB*, xlv, 1963, pp. 43ff. Gianni Carlo Sciolla, *La scultura di Mino da Fiesole*, Turin, 1970, p. 18, n. 25, and John Pope-Hennessy, "The Altman Madonna by Antonio Rossellino," *Metropolitan Museum Journal*, iii, 1970, p. 142, n. 7, disagreed.

Pope-Hennessy claimed the participation of two different assistants in the angels flanking the Virgin and Child.[36]

The outer limits of the date of the tomb have almost invariably been acknowledged as the death of Bruni in 1444 and Bernardo's departure for Rome in 1451. On the basis of the intervention of Desiderio, I proposed a dating of ca. 1449–50 some years ago.[37]

6. The Tabernacle of the Sacrament in S. Egidio (S. Maria Nuova), Hospital of S. Maria Nuova, Florence

The tabernacle is immured in the left wall of the choir close to its entrance. Its *sportello* is kept in the office of the director of the hospital.

Above a corbel containing the arms of the Hospital of S. Maria Nuova—a crutch in a wreath—and a cherub's head, is a base on which stand two Corinthian pilasters supporting an entablature and triangular pediment. Between the pilasters, adoring angels flank a copy of the original *sportello*. The *sportello* contains a seated figure of God the Father holding a book in which are inscribed Alpha and Omega. In the lunette above the door, adoring half-length angels flank a chalice and host, towards which the Holy Ghost descends. In the pediment is a bust-length figure of God the Father, blessing and extending an orb.

White marble with bronze *sportello*. Painted inscription.

The console is a seventeenth-century addition. The inscription is also a later addition. Apart from the damage around the hinges of the *sportello*, the tabernacle is in good condition.

Tabernacle (minus console): 140.9 cm. x 91.7 cm.; pilasters: 71.2 cm. high; shafts: 57.7 cm. x 7.6 cm.; capitals: 8.7 cm. x 11.9 cm.; distance between pilaster shafts: 57.1 cm.; *sportello*: 35 cm. x 22.3 cm.; entablature: 22.3 cm. high; pediment: 30.2 cm. x 91.7 cm.; angels: ca. 33.5 cm. high.

Inscription on base: OLEUM INFIRMORUM

Bibliography: Federigo Fantozzi, *Nuova guida ovvero descrizione storico-artistico-critica della città e contorni di Firenze*, Florence, 1842, p. 378; Giuseppe François, *Nuova guida della città di Firenze*, Florence, 1853, p. 244; Ottavio Andreucci, *Della biblioteca e pinacoteca dell'arcispedale di S. Maria Nuova*, Florence, 1871, pp. 46, 80f, n. 51; ed. Andrea Bettini, *Guida di Firenze e suoi contorni*, Florence, [6]1871, p. 121; Vas-Mil, ii, pp. 176f, n. 3; Burckhardt-Bode, *Cicerone*, [5]1884, ii, 2, p. 386c; "Il tabernacolo scolpito da Luca della Robbia per la Cappella di San Luca," *Il nuovo osservatore fiorentino*, no. 9, April 26, 1885, pp. 65f; Bode, *Denkmäler*, p. 99; Reymond, *Sculpture*, iii, pp. 34f; Fabriczy, *JPK*, 1900, p. 101; Giovanni Poggi, "Il ciborio di Bernardo Rossellino nella chiesa di S. Egidio (1449–1450)," *Miscellanea d'arte*, i, 1903, pp. 105ff; Wilhelm Rolfs, *Franz Laurana*, Berlin, 1907, p. 27; Tysz, *BR*, pp. 32ff, 110; Kennedy, *R. d'arte*, 1933, p. 123; Heydenreich and Schott-

[36] *Ibid.*, p. 144. In *Ital. Ren. Sc.*, p. 298, Pope-Hennessy had limited the intervention of an assistant (not Antonio) in the figurated sculpture to the angel on the right of the lunette.

[37] Op. cit., *AB*, 1963, p. 45.

müller, "BR," T-B, xxix, p. 44; Martin Wackernagel, *Der Lebensraum des Künstlers in der florentinischen Renaissance*, Leipzig, 1938, p. 88; Planiscig, *BR*, pp. 11, 17f, 50; Paatz, *Kirchen*, iv, pp. 15f, 44, n. 52; Otto Kurz, "A Group of Florentine Drawings for an Altar," *WJ*, xviii, 1955, pp. 46f; Pope-Hennessy, *Ital. Ren. Sc.*, pp. 34f, 297; Valentino Martinelli, "Donatello e Michelozzo a Roma," II, *Commentari*, ix, 1958, pp. 21f; Galassi, p. 159; Ursula Schlegel, "Ein Sakramentstabernakel der Frührenaissance in S. Ambrogio in Florenz," *Zeitschrift für Kunstgeschichte*, xxiii, 1960, p. 171; *idem*, "Observations on Masaccio's Trinity Fresco in Santa Maria Novella," *AB*, xlv, 1963, p. 31, n. 90; Hans Caspary, "Tabernacoli quattrocenteschi meno noti," *Antichità viva*, ii, Sept. 1963, pp. 42f; *idem*, *Sakramentstabernakel*, p. 18; Seymour, *Sculpture*, pp. 122, 238, n. 31.

The commission for the tabernacle of S. Egidio is not preserved. Nor do extant payments, which add up to the unlikely sum of 66 lire, seem to be complete.[1] On February 11, 1450 (s.C.), Bernardo received 20 lire; on February 28, 10 lire; on April 4, 8 lire; on April 6, 8 lire; on April 24, 20 lire. The marble portion of the tabernacle must have been finished by April 22, 1450, when porters were paid for having carted the tabernacle. For the *sportello* made in his workshop, Lorenzo Ghiberti received one soldo less than 14 florins. Payments to him date from July 30, 1450; September 19; October 30; and November 27.

According to the payment to Bernardo, the tabernacle was destined for the "side of the women" ("dallato delle donne") or the "Spedale delle donne" as it appears in a payment to Ghiberti. In the fifteenth century the women's ward of the Hospital of S. Maria Nuova occupied the building which is presently the notarial archive on the southeast corner of the Piazza di S. Maria Nuova opposite the church of S. Egidio.[2] In the women's hospital was a chapel founded under the name of S. Maria Nuova.[3] That it was for this chapel that Rossellino's tabernacle was destined and not for the main church of the hospital, also known as S. Maria Nuova or S. Egidio, is confirmed by Luca della Robbia's execution of a sumptuous tabernacle less than a decade earlier for the choir of S. Egidio.[4] This is the tabernacle which was moved in the eighteenth century to the Collegiata at Peretola and is still there today (Fig. 200).[5] By 1842 Bernardo's tabernacle had been transferred to S. Egidio where it stood to the left of the main door.[6] In 1871 Andreucci saw it affixed to the left pilaster of the choir.[7] At some subsequent date it was moved about twenty centimeters beyond the pilaster and immured in the left side of the choir.[8] It was transferred to its present position in the left choir wall in 1948 during the resystematization of the church following the war.

The console is an addition, probably of the seventeenth century. Very likely it replaces

[1] The documents were published by Giovanni Poggi, "Il ciborio di Bernardo Rossellino nella chiesa di S. Egidio (1449-1450)," *Miscellanea d'arte*, i, 1903, pp. 106f and Tysz, *BR*, p. 110, doc. 10. The payments to Ghiberti had appeared in incomplete form prior to Poggi's article. See Doc. 19 (App. 3).

[2] For the building history of the hospital, see Guido Pampaloni, *Lo spedale di S. Maria Nuova e la costruzione del Loggiato di Bernardo Buontalenti*, Florence, 1961, pp. 14ff, esp. p. 19.

[3] Richa, viii, pp. 190f. Although Richa's description of the chapel is ample, he does not mention Rossellino's tabernacle.

[4] Documents published by Allan Marquand, *Luca della Robbia*, Princeton, N.J., 1914, p. 65.

[5] *Ibid.*, p. 61. The church at Peretola was incorporated into the hospital from 1449 to 1787 (Guido Carocci, *I dintorni di Firenze*, Florence, 1906, i, p. 346).

[6] It was seen there by Federigo Fantozzi, *Nuova guida ovvero descrizione storico-artistico-critica della città e contorni di Firenze*, Florence, 1842, p. 378.

[7] *Della biblioteca e pinacoteca dell'arcispedale di S. Maria Nuova*, Florence, 1871, p. 46.

[8] Paatz, *Kirchen*, iv, p. 15. The research for this volume was completed in the early 1940s.

an original one of similar shape. Triangular consoles are common in fifteenth-century tabernacles and the heavy pediment of the S. Egidio tabernacle seems to require a balancing member below. The inscription which designates the tabernacle as the receptacle for the holy oil is also of later date.[9]

Measurements reveal a proportional system in which the width of the central portion of the tabernacle (measured from the outer edges of the shafts of the pilasters) is equal to its height (i.e. the height of the pilasters). The height of the shafts is precisely coordinated with the distance between them. The width of the pediment is not much more than three times its height. A module of one eighth of a *braccio* (7.3 cm.) was employed in the height of the entablature and the width of the *sportello* (3 times), in the height of the pilaster shafts (8 times), and in the distance between the outer edges of the pilasters (10 times).

The earliest mention of the S. Egidio Tabernacle occurred in Florentine guidebooks around the middle of the nineteenth century when it was connected either directly or indirectly with Mino da Fiesole.[10] At about this time Gaetano Milanesi discovered in the archive of the hospital, documents of payment to Luca della Robbia for a tabernacle for the Cappella di S. Luca in the choir of S. Egidio and to Ghiberti, for a bronze *sportello*, all of which he believed referred to Rossellino's tabernacle in the church. The documents were published by Andreucci in 1871.[11] The payments to Luca were identified with the Peretola Tabernacle for the first time in 1884 in an article by Molinier incorporating the discoveries of Baron von Liphart and Jacopo Cavallucci.[12] At the same time, the S. Egidio Tabernacle was recognized as a work of Bernardo Rossellino's with a *sportello* by Ghiberti by Bode in the fifth edition of Burckhardt's *Cicerone*.[13] Rejecting Bode's attribution of the tabernacle to Bernardo, Reymond linked its architecture to Buggiano's lavabos in the Florentine Duomo, though he did not assert the latter's authorship. He dated the tabernacle 1440 or earlier.[14] Fabriczy attributed the tabernacle to Rossellino and dated it to 1448 or 1449 on the basis of the payments of 1450 to Ghiberti.[15] In 1903 Poggi published the payments to Bernardo as well as the authoritative text of the payments to Ghiberti.[16] Attention then turned to the contribution of Bernardo's assistants to the tabernacle. Tyszkiewicz attributed the "easier" parts, including the capitals, to Antonio while retaining the central portion for Bernardo.[17] Kennedy claimed the lunette for Antonio.[18] Planiscig considered the Rossellino

[9] It already existed when Fantozzi saw the tabernacle in 1842 (*op. cit.*, p. 378). It was probably incised after provincial Council of Milan (1565) ordered the replacement of wall tabernacles by the grandiose tabernacle-retables located on the altar and the provincial Council of Aquileia (1596) ordered the conservation of the Holy Oil in the wall tabernacles. At this time countless tabernacles were converted to the custody of the holy oil. See Ch. Rohault de Fleury, *La Messe, études archéologiques sur ses monuments*, Paris, ii, 1883, p. 72 and Caspary, *Sakramentstabernakel*, pp. 118ff.

[10] Fantozzi, *op. cit.*, p. 378; Giuseppe François, *Nuova guida della città di Firenze*, Florence, 1853, p. 244; ed. Andrea Bettini, *Guida di Firenze e suoi contorni*, Florence, [6]1871, p. 121.

[11] *Op. cit.*, pp. 46, 80f, n. 51. In his notes to Vasari's life of Luca della Robbia (ii, pp. 176f, n. 3) Milanesi

cited the S. Egidio Tabernacle as a work of Luca's dating from 1442.

[12] "Une oeuvre inédite de Luca della Robbia: le tabernacle en marbre de l'Eglise de Peretola, près de Florence," *Gazette archéologique*, ix, 1884, pp. 364ff. The identification was circulated among an Italian-reading public the following year in an unsigned article: "Il tabernacolo scolpito da Luca della Robbia per la Cappella di San Luca," *Il nuovo osservatore fiorentino*, no. 9, April 26, 1885, pp. 65f.

[13] *Op. cit.*, [5]1884, ii, 2, p. 386c. In his *Denkmäler*, p. 99, Bode repeated the attribution and dated the tabernacle to 1449.

[14] *Sculpture*, iii, pp. 34f.

[15] *JPK*, 1900, p. 101.

[16] Op. cit., *Miscellanea d'arte*, 1903, pp. 106f.

[17] *BR*, p. 33.

[18] *R. d'arte*, 1933, p. 123.

workshop responsible for the frame[19] while Pope-Hennessy assigned both the design and execution of the entire tabernacle to Bernardo.[20]

7. The Tomb of the Beata Villana in S. Maria Novella, Florence

The tomb is located on the right side of the second bay on the right (Mazzinghi Chapel).

The background of the tomb is formed by a heavy curtain which hangs from a finial suspended from a ring and hook. The curtain is held apart by two angels standing inside the curtain at the head and feet of the effigy. With their free hands they unroll a long scroll with the epitaph. Above the scroll two hands hold a crown from which rays issue. Below it, the effigy, showing Villana in a nun's habit, surmounts a plain slab and a step.

White marble with the exception of the red marble slab beneath the effigy and a sandstone step. Traces of a pattern of gold brocade on the left of the curtain. Traces of gilding elsewhere in the curtain and on its fringe; on the ball of the finial and the ring; in the hair, belt and hem of the chiton of the left angel.

Portions of the base are probably missing, i.e. a black marble step originally set on the floor and two white marble cornices above and below the red marble slab. Three seams are visible at the top and sides of the curtain. The lower left corner of the slab on which the effigy lies is badly cracked and two toes of the left foot of the left angel are missing. The farther foot of the effigy is badly mutilated.

Red marble slab: 81.4 cm. x 193.2 cm.; curtain: 160.4 cm. x 235.7 cm.; effigy: 31 cm. x 164 cm.; right angel: 71 cm. high; left angel: 66.5 cm. high.

Epitaph: OSSA.VILLANE.MVLIERIS.SANCTISSIME.
 IN.HOC.CELEBRI.TVMVLO.REQVIESCVNT.

Bibliography: Billi, p. 46; Antonio Petri, "Memoriale di curiosità artistiche in Firenze," in Billi, p. 58; *Magl.*, p. 89; Vas-Ricci, ii, p. 145; Vas-Mil, iii, p. 108; Raffaello Borghini, *Il riposo*, Florence, 1584, p. 338; Serafino Razzi O.P., *Vite dei santi e beati del sacro ordine de' frati predicatori, cosi huomini, come donne*, Florence, 1588, pt. 2, p. 98; Bocchi, p. 113; Silvano Razzi, *Vite dei santi e beati toscani*, Florence, 1627, p. 836; Bocchi-Cinelli, pp. 243f; Baldinucci, *Notizie*, iii, p. 41; Richa, iii, pp. 51f; Giuseppe Maria Brocchi, *Vite de' santi e beati fiorentini*, Florence, pt. 2, ii, 1761, pp. 88, 93; [Gaetano Cambiagi], *L'antiquario fiorentino o sia guida per osservar con metodo le cose notabili della città di Firenze*, Florence, 1765, p. 127; Antonio Francesco Rau and Modesto Rastrelli, *Serie degli uomini i più illustri nella pittura, scultura, e architettura*, Florence, iii, 1771, p. 101; Vincenzo Fineschi, *Memorie sopra il cimitero antico della chiesa di S. Maria Novella di Firenze*, Florence, 1787, pp. 56ff; *idem, Il forestiero istruito in S. Maria Novella di Firenze*, Florence, 1790, pp. 15f, 86; [Cambiagi], *Guida al forestiero per osservare con metodo le rarità e bellezze della città di Firenze*, Florence, ⁵1790, p. 202; [Follini], *Firenze antica, e moderna*, Florence, vi, 1795, pp. 313f; Leopoldo Cicognara, *Storia della scultura dal suo*

[19] *BR*, p. 18. [20] *Ital. Ren. Sc.*, p. 297.

risorgimento in Italia, Venice, ii, 1816, pp. 71f; Giuseppe Gonnelli, *Monumenti sepolcrali della Toscana*, Florence, 1819, p. 25; Federigo Fantozzi, *Nuova guida ovvero descrizione storico-artistico-critica della città e contorni di Firenze*, Florence, ²1856, p. 507; *Interno della chiesa di S. Maria Novella dopo i restauri fatti nel 1861*, Florence, 1861, pp. 6f; Eugène Müntz, *Histoire de l'art pendant la renaissance*, Paris, i, 1889, pp. 426, n. 1, 543f; Reymond, *Sculpture*, iii, p. 21; Bode, *Denkmäler*, p. 99; Fabriczy, *JPK*, 1900, pp. 49, 101, 111ff; James Wood Brown, *The Dominican Church of Santa Maria Novella at Florence*, Edinburgh, 1902, pp. 122, 125; Burger, pp. 108ff, 392f; Jacques Mesnil, "La compagnia di Gesù Pellegrino," *R. d'arte*, ii, 1904, pp. 70f, n. 1; Odoardo H. Giglioli, "Per una reliquia della B. Villana in S. M. Novella," *L'illustratore fiorentino*, 1905, pp. 16ff; Venturi, *Storia*, vi, pp. 606f; *Guida manuale di Firenze e de' suoi dintorni*, Florence, ⁴⁴1908, p. 132; *Guida artistica di Firenze e dei suoi dintorni*, Florence, ⁷1909, p. 84; Michel, *Histoire*, iv, 1, p. 98; Schubring, *Plastik*, p. 119; Raimondo Diaccini O.P., *La basilica di S. Maria Novella*, Florence, 1920, pp. 33f; Tysz, *BR*, pp. 36ff, 111ff, 140; Weinberger and Middeldorf, *Münch. Jahrb.*, 1928, pp. 90f; "La 'Beata Villana' del Rossellino ed una sua vecchia mutilazione," *La nazione*, Florence, March 9, 1929, n.p.; Luisa Becherucci, "Un angelo di Desiderio da Settignano," *L'arte*, xxxv, 1932, pp. 153ff; Kennedy, *R. d'arte*, 1933, p. 123; Walter Paatz, "Das Grabmal der Beata Villana in S. Maria Novella," *Mitt. d. ksth. Inst.*, iv, 1933, pp. 140f; Heydenreich and Schottmüller, "BR," *T-B*, xxix, p. 44; Becherucci, "BR," *Enc. ital.*, xxx, p. 135; Mary Pittaluga, *La scultura italiana del Quattrocento*, Florence, 1938, p. 43; Martin Wackernagel, *Der Lebensraum des Künstlers in der florentinischen Renaissance*, Leipzig, 1938, pp. 49, 231, 345; Planiscig, *BR*, pp. 19f, 50; Paatz, *Kirchen*, iii, pp. 702f, 786f, n. 183; Henriette s'Jacob, *Idealism and Realism: A Study of Sepulchral Symbolism*, Leiden, 1954, p. 11; Stefano Orlandi O.P., *"Necrologio" di S. Maria Novella*, Florence, 1955, i, pp. 163f; ii, pp. 238ff, 398, 490ff; *idem, La Beata Villana, terziaria domenicana fiorentina del secolo xiv*, Florence, 1955, pp. 43ff; *idem*, "La cappella e la compagnia della Purità in S. Maria Novella di Firenze," *Memorie domenicane*, lxxv, 1958, p. 170; Pope-Hennessy, *Ital. Ren. Sc.*, pp. 298f; Galassi, pp. 159, 173, 254, n. 12; Ida Cardellini, *Desiderio da Settignano*, Milan, 1962, pp. 93, 96, 265; Longhurst, P. 2; Anne Markham, "Desiderio da Settignano and the Workshop of Bernardo Rossellino," *AB*, xlv, 1963, pp. 37ff; Seymour, *Sculpture*, pp. 140, 240, n. 19; Gianni Carlo Sciolla, *La scultura di Mino da Fiesole*, Turin, 1970, p. 18, n. 25; Pope-Hennessy, "The Altman Madonna by Antonio Rossellino," *Metropolitan Museum Journal*, iii, 1970, p. 142, n. 7.

Although her ancestors traditionally had been buried in S. Croce, the Beata Villana requested burial in S. Maria Novella. After her death on January 29, 1361, her body was exposed in the fifth bay on the left for thirty-seven days,[1] then buried in the pavement adjacent to the wall of the fourth bay on the right.[2] A marble tomb slab, raised somewhat

[1] Giuseppe Maria Brocchi, *Vite de' santi e beati fiorentini*, Florence, pt. 2, ii, 1761, pp. 88, 92.

[2] The sources for the description and location of the first tomb are: the commission for the tomb of July 12, 1451 (for the publication of which, see below n. 5); Florence, Archivio di S. Maria Novella, Modesto Biliotti, O.P., *Chronica pulcherrimae aedis S. Mariae Novellae de Florentia*, 1586, foll. 18r, 38r; Florence, Archivio di S. Maria Novella, Vincenzo Borghigiani, O.P., *Cronica annalistica del convento di S. Maria*

Novella, 1757-60, ii, fol. 102; iii, foll. 32f. On November 27, 1441, Donna Villana, first cousin of the son of the Beata Villana, charged Fra Sebastiano Benintendi, the grandson of the Beata Villana, with the task of erecting an altar at the tomb of the Beata Villana, endowing it with a house and loggia in Via Valfonda. It is not known exactly where this altar stood. See Stefano Orlandi, O.P., *"Necrologio" di S. Maria Novella*, Florence, 1955, ii, pp. 231, 483.

above the level of the pavement, contained her effigy in low relief. Above her tomb the crucifix before which she had worshipped was affixed to the wall.[3] There her body remained until 1452.[4]

On July 12, 1451, Fra Sebastiano Benintendi, the grandson of the Beata Villana and procurator of the Dominican convent of S. Maria Novella, wishing to replace the modest tomb slab, by then perhaps worn away, commissioned a new tomb from Bernardo Rossellino.[5] The contract states that the tomb was to stand against the wall below the crucifix which had surmounted her tomb slab. A drawing of it had already been presented by the artist. Starting at the ground, the tomb was to consist of a black marble base ⅓ *braccio* high by 3⅛ *braccia* long; a white marble molding 3½ *braccia* long by ⅙ *braccio* deep; a framed red marble panel 1⅓ *braccia* high by 3¼ *braccia* long; a white marble cornice ⅛ *braccio* wide by ⅙ *braccio* deep.[6] All these members were meant to represent the front of a sarcophagus. These elements were to be surmounted by a white marble canopy just under 4 *braccia* wide by 2½ *braccia* high from the cornice through the finial. The canopy was to fall nearly to the base of the sarcophagus. It was to be fringed in gold, brocaded inside in black and gold, brocaded differently outside and provided with a lion's head, presumably as finial. Under the canopy the reclining effigy of the Beata Villana, 3 *braccia* long and similar in form to the effigy on the tomb slab, was to be carved in *mezzo rilievo*. Two angels in *mezzo rilievo* were to raise the curtain and hold the scroll whose text, incised and painted in oil, would be supplied by Fra Sebastiano. With the exception of the installation of the crucifix, the work was to be executed at Bernardo's expense. His remuneration was fixed at 250 lire. Should the work not be finished by December 31, 1451, Bernardo was to forfeit 20 florins. If Fra Sebastiano defaulted, the produce of his farm at Marignolle was to revert to Bernardo.

On January 27, 1452, a supplement to the contract provided for a tabernacle for the crucifix to be completed by the following Easter. It was to consist of two white marble shafts 2½ *braccia* by ½ *braccio* by ¼ *braccio* supporting a semicircular arch with moldings like those of an architrave. The entire opening was to measure 2 *braccia* wide by 4 *braccia* high. The background was to be painted blue. Bernardo was to attach the crucifix as seemed best to him. The price of the work was established at 100 lire. All expenses except those for iron, lead, painting or the service of a carpenter for the installation of the cross were to borne by the artist. However, if Fra Sebastiano should decide to reduce the size of the tabernacle, the expense of the change would be his.

[3] For the crucifix, see Walter Paatz, "Das Grabmal der Beata Villana in S. Maria Novella," *Mitt. d. ksth. Inst.*, iv, 1933, p. 141; W. R. Valentiner, "Orcagna and the Black Death of 1348," *Art Quarterly*, xii, 1949, p. 62; Paatz, *Kirchen*, iii, pp. 704, 789, n. 194.

[4] Parts of her body, however, were preserved independently as relics. According to Richa, iii, pp. 47f, in 1421 Federigo di Niccolò Gori bequeathed 10½ pounds of silver for a reliquary for the hand of the Beata Villana. It was probably melted down during the siege of Florence of 1530. In the same year Fra Sebastiano commissioned a silver gilt reliquary for unspecified relics of his grandmother. Preserved in the sacristy, it, too, was probably melted down in 1530. See Orlandi, "*Necrologio*," i, p. 163; ii, pp. 231f,

n. 23, 482ff, doc. 65 and *idem, La Beata Villana, terziaria domenicana fiorentina del secolo xiv*, Florence, 1955, pp. 49f, n. 10.

[5] The contract was published nearly in its entirety by Richa, iii, pp. 51f. Both this and the subsequent contract were published by Fabriczy, *JPK*, 1900, pp. 111ff, doc. 4; Burger, pp. 392f, Excursus ix; Tysz, *BR*, pp. 111ff, doc. 11; Orlandi, "*Necrologio*," ii, pp. 490ff, doc. 69. See Doc. 20 (App. 3).

[6] The actual measurements of the tomb only approximate those stipulated in the contract: the red marble slab is 3.6 cm. higher and 3.4 cm. longer than stipulated; the canopy is 14.4 cm. higher and 2.1 cm. wider; the effigy is 11 cm. shorter.

Very likely the tabernacle was not made, for no trace of one exists and not a single description of the tomb mentions it. But the crucifix was installed over the tomb, which occupied the place intended for it in the center of the fourth bay on the right.[7] On August 26, 1569, in the course of Vasari's restoration of the church, the tomb was removed and deposited in the sacristy.[8] It was reinstalled on November 20, 1570, in the fifth bay on the right, appropriated a short time before to the Companies of Gesù Pellegrino and S. Maria, also known as S. Croce del Tempio.[9] The tomb stood to the left of the altar, next to the door leading into the Cappella della Pura within a niche in the form of a portal.[10] Between 1570 and 1761 a small altar was set up in front of the tomb, and on it the relics of the Beata Villana were sometimes displayed.[11] The crucifix was not reinstalled above the tomb. In 1576 it was placed on the altar at the east end of the Cappella della Pura.[12] It is still there. In 1861 the Tomb of the Beata Villana was transferred to the Rucellai Chapel at the end of the right transept.[13] In about 1908–09 it was installed in its present position to the right of the altar of the Mazzinghi Chapel, the second bay on the right.[14]

[7] To the right of it stood the original Tomb of Beato Giovanni da Salerno, flanking the new Tomb of the Beata Villana as it had, the old. On the other side of the tomb were the two steps which traversed the width of the church, followed by the *tramezzo*. The bay was appropriated to the Minerbetti family in ca. 1568 but for the period prior to that there is no notice of patronage. The sources which specify the position of the tomb are: Billi, p. 46; *Magl.*, p. 89; ASF, Comp. relig. sopp. G IV, 910, vol. xi, fol. 52r; Borghigiani, *op. cit.*, iii, foll. 33, 331f, 394; BNCF, MS Conv. sopp. E 5. 777, Vincenzo Fineschi, O.P., *Monumenti della chiesa di S. Maria Novella*, ii, fol. 41r.

In addition to Borghigiani, *loc. cit.*, evidence for the installation of the crucifix over the tomb exists in the *Necrologio* of S. Maria Novella (Orlandi, "Necrologio," i, pp. 163f) and in Biliotti, *op. cit.*, fol. 38r. I consider this evidence more reliable than the contrary testimony of Fineschi, *Memorie sopra il cimitero antico della chiesa di S. Maria Novella di Firenze*, Florence, 1787, pp. 56ff, cited by Paatz, *op. cit.*, *Mitt. d. Ksth. Inst.*, 1933, pp. 140f and *idem*, *Kirchen*, iii, pp. 786f, n. 183.

[8] From a description of the transfer of the bones of the Beata Villana made by the prior of the convent, P. Alessandro Capocchi in Florence, Archivio di S. Maria Novella, *Necrologio*, flyleaf, copied in ASF, MS 812, *Sepoltuario di S. Maria Novella*, 1617, foll. 49f, n. 1. Cf. ASF, Comp. relig. sopp., G IV, 910, vol. xi, foll. 51vff.

[9] Both companies had been associated with the worship of the Beata Villana for a long time. On May 2, 1444, Donna Villana bequeathed to the Società di S. Croce del Tempio a house in the Chiasso dei Velluti as endowment for the annual celebration of the feast day of the Beata Villana in S. Maria Novella. (Orlandi, "Necrologio," ii, p. 232 and *idem*, *La Beata Villana*, p. 50, n. 11.) After commissioning her tomb, Fra Sebastiano charged the Compagnia di S. Maria del Tempio with the celebration of her feast day. He also gave funds to the Compagnia del Pellegrino of S.

Maria Novella which undertook to join the feast day celebration (ASF, Comp. relig. sopp. [S. Croce del Tempio], G 689, c. LXIX, no. 1, n.p.; Borghigiani, *op. cit.*, iii, foll. 34ff; Orlandi, "Necrologio," ii, pp. 239f and *idem*, *La Beata Villana*, pp. 44f). In 1568 the Compagnia del Pellegrino had requested permission to transfer the Tomb of the Beata Villana from the Minerbetti Chapel to their own on the grounds that they, along with the Compagnia del Tempio, were "Padronj" of the tomb (ASF, Comp. relig. sopp. G IV, 910, vol. xi, foll. 33rf).

[10] The major sources for the location and description of the tomb after its reinstallation are: Bocchi, p. 113; ASF, MS 812, *Sepoltuario*, 1617, foll. 49f; BNCF, MS II, IIII, 535, Stefano Rosselli, *Sepoltuario fiorentino ovvero descrizione delle chiese, cappelle, e sepolture, loro armi, et inscrizioni della città di Firenze e suoi contorni*, 1657, ii, foll. 630rf; Florence, Biblioteca Riccardiana, MS Codice Riccardiana 1935, *Sepolcrario della chiesa di S. Maria Novella di Firenze*, 1729, fol. 31v; Borghigiani, *op. cit.*, iii, foll. 394f; Fineschi, *Il forestiero istruito in S. Maria Novella di Firenze*, Florence, 1790, pp. 15f; Federigo Fantozzi, *Nuova guida ovvero descrizione storico-artistico-critica della città e contorni di Firenze*, Florence, ²1856, p. 507. The account of Biliotti, *op. cit.*, fol. 38r, is unreliable in a number of respects.

[11] Brocchi, *Vite de' Santi e Beati fiorentini*, pt. 2, ii, pp. 88f.

[12] Orlandi, "La Cappella e la Compagnia della Purità in S. Maria Novella di Firenze," *Memorie domenicane*, lxxv, 1958, p. 170, n. 25; BNCF, MS Baldovinetti 124, Niccolò di Ser Martelli, *S. Maria Novella*, 1617, n. p. (p. 5); Borghigiani, *op. cit.*, iii, fol. 395; Fineschi, *Memorie sopra il cimitero antico*, pp. 56f.

[13] *Interno della chiesa di S. Maria Novella dopo i restauri fatti nel 1861*, Florence, 1861, pp. 6f.

[14] *Guida manuale di Firenze e de' suoi dintorni*, Florence, ⁴1908, p. 132, and *Guida artistica di Firenze e dei suoi dintorni*, Florence, ⁸1909, p. 84.

From its first mention ca. 1530 until Fineschi's discovery and Richa's publication of the first contract in 1755, the tomb was attributed, with a single negligible exception, to Desiderio da Settignano.[15] Even afterwards, the tomb was more frequently assigned to Desiderio than not.[16] It was only in 1816, with Cicognara's identification of the "Artifice, o sia Scarpellino Bernardo di Matteo" mentioned in the commission with Bernardo Rossellino,[17] that the attribution to Desiderio was abandoned: for over a century the sepulchre was unanimously given to Bernardo. In 1932 Becherucci revived the attribution to Desiderio by claiming the right-hand angel for him.[18] Then, although no one except Pittaluga[19] and Galassi[20] accepted Becherucci's attribution, several scholars began to postulate the intervention of the Rossellino workshop. Heydenreich and Schottmüller,[21] Planiscig,[22] and Paatz[23] did not specify those portions of the tomb for which they thought Rossellino's assistants responsible. Kennedy speculated on the participation of Antonio in the angels.[24] Pope-Hennessy attributed the right angel, first to an unidentified member of the Rossellino workshop, later to Antonio Rossellino.[25] Cardellini gave the same angel to the master responsible for the Desideriesque fireplace in the Victoria and Albert Museum.[26] In 1963 I attributed to Desiderio the effigy and the right hand holding the crown, and to an anonymous assistant influenced by Desiderio, the right angel and possibly also the left hand holding the crown.[27] Seymour proposed the intervention of Mino da Fiesole and Antonio Rossellino as well as Desiderio, restricting Bernardo's role to the design and commencement of the execution of the tomb.[28] Sciolla attributed the right angel to Antonio Rossellino.[29]

The two commissions allow us to date the execution of the tomb between July and December 1451. The only alternative datings can be traced to two mistakes of Cicognara's.[30]

[15] Billi, p. 46; *Magl.*, p. 89; Vas-Ricci, ii, p. 145; Vas-Mil, iii, p. 108; Raffaello Borghini, *Il riposo*, Florence, 1584, p. 338; Bocchi, p. 113; Bocchi-Cinelli, pp. 243f; Baldinucci, *Notizie*, iii, p. 41, Antonio Petrei, "Memoriale di curiosità artistiche in Firenze," Billi, p. 58, attributed the tomb to Ghiberti. However, since he also attributed to Ghiberti the Tomb of Carlo Marsuppini and the tabernacle in S. Lorenzo and never mentioned Desiderio, his, too, practically constitutes an attribution to Desiderio. For the publication of the contract, see n. 5.

[16] [Gaetano Cambiagi], *L'antiquario fiorentino o sia guida per osservar con metodo le cose notabili della città di Firenze*, Florence, 1765, p. 127; Antonio Francesco Rau and Modesto Rastrelli, *Serie degli uomini i più illustri nella pittura, scultura, e architettura*, Florence, iii, 1771, p. 101; Fineschi, *Memorie sopra il cimitero antico*, p. 57, n. 1; [Cambiagi], *Guida al forestiero per osservare con metodo le rarità e bellezze della città di Firenze*, Florence, ⁵1790, p. 202. It was attributed to "Bernardo di Matteo da Settignano" by Fineschi, *Il forestiero istruita*, pp. 15f, 86, copied by [Follini], *Firenze antica, e moderna*, Florence, vi, 1795, pp. 313f.

[17] *Storia della scultura dal suo risorgimento in Italia*, Venice, ii, 1816, p. 71, copied by Giuseppe Gonnelli, *Monumenti sepolcrali della Toscana*, Florence, 1819, p. 25.

[18] "Un angelo di Desiderio da Settignano," *L'arte*, xxxv, 1932, pp. 154ff. This attribution, however, did not appear in Becherucci's subsequent article on Bernardo Rossellino in *Enc. ital.*, xxx, p. 135.

[19] *La scultura italiana del Quattrocento*, Florence, 1938, p. 43.

[20] *Op. cit.*, p. 173.

[21] "BR," T-B, xxix, p. 44.

[22] *BR*, pp. 20, 50.

[23] *Kirchen*, iii, pp. 702f.

[24] *R. d'arte*, 1933, p. 123.

[25] *Ital. Ren. Sc.*, p. 299; *idem*, "The Altman Madonna by Antonio Rossellino," *Metropolitan Museum Journal*, iii, 1970, p. 144.

[26] *Desiderio da Settignano*, Milan, 1962, p. 265.

[27] "Desiderio da Settignano and the Workshop of Bernardo Rossellino," *AB*, xlv, 1963, pp. 38ff. Pope-Hennessy, op. cit., *Metropolitan Museum Journal*, 1970, p. 142, n. 7 and Gianni Carlo Sciolla, *La scultura di Mino da Fiesole*, Turin, 1970, p. 18, n. 25, disagreed.

[28] *Sculpture*, pp. 140, 240, n. 19.

[29] *Op. cit.*, p. 18, n. 25.

[30] *Op. cit.*, ii, p. 71: tomb dated 1457. *Ibid.*, p. 72, n.: tomb dated between July 1452 and Easter 1453. The first mistake was copied by Gonnelli, *op. cit.*, p. 25; the second, by Becherucci, "BR," *Enc. ital.*, xxx, p. 135.

8. The Tomb of Orlando de' Medici in SS. Annunziata, Florence

The tomb is immured in the left wall of the fifth chapel on the right.

The sarcophagus is contained within a niche that is rectangular in plan and semicircular in elevation and is raised on a high foundation. The foundation is composed of a base supporting six fluted Corinthian pilasters grouped so that end pilasters are paired while two single pilasters alternate with three rectangular slabs in the center, and a cornice. The niche is circumscribed by a bound garland of oak leaves and acorns. The sarcophagus, with a sloping and slightly concave lid, rests on four castors. On the front face two seated putti hold the epitaph. A lion's head is carved in relief on each end. On the cover is the defunct's coat of arms: a shield containing six balls in descending order of three, two, one beneath a rake whose four prongs alternate with three *fleurs-de-lis*. The arms are enclosed by a wreath to which beribboned garlands of fruit and flowers are appended.

White marble with the exception of black marble in the lowest, horizontal base and red marble in the slabs in the foundation and the castors. Balls in shield painted red. Traces of gilding in hair and wings of right-hand putto.

The tomb is in excellent condition.

Foundation: 205.2 cm. high; base: 48.4 cm. x 349.6 cm.; pilasters: 144.8 cm. x 14.6 cm. (at the shaft); red slabs: 73.3 cm. wide; cornice: 12 cm. high; frame below niche: 25.4 cm. high; frame around arch: 37.6 cm. wide; niche: 133 cm. x 267.4 cm. x 43.2 cm.; sarcophagus: 98.8 cm. x 206.4 cm. x 51.9 cm.; castors: 19.7 cm. high; cassone: 48.4 cm. high; cover: 30.7 cm. high; epitaph: 27 cm. x 84.1 cm.; putti: 31 cm. high.

Epitaph:

SEPVLCRVM
ORLANDO MEDICI EQVITI FLOREN° CLARISSIMO
CIVI Q · DE RE · P · BENEMERITO · PIENTISSIMI FILII
PARENTI OPTIMO FACIVNDVM CVRARVNT
VIXIT · ANN · LXXV · MENS · VI · DIEB · XII

Bibliography: Vas-Mil, ii, pp. 460, n. 2, 461; Ferdinando Del Migliore, *Firenze città nobilissima illustrata*, Florence, 1684, p. 272; Richa, viii, p. 32; [Follini], *Firenze antica, e moderna*, Florence, iii, 1791, p. 312; Domenico Moreni, *Descrizione della chiesa della SS. Nunziata di Firenze*, Florence, 1791, p. 26; Pompeo Litta, *Famiglie celebri italiane*, series 1, Milan, 1813–49, iii, pl. 75; Federigo Fantozzi, *Nuova guida ovvero descrizione storico-artistico-critica della città e contorni di Firenze*, Florence, 1842, p. 410; Ottavio Andreucci, *Il fiorentino istruito nella chiesa della Nunziata di Firenze*, Florence, 1858, p. 72; Pellegrino Tonini, *Il santuario della Santissima Annunziata di Firenze*, Florence, 1876, p. 210; Wilhelm Bode, "Jugendwerke des Benedetto da Majano," *Rep. f. Kstw.*, vii, 1884, pp. 154f; Burckhardt-Bode, *Cicerone*, ⁶1893, ii, pp. 148b, 384d; *Il Santuario fiorentino ossia la Basilica della SS. Annunziata illustrata per un religioso dei Servi di Maria*, Florence, 1897, p. 57; C. Cristofani, *La Basilica della Santissima Annunziata e la metropolitana di S. Maria del Fiore*, Florence, 1897, p. 52; Bode, *Denkmäler*, pp. 99f; Fabriczy, *JPK*, 1900, pp. 48ff, 103; Burckhardt-Bode, *Cicerone*, ⁸1901, ii, pp. 179 k-l, 447i; Jacques Mesnil, "Arte retrospettiva: le tombe del rinascimento a Firenze," *Emporium*, xvi, 1902, p. 369; Giovanni Poggi, *La cappella e la tomba di Onofrio Strozzi nella chiesa di Santa Trinita*, Florence, 1903, pp.

23, 29; Paul Schubring, *Das italienische Grabmal der Frührenaissance*, Berlin, 1904, p. 14; Burger, pp. 186ff; Venturi, *Storia*, vi, p. 606; Michel, *Histoire*, iv, 1, pp. 98f; L. Dussler, *Benedetto da Majano, ein florentiner Bildhauer des späten Quattrocento*, Munich, 1924, p. 14; Tysz, *BR*, pp. 42 ff; Ybl, i, p. 214; ii, p. 320; Kennedy, *R. d'arte*, 1933, p. 123; Heydenreich and Schottmüller, "BR," T-B, xxix, p. 44; Paatz, *Kirchen*, i, pp. 101, 161f, n. 257; Planiscig, *BR*, pp. 21, 50f; Henriette s'Jacob, *Beschouwingen over Christelijke Grafkunst voornamelijk in Frankrijk en Italië*, Leiden, 1950, p. 147; Giuseppe Marchini, *Il Duomo di Prato*, Milan, 1957, p. 67; Pope-Hennessy, *Ital. Ren. Sc.*, p. 296; Piero Bargellini in *Il Santuario di Firenze*, Florence, Milan, 1957, p. 26; Margrit Lisner, "Zur frühen Bildauerarchitektur Donatellos," *Münchner Jahrbuch der bildenden Kunst*, ix-x, 1958-59, pp. 94, 113, n. 157; Longhurst, P. 4; Hannelore Glasser and Gino Corti, "The Litigation concerning Luca della Robbia's Federighi Tomb," *Mitt. d. ksth. Inst.*, xiv, June 1969, pp. 18ff.

In his testament of December 6, 1455,[1] Orlando de' Medici requested burial in a marble tomb in the chapel in SS. Annunziata dedicated to Mary Magdalene which he had founded in 1449.[2] Within one year from the date of his death his heirs, his two sons, Piero and Gianfrancesco, were to have spent 100 florins on his sepulcher. Orlando also bequeathed to the *Arte del Cambio* 150 florins of which 100 were to be spent on his tomb should his sons prove negligent. Orlando endowed a daily Mass in his chapel and observance of the feast day of S. Giuliano with a shop in the parish of S. Stefano.

Neither the commission nor the record of payment remains. A debt of 148 lire "dalle redj di messer Orlando" reported in Bernardo Rossellino's *catasto* of February 1458,[3] however, is generally assumed to refer to the tomb. From this we may deduce that the tomb had been commissioned from Bernardo, that at least it had been started at the beginning of 1458, and that the intervention of the *Arte del Cambio* had not been necessary.

The dimensions of the tomb testify to the use of the *braccio* (58.4 cm.) as unit of measurement. In the foundation, the shafts are exactly ¼ *braccio* wide, approximately one-tenth the height of the entire pilaster. The red marble slabs are 1¼ *braccia* wide. The distance between the bases of the pilasters is exactly 1⅓ *braccia*. The foundation of the tomb is 3½ *braccia* high by 5 *braccia* wide (measured at the base). The niche is ¾ *braccio* deep. The base of the foundation is four times as high as the cornice and precisely as high as the face of the sarcophagus. The depth of the sarcophagus is a quarter of its length.

Vasari[4] and Richa[5] assigned the tomb to Simone di Niccolò de' Bardi, the putative brother of Donatello. This attribution was perpetuated from the end of the eighteenth century to the end of the nineteenth century in the guidebooks to SS. Annunziata[6]

[1] Doc. 21 (App. 3). A summary of the testament was published by Pellegrino Tonini, *Il Santuario della Santissima Annunziata di Firenze*, Florence, 1876, pp. 312f, doc. 82.

[2] BNCF, MS, Alfredo Cirri, *Sepoltuario delle chiese di Firenze e dintorni*, early twentieth century, i, p. 256. On January 12, 1452, (s.C.) Maso di Bartolommeo paid for the transport of a stone to be used in the construction of the altar of Orlando's chapel (Charles Yriarte, *Livre de souvenirs de Maso di Bartolommeo dit Masaccio*, Paris, 1894, p. 66). Castagno's lost fresco of Lazarus, Martha and Mary Magdalene

made for the chapel dates from 1455 (Paatz, *Kirchen*, i, pp. 125, 186, n. 524; Fabriczy, "Urkundliches zu den Fresken Baldovinetti's und Castagno's in S. Maria de' Servi zu Florenz," *Rep. f. Kstw.*, xxv, 1902, p. 393).

[3] Published in Hartt, Corti, Kennedy, p. 181.

[4] Vas-Mil, ii, p. 461.

[5] Richa, viii, p. 32.

[6] Domenico Moreni, *Descrizione della chiesa della SS. Nunziata di Firenze*, Florence, 1791, p. 26; Ottavio Andreucci, *Il fiorentino istruito nella chiesa della Nunziata di Firenze*, Florence, 1858, p. 72; Tonini,

and to Florence.[7] A drawing of the tomb, identified only by its location, is found in the *Sepoltuario* of Giovanni di Poggio Baldovinetti (ca. 1722–ca. 1766).[8] An accurate engraving of it appeared in Litta's work on Italian families.[9] In 1878 Milanesi, interpreting the debt of the heirs of Orlando de' Medici in Bernardo's tax declaration as a reference to the monument in SS. Annunziata, attributed the tomb to Rossellino.[10] Nevertheless, Bode subsequently dated the tomb ca. 1450 and attributed it once to a follower of Donatello and once to a follower of Desiderio da Settignano.[11] Influenced by Fabriczy's reaffirmation in 1900 of Milanesi's attribution,[12] the tomb was accepted as a work of Bernardo's by Bode,[13] Poggi,[14] Burger,[15] Schubring,[16] Venturi,[17] Michel,[18] Tyszkiewicz,[19] and others. Dussler assigned the tomb to Antonio Rossellino[20] while Planiscig suggested the participation of the workshop, if not in the design, then in the execution of the tomb.[21]

9. The Tomb of Neri Capponi in S. Spirito, Florence

The tomb is located within a niche on the right side of the seventh chapel of the right transept (Capponi Chapel).

The tomb is placed in a niche whose arched entrance is closed by a concave bronze grill simulating rope knotted at regular intervals to form a pattern of lozenges. The irregular five-sided niche is quite deep but hardly any wider than the sarcophagus. There is a shallow recess hollowed out of the north side of the niche and a small door behind the sarcophagus. The niche is roofed by a flat segmental vault. On the vault is a fresco of the Capponi coat of arms surrounded by a beribboned wreath. The rear wall is decorated with frescoes in ascending order of red marble panels, garlands, consoles supporting an entablature and a shell with wings. Immediately behind the grill stands the sarcophagus. It consists of a rectangular *cassone* with a sloping cover and rests on console-shaped supports. The epitaph is located between the supports. On the front face of the *cassone* two flying putti support a profile, bust-length portrait of Capponi in a medallion. On the cover, within a wreath is the Capponi coat of arms: a shield divided obliquely into dark

op. cit., p. 210; *Il Santuario fiorentino ossia la Basilica della SS. Annunziata illustrata per un religioso dei Servi di Maria*, Florence, 1897, p. 57; C. Cristofani, *La Basilica della Santissima Annunziata e la metropolitana di S. Maria del Fiore*, Florence, 1897, p. 52.

[7] E.g. [Follini], *Firenze antica, e moderna*, Florence, iii, 1791, p. 312; Federigo Fantozzi, *Nuova guida ovvero descrizione storico-artistico-critica della città e contorni di Firenze*, Florence, 1842, p. 410.

[8] Florence, Biblioteca Riccardiana, Codice Moreni, 339, fol. 56r.

[9] *Famiglie celebri italiane*, series 1, Milan, 1813-49. iii, pl. 75.

[10] Vas-Mil, ii, p. 460, n. 2. Milanesi evidently knew the *catasto* of 1458 from its partial publication by Giovanni Gaye, *Carteggio inedito d'artisti dei secoli xiv, xv, xvi*, Florence, i, 1839, pp. 188f.

[11] Burckhardt-Bode, *Cicerone*, [6]1893, ii, pp. 148b,

384d. The dating and the attribution to a follower of Donatello were adopted by Jacques Mesnil, "Arte retrospettiva: le tombe del rinascimento a Firenze," *Emporium*, xvi, 1902, p. 369.

[12] *JPK*, 1900, pp. 48f.

[13] Burckhardt-Bode, *Cicerone*, [8]1901, ii, pp. 179l, 447i.

[14] *La cappella e la tomba di Onofrio Strozzi nella chiesa di Santa Trinita*, Florence, 1903, p. 29.

[15] *Op. cit.*, p. 187.

[16] *Das italienische Grabmal der Frührenaissance*, Berlin, 1904, p. 14.

[17] *Storia*, vi, p. 606.

[18] *Histoire*, iv, 1, p. 98.

[19] *BR*, p. 42.

[20] *Benedetto da Majano, ein florentiner Bildhauer des späten Quattrocento*, Munich, 1924, p. 14.

[21] *BR*, pp. 21, 50f.

and light fields. At either end of the sarcophagus are bosses. The rear of the *cassone* is plain. The rear of the cover is unfinished.

White marble with the exception of the bronze grill and the dark green marble field in the coat of arms.

For missing elements and later additions, see text. The left side of the sarcophagus behind the front face has been broken off. Pieces are missing from the upper and lower moldings of the *cassone*. The cover and epitaph are cracked. The upper feet of both putti are partially broken. There is a chip in the coat of arms.

Opening of arch: 178 cm. x 122 cm.; molding around arch: 21 cm. wide; sarcophagus: 99 cm. x 214.5 cm.; epitaph: 22.1 cm. x 131 cm.; *cassone*: 47.7 cm. high; medallion: 36.3 cm. in diameter (including frame); left putto: 73.5 cm. long; right putto: 71.8 cm. long; cover: 29.2 cm. high x 74 cm. deep.

Epitaph: D S

NERIO CAPONIO GINI FILIO CIVI PRECLARO · AC DE · R · P · FLO · DOMI

FORIS QVE OPTIME MERITO GINVS PATRI PIENT · PONI PROCVRAVIT ·

VIX · AN · LXVIIII · MEN · IIII · DI · XXI ·

Bibliography: Coll. Bernard Ashmole, Bartholomaeus Fontius, *Liber monumentorum Romanae urbis et aliorum locorum*, fol. 129r, published by Fritz Saxl, "The Classical Inscription in Renaissance Art and Politics," *WJ*, iv, 1940–41, p. 44; Bocchi-Cinelli, p. 147; Lodovico Antonio Muratori, Preface to Gino Capponi, "Monumenta historica de rebus florentinorum," *Rerum italicarum scriptores*, Milan, xviii, 1731, p. 1100; Richa, ix, pp. 23f; *Serie di ritratti d'uomini illustri toscani*, Florence, ii, 1768, p. 47v; *Elogi degli uomini illustri toscani*, Lucca, i, 1771, pp. ccclvf; [Follini], *Firenze antica, e moderna*, Florence, vii, 1797, p. 368; Pompeo Litta, *Famiglie celebri d'Italia*, Milan, series 2, 1847–99, ii, "Capponi di Firenze"; Burckhardt-Bode, *Cicerone*, [5]1884, ii, pp. 146, 388; Hans Semper, *Donatellos Leben und Werke*, Innsbruck, 1887, p. 3, n.; Bode, *Denkmäler*, p. 100; Fabriczy, *JPK*, 1900, pp. 53, 103f; Burckhardt-Bode, *Cicerone*, [8]1901, ii, p. 448b; Burger, pp. 205f: Paul Schubring, *Das italienische Grabmal der Frührenaissance*, Berlin, 1904, p. 16; Vasari, *Die Lebensbeschreibungen der berühmtesten Architekten, Bildhauer und Maler*, trans. and ed. Adolf Gottschewski, Strasbourg, iii, 1906, p. 280, n. 23; Venturi, *Storia*, vi, p. 606; Michel, *Histoire*, iv, 1, p. 99; Augusto Garneri, *Firenze e dintorni*, Florence, 1910, p. 360; Schubring, *Plastik*, p. 117; Tysz, *BR*, pp. 46ff; Weinberger and Middeldorf, *Münch. Jahrb.*, 1928, p. 93; Graves, pp. 69f; Ybl, ii, p. 322; Heinz Gottschalk, *Antonio Rossellino*, Liegnitz, 1930, p. 11; Kennedy, *R. d'arte*, 1933, p. 123; Heydenreich and Schottmüller, "BR," T-B, xxix, p. 44; Becherucci, "BR," *Enc. ital.*, xxx, p. 135; Planiscig, *BR*, pp. 26, 52; Paatz, *Kirchen*, v, pp. 142, 188, n. 156; Pope-Hennessy, *Ital. Ren. Sc.*, pp. 50, 301; Giovanni Mardersteig, "Leon Battista Alberti e la rinascita del carattere lapidario romano nel Quattrocento," *Italia medioevale e umanistica*, ii, 1959, p. 304; John Shearman, "The Chigi Chapel in S. Maria del Popolo," *WJ*, xxiv, 1961, p. 136, n. 41; Longhurst, p. 6; R. W. Lightbown, "Il busto di Giovanni Chellini al Museo Victoria e Albert di Londra," *Bollettino della Accademia degli Euteleti della città di San Miniato*, xxvi, 1963, p. 22, n. 17; Pope-Hennessy, *V & A Cat.*, i, p. 126; idem, *The Portrait in the Renaissance*, New York, 1966, pp. 75, 77ff; Seymour, *Sculpture*, pp. 139, 240, n. 17; Pope-Hennessy, "The Altman Madonna by Antonio Rossellino," *Metropolitan Museum Journal*, iii, 1970, p. 141.

The only extant document concerning the Capponi Tomb is one of September 12, 1488, in which permission was granted the grandsons of Neri Capponi to break the wall of their chapel in the new church of S. Spirito and to install a bronze or brass grating in order to make the sarcophagus visible.[1] The document thus provides a *terminus ante quem* for the tomb. It also gives cause to doubt that the tomb was destined originally for that chapel which, indeed, was acquired only in 1459 or 1464, some years after Capponi's death. Circumstantial evidence supports the hypothesis that the tomb was intended for an earlier Capponi Chapel located in the old church of S. Spirito.[2]

The first notice of the Capponi Tomb occurred at the end of the fifteenth century in Bartholomaeus Fontius's collection of inscriptions.[3] Early notices of the tomb are singularly uninformative.[4] In 1871 the tomb was engraved for Litta's work on Italian families where it was attributed to Simone di Niccolò de' Bardi, the putative brother of Donatello.[5] Perhaps it was of this that Bode was thinking when, in 1884, he claimed documentary evidence for his attribution of the Capponi Tomb to Simone.[6] Yet he observed a relationship between the tomb and the work of Bernardo Rossellino. In 1900 Fabriczy affirmed the provenance of the tomb in the Rossellino workshop, attributing to Giovanni Rossellino all but the portrait of Capponi which he thought worthy of Bernardo himself.[7] Fabriczy's attribution of the portrait to Bernardo was accepted, with or without reservations, by Bode,[8] Burger,[9] Weinberger and Middeldorf,[10] Ybl,[11] Gottschalk,[12] Heydenreich and Schottmüller,[13] Pope-Hennessy (later repudiated),[14] and Seymour.[15] Fabriczy's attribution of the rest of the tomb to Giovanni was accepted by Burger[16] and Gottschalk.[17] Graves attributed only the angels to Giovanni.[18] In most brief discussions of the tomb, however, it appears as the work of Bernardo Rossellino.[19] Bode,[20] Weinberger and Middeldorf,[21] Tyszkiewicz,[22] Planiscig,[23] Paatz,[24] Lightbown[25] and Pope-Hennessy[26] did not designate the member or members of the workshop they thought responsible for having carved the angels

[1] Doc. 22 (App. 3).

[2] See text.

[3] *Liber monumentorum Romanae urbis et aliorum locorum*, fol., 129r, Coll. Prof. Bernard Ashmole (published by Fritz Saxl, "The Classical Inscription in Renaissance Art and Politics," *WJ*, iv, 1940-41, p. 44).

[4] Bocchi-Cinelli, p. 147; Lodovico Antonio Muratori, Preface to Gino Capponi, "Monumenta historica de rebus florentinorum," *Rerum italicarum scriptores*, Milan, xviii, 1731, p. 1100; Richa, ix, pp. 23f.

[5] *Famiglie celebri d'Italia*, Milan, series 2, 1847-99, ii, "Capponi di Firenze."

[6] Burckhardt-Bode, *Cicerone*, [8]1884, ii, pp. 146, 388. Hans Semper, *Donatellos Leben und Werke*, Innsbruck, 1887, p. 3, n., expressed a certain scepticism with regard to the documentary basis for Bode's attribution.

[7] *JPK*, 1900, pp. 53, 103f.

[8] Burckhardt-Bode, *Cicerone*, [8]1901, ii, p. 448b. Nothing more was said of Simone.

[9] Burger, pp. 205f.

[10] *Münch. Jahrb.*, 1928, p. 93.

[11] Ybl, ii, p. 322.

[12] *Antonio Rossellino*, Liegnitz, 1930, p. 11.

[13] "BR," T-B, xxix, p. 44.

[14] *Ital. Ren. Sc.*, p. 301. In *idem*, *V & A Cat.*, i, p. 126, the attribution was withdrawn.

[15] *Sculpture*, pp. 139, 240, n. 17.

[16] *Loc. cit.*

[17] *Loc. cit.*

[18] Graves, pp. 69f.

[19] Bode, *Denkmäler*, p. 100; Paul Schubring, *Das italienische Grabmal der Frührenaissance*, Berlin, 1904, p. 16 (in *Plastik*, p. 117, he transferred the entire tomb to an unknown artist); Venturi, *Storia*, vi, p. 606; Becherucci, *Enc. ital.*, xxx, p. 135.

[20] Burckhardt-Bode, *Cicerone*, [8]1901, ii, pp. 447f.

[21] *Loc. cit.*

[22] *BR*, p. 48. Neither could she decide upon the authorship of the portrait.

[23] *BR*, pp. 26, 52.

[24] *Kirchen*, v, p. 142.

[25] "Il busto di Giovanni Chellini al Museo Victoria e Albert di Londra," *Bollettino della Accademia degli Euteleti della città di San Miniato*, xxvi, 1963, p. 22, n. 17.

[26] *V & A Cat.*, i, p. 126 and *idem*, "The Altman Madonna by Antonio Rossellino," *Metropolitan Museum Journal*, iii, 1970, p. 141.

and decorative portions of the tomb. Graves tentatively attributed the ornament of the lid to Antonio.[27] She was the first to recognize Antonio's hand in the portrait medallion. Planiscig,[28] Paatz,[29] Lightbown[30] and Pope-Hennessy[31] concurred.

The dating of the tomb has aroused little discussion: with the exception of Pope-Hennessy, who dated the portrait medallion before Capponi's death,[32] a dating soon after 1457 is generally accepted.[33]

10. The Tomb of Giovanni Chellini in S. Domenico, S. Miniato al Tedesco

The tomb is located in the left wall of the chapel which occupies the right transept (Samminiati Chapel).

The effigy is contained within a shallow rectangular niche, framed by carved Corinthian pilasters supporting consoles and a triangular pediment with a broken lintel. In the pediment is a half-length Madonna and Child in a beribboned garland. A festoon hangs from the two corners of the lintel. Below the effigy is a base consisting of two steps supporting lesenes surmounted by consoles at either end and in the center, a bordered and framed rectangular slab surmounted by the epitaph. The effigy shows Chellini wearing a fur-lined garment under a *tabarro* and a *cappuccio*.

White marble: moldings of base, lesenes, lower consoles, epitaph, effigy, pilasters, upper consoles, projecting portion of lintel and cornice of pediment. Dark green marble: upper step and border of rectangular slab. Red marble: rectangular slab and margins on either side of the epitaph. Stucco: festoon, recessed portion of lintel and ornamentation of the pediment. Stucco covering brick: lower step. Traces of gilding, probably not original, on the upper consoles, capitals, pilasters and their plinths, the pages of the book held by the effigy and the lettering and tassels of the cushion beneath the head. For missing elements and later additions, see below.

There are innumerable cracks throughout the left side of the base. The right side of the base is damaged at the joint of corbel and red marble. Stucco has been introduced into several seams of the base. The effigy's nose, little finger of the left hand, index finger of the right hand, the hem of the *tabarro* and the *becchetto* have been chipped.

Base: 159 cm. x 263 cm.; lower step: 27 cm. high; upper step: 26 cm. high; lesenes: 74.7 cm. x 27.6 cm.; distance between lesenes: 184.8 cm.; lower corbels: 31.2 cm. x 27.4 cm.; red marble slab: 59 cm. x 143.8 cm.; rectangle of epitaph: 26.6 cm. x 117.5 cm.; cornice below slab on which effigy lies: 9 cm. high; slab on which effigy lies: 5 cm. high; bases under plinths: 3.8 cm. high; plinths: 7.4 cm. x 28.4 cm.; pilasters minus capitals: 179.5 cm. x 19.5 cm.; capitals: 20 cm. x 20.5 cm.; upper corbels: 21.5 cm. x 20 cm.; pediment: 47.6 cm. high.

[27] *Loc. cit.*
[29] *Loc. cit.*
[31] *The Portrait in the Renaissance*, New York, 1966, p. 75.
[32] *Ibid.*, p. 75. In *Metropolitan Museum Journal*, 1970, p. 141, Pope-Hennessy dated the entire tomb

[28] *Loc. cit.*
[30] *Loc. cit.*

chest before 1457.
[33] Fabriczy, *JPK*, 1900, p. 103; Burger, p. 205; Venturi, *Storia*, vi, p. 606; Michel, *Histoire*, iv, 1, p. 99; Tysz, *BR*, p. 48; Planiscig, *BR*, p. 26; Paatz, *Kirchen*, v, p. 142.

Epitaph: IOHANNI CHELLINO FLORENTINO CIVI PRECLARO · ARTIVM
MEDICINE Q3 EXIMIO DOCTORI · SEPVLCHRVM HOC
BARTHOLOMEVS NEPOS ET GRATVS HERES · CONSTRV
ENDVM CVRAVIT · VIXIT AVTEM HONORE DIGNVS ANĪS
FERE NONAGINTA · OBIIT DIE IIII° FEBRVARII M̊CCCCLXI

Bibliography: Emanuele Repetti, *Dizionario geografico fisico storico della Toscana*, Florence, v, 1843, p. 92; Giuseppe Rondoni, *Memorie storiche di S. Miniato al Tedesco*, S. Miniato al Tedesco, 1876, p. 224; Vas-Mil, ii, p. 447, n. 5; Stegmann-Geymüller, vi, "Pagnio di Lapo di Portigiani," p. 1; H. von Tschudi, *Donatello e la critica moderna*, Turin, 1887, p. 11; H. Geymüller, "Die architektonische Entwickelung Michelozzos und sein Zusammenwirken mit Donatello," *JPK*, xv, 1894, p. 255; G. Piombanti, *Guida della città di San Miniato al Tedesco*, S. Miniato al Tedesco, 1894, p. 65; Wilhelm Bode, "Donatello als Architekt und Dekorator," *JPK*, xxii, 1901, p. 27, n. 1; Bode, *Florentiner Bildhauer der Renaissance*, Berlin, 1902, pp. 66f, n. 1; Guido Battelli, "Luoghi romiti: San Miniato al Tedesco—Cigoli," *Emporium*, xviii, 1903, p. 58; H. Mackowsky, "San Miniato al Tedesco," *Zeitschrift für bildende Kunst*, n.F., xiv, 1903, pp. 216f; C. von Fabriczy, "Pagno di Lapo Portigiani," *JPK*, xxiv, 1903, Beiheft, p. 123; *idem*, "Michelozzo di Bartolomeo," *JPK*, xxv, 1904, Beiheft, p. 43; Burger, p. 130; L. Ferretti, "La chiesa di San Domenico in San Miniato," *L'illustratore fiorentino*, 1904, p. 111; G. Rondoni, "Arte e storia nel convento e chiesa de' SS. Jacopo e Lucia di S. Miniato al Tedesco," *Miscellanea storica della Valdelsa*, xii, 1904, pp. 6f; Guido Carocci, *Il Valdarno da Firenze al mare*, Bergamo, 1906, pp. 93f; D. Brunori, "Giovanni Chellini da S. Miniato e Pagno Portigiani da Fiesole," *L'illustratore fiorentino*, vii, 1910, pp. 40ff; Francesco Galli-Angelini, *San Miniato, la sveva città del Valdarno*, Milan, 1925, p. 13; Mario Battistini, "Giovanni Chellini, medico di S. Miniato," *Rivista di storia delle scienze mediche e naturali*, xviii, 1927, pp. 112ff; Weinberger and Middeldorf, *Münch. Jahrb.*, 1928, pp. 85ff; Tysz, *BR*, pp. 54, 115; Graves, pp. 52f, 65ff; *idem*, "Early Works of Antonio Rosselino," *Parnassus*, i, Feb. 15, 1929, p. 18; Ybl, ii, p. 322; Heinz Gottschalk, *Antonio Rossellino*, Liegnitz, 1930, p. 47; Luisa Becherucci, "Un angelo di Desiderio da Settignano," *L'arte*, xxxv, 1932, p. 155; Kennedy, *R. d'arte*, 1933, pp. 125f; Heydenreich and Schottmüller, "BR," T-B, xxix, p. 44; Becherucci, "BR," *Enc. ital.*, xxx, p. 135; Joseph Pohl, *Die Verwendung des Naturabgusses in der italienischen Porträtplastik der Renaissance*, Würzburg, 1938, pp. 32f; Planiscig, *BR*, pp. 23f, 52; Anna Matteoli, "Il monumento sepolcrale di Giovanni Chellini nella chiesa sanminiatese di S. Domenico," *Bollettino della Accademia degli Euteleti della città di San Miniato*, xiv, 1948–49, pp. 17ff; Pope-Hennessy, *Ital. Ren. Sc.*, pp. 56, 296; Aldo de Maddalena, "Les *Archives Saminiati*: de l'économie à l'histoire de l'art," *Annales: Economies, sociétés, civilisations*, xiv, 1959, pp. 742f; Galassi, p. 160; Longhurst, P. 9; R. W. Lightbown, "Giovanni Chellini, Donatello and Antonio Rossellino," *BM*, civ, 1962, pp. 102, 104; *idem*, "Il busto di Giovanni Chellini al Museo Victoria e Albert di Londra," *Bollettino della Accademia degli Euteleti della città di San Miniato*, xxvi, 1963, pp. 15f, 19, 21, n. 8; H. W. Janson, "Giovanni Chellini's *Libro* and Donatello," *Studien zur toskanischen Kunst, Festschrift für Ludwig Heinrich Heydenreich*, Munich, 1964, pp. 137f; Pope-Hennessy, *V & A Cat.*, i, p. 125; Caspary, *Sakramentstabernakel*, p. 26; Hartt, Corti, Kennedy, pp. 80, 90; Seymour, *Sculpture*, p. 240, n. 17; Howard Saalman, "Tommaso Spinelli, Michelozzo, Manetti, and Rosselino," *Journal of the Society of Architectural*

Historians, xxv, 1966, p. 159, n. 38; A. Matteoli, "La pala d'altare della venerabile Arciconfraternità di Misericordia di San Miniato (Pisa) proveniente dal locale Oratorio di Santa Maria al Fortino," *Bollettino della Accademia degli Euteleti della città di San Miniato*, xxx, 1967, pp. 15, 35f, n. 4; Anne Markham Schulz, "The Tomb of Giovanni Chellini at San Miniato al Tedesco," *AB*, li, 1969, pp. 317ff; Charles Seymour, Jr., *The Sculpture of Verrocchio*, Greenwich, Conn., 1971, p. 116.

The only documentary notice of the Chellini Tomb occurs in the testament of Giovanni Chellini dated February 20, 1460 (s.C.), in which Chellini requested burial "in a tomb ordered for him in his chapel" in S. Domenico at S. Miniato al Tedesco.[1] Therefore we may deduce at least that the tomb had already been commissioned. The inscription and the use of death masks for the carving of the effigy, however, indicate that the tomb was completed only after Chellini's death in 1462 (s.C.).

The first extant notice of the tomb occurred in the sixteenth-century family chronicle by Baccio di Francesco Samminiati, probably a descendant of Bartolommeo Chellini.[2] Baccio's attribution of the tomb to Donatello was repeated, if with a certain scepticism, by Scipione Ammirato[3] and Baldovinetti[4] and reappears in an unspecified eighteenth-century source.[5] The claim of Donatello's authorship seems to have been invented and fostered by the descendants of Chellini, for no such tradition was preserved among the *frati* of the convent of S. Jacopo. Indeed, what information Prior Fra Gerolamo Rosati transmitted in his chronicle of the convent of 1595 seems to have been derived almost entirely from the monument itself.[6] In the nineteenth century the tomb was sometimes attributed to Mino da Fiesole, sometimes to Donatello.[7] In 1878 Milanesi cited the Tomb of Giovanni Chellini in connection with a passage from the 1568 *Vite* by Vasari which reads, "Lavorò anco Pagno, a San Miniato al Tedesco, alcune figure in compagnia di Donato suo maestro, essendo giovane."[8] Thereupon, Vasari's statement was accepted as documentary proof of Pagno's authorship.[9] Pagno, however, was considered to be only an executant of Donatello's

[1] Mario Battistini, "Giovanni Chellini, medico di S. Miniato," *Rivista di storia delle scienze mediche e naturali*, xviii, 1927, p. 112, n. 5.

[2] Aldo de Maddalena, "Les *Archives Saminiati*: de l'économie à l'histoire de l'art," *Annales: Economies, sociétés, civilisations*, xiv, 1959, p. 743.

[3] *Discorso sopra la Famiglia dei Saminiati*, end of the sixteenth century, preserved in a seventeenth century copy and published by R. W. Lightbown, "Giovanni Chellini, Donatello and Antonio Rossellino," *BM*, civ, 1962, pp. 102ff, and *idem*, "Il busto di Giovanni Chellini al Museo Victoria e Albert di Londra," *Bollettino della Accademia degli Euteleti della città di San Miniato*, xxvi, 1963, p. 19.

[4] Florence, Biblioteca Riccardiana, Codice Moreni 339, *Sepoltuario*, fol. 42r published by Anne Markham Schulz, "The Tomb of Giovanni Chellini at San Miniato al Tedesco," *AB*, li, 1969, p. 328, n. 42.

[5] Maddalena, op. cit., *Annales: Economies, sociétés, civilisations*, 1959, p. 743. This document, along with the chronicle of Baccio Samminiati, is presumably to be found among the Samminiati papers at the Università Bocconi at Milan. On the basis of these early attributions, Maddalena, *ibid.*, p. 744, recently reasserted Donatello's authorship of the tomb.

[6] San Miniato, Biblioteca Comunale, MS U. 2, *Cronache del convento*, i, fol. 42r, published by Schulz, op. cit., *AB*, 1969, p. 328, n. 41.

[7] Emanuele Repetti, *Dizionario geografico fisico storico della Toscana*, Florence, v, 1843, p. 92; Giuseppe Rondoni, *Memorie storiche di S. Miniato al Tedesco*, S. Miniato al Tedesco, 1876, p. 224; G. Piombanti, *Guida della città di San Miniato al Tedesco*, S. Miniato al Tedesco, 1894, p. 65.

[8] Vas-Mil, ii, p. 447 and n. 5.

[9] Ernest von Liphart is credited in several places with having originated this attribution, but a published source for it is never cited and I have not been able to find one. The attribution was seconded by H. von Tschudi, *Donatello e la critica moderna*, Turin, 1887, p. 11; H. von Geymüller, "Die architektonische Entwickelung Michelozzos und sein Zusammenwirken mit Donatello," *JPK*, xv, 1894, p. 255; *idem* in Stegmann-Geymüller, vi, "Pagnio di Lapo di Portigiani," p. 1; Wilhelm Bode, "Donatello als Architekt und Dekorator," *JPK*, xxii, 1901, p. 27, n. 1; *idem*, *Florentiner Bildhauer der Renaissance*, Berlin, 1902, pp. 66f, n. 1; Burger, p. 130; Lodovico Ferretti, "La chiesa di S. Domenico in S. Miniato," *L'illustratore fiorentino*, 1904, p. 111; D. Brunori, "Giovanni Chel-

design by Rondoni[10] and Galli-Angelini.[11] In 1903 Fabriczy refuted the attribution to Pagno on the basis of documents which established Pagno's presence in Bologna from 1451 to ca. 1469, and ascribed the tomb to Michelozzo,[12] an artist whose style Bode had already linked with the tomb.[13] This attribution was reasserted by Mackowsky.[14] Similar considerations of style induced Weinberger and Middeldorf to assign the tomb to Bernardo Rossellino.[15] Tyszkiewicz qualified their conclusions by an attribution of the ornamental portions of the tomb to Antonio Rossellino,[16] while Graves gave the entire tomb to Antonio.[17] Graves's attribution was reviewed circumspectly by Heydenreich and Schottmüller,[18] and accepted by Pohl[19] and Kennedy.[20] Most recent criticism, however, has affirmed the attribution of the tomb to Bernardo.[21] In a recent article I accepted the provenance of the tomb in the shop of Bernardo Rossellino but attributed it to an anonymous assistant, evidence of whose hand I was unable to find outside of this tomb.[22] Seymour believed the effigy to have been carved either by Andrea Verrocchio working in Rossellino's shop or else by another assistant close to Verrocchio in style.[23]

lini da S. Miniato e Pagno Portigiani da Fiesole," *L'illustratore fiorentino*, vii, 1910, pp. 40ff.

[10] "Arte e storia nel convento e chiesa de' SS. Jacopo e Lucia di S. Miniato al Tedesco," *Miscellanea storica della Valdelsa*, xii, 1904, p. 7.

[11] *San Miniato, la sveva città del Valdarno*, Milan, 1925, p. 13. Guido Carocci, *Il Valdarno da Firenze al mare*, Bergamo, 1906, p. 94 disagreed.

[12] "Pagno di Lapo Portigiani," *JPK*, xxiv, 1903, Beiheft, p. 123. He reasserted the attribution more forcefully in "Michelozzo di Bartolomeo," *JPK*, xxv, 1904, Beiheft, p. 43.

[13] Op. cit., *JPK*, 1901, p. 27, n. 1; idem, *Florentiner Bildhauer*, pp. 66f, n. 1.

[14] "San Miniato al Tedesco," *Zeitschrift für bildende Kunst*, n.F., xiv, 1903, pp. 216f.

[15] *Münch. Jahrb.*, 1928, pp. 87ff.

[16] *BR*, pp. 54, 115.

[17] Graves, p. 67; idem, "Early Works of Antonio Rosselino," *Parnassus*, i, February 15, 1929, p. 18.

[18] "BR," T-B, xxix, p. 44.

[19] *Die Verwendung des Naturabgusses in der italien-* ischen *Porträtplastik der Renaissance*, Wurzburg, 1938, pp. 32f.

[20] Hartt, Corti, Kennedy, p. 80.

[21] Ybl, ii, p. 332; Heinz Gottschalk, *Antonio Rossellino*, Liegnitz, 1930, p. 47; Luisa Becherucci, "Un angelo di Desiderio da Settignano," *L'arte*, xxxv, 1932, p. 155; idem, "BR," *Enc. ital.*, xxx, p. 135; Planiscig, *BR*, pp. 23, 52; Anna Matteoli, "Il monumento sepolcrale di Giovanni Chellini nella chiesa sanminiatese di S. Domenico," *Bollettino della Accademia degli Euteleti della città di San Miniato*, xiv, 1948-49, pp. 17ff; Pope-Hennessy, *Ital. Ren. Sc.*, pp. 56, 296; idem, *V & A Cat.*, i, p. 125; Galassi, p. 160; Seymour, *Sculpture*, p. 240, n. 17; H. W. Janson, "Giovanni Chellini's *Libro* and Donatello," *Studien zur toskanischen Kunst, Festschrift für Ludwig Heinrich Heydenreich*, Munich, 1964, p. 137, more cautiously claimed the tomb as a product of the workshop of Bernardo Rossellino.

[22] Op. cit., *AB*, 1969, pp. 329ff.

[23] Charles Seymour, Jr., *The Sculpture of Verrocchio*, Greenwich, Conn., 1971, p. 116.

Chronology of the Lives and Works of Bernardo Rossellino and his Brothers

1402, 1403 or 1405 Birth of Bernardo's brother, Domenico.[1]

1407 or 1409–10 Birth of Bernardo Rossellino, probably in Settignano.[2] His father, Matteo Gamberelli,[3] son of Domenico di Bartolo, called Borra, was born in 1373[4] and was dead by 1451.[5] Matteo matriculated in the *Arte dei Maestri di Pietra e Legname* on July 19, 1399.[6] Bernardo's mother, Mea, was born in 1387–88 or 1389[7] and died between 1458 and 1469.[8] A paternal uncle, Jacopo di Domenico del Borra da Settignano (d. ca. 1448)[9] matriculated in the stonemasons' guild on May 31, 1399,[10] and was at work at the Badia, Florence, in 1436.[11] His son, Giovanni, was also a stonemason. Another paternal uncle, Giovanni di Domenico, may also have worked as a stonemason at the Badia in 1436.[12]

1412–13 Birth of Bernardo's brother, Giovanni.[13]

1415, 1417, 1419 or 1421–22 Birth of Bernardo's brother, Tomaso.[14]

[1] Domenico's age is given in four tax declarations. For the *estimo* of Matteo's heirs of 1451, see Doc. 2 (App. 3); for the *catasto* of Domenico, Giovanni, Tomaso and Antonio Rossellino of 1458, see Hartt, Corti, Kennedy, p. 177, doc. 30; for Domenico's and Giovanni's *catasto* of 1469, see Doc. 6 (App. 3); for Domenico's and Giovanni's *catasto* of 1480, see Doc. 8 (App. 3).

[2] Bernardo's age is given in two tax declarations. For the *estimo* of Matteo's heirs of 1451, see Doc. 2 (App. 3); for Bernardo's *catasto* of 1458, see Hartt, Corti, Kennedy, p. 184, doc. 31.

[3] The name Gamberelli derives from the region in the vicinity of Settignano called Gamberaia where Matteo's father lived. The surname Rossellino does not appear in the fifteenth-century documents. Nor is there a work signed with that name. The surname Rossellino, signifying little redhead, was first used for Antonio. It occurs for the first time in 1494 in Giovanni Santi's *Principio del opera* (*Federigo di Montefeltro, Duca di Urbino. Cronaca di Giovanni Santi*, ed. Heinrich Holtzinger, Stuttgart, 1893, ch. xcvi, verse 130, p. 189). In the apologia to his commentary on Dante of 1481, Cristoforo Landino called him "Antonio, cognominato Rosso" ("Fiorentini eccellenti nella pittura, et nella scultura," *Dante con l'esposizione di Christoforo Landino*, Venice, 1564, n.p.).

[4] Milanesi in Vas-Mil, iii, p. 105.

[5] Doc. 2 (App. 3).

[6] Doc. 11 (App. 3).

[7] Mea's age is given in two tax declarations. For the *estimo* of Matteo's heirs of 1451, see Doc. 2 (App. 3). For the *catasto* of Domenico, Giovanni, Tomaso and Antonio of 1458, see Hartt, Corti, Kennedy, p. 177, doc. 30.

[8] She is not mentioned in the tax declarations of the Rossellino brothers of 1469.

[9] ASF, Not. A 192 (Ser Francesco Albini, 1455-75), fol. 151r.

[10] Doc. 11 (App. 3).

[11] Piero Sanpaolesi, "Costruzioni del primo Quattrocento nella Badia fiorentina," *R. d'arte*, xxiv, 1942, p. 169.

[12] *Ibid.*, p. 168.

[13] Giovanni's age is given in four tax declarations. For the *estimo* of Matteo's heirs of 1451, see Doc. 2 (App. 3); for the *catasto* of Domenico, Giovanni, Tomaso and Antonio of 1458, see Hartt, Corti, Kennedy, p. 177, doc. 30; for Domenico's and Giovanni's *catasto* of 1469, see Doc. 6 (App. 3); for Domenico's and Giovanni's *catasto* of 1480, see Doc. 8 (App. 3). The birth date of 1404, making Giovanni older than Domenico, derived from the *catasto* of 1469, may be explained by the fact that in the city men over 60 (and boys under 18) were tax exempt. The *catasto* of 1480 which yields a birth date of 1408 is not to be trusted either in view of the agreement of the two earliest sources.

[14] Tomaso's age is given in four tax declarations. For the *estimo* of Matteo's heirs of 1451, see Doc. 2

1427 or 1428 Birth of Bernardo's brother, Antonio.[15] There was also a sister, Angela, of marriageable age in 1444.[16]

1433 Commission to Bernardo for the Tabernacle of the Sacrament from Abbot Jacopo Niccolini da Firenze for the Abbey of SS. Fiora e Lucilla, Arezzo. Painted in 1434 by Andrea di Giusto da Firenze.[17] The tabernacle is lost.

April 24, 1433 Commission to Bernardo and three other masons from Settignano for the architectural facing of the second story of the facade of the Palazzo della Fraternità, Arezzo.[18] Work to be completed by November 31, 1433. Final payment on July 23, 1434.

June 17, 1433 to November 4, 1433 Payments to "magistro Bernardo architectori" for work for Eugene IV in the Cappella "Magna" or Cappella di S. Niccolò in the Vatican Palace.[19] The document probably does not refer to Bernardo Rossellino, who was occupied elsewhere at this time.

March 21, 1434 First payment to Bernardo for the relief of the Madonna del Manto for the facade of the Palazzo della Fraternità. June 30, 1434, the relief was installed. Final payment on July 16, 1434.

May 27, 1434 First mention of the statues of SS. Gregory and Donatus for the facade of the Palazzo della Fraternità. They had probably been commissioned from Bernardo on April 16, 1434. Completed by June 21, 1435, probably considerably before then.

August 31, 1434 Commission to Bernardo for SS. Lorentinus and Pergentinus for the facade of the Palazzo della Fraternità. To be completed by October 31, 1434.

July 22, 1435 Commission to Bernardo for the brackets and friezes above the cornice of the facade of the Palazzo della Fraternità. August 20, 1435, second, more specific, commission. Work to be completed within a year. August 26, 1436, the fraternity received a final quittance from Bernardo.

From November 1, 1435, Bernardo rented a shop in Florence in the Via del Corso near the palace of Folco Portinari.[20]

February 1, 1436 First mention of Bernardo in the documents of the Badia, Florence,[21]

(App. 3); for the *catasto* of Domenico, Giovanni, Tomaso and Antonio of 1458, see Hartt, Corti, Kennedy, p. 177, doc. 30; for Tomaso's *catasto* of 1469, see Doc. 7 (App. 3); for Tomaso's *catasto* of 1480, see Doc. 9 (App. 3).

[15] Antonio's age is given in two tax declarations. For the *catasto* of Domenico, Giovanni, Tomaso and Antonio of 1458, see Hartt, Corti, Kennedy, p. 177, doc. 30; for Antonio's *catasto* of 1469, see Doc. 5 (App. 3).

[16] ASF, Not. P 99 (Ser Paolo di Ser Simone Paoli, 1442-47), foll. 59v, 61v.

[17] Mario Salmi, "Ricerche intorno alla Badia di SS. Fiora e Lucilla ad Arezzo," *L'arte*, xv, 1912, p. 286; Tysz, *BR*, p. 101, doc. 3.

[18] The documents regarding Bernardo's work on the Palazzo della Fraternità were published by Fabriczy, *JPK*, 1900, pp. 106ff, doc. 1; Alessandro Del Vita,

"Contributi per la storia dell'arte aretina," *Rassegna d'arte*, xiii, 1913, p. 188; Tysz, *BR*, pp. 100f, doc. 2. See Doc. 15 (App. 3).

[19] Anna Maria Corbo, *Artisti e artigiani in Roma al tempo di Martino V e di Eugenio IV*, Rome, 1969, pp. 18f. The first payment was published by Adamo Rossi, "Spogli Vaticani," *Giornale di erudizione artistica*, Perugia, vi, 1877, p. 198. The first two payments were published by Eugène Müntz, *Les arts à la cour des papes pendant le xve et le xvie siècle*, Paris, 1878, i, p. 40 and Tysz, *BR*, p. 101, doc. 4.

[20] See below, n. 21. Bernardo was first recorded there in a document of February 11, 1436, but paid his rent every six months, on May 1 and November 1.

[21] For the documents concerning the work of the Badia and the Chiostro alle Campora and the rent for Bernardo's shop, see Fabriczy, *JPK*, 1900, pp. 108ff, doc. 2; Tysz, *BR*, pp. 102ff, doc. 6; Sanpaolesi, op. cit.,

although he may have been employed there earlier.[22] Small payments for work done by Bernardo or one of his "garzoni," generally spaced one or two weeks apart in 1436, began to abate in spring, 1437. A large settlement on April 6, 1437, was followed by a small additional payment on February 22, 1438. Work involved minor jobs of construction, such as the insertion of doors and windows, for the monastery and the Chiostro degli Aranci of the Badia and the Chiostro alle Campora (near the Porta Romana) which belonged to the Badia. Bernardo was assisted by his brother, Giovanni.

September 22, 1436, to February 3, 1438 Payments to Bernardo for a Tabernacle of the Sacrament for the Badia, Florence.[23] March, April and May 1439, payments to others for the lock, hinges, making and gilding of the *sportello*.[24] Only fragments and the *sportello* by the goldsmith, Agnolo di Niccolò, remain.

1437 *Estimo* filed in Settignano by Matteo Gamberelli.[25] Bernardo, followed by Domenico and Giovanni, and finally, by Tomaso and their father, was evidently the most productive member of the family.

January 1, 1438 Matriculation of Giovanni in the *Arte dei Maestri di Pietra e Legname*.[25a]

September 1, 1441 Matriculation of Tomaso in the *Arte dei Maestri di Pietra e Legname*.[26]

December 30, 1441 Payment to Bernardo by the *Opera* of S. Maria del Fiore, Florence, for portions of jambs. September 12, 1442, commission to Bernardo for 100 *braccia* of the lowest of the parapets of the Duomo. November 4 or 5, 1442, commission to Bernardo for 100 *braccia* of a gallery encircling the drum of the Duomo. March 15, 1443, commission to Bernardo for the cornices to go above the colonettes of the gallery. Payments to Bernardo and brothers and associates from June 8, 1443, to February 11, 1444. Final settlement on January 26, 1445.[27]

January 20, 1443 Bernardo sat on a commission debating the color of the glass of the oculi of the drum and the material of the cupboards of the Sagrestia dei Canonici of the Florentine Duomo.[28]

November 28, 1443 Payment to Bernardo for hewn stones for the new dormitory of S. Miniato al Monte, Florence. Final settlement on December 24, 1443. Bernardo was last recorded in documents concerning the convent in February 1450. Ca. April 1, 1451, payment to Antonio Rossellino for the foundations of the new dormitory as well as for other

R. d'arte, 1942, pp. 164ff; M. Tyszkiewicz, "Appunti d'archivio, il Chiostro degli Aranci della Badia fiorentina," *R. d'arte*, xxvii, 1952, p. 208.

[22] Records predating 1436 are missing from the archive of the Badia.

[23] The first four payments were published by Fabriczy, *JPK*, 1900, p. 109, doc. 2; Tysz, *BR*, pp. 103f, doc. 6; Sanpaolesi, op. cit., *R. d'arte*, 1942, pp. 166ff. The last two payments were first published by Sanpaolesi, *loc. cit.* See Doc. 16 (App. 3).

[24] Ulrich Middeldorf, "Un rame inciso del Quattrocento," *Scritti di storia dell'arte in onore di Mario Salmi*, Rome, 1962, ii, p. 288, n. 49. See Doc. 16 (App. 3).

[25] Doc. 1 (App. 3).

[25a] Doc. 11a (App. 3).

[26] Doc. 12 (App. 3).

[27] Giovanni Poggi, "Bernardo Rossellino e l'Opera del Duomo," *Miscellanea d'arte*, i, 1903, pp. 146f; Fabriczy, "Brunelleschiana, Urkunden und Forschungen zur Biographie des Meisters," *JPK*, xxviii, 1907, Beiheft, pp. 21ff; Tysz, *BR*, pp. 104ff, doc. 7. It is not known whether the documents refer to the gallery below or above the oculi of the drum.

[28] Cesare Guasti, *La cupola di Santa Maria del Fiore*, Florence, 1857, pp. 76f, doc. 202. Partially published by Tysz, *BR*, p. 107, doc. 7.

work of construction.[29] Between late July and early September 1451 Giovanni Rossellino paid Maso di Bartolomeo for work in connection with the steps of a stairway at S. Miniato.[30]

March 9, 1444 Death of Leonardo Bruni. Bernardo's design for his tomb in S. Croce, Florence before December 31, 1451.[31]

August 8, 1444 Request by "Domenico di Matteo intagliatore" for payment from Messer Francesco Castellani for a terracotta figure of St. Anthony of Padua commissioned about two years earlier.[32] This does not necessarily refer to Domenico Rossellino.

June 24, 1446 Commission to Bernardo from the Commune of Siena for the marble framework of the Portal of the Sala del Concistoro, Palazzo Pubblico, Siena, to be completed, exclusive of the figures, by August 15, 1446. The figures were never made and Bernardo received less than the stipulated recompense.[33]

March 30, 1447 Payment to Bernardo for an oculus for the *Udienza* of the Palazzo dell'Arte de' Giudici e Notai.[34]

August 2, 1447 Commission to Bernardo from the Compagnia della SS. Annunziata, Empoli, for the Annunciation for the altar of their oratory in S. Stefano, to be completed within four months. The figures were appraised by Ghiberti.[35] The company still owed Bernardo money in February 1458.[36]

Ca. 1448—after 1461 Palazzo Rucellai, Florence, built for Giovanni Rucellai.[37] Bernardo's contribution to the building, if any, is moot.[38]

February 18 and May 15, 1448 Bernardo's name appeared in the archives of the Florentine Duomo in connection with acquisitions of lumber.[39]

June 20, 1448 Payment to Tomaso for carving two of the seraphim friezes above the capitals of the nave columns in S. Lorenzo, Florence. October 31, 1449, payment to Antonio for two more seraphim friezes.[40]

February 11, 1450, to April 24, 1450 Payments to Bernardo for the Tabernacle of the Sacrament for the chapel of the women's wing of the Hospital of S. Maria Nuova, Flor-

[29] Howard Saalman, "Paolo Uccello at San Miniato," *BM*, cvi, 1964, p. 560, docs. 1, 2, 3.

[30] Charles Yriarte, *Journal d'un sculpteur florentin au xvᵉ siècle, Livre de souvenirs de Maso di Bartolommeo dit Masaccio*, Paris, 1894, p. 69.

[31] See above, text pp. 33f.

[32] Fabriczy, "Kritisches Verzeichnis toskanischer Holz- und Tonstatuen bis zum Beginn des Cinquecento," *JPK*, xxx, 1909, Beiheft, p. 42, no. 147.

[33] Gaetano Milanesi, *Documenti per la storia dell'arte senese*, Siena, 1854, ii, pp. 235f; Tysz, *BR*, pp. 108f, doc. 8. See Doc. 17 (App. 3).

[34] Fabriczy, *JPK*, 1900, p. 100.

[35] The document was incompletely published by Eugène Müntz, *Les Archives des arts, Recueil de documents inédits ou peu connus*, Paris, 1890, pp. 28f; published in its entirety by Odoardo H. Giglioli, *Empoli artistica*, Florence, 1906, pp. 160f and Tysz,

BR, pp. 109f, doc. 9. See Doc. 18 (App. 3).

[36] See Bernardo's *catasto* of 1458 in Hartt, Corti, Kennedy, p. 181.

[37] The dating of the palace derives from a variety of sources, among them the tax declarations of Giovanni Rucellai. See Charles Randall Mack, "The Rucellai Palace: Some New Proposals," *AB*, lvi, 1974, pp. 520ff.

[38] *Ibid.*, pp. 517ff.

[39] Tysz, *BR*. p. 131, doc. 24.

[40] Leandro Ozzòla, "La Basilica di S. Lorenzo in Firenze," *La rassegna nazionale*, Florence, cxxxiii, September 16, 1903, p. 242; idem, "Lavori dei Rossellino e di altri in San Lorenzo a Firenze," *Bollettino d'arte*, series 2, vii, 1927-28, pp. 232f. For the precise information, I am grateful to Professor Isabelle Hyman.

ence. The tabernacle was completed by April 22, 1450. July to November, 1450, payments to Ghiberti for the *sportello*.[41] The tabernacle is presently in S. Egidio, Florence.

1451 *Estimo* filed in Settignano by the heirs of Matteo di Domenico, namely, Domenico, Bernardo, Giovanni and Tomaso Rossellino.[42] Bernardo was married to Mattea, b. 1413 or 1417–18.[43] Giovanni was married to Ginevra di Antonio Simone, called *monacho*,[44] b. 1423, 1427–28 or 1429,[45] d. 1474–80.[46] The four brothers lived in a house in Borgo Allegri near S. Ambrogio.

1451 *Estimo* filed in Settignano by Antonio together with Bernardo's sons, Gilio and Giovanni.[47]

May 1, 1451 Matriculation of Antonio in the *Arte dei Maestri di Pietra e Legname*.[48]

July 12, 1451 Commission to Bernardo from Fra Sebastiano di Jacopo Benintendi for the Tomb of the Beata Villana (d. 1361) in S. Maria Novella, Florence, to be completed by December 31, 1451. January 27, 1452, supplement providing for a tabernacle for the crucifix which was intended to surmount the tomb.[49] The tabernacle was never executed.

August 5, 1451 Bernardo and Pagno di Lapo Portigiani appraised Luca della Robbia's relief of the Ascension and two candelabra-bearing angels now in the Sagrestia dei Canonici, Duomo, Florence.[50]

December 31, 1451 Bernardo was in Rome, although he returned briefly to Florence in January 1452.[51] December 31, 1451, first payment of Bernardo's salary as "ingegniere in palazo" of the Vatican. May to November 1452, payments to Bernardo for one hoisting-machine and an advance payment for another. November 1452 to June 1453, a payment and installments of a loan in return for work of construction in S. Stefano Rotondo, Rome. December 29, 1453, last payment to Bernardo from the Vatican.[52] According to Giannozzo

[41] Giovanni Poggi, "Il ciborio di Bernardo Rossellino nella chiesa di S. Egidio (1449-1450)," *Miscellanea d'arte*, i, 1903, pp. 106f; Tysz, *BR*, p. 110, doc. 10. See Doc. 19 (App. 3).

[42] Doc. 2 (App. 3).

[43] Mattea's age is given here and in two other tax declarations. For Bernardo's *catasto* of 1458, see Hartt, Corti, Kennedy, p. 184, doc. 31. For the *catasto* of the heirs of Bernardo of 1469, see Doc. 4 (App. 3).

[44] Her full name is given in ASF, Not. A 192, foll. 435rff.

[45] Ginevra's age is given here and in two other tax declarations. For the *catasto* of Domenico, Giovanni, Tomaso and Antonio of 1458, see Hartt, Corti, Kennedy, p. 177, doc. 30; for Domenico's and Giovanni's *catasto* of 1469, see Doc. 6 (App. 3).

[46] In ASF, Not. A 192, foll. 435rff she is still alive. She is not mentioned in Domenico's and Giovanni's *catasto* of 1480.

[47] Doc. 3 (App. 3).

[48] Doc. 13 (App. 3). The document of matriculation published by Rufus Graves Mather, "Documents Mostly New Relating to Florentine Painters and

Sculptors of the Fifteenth Century," *AB*, xxx, 1948, p. 37, doc. 4, does not refer to Antonio Rossellino.

[49] The commission was published nearly in its entirety by Richa, iii, pp. 51f. Both documents were published by Fabriczy, *JPK*, 1900, pp. 111ff, doc. 4; Burger, pp. 392f, Excursus 9; Tysz, *BR*, pp. 111ff, doc. 11; Stefano Orlandi, O.P., "Necrologio" di S. Maria Novella, Florence, 1955, ii, pp. 490ff, doc. 69. See Doc. 20 (App. 3).

[50] Allan Marquand, *Luca della Robbia*, Princeton, N.J., 1914, pp. 76, 94; Tysz, *BR*, p. 131, doc. 24.

[51] On January 27, 1452, Bernardo personally signed the contract for the addition to the Tomb of the Beata Villana. Indeed, Bernardo received no salary from the Vatican in January or February 1452.

[52] Rossi, op. cit., *Giornale di erudizione artistica*, 1877, pp. 200ff; E. Müntz, "Documents inédits sur l'architecte florentin Bernardo Rossellino," *La chronique des arts et de la curiosité*, May 5, 1877, pp. 182f; Müntz, *Les arts à la cour des papes*, i, p. 80, n. 5, p. 81, n. 2, p. 142; Tysz, *BR*, p. 116, doc. 15, p. 118, doc. 17.

Manetti's biography of 1455 of Pope Nicholas V (1447–55),[53] Bernardo, as chief architect
of the Pope, was in charge of all the papal building projects inside and outside of Rome.
Within Rome these included, first, the reconstruction of the city walls with the addition
of several towers and a new fortress outside the Castel S. Angelo; secondly, the restoration
and rebuilding of the forty station churches; thirdly, the restoration of the quarter between
the Castel S. Angelo and the Vatican which was to house the Curia and which involved
the construction of three streets leading to St. Peter's lined with loggias; fourthly, the
reconstruction and decoration of the papal palace including the addition of a theatre,
gardens, fountains, chapels, libraries and a separate conclave hall; fifthly, the rebuilding
of St. Peter's. Outside of Rome Bernardo was supposed to have directed the restoration
of S. Benedetto, Gualdo and S. Francesco, Assisi; the construction of several buildings at
Civitavecchia; the construction or reconstruction of a part of the walls at Civitacastellana;
the reconstruction of the baths at Viterbo. According to Vasari, Bernardo also enlarged
the *piazza* and restored the church of S. Francesco at Fabriano. Outside of Bernardo's
work on S. Stefano Rotondo, no documents have yet come to light which corroborate
his contribution to these projects.

February 26, 1453 Antonio, Desiderio da Settignano and Giovanni di Pierone appraised
Buggiano's pulpit in S. Maria Novella, Florence.[54]

December 10, 1455 Death of Orlando de' Medici.[55] Work on his tomb in SS. Annunziata,
Florence, at least in progress, and possibly completed by February 1458.[56]

1456 Antonio inscribed his name and the date on his Bust of Giovanni Chellini, Victoria
and Albert Museum, London.[57]

February 15, 1457 Commission to Bernardo from the *Arte del Calimala* for the marble
steps which lead from the aisles of S. Miniato al Monte, Florence, to the choir. December
1, 1457, work was in progress. Steps not yet finished on December 8, 1467.[58]

February 26, 1457 Bernardo and his brothers petitioned the *Consiglio Maggiore* of Flor-
ence to be exempted from paying the *estimo*, including the one levied prior to the petition
(1455).[59] The petition was granted. In return, the Rossellino brothers were obliged to
make annual contributions of 153 lire to the *Monte Comune*.[60] Thenceforth Bernardo and
his brothers paid the Florentine *catasto*.

[53] Reprinted in part by Müntz, *Les arts à la cour
des papes*, i, pp. 339ff, and Torgil Magnuson, *Studies
in Roman Quattrocento Architecture*, Stockholm,
1958, pp. 351ff, from Lodovico Antonio Muratori,
Rerum italicarum scriptores, Milan, iii, pt. 2, 1734,
coll. 907-960. Vasari (Vas-Mil, iii, pp. 98ff) made use
of it for his account of Bernardo's Roman activity.

[54] Giovanni Poggi, "Andrea di Lazzaro Cavalcanti
e il pulpito di S. Maria Novella," *R. d'arte*, iii, 1905,
pp. 81f; Fabriczy, op. cit., *JPK*, 1907, Beiheft, pp. 12f;
Clarence Kennedy, "Documenti inediti su Desiderio
da Settignano e la sua famiglia," *R. d'arte*, xii, 1930,
pp. 264f, doc. 5.

[55] Doc. 21 (App. 3).

[56] The heirs of Orlando were listed as debtors in
Bernardo's *catasto* of 1458 (Hartt, Corti, Kennedy,
p. 181).

[57] Pope-Hennessy, *V & A Cat.*, i, pp. 124ff.

[58] Fabriczy, *JPK*, 1900, p. 103, n. 2; O. H. Gig-
lioli, "La Cappella del Cardinale di Portogallo nella chiesa
di San Miniato al Monte e le pitture di Alesso Bal-
dovinetti," *R. d'arte*, iv, 1906, p. 96; Vasari, *Le vite de
più eccellenti pittori scultori e architettori*, ed. Karl
Frey, Munich, 1911, p. 324, docs. 47, 50, p. 326, docs.
60, 61; Tysz, *BR*, p. 130, doc. 22.

[59] Doc. 10 (App. 3). In contrast to the *catasto*, paid
by citizens of the city, the *estimo* was the tax im-
posed at irregular intervals on the residents of the
countryside surrounding Florence.

[60] This was a loan which every citizen of Florence
was obliged to make to the government of the city.
The rate of interest, at five percent, was favorable,
but the principal was not always returned.

July 2, 1457 Bernardo, subsequently called "chapo maestro della muraglia . . . e della inschaleje della logia" employed at the Spedale degli Innocenti, Florence. August 30, 1457, large credit to Bernardo from the *Arte di Por Santa Maria* for the steps, plastering the wall, and other work on the exterior portico. Payments continued until 1459.[61]

November 22, 1457 Death of Neri Capponi. September 12, 1488, permission granted Neri's grandsons to install a grating in the Capponi Chapel, S. Spirito, Florence, to make Neri's sarcophagus visible.[62]

February 28, 1458 *Catasto* filed in Florence by Bernardo Rossellino.[63] Bernardo had four children: Gilio, b. 1439–40, Giovanni Battista, b. 1440–41 who later became a Doctor of Law and Lector at the University of Pisa,[64] Franchesca, b. 1447–48 and Girolamo, b. 1454–55. Bernardo and his family still inhabited the house in the parish of S. Ambrogio purchased in 1439. Bernardo's real property indicates increasing prosperity in the 1450's. His list of debtors is filled with members of Florence's most illustrious families: Cosimo de' Medici, Luca Pitti, Carlo Pandolfini, Agnolo Strozzi. Bernardo and his brothers jointly occupied a shop in the parish of S. Margherita or S. Stefano della Badia. It was probably in the Via del Proconsolo and was rented as early as February 1453[65] when Bernardo was in Rome. Bernardo probably retained it until his death.[66]

February 1458 *Catasto* filed in Florence by Domenico, Giovanni, Tomaso and Antonio Rossellino.[67] Giovanni had one son, Jacopo, b. 1449–50. Tomaso was married to Benedetta, b. 1429–30, dead by 1469.[68] They had three children: Matteo, b. 1452–53, who later became a sculptor,[69] Lucherezia, b. 1454–55 and Biliotto, b. 1456–57. The four brothers lived together with their respective families and their mother in a house in Via Fiesolana in the parish of S. Pier Maggiore. They appear considerably less prosperous than their brother.

February 22, 1459 Decision of Pope Pius II (1458–64) to build a church and palace in his native town of Corsignano (Pienza).[70] May 18, 1459, approval of the government of Siena for the construction of a palace and church at Corsignano.[71] Bernardo was probably employed on the project from the spring of 1459. In 1460 the Cathedral and Palazzo

[61] Hartt, Corti, Kennedy, p. 181, n. 2, and more fully, Manuel Cardoso Mendes Atanásio and Giovanni Dallai, "Nuove indagini sullo Spedale degli Innocenti a Firenze," *Commentari*, xvii, 1966, p. 104, docs. 24, 25 and n. 4.

[62] Doc. 22 (App. 3).

[63] Published in full by Hartt, Corti, Kennedy, pp. 177ff, doc. 31 and in part by Giovanni Gaye, *Carteggio inedito d'artisti dei secoli xiv, xv, xvi*, Florence, 1839, i, pp. 188ff, doc. 73; Fabriczy, *JPK*, 1900, pp. 110f, doc. 3; Tysz, *BR*, pp. 97ff, doc. 1; Mather, op. cit., *AB*, 1948, pp. 35f, doc. 1.

[64] Domenico Maria Manni *Osservazioni istoriche sopra i sigilli antichi*, Florence, 1746, xvii, p. 152. See also BNCF, MS 906, Gargano Gargani, *Poligrafo della erudizione toscana*.

[65] In a document of February 26, 1453 (for which, see above n. 54) we read: "Antonio di Mateo . . .

che sta a Proconsolo."

[66] See the payment of May 12, 1464, to Bernardo for the Tomb of the Cardinal of Portugal (Hartt, Corti, Kennedy, p. 145, doc. 9).

[67] Published in full by Hartt, Corti, Kennedy, pp. 174ff, doc. 30, and in part by Mather, op. cit., *AB*, 1948, p. 36, doc. 2.

[68] She was not mentioned in Tomaso's *catasto* of 1469.

[69] BNCF, MS 906, Gargani, *op. cit.*

[70] Aeneas Sylvius Piccolomini, *The Commentaries of Pius II*, trans. F. A. Gragg, Smith College Studies in History, Northampton, Mass., 1936–57, bk. ii, p. 147.

[71] S. Borghesi and L. Banchi, *Nuovi documenti per la storia dell'arte senese*, Siena, 1898, p. 217; G. B. Mannucci, *Pienza: i suoi monumenti e la sua Diocesi*, Montepulciano, 1915, p. 169, n. 1; idem, *Pienza, arte e storia*, n.p., ³1937, p. 86, n. 1; Tysz, *BR*, p. 118, doc. 18.

Piccolomini were under construction.[72] Payments for the work began on December 28, 1460, were largest and most frequent during 1462 and continued almost monthly until August 17, 1463. Bernardo's name, however, does not appear in the Vatican documents until August 21, 1462. The Cathedral was consecrated on August 29, 1462.[73] The well in the *piazza* is inscribed with the date of 1462. September 2 and 23, 1462, purchases of houses on the site of the projected Palazzo del Comune. October 4, 1462, payment to Bernardo's assistant, Puccio di Paolo, for work on the *campanile* and Palazzo del Comune. Payments for the *campanile* and the Palazzo del Comune continued until August 17, 1463.[74] July 19, 1463, the Pope gave the completed Palazzo Piccolomini to his nephews.[75] In the documents Bernardo's name is mentioned in connection with the church, *campanile*, the Palazzo Piccolomini and the Palazzo del Comune. He was probably also responsible for the *piazza*, the Palazzo dei Canonici and the Palazzo Vescovile.

August 27, 1459 Death of Cardinal James of Portugal. June 7, 1460, permit issued for the construction of his tomb and chapel in S. Miniato al Monte, Florence.[76] July 19, 1460 to April 4, 1461, payments at approximately fortnightly intervals to Giovanni Rossellino for architectural members. Final payment on October 15, 1461.[77] December 1, 1461, contract between Antonio Rossellino and Bishop Alvaro for the Cardinal's tomb at a price of 425 florins.[78] December 23, 1461, second contract between Antonio and Bernardo and the Cambini bank for the tomb, to be completed by Christmas 1462 at the same price.[79] A model had been submitted. December 19, 1462, and May 12, 1464, payments to Bernardo totaling 100 florins.[80] February 4, 1466 a jury of artists evaluated Bernardo's share of the tomb.[81] December 24, 1462, to June 20, 1465, payments to Antonio.[82] Final payment making a total of 421 florins on February 8, 1466.[83] September 12, 1466, the Cardinal's body was placed in the tomb.[84] April 15, 1466, to September 9, 1466, payments to Antonio for the throne.[85]

January 22, 1461 Payment to Antonio for a holy water font for the chapel of the Spedale degli Innocenti, Florence.[86]

[72] C. F. Rumohr, *Italienische Forschungen*, Berlin, Stettin, 1827, pt. 2, p. 179. See also Piccolomini, *op. cit.*, bk. iv, p. 336. Flavio Biondo, "Additiones correctionesque, *Italiae illustratae*," *Scritti inediti e rari di Biondo Flavio*, intro. Bartolomeo Nogara, Rome, 1927, p. 236, dated the laying of the foundation stone of the cathedral August 10, 1460, but according to the *Commentaries*, the Pope did not go to Corsignano until September 11.

[73] Piccolomini, *op. cit.*, bk. ix, p. 604.

[74] Rossi, op. cit., *Giornale di erudizione artistica*, 1877, pp. 130-42; Müntz, *Les arts à la cour des papes*, i, pp. 301-4; G. B. Mannucci, "Pio II e Pienza, notizie d'archivio," *Bullettino senese di storia patria*, xxi, 1914, pp. 536ff; Tysz, *BR*, 126ff, doc. 20; Eugenio Casanova, "Un anno della vita privata di Pio II," *Bullettino senese di storia patria*, n.s. ii, 1931, p. 30.

[75] Mannucci, "Il palazzo di Pio II ed i suoi restauri," *Rassegna d'arte senese*, vii, 1911, pp. 26f; *idem*, op. cit., *Bullettino senese di storia patria*, 1914, pp. 535f; *idem*, *Pienza: i suoi monumenti*, pp. 172f; *idem*, *Pienza, arte e storia*, pp. 90ff.

[76] Vasari, *Vite*, ed. Frey, p. 325, doc. 59.

[77] Hartt, Corti, Kennedy, pp. 136ff, docs. 4, 5; M. C.

Mendes Atanásio, *A Capela do Cardeal de Portugal em Florença a luz de novos documentos*, Milan, 1961, pp. 20ff, doc. 19, pp. 25f, doc. 23.

[78] Manni, *op. cit.*, xvii, pp. 151f. The pertinent passage is quoted in Giovanni Lami, *Sanctae Ecclesiae Florentinae Monumenta*, Florence, 1758, i, p. 583, and reprinted in part in Hartt, Corti, Kennedy, pp. 134f, doc. 3.

[79] Hartt, Corti, Kennedy, p. 141, doc. 6; Mendes, *op. cit.*, pp. 23f, doc. 21.

[80] Hartt, Corti, Kennedy, pp. 144f, docs. 8, 9; Mendes, *op. cit.*, p. 34, doc. 32, p. 37, doc. 36.

[81] Hartt, Corti, Kennedy, pp. 150, doc. 13; Mendes, *op. cit.*, pp. 46f, doc. 46.

[82] Hartt, Corti, Kennedy, pp. 143ff, docs. 7, 8, 9, 10; Mendes, *op. cit.*, pp. 32ff, docs. 28, 30, 31, 32, 36, 40.

[83] Hartt, Corti, Kennedy, p. 150, doc. 13; Mendes, *op. cit.*, p. 47, doc. 46.

[84] Hartt, Corti, Kennedy, pp. 55f.

[85] *Ibid.*, pp. 152ff, docs. 14, 15; Mendes, *op. cit.*, pp. 50ff, docs. 48, 50.

[86] Mendes Atanásio and Dallai, op. cit., *Commentari*, 1966, pp. 104f, doc. 26.

February 20, 1461 Bernardo, absent—presumably in Pienza[87]—was elected *capomaestro* of the Florentine Duomo, succeeding Antonio Manetti (d. November 8, 1460).[88] April 9, 1461, Bernardo witnessed the commission to Giovanni di Bartolommeo to clean and assemble the bronze doors made by Luca della Robbia for the Sagrestia delle Messe.[89] Work progressed on the lantern which was consecrated on April 23, 1467. The external exedrae may have been completed during Bernardo's tenure. Payment of Bernardo's salary recorded from November 1, 1461, to June 30, 1462.[90] November 23, 1463, Bernardo had appraised Agostino di Duccio's colossal statue of Hercules intended for a buttress of a tribune of the Duomo. August 18, 1464, probably because of grave illness, Bernardo was absent when Agostino di Duccio received the commission for the second colossal statue.[91] The statue was not executed.

July 20, 1461 Payment to Bernardo and his associate for stone cannonballs for the papal cannons.[92]

January 23, 1462, to April 4, 1462 Payments to Bernardo for procurement of marble and porphyry for the pavement and pilasters of the Chapel of the SS. Annunziata commissioned by Piero de' Medici in SS. Annunziata, Florence, and of marble for the inscription commemorating the consecration of the tabernacle of the SS. Annunziata. November 6, 1462, *Opera del Duomo* paid for marble taken by Bernardo in order to make two portals for the chapel.[93] Bernardo approved friezes made by Giovanni di Bartolo for the chapel.[94]

February 4, 1462 Death of Giovanni Chellini. The commission for his tomb in S. Domenico, S. Miniato al Tedesco preceded his death. The tomb was completed afterward.[95]

April 20, 1462 Commission to Bernardo from the consuls of S. Jacopo, Pistoia, for the Tomb of Filippo Lazzari (d. 1412) in S. Domenico, Pistoia, for which a design had already been submitted.[96] Construction of the tomb had been ordered by Filippo's father, Sinibaldo di Doffo, in a testament of April 5, 1447.[97] Execution of it did not begin before Bernardo's death. October 29, 1464, second contract in which the tomb was reallocated to Giovanni

[87] A document of December 14, 1461, states that prior to his election Bernardo was sent to Corsignano to give advice on certain stones. Document published by Fabriczy, *JPK*, 1900, p. 104, n. 2; G. B. Mannucci, "Il Rossellino architetto di Pienza?" *Rassegna d'arte senese*, iii, 1907, p. 18; *idem*, op. cit., *Rassegna d'arte senese*, 1911, p. 27; *idem*, *Pienza: i suoi monumenti*, p. 160; *idem*, *Pienza, arte e storia*, p. 68; Tysz, *BR*, p. 132, doc. 24.

[88] Fabriczy, "Mitteilungen über neue Forschungen," *Rep. f. Kstw.*, xxvii, 1904, p. 286; Tysz, *BR*, pp. 131f, doc. 24. Bernardo's confirmations as *capomaestro* by the *Arte della Lana* on August 26, 1462, and August 16, 1463, were published by Guasti, op. cit., pp. 103f, docs. 301, 302; Tysz, *BR*, pp. 132f, doc. 24.

[89] Maud Cruttwell, *Luca and Andrea della Robbia and their Successors*, London, 1902, pp. 297f, doc. 12; Marquand, op. cit., pp. 198f, doc. 9.

[90] Tysz, *BR*, pp. 132f, doc. 24.

[91] Both documents were published in part by Gaye, op. cit., ii, pp. 466f, and in full by Karl Frey, "Studien zu Michelagniolo Buonarroti und zur Kunst seiner Zeit," *JPK*, xxx, 1909, Beiheft, p. 105; Giovanni Poggi, *Il Duomo di Firenze*, Berlin, 1909, pp. 81f,

[92] Müntz, op. cit., *La chronique des arts*, May 26, 1877, p. 205; *idem*, *Les arts à la cour des papes*, i, pp. 232f, n. 4.

[93] Pellegrino Tonini, *Il Santuario della Santissima Annunziata di Firenze*, Florence, 1876, p. 297, doc. 54; Fabriczy, "Mitteilungen über neue Forschungen," *Rep. f. Kstw.*, xxv, 1902, pp. 475ff; Tysz, *BR*, p. 130, doc. 23. The inscription was executed on April 24, 1462, by Francesco di Meo Bitochi (Kennedy, *R. d'arte*, 1933, pp. 124f).

[94] Tyszkiewicz, op. cit., *R. d'arte*, 1952, p. 209.

[95] See above, text p. 75.

[96] Gaetano Milanesi, *Nuovi documenti per la storia dell'arte toscana dal xii al xv secolo*, Florence, 1901, pp. 112ff, doc. 133; Tysz, *BR*, pp. 113ff, doc. 12.

[97] Stefano Orlandi, O. P., *Il Beato Lorenzo da Ripafratta, campione della riforma domenicana del secolo xv*, Florence, 1956, pp. 8off, doc. 9. For the expenditure of part of the money bequeathed by Sinibaldo on the construction of the new choir of S. Domenico and the controversy it aroused, see *ibid.*, pp. 83ff, doc. 12, 90f, doc. 18.

docs. 440, 441.

and Antonio Rossellino.[98] January 13, 1465, to April 13, 1467, payments to Giovanni and Antonio. July 1467, the tomb was installed. June 29, 1468, the tomb was appraised by Matteo Civitali and a quittance was given by Giovanni and Antonio.[99]

June 1, 1462 Request by Bernardo, on behalf of Giovanni and Pagno di Lapo Portigiani, for the final payment for the tabernacle of the baptismal font in the Duomo, Massa Marittima, from the *Opera del Duomo*. The tabernacle had been executed in 1447 by Giovanni and Pagno or either one of them at the behest of Ser Tommaso di Piero Cerboni.[100]

May 4, 1463 Reimbursement for expenses incurred by Bernardo's visit from Pienza to Perugia to advise on the *campanile* of the monastery of S. Pietro. The design for the new tower was delivered by May 21, 1463. Bernardo was assisted by Puccio di Paolo. The tower was completed in 1468.[101]

June 1, 1463 Letter from the *Signoria* of Siena to Caterina Piccolomini in which Bernardo was cited as arbiter in regard to a debt incurred by Caterina during the construction of her palace (Palazzo Piccolomini or delle Papesse) at Siena.[102]

September 1464 Bernardo died after a long illness. September 23 or 24, 1464, buried in S. Pier Maggiore, Florence.[103]

August 26, 1469 *Catasto* filed in Florence by Bernardo's heirs, namely, his wife, Mattea and his sons, Giovanni Battista and Girolamo.[104] Bernardo had left a very large estate including a bequest for the construction of a chapel in S. Maria at Settignano which was not yet built.

1469 *Catasto* filed in Florence by Antonio Rossellino.[105] Antonio was married to Lisabetta, b. 1441. They had three daughters: Margherita, b. 1465, Chasandra, b. 1467 and Bartolomea, b. 1468. Lisabetta was seven months pregnant. The family house in Via Fiesolana was now divided between Antonio and Giovanni. Antonio rented a shop, which he no longer shared with his brothers, opposite the Proconsolo.

1469 *Catasto* filed in Florence by Domenico and Giovanni Rossellino.[106] Their shop in Piazza S. Firenze had been sold.

1469 *Catasto* filed in Florence by Tomaso Rossellino.[107] In addition to the children mentioned in the *catasto* of 1458, there was a daughter, Benedetta, b. 1457. Tomaso resided in a quarter of a house in Gamberaia, the rest of which was owned by Antonio, Giovanni and Domenico, and he worked a quarry. He was frequently at Rome. A controversy of unknown nature involving him was adjudicated there in 1469 in favor of his adversary.[108]

[98] Milanesi, *Nuovi documenti per la storia dell'arte toscana*, pp. 115ff, doc. 135.

[99] Peleo Bacci, "Una celebre opera d'arte fiorentina," *Il messaggero toscano*, Pisa, December 27, 1916, n.p., reprinted in *Il popolo pistoiese*, Pistoia, January 6, 1917, n.p.

[100] Doc. 14 (App. 3).

[101] Mario Montanari, "E di Bernardo Rossellino il progetto del campanile di S. Pietro in Perugia," *Bollettino della deputazione di storia patria per l'Umbria*, lviii, 1961, p. 114.

[102] Gaye, *op. cit.*, i, pp. 197f, doc. 81; Milanesi, *Documenti per la storia dell'arte senese*, ii, pp. 323f,

doc. 226; Mannucci, op. cit., *Rassegna d'arte senese*, 1907, p. 17; *idem*, *Pienza, arte e storia*, p. 67; Tysz, *BR*, pp. 129f, doc. 21.

[103] Fabriczy, *JPK*, 1900, p. 106, n. 1; Tysz, *BR*, p. 133, doc. 25; Mather, op. cit., *AB*, 1948, p. 37, doc. 5.

[104] Doc. 4 (App. 3). Gilio was not dead, as his omission from the *catasto* implies. See ASF, Not. A 193 (Ser Francesco Albini, 1476-96) fol. 194v.

[105] Doc. 5 (App. 3) partially published by Mather, op. cit., *AB*, 1948, p. 37, doc. 3.

[106] Doc. 6 (App. 3). [107] Doc. 7 (App. 3).

[108] ASF, Not. G 617 (Simone Grazzini, 1473-75), fol. 49v.

1471 Antonio inscribed his name and the date on his Bust of Matteo Palmieri, Bargello, Florence.[109]

June 8, 1473 Antonio appraised Matteo Civitali's Tomb of Pietro Noceto in the Duomo, Lucca.[110]

August 23, 1473 Appraisal by Verrocchio and Pasquino da Montepulciano of the interior pulpit of the Duomo, Prato, by Antonio and Mino da Fiesole and payment to Antonio for his reliefs of the Stoning of St. Stephen, the Funeral of St. Stephen and the Assumption of the Virgin.[111]

June 15, 1474 Testament of Giovanni Rossellino.[112]

February 12, 1475, to October 12, 1475 Payments to Antonio for part of the Tomb of Bishop Lorenzo Roverella in S. Giorgio, Ferrara.[113] The tomb is inscribed with the name of Ambrogio da Milano and the date of 1475.

May 6, 1476 Commission to Antonio from the *Opera del Duomo*, Florence, to finish the marble giant intended for a buttress of a tribune of the cathedral that had been commissioned from Agostino di Duccio in 1464.[114] The statue was not executed. Commission given to Michelangelo in 1501 and stone designated for this purpose used for his David.

1477 Payment to Antonio for the striding S. Giovannino for the lunette over the door of the Palazzo dell'Opera di S. Giovanni, Florence.[115] The statue is presently in the Bargello, Florence.

1478 Antonio paid the annual tax of the *Arte dei Maestri di Pietra e Legname* for the last time.[116] He probably died soon after.

1480 *Catasto* filed in Florence by Domenico and Giovanni Rossellino.[117] Giovanni had a second wife, Caterina di Giovanni Bottari,[118] b. 1435, whom he had married after 1474. He no longer shared his house in Via Fiesolana with Antonio, who was probably dead. Domenico was no longer a stonemason and both brothers devoted some time to farming. No mention was made of a shop.

1480 *Catasto* filed in Florence by Tomaso Rossellino.[119] There were three additional daughters, Marietta, b. 1469, Susanna, b. 1476 and Dianora, b. 1477. Tomaso's finances were in a pitiable state.

July 18, 1481 Request for restitution of 50 florins by Antonio Piccolomini from the heirs of Antonio Rossellino for the work on the tomb of Piccolomini's wife, Maria of

[109] U. Rossi and I. B. Supino, *Catalogo del R. Museo Nazionale di Firenze*, Rome, 1898, p. 411, no. 160.

[110] Michele Ridolfi, *Scritti d'arte e d'antichità*, Florence, 1879, pp. 134f.

[111] Ferdinando Baldanzi, *Della chiesa Cattedrale di Prato, descrizione corredata di notizie storiche*, Prato, 1846, pp. 95f, n. 1; O. H. Giglioli, *A Prato, impressioni d'arte*, Florence, 1902, pp. 29f.

[112] ASF, Not. A 192, foll. 435r-436v.

[113] Fabriczy, "Documenti su due opere di Antonio Rossellino," *R. d'arte*, v, 1907, pp. 165f; *idem*, "Ambrogio di Antonio da Milano," *Rep. f. Kstw.*, xxx, 1907, pp. 251f, n. 3.

[114] Poggi, *Duomo*, p. 83, docs. 446, 447.

[115] Vasari, *Vite*, ed. Frey, p. 385, doc. 50; Vas-Mil, ii, p. 433, n. 1.

[116] *Ibid.*, iii, p. 97, n. 1.

[117] Doc. 8 (App. 3).

[118] Her full name is given in ASF, Not. A 193, fol. 283.

[119] Doc. 9 (App. 3).

Aragon (d. 1470) in S. Anna dei Lombardi, Naples, left incomplete by the sculptor's death.[120] The tomb was completed by Benedetto da Maiano.

July 19, 1483 Bequests of Domenico and Giovanni to one another.[121]

1493 Giovanni paid the annual tax of the *Arte dei Maestri di Pietra e Legname* for the last time.[122] He probably died soon after.

[120] Fabriczy, op. cit., *R. d'arte*, 1907, pp. 162ff.

[121] ASF, Not. A 193, foll. 194v, 196v.

[122] ASF, *Arte dei Maestri di Pietra e Legname*, 4, *Registro intitolato: Campione di debitori e creditori per cause di matricoli, 1465-1534*, p. 94v.

ADDENDUM

Unfortunately, the doctoral dissertation of Charles Randall Mack, *Studies in the Architectural Career of Bernardo di Matteo Ghamberelli called Rossellino*, Ph.D. Dissertation, University of North Carolina, Chapel Hill, N. C., 1972, came to my attention too late for its contents to be incorporated into the chronology of the lives of the Rossellino brothers. Mack transcribes some hitherto unpublished documents relating to Bernardo Rossellino and his relatives. They are:

1. *Catasto del contado* of Matteo di Domenico del Borra, 1427 (Section I, p. 380, doc. 1).
2. *Catasto del contado* of Jacopo di Domenico del Borra, 1427 (Section I, p. 381, doc. 2).
3. *Catasto del contado* of Matteo di Domenico del Borra, 1429 (Section I, p. 382, doc. 5).
4. *Catasto del contado* of Jacopo di Domenico del Borra, 1429 (Section I, p. 382, doc. 6).
5. Some documents relating to Bernardo Rossellino's work for Nicholas V (Section IV, pp. 390–395).
6. Some documents relating to the purchase of sites and construction of buildings at Pienza (Section V, pp. 396–414).

Documents

1. *Estimo* of Matteo di Domenico 1437
2. *Estimo* of the Heirs of Matteo di Domenico 1451
3. *Estimo* of Antonio Rossellino 1451
4. *Catasto* of the Heirs of Bernardo Rossellino 1469
5. *Catasto* of Antonio Rossellino 1469
6. *Catasto* of Domenico and Giovanni Rossellino 1469
7. *Catasto* of Tomaso Rossellino 1469
8. *Catasto* of Domenico and Giovanni Rossellino 1480
9. *Catasto* of Tomaso Rossellino 1480
10. Petition by the Rossellino Brothers to be exempted from paying the *Estimo* 1457
11. Matriculation of Jacopo di Domenico and Matteo di Domenico in the *Arte dei Maestri di Pietra e Legname* 1399
11a. Matriculation of Giovanni Rossellino in the *Arte dei Maestri di Pietra e Legname* 1438
12. Matriculation of Tomaso Rossellino in the *Arte dei Maestri di Pietra e Legname* 1441
13. Matriculation of Antonio Rossellino in the *Arte dei Maestri di Pietra e Legname* 1451
14. Bernardo Rossellino, on behalf of Pagno di Lapo Portigiani and Giovanni Rossellino, requests payment for the Tabernacle of the Baptismal Font in the Duomo, Massa Marittima 1462
15. The Sculpture of the Facade of the Palazzo della Fraternità, Arezzo 1433–36
16. The Tabernacle of the Sacrament in the Badia, Florence 1436–39
17. The Portal of the Sala del Concistoro in the Palazzo Pubblico, Siena 1446
18. The Annunciation in the Museum of the Collegiata, Empoli 1447
19. The Tabernacle of the Sacrament in S. Egidio (S. Maria Nuova), Hospital of S. Maria Nuova, Florence 1450
20. The Tomb of the Beata Villana in S. Maria Novella, Florence 1451–52
21. Testament of Orlando de' Medici 1455
22. Permission to install an arch in the Capponi Chapel, S. Spirito, Florence 1488

DOC. 1. *Estimo* of Matteo di Domenico 1437

ASF, Archivio del Catasto, Filza 601, S. Giovanni, 1437, fol. 411v

<div align="center">

Piviere di Ripoli
Popolo di Santa maria a settignano

</div>

Matteo. didomenicho. detto. Borta. (*sic*)

Perlo. valsente. lira una soldi otto danari undicj lira 1ª soldi 8 danari	11
Perla. testa. sua soldi due denari ... soldi	2
Perla. testa. didomenicho. suo. figluolo soldi tre .. soldi	3
Perla. testa. di Bernardo. suo figluolo soldi quatro soldi	4
Perla. testa. di Giovannj suo. figluolo soldi tre ... soldi	3
Perla. testa. di tomaso suo figluolo soldi due ... soldi	2
.......... lire 2 soldi 2 danari 11	

DOC. 2. *Estimo* of the Heirs of Matteo di Domenico 1451

ASF, Archivio del Catasto, Filza 767, S. Giovanni, no. 216–273, 1451, foll. 517r–517v (no. 258)

<div align="center">

Quartiere di Santo Giovanni
Piviere di Ripoli
Popolo diSanta Maria diSettingnano
Podesteria delGhaluzo

</div>

Rede di matteo di domenicho in detto popolo anno destimo in detto popolo lire 2 soldi 5 sotto nome dimatteo di domenicho di poj e morto

Una casa per mio abitare chonunpezoditerra Lavoratia e vignata di staiora 3 incircha posta in detto popolo che daprimo via secondo antonio di Barto 3º ilradda sensale 4º ibenj della badia di Santo Salvj. di stima di fiorini 30 Rende

Grano	staia 6
Vino	barili 6
Olio orcio	orcio 1º

Unpezo di boschetto posto nelpopolo diSanto Lorenzo avincigliata che deprimo alesandro deglialesandrj secondo Simone Zatj 3º Lavia di stima di fiorini 10 non mj Rende nulla perche pastura e sodo

Una quarta chasa posta nelpopolo diSanto piero magiore di firenze chonfina deprimo via secondo bartolomeo di Lorenzo 3º giovannj dameleto o nne di pigione fiorini 2 dacharllo setauolo aminuto di stima di fiorini 20

E ci su uno incharicho duno rinovale overo uficio di lire 6 lanno ilquale cifulasciato per testamento dallo quale nabiamo carta e none faciendo detto uficio overo rinovale detta ¼ chasa richaderebbe a Santa maria nuova.

Una chasa per nostro abitare postanelpopolo diSanto Ambruogio di firenze nella via di borgho alegrj che daprimo via secondo giovannj di pierone 3° giuliano righatiere di stima di fiorini 30

<div align="center">Bocche</div>

domenicho dimatteo deta dannj	46
Bernardo di matteo deta dannj	44
Giovannj dimatteo a annj	38
tomaso dimatteo annj	34
Monna mea donna fu dimatteo dannj	62
Monna mattea donna diBernardo annj	38
Monna ginevra donna digiovannj annj	28

DOC. 3. *Estimo* of Antonio Rossellino 1451

ASF, Archivio del Catasto, Filza 692, S. Spirito Drago, 1451, fol. 494r, and Filza 694, S. Spirito Drago, 1451, fol. 391r.

255 Quartiere di S° Spirito Gonfalone Drago Drago
Antonio dimatteo didomenicho

Gilio ⎫ dibernardo dimatteo
E Giovannj ⎬ suoj nipotj
 ⎭

Anno di decima soldi 2. neldrago. S°. Spirito
Nonne ebono catasto

Trvovansj gli infra scrittj Benj unopezo diterra nella corte dicastello Santo Giovannj di Valdarno asene difitto staia. 20. di grano cioe staia ventj lavoralo antonio di Bartolo tassj confinj da primo pipo dipiero porinj dasechondo antonio Bilacj daterzo macione per soldi 15. lo staio. lire 15 fiorini 3 soldi 15
(*in the left margin*: El detta terra viene dauna loro avolo laquale non sitrova a gravezza veruna)
(*in the right margin*: Va al 69 chiavi a rede di bernardo ghanberellj in margine per rendita di fiorini 3 . 15)

Iqualj Benj ebono damona antonia di matteo diciennj loro avola
(*in the left margin*: nulla)

Questi Benj sono stati ala graveza di figuolj didetta mona antonia equalj sono mortj E perche el(l)a nona graveza nonsa dove siano stati portatj fiorini

E aestimo

Soma fiorini 3 soldi 15 aoro Abattj soldi 3 danari 9 aoro
Resto fiorini 3 soldi 11 danari 3 aoro
Tochalj a soldi 4 . per lire fiorini soldi 14 soldi (*sic*: danari) 3 aoro
(*at the back of the folio sheet*: Recho bernardo di matteo)

DOC. 4. *Catasto* of the Heirs of Bernardo Rossellino 1469

ASF, Archivio del Catasto, Filza 928, S. Giovanni Chiavi, 1470, foll. 1235r–1236v and
Copia del Monte, Filza 100, S. Giovanni Chiavi, 1469, letters I–Z, foll. 1251r–1252v

Quartiere Sto. Giovanni Gonfalone Chiavj

Per Heredj diBernardo dimatteo didomenicho ganbereglj quartiere Santo Giovanni gonfalone
chiavj. MCCCCXXVII. niente peconsiglj MCCCCLIII fu rimesso detto Bernardo nostro
padre a conservadore delle leggi et alla dichiaratione fu dichiarato avessi divalsente soldi
14 in nome didetto Bernardo et frateglj nel quartiere di Santo Spirito et nel gonfalone del
drago. Nel MCCCCLVII nel gonfalone delle chiavj ebbe di catasto soldi 8.
Ebbeano diventina 1468 soldi. 14 in nome di Giovannj batista diBernardo. dimatteo gan-
bereglj et frateglj.
(*in the left margin*: Vedemo laprovisione in publicha forma per mano di Ser Giovanni
da tia choimtore di messer Lione notaio allo riformagionj sotto di 28 di febraio 1456.
eperosi puo mettere agraveza perche furo fatti abilj adetta graveza chome apare abanno
perdetta riformagione)

Sustanze

Una casa per nostro habitare con nostra famiglia e masseritia posta nel popolo di San
anbruogio gonfalone chiavj daprimo via di borgo allegrj a ij Giuliano di sendj rigattiere
aiij lorenzo degli obriachj aiiij nicholo di giovannj chalzaiuolo venne da Ser anbruogo
angenj inbernardo detto diSeptembre 1439. Rogato Ser pagolo di Ser Simone pagoli per
fiorini 108½ dalla per alienata al 69 bue n. 46 francesco di Ser anbruogio angienj
fiorini .
(*in the left margin*: Viene dal 27. dambrogio Ser anbruoge dagnolo in Gonfalone chiavj
237 per loro uso)
(*in the right margin*: data al 80 chiavj 259 a chonto di messer giovannibatista suo filuolo
per abitare)

Piu pezi diterra conperati dapiu personi posti aSangiovannj divaldarno disopra luogho
detto aqua viva chon vingne et altrj fruttj
(*in the left margin*: Vadj la lapostilla dove e larendita)

1° pezo diterra sebbe per parte di dota di mona mattea nostra madre ebbe Bernardo detto
damona mattea detta per fiorini 42½ posto in aqua viva detta. Cuj aprimo pippo di piero
porrj ij goro di donato didetto luogo iij lapieve di Sangiovannij iiij heredj dantonio bellaccj

1° pezo dafinuccio dimariano di detto luogho di staiora 2 in detto luogo per fiorini 10
daprimo fossato ij mariotto di cristofano dipintore furogato Ser angniolo daterra nuova
addj 26 digennaio 1448

1° pezo di terra di staiora dua dimariotto detto indetto luogho per fiorini 10 daprimo
mariotto detto aij fossato iij finuccio detto rogato Ser Jacopo del maestro thomasino addj
26. digennaio 1448

1° pezo di terra posto indetto luogo di staiora 6. per fiorini 28 dagiovannj di grazia didetto
luogho rogato Ser nicholo da prato addj 16 dottobre 1453 aprimo Begnj di Simone ij
Bernardo detto comperatorj

1° pezo diterra di staiora 3. dabegnj detto per fiorini 10 Rogato Ser nicholo detto addj 16 dottobre 1453 aprimo Bernardo detto ij angniolo puccereglj aiij michele Lapinj

1° pezo di terra posto in detto luogo daLorenzo Bussi di staiora 4 per fiorini 22½ rogato Ser nicholo detto addj 30 dinovembre 1453, daprimo fossato aij guccio di lionardo Borsj aiij charlo di Serpagolo puccinj
(*in the right margin*: Va alla)

1° pezo di terra dapippo dipiero porri indetto luogho di staiora 4 per fiorini 26 rogato Ser Bartolomeo mangierj addj 22 diSeptembris MCCCCLV daprimo et ij detto Bernardo compera- tore aiij heredj antonio bellaccj

1° pezo diterra in detto luogho daqua viva dapiero dandrea chanbj didetto luogho di staiora 3½ per fiorini 20¾ rogato Ser Bartolomeo detto daprimo Bernardo detto aij et iij Barto- luccio da castelfrancho

1° pezo di terra in detta aqua viva dagoro di donato di staiora 4 per fiorini 23½ rogato detto Ser Bartholomeo addj 18 didicembre 1455 primo et ij detto Bernardo da iij Lorenzo di toto

1° pezo di terra indetto luogho daLorenzo ditoto chalzolaij didetto luogho di staiora 6 in circha per fiorini 50 rogato Ser angniolo daterra nuova primo Bernardo comperatore ij Bartoluccio da chastelfrancho aiij pichierino

fiorini

(*in the left margin*: Viene il primo pezzo di questa iscritta dal 51 da antonio di matteo didomenicho e altrj dragho Santo Spirito n.° 255 per rendita di fiorini iij soldi xv.
E tutti glialtrj pezzi adrieto
Vengono dal 58 di bernardo di matteo Ghanbereglj
chiavj n° 663. per rendita di fiorini 19 . 0 . 0)

1° pezo diterra daLorenzo detto efrategli Rogato Ser angniolo daterra nuova per fiorini 17 staiora cinque e mezo nonobstante che dicha staiora 8. luogo detto Bruschosa aprimo fossato ij redj di antonio bellaccj iij pipo dichanbio

Lavora dette terre parte lippo di nina dantonio dilippo efrateglj didetto luogo et partj santi di piero montonj et evvj su uno bue di fiorini 8 evvj di presta fiorini cinque none chasa evvj su una cappanna datenere paglio Rendono lanno in parte
Grano staia 4°
Vina danguillarj barili 10
Biade dipiuragionj staia 16 et sagina miglio et panicho
pesegli in parte staia uno
fagiuolj staia 2
nocj staia 3 . fiorini 271 . 8 . 7

1ª vigna achastel Sangiovannj detto luogo detto fossato alla villa di staiora 7 in circha venne dagiovanni di minozo vochato Bargiglia didetto luogo per fiorini 25 non obstante lacarte dicha 35. Carte Ser bartholomeo mangierj addj 14 didicembre 1450 confinj primo fossato lj Benedetto dibaldo iij michele dilotto Barbiere didetto luogho rende lanno Barili 12 inparte
fiorini 114 . 5 . 9

(*in the left margin*: Viene del 27 di puccino di Ser andrea chiavj 143. per rendita di fiorini 8)

(*in the right margin*: Allo 80. chome di sopra per rendita di fiorini 8)

1° chasa per nostro habitare posta in chastelsangiovannj divaldarno di sopra luogo detto lastradella in sulla via del Rosso della quale parte cene vende soldo dantonio dandrea delsoldato per fiorini 23 et parte cene vende francescho dimariotto dipintore per fiorini 40 rogato Ser nichalio didienj notaio dellopera addj 19 digennaio 1462 confinj primo e ij et iij via e 4° detto francescho vienne prima parte dal 69 del Santo Spirito c 1253 da Soldo dantonio delsoldato fiorini

(*record of this sale is found in Notarile N 120* [Nicholaio di Dieni, 1460–65], *fol. 151v under the date of June 19, 1462*)

(*in the left margin*: Viene dal 58 di bernardo di matteo ghanberegli chiavj n° 663 per loro uso)

(*in the right margin*: Allo. 80. chome di sopra per loro uso)

1° poderetto posto nella corte di castel Sangiovannj luogho detto alfosatello compiu pezi diterra. Lavorativj et vigniatj chon una chasetta dallavoratore con suo vochaboIj et chonfinj conperossj daLorenzo. ditoto efrateglj calzolaj dicastel Sangiovannj funne rogato Ser michele dandrea dacarmignano addj 15 daprile 1458

(*in the left margin*: Danonsoportanti per chosto di fiorini 248 chome apare albiro suo rize . 1 . 9 di detto Bernardo Ghabereglj perche nonsene potete avere fede e a sette per cento rendono fiorini 17 . 7 . 3)

(*in the right margin*: dato al 80 chiavj 259 amesser giovanbattista detto per rendita di fiorini 26 . 10 . 1 interchiuso)

1° pezo diterra dabartholo di Simone calzolaio dachastel francho posta in aqua viva confinj primo et ij et iij detto Bernardo comperatore Rogato Ser antonio dalbucine

(*in the left margin*: Danonsoportanti et avemo fede dachontanti chome ne furo dato Ser pierfrancesco di Ser antonio dalbucine B 110 . 38 per fiorini 47 che a 7 per cento rendono fiorini 3 . 5 . 10)

(*in the right margin*: 1° podere per rendita di fiorini 19 . 8 . 7 fa tuta larendita di fiorini 45 . 18 . 8)

1° pezo diterra danicholo didomenicho di nina da chastel Sangiovannj posta in detto luogho rogato Ser angniolo diauto daterra nuova confinj primo pieve diSangiovannj aii e iij Bernardo detto

(*in the left margin*: Danonsoportanti per chosto di fiorini 17 apare alibro didetto Bernardo pagine 10 che a 7 per cento rendono fiorini 1 . ? . 10)

1° pezuolo diterra dapiero chanbj di detto luogho per fiorini 12 rogato Ser giovanni dimichele dilotto confinj primo pieve di Sangiovannj ii et iij via

1° pezo diterra parte vigniata dagniolo dilucha di Ser angniolo didetto luogho posta in aqua viva comperossi fradua volte rogato Ser giovannj dimichele addj 9 dicembre 1463. confinj angniolo detto aij giovannj dibartholomeo dalanasa aiij pipo di cambio

(*in the left margin*: Danonsoportanti per chosto di fiorini xxxiiii$\frac{1}{11}$ in 2 chonpera fede dachotanti b. 114 54 b. 112 10 per Ser Giovanni di michele di Lotto che a 7 per cento rendono fiorini 2 . 8 . 4)

1° pezo di terra di staiora 3 parte dafanetto dantonio fanettj e parte dabartolo fanettj prezio di fiorini 22 rogato Ser giovanni detto
(*in the left margin*: Danonsoportanti per chosto di fiorini 22 che di parte se nebbe fede da chontanti b. 115 4 che a 7 per cento rendono fiorini 1 . 10 . 10)

1° pezuolo diterra dafigliuolj dagnolo puccereglj didetto luogho di staiora 2 per fiorini 10 posto indetto luogho funne rogato Ser Giovannj dandrea di Ser Lacho primo via nuova ij fossato iij Giovannj lucuccj
(*in the left margin*: Chon fede per Ser Giovanni di piero dandrea sotto dj 15 dinovembre 1466 per fiorini x che rende fiorini soldi 14 . o)

Lequalj (terre) sono unite chondetto poderetto lavorate matteo Lucha et santj di piero montonj et anno uno paio dibuoj di fiorini 14 anno dipresta fiorini cinque et anno una asina rendono inparte fiorini 378 10
(*in the left margin*: .

fiorini 53 . 10 . 1)

764 . 4 . 4

Rendono inparte

Grano staia 48
Vino inparte barilj 15 }
Biade dipiuragioni staia 15 } panicho et miglio
fave staia dua 2
pesegli staio uno 1°

. fiorini

(*in the left margin*: Non si va fuorj questa redita che e tutta nella faccia dirimpetto 111)
(*in the right margin*: Va alla)

Uno pezuolo di sodo posto nel popolo diSanta Maria a omtingniano luogho detto pezalungha di staiora 1° et uno terzo in circha confinj antonio Maghalottj ii heredj dibastiano didolpho daSeptignano rogato Ser francesco daprato vechio

Una altro pezo disodo chon alcunj quercuolj posto aGhanberaia confini dadua latj via dicomune aiij Maestro francesco aiiij giovannj dibisognio rende lanno lire 2 dilegnia fiorini 13
(*in the left margin*: Danonsoportanti per chosto di fiorini xiii fede per Ser francesco di Ser Jacopo . dapratovechio. sotto di 26 dimagio. 1466. che a 7 per cento rendono fiorini 18 . 3)
(*in the right margin*: Allo 80. chiavj 259 a chonto di messer Giovanbattista suo figliuolo)

Benj alienati
La quinta parte della heredita dimatteo di Domenicho mio avolo e padre didetto Bernardo et laquinta parte della heredita diciglio suo fratello equalj Benj sono pervenutj afrategli di Bernardo suo padre perlle divise fatte fralloro nellanno 1464 e datj acatasto per Bernardo perlla quinta parte nel 1457 alla portata del quale in tutto ci riferiamo
(*in the right margin*: domenicho di matteo Ghanberegli chiavj ora
 Giovannj di matteo Ghanbereglj
 Antonio di matteo Ghanbereglj
 Tomaso di matteo Ghanbereglj)

Uno pezo diterra venduto ad andrea dichecho diSer andrea puccinj distaiora 3 . in circha. per prezio di fiorini 10. posta nella corte di chastel Santo Giovannj luogho detto fossato alla villa. Confinj da primo via comune da ij Giovannj chalderino da iij lachiesa di Santo Lorenzo di Santo giovannj a iiij lachiesa di Santa Lucia

Incharichi

Troviancj affare omgnj anno i Rinovale per lanima di nostro padre allosservanza di santo francesco di fiorini 4 di questo abbiamo affare in perpetuo

Abbiamo affare una cappella nella chiesa di Santa Maria aSeptignano per lascio di nostro padre et assj aspendere fralla muraglia et dota fiorini 100. didettj benj disopra

Troviancj debito chonthomaso dichimentj dagniolo nostro cognato fiorini 40 equalj sono per resto di dota ghabbiamo addare perlla francescha sua donna et nostra sorella
(*in the left margin*: in chiavj)

Troviancj piu staiora diterra in arno diquelle sono conposte in questa scripta posta nella corte dicastel Sangiovannj luogho detto acqua viva cioe parte della terra comperamo dagiovannj di giovanni della quale ne in arno staiora 4 et piu

Et piu et in arno uno pezo di terra conposto chol poderetto del fossatello ilquale pezo diterra e distaiora cinque et piu et e in arno tutto quanto

Et piu e in arno parte della terra comperamo da begnj bassj sopra conposta circha alla meta

Boche

Mona Mattea donna che fu di Bernardo nostra madre dannj 51 fl. 200
Giovannj Batista di Bernardo deta dannj 28 . fiorini 200
Girolamo di Bernardo deta dannj 14 . fiorini 200

Sopra prima faccia di suo valsente . fiorini
2 faccia . fiorini 764 . 4 . 4
3 faccia . fiorini 13
 777 . 4 . 4

(*in the left margin*: Somma lentrata
 fiorini 54 . 9 . 1
 Tocchagli di decima fiorini 5 . 8 . 11)

 in tutto fiorini 777 . 4 . 4

Abatti per 5 per cento di fiorini 777 . 4 . 4 fiorini 37 . 17 . 3
Abatti per boche 3 . fiorini 600

Avanzali chome si vede . fiorini 138 . 7 . 1 cha a soldi x a 7 per cento gli tocha di chatasto
. fiorini soldi xiii danari x a oro fiorini soldi 13 danari 10
E per una testa . fiorini soldi 6 danari

Agiungniesi per beni immobilj chonperati da monna lisa donna fu di marcho di domenicho legnaiuolo da chastello San Giovanni cioe 1ª chasa posta in detto luogho. per fiorini 100 adj 16 dagosto . 1466

Rogato anotifichagionj e 175 dicie detta chonpera in maestro Giovannj
(*in the left margin*: Non si atrarre fuorj perche e per notificagione none chiarito)

Recho messer Giovannibattista di bernardo di matteo adi 26 daghosto

DOC. 5. *Catasto* of Antonio Rossellino 1469

ASF, Archivio del Catasto, Filza 927, S. Giovanni Chiavi, 1469, foll. 50r–50v. This *catasto* was partially and incorrectly published by R. Mather, "Documents Mostly New Relating to Florentine Painters and Sculptors of the Fifteenth Century," *Art Bulletin*, xxx, 1948, p. 37, doc. 3.

MCCCCLXVIIII

Q Scto Giovanni Ghonfalone Chiavi

Antonio di Matteo Ghamberellj Scarpellatore conparisce dinanzi ad voj Signorj uficialj delchatasto con tutte sue sustanzie et incharichj eprima

Nelchatasto del 27 non e nominato perche dicittadinj antichj sitrovarono in contado, poi peconsiglj oportunj furono rientegratj cittadinj

. fiorini soldi danari

Nelvalsente del 51 in el Gonfalone drago S. Spirito. In antonio detto imposto

. fiorini soldi 16 danari 3

Nelchatasto del 58 in domenicho di matteo gaberellj e fratellj in el Gonfalone delle Chiavj

. fiorini soldi 6 danari 1

Nellaventina del 68 in dettj nomi e gonfalone

. fiorini soldi 9 danari 2

Sustanzie

1ª chasa posta in via fiesolana fu portata nelchatasto del 58 in e sopradettj nomj, domenicho efratellj e in detto Gonfalone Chiavj. Dipoi sidivison detti fratellj et toccho Lameta aldetto antonio e ridotto a uno abitturo in quella sta con la sua famigla, nellaltra meta sta Giovannj suo fratello

(*in the left margin*: Viene dal 58 da domenicho di matteo chanberegli chiavi n° 664 ½ e laltra ½ va aGiovannj suo fratello per suo uso 69 chiavi 190 suo abittj)

(*in the right margin*: data al 80 chiavi 431 a chonto di domenicho Ghamberegli per suo uso elaltra metta ad chonto di Giovanni suo fratello)

1° pezzuolo diterra lavoratia con alchune vite e alchunj ulivi di stajora tre posto nel popolo di Santa Maria a Settignano, aprimo fossato o vero chiassaiurola a 2 Giovanni suo fratello. a. 3. mona Madalena donna fu di Lucha Ghamberellj. a. 4. antonio detto

(*in the left margin*: Viene chome di sopra ¼ di staiora dodicj rendene lanno fiorini ii soldi xiii danari 1°)

(*in the right margin*: va di soto)

1° pezzo di terra lavoratia parte vignata sita presso di stajora iiii° incircha con chasa dalavora-tore a 1° via a 2 via a 3 tomaso suo fratello. a. 4. antonio detto. Conperossj daGiovanni di Simone del Nente carte per Ser francesco di Ser Jacopo dapratovecchio adj dj

Lavora i detti due pezzi di terra Bartolo di Pippo di mona chiara et rendemj lanno

Grano staia vi
Vino barili viiii°
Olio staia 1°
Fichi secchi staia i

Mandorle staia ½ . fiorini 167 . 18 . 6
(*in the left margin*: da 27 da Ghamberello di Paolo di Ghamberello chiavi 370 per un altra parte per renditta di fiorini viiii° soldi ii in tutto rende fiorini 11. 15. 1)
(*in the right margin*: va di sotto
 data al 80 chiavi . . . [*illegible*])

1° Pezzo di terra lavoratia di stajora sei aseme popolo. S. Maria aontignano luogho detto alle Lame confinato a 1 lachiesa detta a 2 via a 3 marcho delpoppa contadino. a. 4. canonaca o vero ilveschovo diFiesole. Comperossi in somma di 1° podere per tuttj noj fratellj carta per Ser Francesco di Ser Jachopo dapratovechio sotto dj xxx di maggio 1468 da Mona Pippa donna fu di Piero diFrancesco dipiero Baccellj. Ilquale champo tocho in divisa daltri fratelli al detto antonio

Lavorato Bartolomeo dipapi de Giottj rendemj lanno
(*in the left margin*: Da non soportantj in Firenze e recho fede per mano di Ser Francesco di Ser Jachopo daprato vechio sotto di 15 di luglio 1462 per prezio di fiorini 405 dequali ne ve fiorini 285 a Domenicho e Giovanni suo fratelli in questo a car[ta] 190. E resto che sono fiorini 120 resto a detto antonio che a 7 percento rende fiorini 8. 8. 0)
(*in the right margin*: dato al 80 chiavj carta da chonto di domenicho di matteo Ghamberegli per rendita di fiorini 8 . 8 . 0)
Grano staia viiii°
Vino b. vj
Olio libbrj ii libbrj ii fiorini 120 . 0 . 0

Tengho a pigione 1ª bottegha dapiero di Francesco baldovinj dirimpetto alroncosolo nella quale fa el suo exertizio della scharpellare e paghaglene lanno fiorini sei
 287 . 18 . 6
(*in the left margin*: dalla piero daldovini a. 69. Vaio n° 296)

Bocche

Antonio di matteo sopradetto deta danj xlii fiorini 200
Monna Lisabetta sua donna danj xxviij fiorini 200
Margherita loro figliuola danj iiij° fiorini 200
Chasandra loro figliuola danj ii fiorini 200
Bartolomea loro figliuola danj i fiorini 200
Et e gravida di 7 mesj detta monna Lisabetta

Somma suo valsente fiorini 287 . 18 . 6
E per danari chontanti in sulla bottegha di lastrauolo fiorini
 in tutto fiorini
Abatti per percento di fiorini 287 . 18 . 6 fiorini 14 . 7 . 11
Abatti per boche 5 . fiorini 1000
(*in the left margin*: Somma entrata
 fiorini 20 . 3 . 1
 tocchagli fiorini 2 . 0 . 4)
Chomposto per partito degliuficiali in fiorini soldi vii roghato Ser Niccolo Ferrinj nostro cancielliere
 fiorini soldi 7

DOC. 6. *Catasto* of Domenico and Giovanni Rossellino 1469

ASF, Archivio del Catasto, Filza 927, S. Giovanni Chiavi, 1469, foll. 371r–372r.

1469
Quartiere Santo Giovanni Gonfalone Chiavi

Domenicho e Giovannj frategli e figluolj che furono di Matteo di domenicho Ghambereglj scharpellatorj di pietra vanno agraveza insieme advengha che sieno divisi.

non ebbono nelcatasto. 27. gravezza perche dicittadinj antighi percerte cagionj dibriga sitrovovano aestimo inchontado. poj. peconsiglj oppotunj furono rientigratj e remessi cittadinj. Et vinta lapetitione furono gravezzati in soldi dodicj. Gonfalone. chiavj quartieri di San Giovanni e disse lagravezza in Bernardo efrateglj. Nelvalsente. 51. non ebbono perche anchora erano aestimo

Nelchastato. 58, disse lagraveza indomenicho efrateglj ebbono dicatasto soldi sei
. soldi 6. d. 1

Nellaventina. 68. ebbono . soldi 9. d. 2

Sustanze

Una chasa posta in via fiesolana. fu portata nelcatasto 58. in dettj nomj per loro habitare. Dipoi sidivise et nellameta habita detto Giovanj Et nellaltra meta Antonio loro fratello carnale. dapoi che sidivise da frateglj.
(*in the left margin*: Da 58. da domenicho di matteo e altri chiavi n° 664 e da per sua abittare e laltra meza va antonio suo frattello in questo 30)
(*in the right margin*: Allo 80 chiavj 431 in lui detto per uso)

Lameta duna chasa perloro habitare posta Invilla nelpopolo di santa Maria a Setignano luogho detto Ghamberaia. confinj. a j° via. a ij° rede di lucha di bartholo. a iij° Antonio nostro fratello detto
(*in the left margin*: Dal 58 chome di sopra una parte per rendita di fiorini ii soldi xiii denari j° e unaltra parte daestimo da Jachopo di domenicho. San Giovanni n° 9. 237 per fiorini 50 di valsante e pigliasi la rendita di qui perche maggiore che sechondo prezi del 27 rendono fiorini 5 . 7 . 9)

Uno pezzo di terra vignata e ulivata di staiora 5 inchircha che a j°. via a ij°. labate di San +
Salvj a iij° fossato. a iiij° antonio di matteo detto rende lanno
Vino b. 10 cioe diecj
Olio b. 1
Grano staia 3
fallo lavorare asuo mano detto Giovannj

fiorini 76. 19. 3
dalestimo viene el pezo segnato + dal 27 quarticre di Santo Giovanni n° 9. 237 per fiorini 50 e meza lachasa di sopra e per fiorini 30 detto quartiere e dette 237
(*in the right margin*: Allo 80 chiavi 431 come di sopra per rendita di fiorini 5. 7. 9)

Uno pezzo di sodo cioe pastura di staiore dua posta nelpopolo di Santo Lorenzo avincigliata luogho detto allechave conuna cava dachavare pietre di macigno dove facciamo larte nostra

dello scharpellare. Confinj a j° antonio di messer alessandro. a ij° sandro dipiero davinciglata. a iij° rede di Luca di Bartholo. Rende lanno quando saffittano cave dapietra disimile arte fiorini uno per cava. Et per rispetto della pastura metto renda lanno fiorini uno ½ fiorini (*in the left margin*: da 58 come di sopra e ⅔ per rendita di soldi vj denare vii aoro epigliasi la rendita di qui perche maggiore cherede fiorini 1.10)
(*in the right margin*: Allo 80 chiavi 431 come e di sopra per fiorini 1. 10)

Uno poderuzzo conuna chasetta dallavoratore posta nelpopolo di Santa Maria aontignano luogho detto allachasellina. Confinj a j° rede di nicholaio deglalexandrj. aij° lachiesa di detta Santa Maria aontignano. aiij° elveschovo difiesole. a iiij° fiume. Lavoratia sodo conparecchi ulivj distaiora 15. Lavoratia. staiora xx. sode. Rende lanno inparte
Grano staia 20
Vino barili 10
Olio barili 1
(*in the left margin*: Da non soportantj in Firenze recho fede delchosto per mano di Ser Francesco di Ser Jacopo daprato vechio. sotto dj 15 diluglio 1462 per prezio di fiorini 405 diquali ne ve a antonio suo frattello in questo n° carta 30 fiorini 120 e resto cheseno fiorini 285 resta a domenicho sopradetto. che a 7 percento rende fiorini 19.19)
(*in the right margin*: Allo 80 chiavi 431 come di sopra per fiorini 19.1)
(*in the left margin*: Entrata fiorini 26 . 16 . 9)

Tengovi suso un paio di buoj di fiorini 15 perche tengo afitto tanti terrenj dalveschovo difiesole che nedo lanno di fitto fiorinj sette che sono conpresj et lavoratj daquesto medisimo lavoratore condetto uno paio dibuoj. Lavoralo Jacopo dello stiabbio fiorini

1° pezzo diterra posto in detto popolo luogo detto lunga di staiora. nova. confinj a j°. bese Magaloctj. a ij° Nicholaio deglalexandrj. a iiij°. Saccho Donzollj deldetto popolo. a iiij° monastero di Santa agata. Lavorala detto Jacopo delo stabbia condettj buoj. Compramolo da domenicho dipiero di detto popolo fiorinj trentatre. fune rhogato Ser francesco di Ser Jacopo dapratovecchio. Rende lanno
Grano staia 5
Legna catasta ½

 fiorini 33
(*in the left margin*: Non soportantj in Firenze recho fede del chosto per mano di Ser francesco di Ser Jacopo di Prato vechio sotto dj 6 di luglio 1462 per prezio di fiorini xxxiii che a 7 percento rendon fiorini 2 . 6 . 3)
(*in the right margin*: Allo 80 chiavi 431 in luj detto per rendita di fiorini 2 . 6 . 3.)

<div align="center">Bocche</div>

Domenicho . deta dannj 64 fior. 200
Giovannj . deta dannj 65 fior. 200
Monna Ginevra donna digiovannj danj 40 fior. 200

<div align="center">Benj Alienatj</div>

Una bottega discharpellatore posta in sulla piazza diSanpulinarj in Firenze. Vendila. a Lorenzo di Salvadore daSetignano lire trecento sessanta fune (roghato da mano di . . .)

Benj mobilj alienatj che siderono alcatasto 58

Barilj trenta dolio fiorini 50

Uno brachetto dipecore fiorini 6

Pietre chonce e abozzate che erano nello bottega delapiazza di Sanpulinarj. Comprollo

Lorenzo di Salvadore daSettignano lire cioe Lire 360

(*in the right margin*:

 Entrata fiorini 2 . 6 . 3

 Somma prima faccia di suo valsente fiorini 383 . 7 . 11

 2 faccia . fiorini 33

 E per denari chonttanti fiorini 416 . 7 . 11

 in tutto fiorini)

Abatti per 5 percento di fiorini 407 . 19 . 3 fiorini 20 . 7 . 11

Abatti per boche 3 . fiorini 600

(*in the left margin*: Somma entrata

 fiorini 29 . 3 . 0

 fiorini 2 . 18 . 4

 Tocchagli di decima fiorini 2 . 18 . 4)

E chomposto. per partito degliuficialj in soldi diecj rhogato Ser nicholo ferrini nostro

chancelliere fiorini soldi 10

DOC. 7. *Catasto* of Tomaso Rossellino 1469

ASF, Archivio del Catasto, Filza 928, S. Giovanni Chiavi, 1470, foll. 1323r–1323v and
Filza 100, S. Giovanni Chiavi, 1469, t. ii, letters I-Z, foll. 1338r–1338v

<div align="center">

1469

Quartiere di Santo Giovanni Gonfalone Chiavj

</div>

Tomaso di matteo Ghamberegli scharpellatore dipietra. diviso dafrateglj.

non ebbe catasto. nel. 27. perche dicittadinj antighi percerte cagionj dibriga sitrovorono
aestimo inchontado. poj peconsigli opportunj furono rientegratj et rimessj cittadinj. Et
vinta lapetitione furono gravezzatj insoldi dodicj. Gonfalone Chiavj Quartiere di Santo
Giovanni. Et disse lagravezza inBernardo efratgelj. Nelvalsente. 51. non ebbono perche
anchora erono aestimo Nelcatasto. 58. disse lagravezza indomenicho efrateglj ebbono
dicatasto soldi sei soldi 6. danari 1°. indivisj

Nella ventina. 68 ebbono soldi. 9. denari soldi 9. danari 2 indivisj

<div align="center">

Sustanze

</div>

Una quarta chasa persuo habitare acomune cofrategli. posta nelpopolo di Santa Maria
aSetignano luogo detto Ghamberaia. confinj aj°. via. aij° rede di lucho di Bartholo. aiij°
antonio suo fratello

(*in the left margin*: Viene da 58 da domenicho di matteo Ghanbereglj Chiavj n° 664.
rendita questa parte di fiorini v soldi xii danari ii e pigliasi larendita qui perche maggiore
che rende fiorini 5 . 12 . 0)

Uno pezzo di terra vignata e ulivata posta nel popolo di Santa Maria aSetignano luogo detto

Ghamberaia confinj aj° via. a ij° Nicholo dantonio di Berto e maso suo fratello. a iij° rede di Bartholomeo da Radda. aiiij° Giovannj suo fratello. E di staiora sei incircha. rende lanno inparte

Grano staia 4 a soldi 17 staia
Vino b. 10 a soldi 28 barile
Olio b. 1 a lire 5 barile fiorini 80
(*in the right margin*: data al 80 chiavj 358 in chonto di tomaso di mateo detto (per) rendita di fiorini 5 - 12 - 0)

Uno staioro di terra soda che era la terza parte duna chava dachavare pietra di macigno daffare larte sua. Confina aj° antonio di messer alexandro. aij° Sandro. di piero davinciglata. aiij° rede di lucho di Bartholo. Rende lanno quando affitassi soldi quaranta.

Laquale cava sta per volta due e tre annj. Non vilavora non laffitta. Perche molto sta a Roma e difuorj

Rende lanno lire 2 fiorini 7 . 3
 87 . 3 . 0
(*in the left margin*: Da 58 chome di sopra la ⅓ parte per rendita di soldi iii danari iiij° e pigliasi larendita di qui perche maggiore che rende fiorini 10)
(*in the right margin*: data al 80 chiavj 358 al chonto di tomaso di mateo per rendita)
(*in the left margin*: Entrata fiorini 6 . 2 . 0)

 Bocche
Tomaso danj 50 ... fiorini 200
Monna Sandra sua donna danj fiorini 200
Matteo suo figluolo dannj 13 none sano fiorini 200
Biliotto suo figluolo dannj 8 fiorini 200
Benedetta suo figluola dannj 12 fiorini 200⎤ senza dote
Lucretiasuo figluola dannj 7 fiorini 200⎦ amendue
Trovasj detto tomaso indebito di fiorini. 60. E in grande disordine dogni cosa.

Somma suo valsente fiorini 87 . 3 . 0
E per denari chonttanti fiorini fiorini
 in tutto fiorini
(*in the left margin*: Somma lentrata

 fiorini 6 . 2 ————
 Tocchagli di decima fiorini 12 . 3)

Abatti per 5 percento di fiorini 80 fiorini 4
Abatti per boche 3 fiorini 600

Et chomposto per partito degliuficialj in soldi sei aoro roghato Ser nicholo ferrini nostro cancelliere fiorini soldi 6

DOC. 8. *Catasto* of Domenico and Giovanni Rossellino 1480

ASF, Archivio del Catasto, Filza 1020, S. Giovanni Chiavi, 1480, foll. 402r–402v, and Copia del Monte, Filza 101, S. Giovanni Chiavi, 1480, foll. 499r–499v.

MCCCCLXXX Quartiere di Santo Giovanni, Gonfalone de la Chiavi

Domenicho di Mateo di Domenicho fu ischarpellatore et Giovanni di Mateo suo fratelo ischarpelatore chonparischono dinanzi a voi uficiali della ghraveza chotute loro sustaze.

Et i prima nel chatasto 1469 et ebono di chatasto soldi dieci soldi 10

Et piu ebbono di sesto libre dua soldi 1 danari 10 piccioli cioe lire 2 soldi 1 danari 10

Sustanse

Una chasetta posta in via Fiesolana per nostero abitare in detto ghonfalone chonfini da primo via et sechondo Puerne di Tomaso Puerni et 3 . 4 detto Puerno detto et 4 Giovanni di Zanobi da Melletto

(*in the left margin*: Dal 70 chiavi 490 dallui detto per suo uso)

(*in the right margin*: A195. chiavj n°, 344. A Giovanni sopradetto proprio)

E piu uno pezo di tera chonuna chasetta di staiora . 5 . ocircha che e per nostero abitare e chelavoriano detta tera a nostera mano posta nepopolo di Santa Maria a Settignano luogho detto Chanberaia chonfini da primo via sechondo San Salvi et 3 . 4 . Tomaso di Mateo re(n)de detta tera

v(i)no barili dieci	cioe barili 10
staia tre di chrane	staia 3
olio barili una	barili j°

fiorini 76 – 19 – 3

(*in the left margin*: Dal 70 chome di sopra per rendita di fiorini 5 . 7 . 9)

(*in the right margin*: A195 chiavj. n°. 344 chome disopra per rendita di fiorini 5 . 7 . 9)

Uno pezo di tera posta nepopollo di Sa Lorenzo a Vecigliatta di staiora dua o circha detta tera e pastura chon unachava da chavare pietere chonfina da primo via et sechondo Antonio di messer Alexandero Alexanderi et . 3 . Tomaso di Mateo et 4 Monna Lodovicha rende lano fiorini uno et mezo cioe fiorini 1½ fiorini 21 – 8 – 8

(*in the left margin*: Dal 70 come disopra per rendita di fiorini 1 – 10 –)

E piu uno poderuzo posto ne popolo di Santa Maria a Ontignano luogho detto la Chaselina chonfini primo e fiume di Sanbere (Sambra) et sechondo Lorenzo di Salvadore et 3 el veschovo di Fiesole et 4 Martino di Ciatto di staiora trentacinque quindici lavoratia e 20 di pastura re(n)de lano

ghrano staia venttj	staia 20
vino barili diecj	barili 10
olio barili dua	barili 2

fiorini 285 – 0

(*in the left margin*: Dal 70 come disopra per rendita di fiorini 19–19-0)

(*in the right margin*: A195 chiavj n° 344 chome disopra per rendita di fiorini 19–19–)

E piu uno pezo di tera posta i detto popolo di Santa Maria a Ontignano lugho detto peza lu(n)gha di staiora nove rende staia cinque di chrano staia 5

(*in the left margin*: Dal 70 come disopra per rendita di fiorini 2 . 6 – 3)

E piu una meza catasto di legne confina detta tera primo esechondo maso alessandri e 3 . besse maghalottj e sta isudetto poderuzo et in detta terra uno paio di buerellj di valutta di fiorini qatordiecj fiorini 14

fiorini 33 – 0 – 0

(*in the left margin*: *illegible* . . . per rendita fiorini 5 . 8)

(*in the right margin*: A195 chiavj n°. 344 chome disopra per rendita di fiorini 12 . 0)

Legnie una mezo catasta confina detta tera primo esechondo Maso alessandrj terzo Besse Maghalottj ista isudetto poderuzo et detta tera uno paio di Buocegli di valutto di fiorini 14 e piu vista suso diecj pecore cioe pecore 10 elavoratore di dette tere Jachopo di Nanj dele pescie fiorini 3 – 15 – 0

(*in the left margin*: Entrata fiorini 29 – 8 – 8)

E piu un pezo di tera di staiora sei posto nelpopolo di Santa Maria a Ontignano confina ladetta tera chola detta chiesa di Santa Maria e sechondo via e terzo marco delpopa e 4 chalonaca di Fiesole luogho detto lame rende staia 9 di ghrano cioe

ghrano staia 9 staia 9

vino barili 5 cioe barili 5

olio uno mezo barile mezo

fiorini 120 – 0 – 0

(*in the left margin*: *illegible*)

(*in the right margin*: A195 chiavj n° 344 a Giovanni dimatteo per rendita di fiorini 8 . 8 –)

E piu uno pezo di tera posta nepopolo Santa Maria a Ontignano luogho detto a Giotti chonfini da primo via e sechondo e vescovo di Fiesole e 3. Nicholo di Jacopo e 4. maso e francesco alessandrj e 5. Besse maghalotti e ladetta tera chonpero antonio di Mateo nostero frattello da francesco dantonio Bastiano chosto fiorini ottantacinque o deta chonpera nefu roghatto ser Domenico di ser santtj le dette tera lavora Giovanni di pagholo da giotti e a vj susu uno mezo Buerello fiorini tre le sopra a dette tere cioe lelame e giotti abiano avtte per reditta dantonio di Mateo nostero fratelo perche e mortto rende detta tera staia otto di ghrano cioe . . . staia 8

barili uno dolio barile 1

legnie una meza chatasta

fiorini 38 – 18 – 8

(*in the left margin*: *illegible*)

(*in the right margin*: A195 chiavj n° 344 e chome disopra per rendita di fiorini 2 – 14 – 6)

E piu tengho afitto uno pezo di tera conuna casetta lugho detto a Giotti posto nelpopolo di Santa Maria a Ontignano ladetta tera e di Nicholo di Jachopo dantonio e pagho difitto detta tera lano libra quidici a detto Nicholo chonfini daprimo maso degli alessandrj chorede dantonio di mateo sechondo e 3. Besse Maghalottj

fiorini 39 – 6 – 5

(*in the left margin*: Da non sopportanti fede da Ser domenicho di bartolomeo dandrea sotto di 7 daghosto per rendita di fiorini 2 – 15 – 0)

Boche

Domenicho di Mateo di Domenicho fu ischarpelatore detta danj settantta sette cioe anj 77
Giovanni di Mateo di Domenicho detta danj setantta dua cioe anj 72
Monna Chaterina dona di detto Giovanni detta danj quarattacinque cioe anj 45

Somma la prima faccia del valsente fiorini 420 – 2 – 11
Somma la sechonda faccia di sopra fiorini 198 – 5 – 4
 ——————————
 618 – 8 – 3

Abatti per 5 percento per la conservazione de beni fiorini 30 – 18 – 3

 587 – 10 – 0

(*in the left margin*: Entrata della prima faccia
 fiorini 29 – 8 – 8
 fiorini 13 – 17 – 6

 43 – 6 – 4)

Somma il valsente netto fiorini 587 – 10 a 7 per cento fanno di rendita fiorini 41 – 3 – 0

Avansagli fiorini 41 – 3: tocchagli di gravezza per la schala a 7 percento fiorini due soldi
diciasete denari sette Fiorini 2 – 17 – 7 aoro

DOC. 9. *Catasto* of Tomaso Rossellino 1480

ASF, Archivio del Catasto, Filza 1022, S. Giovanni Chiavi, 1480, fol. 358 and Filza 103,
S. Giovanni Chiavi, 1480, letters M-Z, foll. 406r–406v

Quartiere Santo Giovanni
Gonfalone Chiavj

Tomaso dimatteo didomenicho ghanbereglj ischarpellatore

Ebbe di chatasto in suo nome 1470 soldi 6

Ebbe difitto in suo nome lira 1 soldi 6 danari 8

Sustanze

Una quarta parte dichasa rovinata elpalcho era per suo abitare nollabita perche nona ilmodo
arachoncialla abita chondomenicho suo fratello posta popolo di Santa Maria aSettignano
a primo via secondo ⅓ ¼ dantonio e giovannj mio frateglj
(*in the left margin*: dal 70 chiavj 1323 datomaso di mateo Ghamberegli per rendita di
fiorini 5 – 12 – 0)

Unpezo diterra lavoratia evignata chonalchuno ulivo posta nelpopolo di Santa Maria
aSettignano luogho detto aghanberaia di staiora 7 aseme apartente chonquello pocho
dichasa a primo via secondo nicholo dantonio di Berto ⅓ Monna Lucia di meo daradda ¼
Giovannj mio fratello ⅕ antonio mio fratello follo lavorare aopere non posso tenere
lavoratore fiorini 80

Rende dimezo

Grano staia 4
Vino barili 10
Olio barile 1

(*in the right margin*: Al 95. chiavj. n°.629 carta 3 parte atommaso. sopradetto. In jᵃ partita
sola di rendita di fiorini 17 . 17 . 1)

Una parte dichava solevo adoperare oggi non fonulla per lire 2
(*in the left margin*: dal 70 come di sopra per rendita fiorini 10)
(*in the right margin*: Al 95 chome di sopraedetto)

2 pezuolj diterra lavoratia chonalchuna vita di staiora 7 e chasa posta nelpopolo di Santa Maria aSettignano luogho detto aGhanberaia laquali one avto per redita dantonio mio fratello edetta chasa mibisogna chosi adoperare per me chome facieva antonio mio fratello nonsene trasse nulla per niun modo maj fiorini 167 – 18 – 6

<div align="center">Rende dimezo 255 . 1 . 6</div>

Grano staia 4
Vino barili 8
Olio libbre 4

(*in the left margin*: dal 70 chiavj. <u>62</u>. da antonio dimatteo gambereglj suo fratello per rendita di fiorini 11 – 15 – 1)
(*in the right margin*: Al 95 chome di sopraedetto)

<div align="center">Boche</div>

Tomaso deta . annj 65
matteo suo figluolo annj 22
Monna Sandra mia donna annj 45
benedetta mia figluola annj 20 nonauno dota
lucrezia mia figluola annj 16 nonauno dota
Marietta mia figluola annj 11 nonauno dota
Susanna mia figluola annj 4 nonauno dota
dianora mia figluola annj 3 nonauno dota

Somma ilvalsente fiorini 255 – 1 – 6
Abatti per 5 percento per la conservazione de benj f. 12 – 19 . . .
 242 . 6 . 6

(*in the left margin*: Entrata fiorini 17 – 17 – 1)
Rendita ilvalsente netto fiorini 242 . 6 . 6 a 7 percento fano fiorini 17
Avansaglj fiorini 17. tocchagli per la scala a 7 percento fiorini uno soldi tre danari diecj fiorini 1 – 3 – 10

DOC. 10. Petition by the Rossellino Brothers to be exempted from paying the *Estimo* 1457

ASF, Consigli Maggiori della Repubblica Fiorentina, Provvisioni e Registri, no. 148, Anno 1457

fol. 43v:

In Dei Nomine amen, anno Incarnationis Domini nostri Jesu Christi millesimo quadringentesimoquinquagesimosexto, Indictione quinta, die vigesimo sexto mensis februari, in consilio populi civitatis Florentie: Mandato magnificorum dominorum dominorum priorum Artium et vexilliferi Justitiae populi communis Florentiae, precona convocatione, campaneque sonitu in palatio populi Florentie more solito congregato, quorum dominorum priorum et vexilliferi nomina ista sunt, videlicet: Rossus Niccoli Antonii de Ridolfis,

Laurentius Bartholommei Johannis Michelozzi, Antonius Laurentii Antonii Spinelli, Miniatus Tommasii Francisci Busini, Nero Stefani Allexandri Ser Lamberti, Ciprianus Clementis Cipriani Ser Nigi, Bonaiutus Ser Jacobi Bonaiuti Landi cassettarius, Jacobus Bartholommei Jacobi Casini bottarius, priores Artium, et Andreas Lotteringhi Andree domini Ugonis de Stufa vexillifer Justitiae. Ego Leo Francisci Leonis civis florentinus, legum doctor, officialis et scriba Reformationum consiliorum populi et communis Florentie in presentia de voluntate et mandato officii dictorum dominorum et vexilliferi in dicto consilio presentium in numero opportuno legi et recitavi inter consiliarios dicti consilii in sufficiente numero congregatos, infrascriptas provisiones et quamlibet earum vulgariter distinctas et ad intelligentiam deliberatas et factas prout infra apparebit, Et observatis solemnitatibus opportunis et observari debitis et requisitis secundum ordinamenta dicti communis et modo et forma et ordine infrascriptis videlicet:

fol. 48v ff.
(*in the left margin*: Bernardi Mactei Gamberelli lastraiuoli pro extimo)
OCTAVO Provisionem infrascriptam super infrascriptam petitionem, et omnibus et singulis in ea contentis deliberatam et factam per dictos dominos priores et vexilliferum Justitiae, gonfalonieros societatum populi, et duodecim bonos viros communis Florentie, secundum ordinamenta dicti communis. Omnes quidem petitiones et super ea edite provisionis tenor talis est videlicet: Cum debita reverentia exponitur vobis magnificis et potentibus dominis dominis prioribus Artium et vexillifero Justitiae populi et communis Florentie pro parte Bernardi Mactei Dominici Gamberelli lastraiuoli dal proconsolo et fratruum quod ipsi sub hac descriptione videlicet: heredes Mactei Dominici descripti fuerunt in presenti extimo comitatus in populo Sancti Petri Maioris intra muros civitatis Florentie pro valente in libra una soldis decemocto et pro testis in soldis sedecim, in totum in libris duabus soldis quatuordecim. Item in alia parte sub ista descriptione videlicet: Antonius Mactei Dominici et fratres fuerunt etiam in extimo prefato descripti in comitatu Sancti Johannis Vallis arni superioris pro valente in soldis quatuor et pro certis testis in soldis sex, hoc est in soldis decem inter ambas summas proxime dictas. Et per officiales augmenti extimi dicte prime partite librarum duarum soldorum quatuordecim descripte in dicto populi Sancti Petri maioris addita et superposta fuit eis summa et quantitas librarum quinque soldorum sex. Et sic inter omnes dictas summas habent de extimo in totum et in summa libras octo, soldos decem. Et quod respectu eroum parve substantie fuerunt minus ultra debitum pregravati. Sed ut bene intelligatur casus eorum: Antiquitas ipsorum progenitores et agnati presentantiarum onera hic in civitate una cum civibus supportarunt, ut clare pro narranda infra proxime apparebit nam in libro distributionis prestantiarum civitatis Florentie appellata extimum civitatis incamerata in anno millesimo trecentesimoquinquagesimo primo dictus Giambonellus eorum proavus reperitur descriptus in libris viginti duabus, soldis decem, in vexillo clavium, et in altera distributione presentiarum civium civitatis Florentie vocata La Segha incamerata de anno MCCC° quinquagesimo quarto idem Giambonellus in dicto gonfalone clavium similiter fuit descriptus in libris vigintiduabus, soldis decem. Et subsequentur postea in distributione prestantiarum civium civitatis Florentie incamerata in anno MCCC° sexagesimo nono mortuo jam dicto Ghamborello fuerunt in eodem gonfalone descripti domina Jacoba eius uxor et filii ad car. 153, inter quos comprehenditur eorum avus patruus in florenis duobus, soldis undecim. Et in

alia distributione civium predictorum incamerata in anno millesimo trecentesimo septua-
gesimo quinto in dicto vexillo prefata domina Jacoba eorum proavia et filii descripti
fuerunt in florenis duobus, soldis undecim, denariis novem ad aurum. Item in alia distri-
butione civium incamerata in anno millesimo trecentesimo octuagesimo secundo similiter
eorum avus patruus et fratres sub ista descriptione videlicet: Pierus Gamberelli et fratres
descripti fuerunt in florenis duobus, soldis quatuordecim denariis octo ad aurum. Et in
eadem distributione quidam nepos ex fratre dicti eorum avi patrui vocati Blaxii Pucii
Gamberelli fuit descriptus in eodem vexillo in florenis quinque, soldis duodecim, denariis
decem ad aurum. Et in distributione septime incamerata in anno millesimo trecentesimo
nonagesimo septimo extiterunt descripti Pierus et Zenobius Gamberelli et domina Jacoba
eorum mater in floreno uno soldis tribus, denariis quinque in vexillo predicto, et in ipsa
distributione septime dictus Blaxius Gamberelli sub ista vulgari descriptione videlict:
Biagio di Piero di Gamberello affinatore fuit descriptus in dicto gonfalone in florenis
decem, soldis quatuor, denariis octo. Et in distributione prestantiarum incamerata in anno
millesimo quadringentesimo quarto reperitus quod domina Francesca Blaxii Gamberelli
vidua descripta fuit in florenis duobus, soldis tribus, denariis novem. Et ne minus tedio
afficiat magnificentias vostras et reverentias audentium seu uno verbo complectatur, sui
fuerunt ad onera civitatis per multum tempus, et in satis bonis summis onera civium
supportaverunt, prout dictis omnibus descriptionibus apparet per fedes scriptas manu Ser
Johannis domini Peri notarii florentini. Et pater suus propter paupertatem reduxit se ad
habitandum in comitatu unde scriptum est, quod post certum tempus intravit ad extimum.
Et ipse Bernardus cum esset puer annorum septem venit ad trahendum moram in hac
civitate et fuit positus ad exercitium lastraiuoli quod continuo exercuit et jam per trigin-
tatres annos et ultra tamquam principalis magister tenuit apotecam inter locum appel-
latum porta San Piero et locum dal proconsolo, in quo existit ad presens, et similiter in
sua pueritia venerunt fratres sui et omnes familiariter habitant in hac vostra civitate, et
eorum intentionis est, semper Domino concedente, in eadem habitatione prosequi, et se
ut habitatores civitatis habere. Dictus enim Bernardus fecit studere duos suos filios ut
credivit esse notum. Et sperantes gratium invenire maxime cum possit dici quod redire
querant ad regulam antiquorum suorum decreverunt a vostra piissima dominatione postu-
lare cum consensu nobilium virorum Caroli Silvestri de Gondis et Pauli Michaelis de Ric-
cialbanis ex vostris venerabilibus collegiis auditorum suorum ad hec examinandum assump-
torum quod et prout inferius describetur. Quare vobis dominis supradictis pro parte
predicta devotissime supplicatur et petitur quatenus vobis eisdem placeat et dignemini
opportune providere et facere solenniter reformari quod etiam absque aliqua fide aut
probatione de supra narratis vel aliquo eorum fienda seu aliter requisita vel alia solennitate
aut substantialitate servanda dicti Bernardus et fratres teneantur et debeant infra decem
dies proxime futuros a die qua presens petitio fuerit in consilio communis Florentie appro-
bata facere se ipsos describi per homines officum montis dicti communis in debitores et
pro debitoribus eiusdem communis de summa et quantitate librarum centum quinquaginta-
trium florenorum parvorum pro quolibet anno et ad rationem anni quo in futurum durabit
seu vigebit dicta presens distributio extimi comitatus et ipsam quantitatem librarum centum
quinquagintatrium pro singulo anno predicto incipiendo primum annum immediate a
die qua presens petitio fuit obtenta in consilio communis facere teneantur ad camerarium
seu capserium montis pro communi Florentie et dicto officio montis recipienti in tribus
pagis seu terminis, videlicet quolibet quadrimestri tertiam partem scilicet libras quinqua-

gintaunam sub pena dumtaxat quarti pluris eius quod in suo termino solutum non esset singula singulis reficiendo. Et quod ipsa solutio librarum centumquinquagintatrium pro anno et ad rationem anni fienda ut supra sit et cedat in locum totius eius quod pro imposita librarum quatuordecim seu duodecim pro libra vel alterium imposite succedentis illi solvere habuissent seu debuissent dicti Bernardus et fratres et alii comprehensi in eorum partitis extimi supradictis pro futuro seu respectu dumtaxat temporis futuri et post dictam diem consilli communis si presens provisio facta et obtenta non foret.

Item quod conservatores legum et ordinamentorum dicti communis Florentie et due partes eorum possint ac etiam teneantur et debeant addere et distribuere poste et partite oneris civitatis Florentie quod habet in presenti distributione quattuor et in distributione diaconis quarterii Sancti Spiritus Antonius Mactei Dominici unus ex fratribus dicti Bernardi in qua partita oneris civitatis comprehensi sunt Gilius et Johannes filii prefati Bernardi quivis aliter in parentela denominati sunt in ea dictos Bernardum et fratres in ea summa et quantitate de qua eisdem conservatoribus iustum equum fore videbitur supradictos habere in totum et inter omnes de prestantia in distributione quantorum predicta. Et quod dicta additio et nova impositio intelligatur esse et sit una cum partita dicti Antonii de qua supra una et eadem prestita predictorum in prefata distributione quantorum et secundum ipsam partitam sic unitam teneantur et debeant ipse Bernardus et fratres et alii in eadem comprehensi solvere et supportare omnia et singula onera tam imposita super et secundum dictam distributionem quantorum quorum onerum impositorum principales termini solutionum assignati venient et seu exeunt post dictam diem consilii communis quod de cetero imponenda secundum distributionem prefatam et per hoc sint obligati eo modo prout fuissent et seu essent si a principio dicte distributionis quantorum fuissent in causa descripti incirca summam quam capite seu constitutionem et summam dicte partite unicam dent supra et in omnibus et per omnia tractentur, reputentur et sint quo ad dictam solutionem onerum civitatis et quo ad alia quecumque ab ipsa dependentia vel connexa prout ac sicut promictitur a principio eiusdem distributionis fuissent in eadem summa proximam dictam descripti et reducti et deinde in posterum prosequantur et reducantur in oneribus et ad onera prestantiarum et similium civitatis et de tempore in tempus prout de florentinis civibus ordinarie supportantibus fieri et observari debebit, non obstant quod teneantur solvere monti respectu extimi ut supra quam solutionem etiam facere teneantur ut superius dictum est.

Item quod factis dictam descriptionem ad montem de libris centumquinquagintatribus pro anno a dicta additione seu reductione unione partite oneris civitatis ut supra dicte partite extimi dantes videlicet una in heredes Mactei Dominici existens cum augmento seu additione eidem facto in et seu de libris octo in dicto populo sancti petri maioris intra muros civitatis florentie et altera existens de soldis decem sub nomine Antonii Mactei dominici et fratrum in communi Vallis Arni Superioris possint et debeant cancellari seu circumdari vel penes eas marginari quod sint abolite et cancellate pro pagis que predicta imposita librarum quatuordecim seu duodecim pro libra et seu pro alia imposita et succedente fieri debuissent per descriptos et comprehensos in dictis partitis extimi respectu dumtaxat temporis secuturi post dictum diem consilii communis si presens petitio non fuisset data et reformatio super causa nullitatis substituta Salvo eo quod supra de solutione librarum centumquinquagintatrium pro anno fienda monti dictum est. Pro pagis vero de imposte librarum quatuordecim vel duodecim pro libra jam decursis et pro iis que decurrerent ante dictam diem consilii communis non intelligatur presens gratia vel bene-

ficium sed pro ipsis pagis decursis et que decurrerent ante dictam diem consilii communis habeantur et tractari debeant tanquam si presens petitio ut promictitur data et facta non esset et ad nihil ultra solvendum quod superius dictum sit respectu dicti extimi comitatus pro se vel aliis aliquatenus teneantur. Nec etiam de novo describi vel reduci queant in presenti extimo comitatus quecumque foret sive ordinaria sive extraordinaria vel alia quecumque quoviscumque nomine appellaretur et quod secus fieret non teneatur ipso iure et pro infacto pariter habeatur et omnis scriptura que preterea facta esset vel fieret possit et debeat cancellari ubi et prout fuerit expediens. Et quod dicte omnes cancellationes contente in presenti capitulo fieri possint et debeant licite et in primis per notarios custodes actorum camere communis Florentie pro tempore existentes vel aliquem aut aliquos ex eis ad omnem simplicem requisitionem dicti Bernardi et fratrum vel alicui eorum aut alterius cuiuscumque ad quem quolibet pertineret omni oppositione remota.

Item quod in locum denariorum secundum pro libra qui alio non previsa deberetur per dictos Bernardum, et fratres pro presenti gratia inter operam Sancte Marie del Fiore et montem carminium sufficiat quod solvatur id dumtaxat de quo infra unum mensem proxime futurum a dicta die consilii communis fuerit deliberatum et declaratum per dominos priores artium et vexilliferum Iustitie populi et communis Florentie vel duas partes eorum et ad nihil ultra solvendum propterea teneatur vel cogi possit aliqualiter ullo tempore in futurum.

Super qua quidem petitione et omnibus et singulis in causa quantitatis dicti domini priores et vexillifer habita super predictis et infrascriptis omnibus et singulis invicem et una cum officiis gonfalonis societatum populi et duodecim bonorum virorum communis Florentie deliberatione solemni et demum inter ipsos omnes in sufficienti numero congregatos in palatio populi florentini premisso facto et celebrato in secreto scrutinio ad fabas nigras et albas et obtento prestito secundum forman statuti et ordinis dicti communis eorum proprio motu pro utilitate communis eiusdem et omni modo via iure et forma quibus magis et melius potuerunt providerunt ordinaverunt et deliberaverunt die vigesimo tertio mensis februarii Anno domini millesimo quadringentesimo quinquagesimo sexto indictione quinta. Quod dicta petitio et omnia et singula in ea contenta precedant firmentur et fiant et firma et stabilita esse intelligant et sunt et observantur et observari et executioni mandari possint et debeant in omnibus et per omnia secundum petitionis eiusdem continentiam et tenorem.

Non obstantibus in predictis vel aliquo predictorum aliquibus legibus statutis ordinamentis provisionibus aut reformationibus consiliorum populi et communis Florentie obstaculis seu repugnantiis quibuscumque etiam quantumcumque derogatoriis personalibus vel precisis vel etiam si de eis vel ipsorum aliquo debuisset vel deberet fieri spetialis mentio expressa quibus omnibus intelligatur esse et sit nominatum et expresse spetialiter et generaliter derogatum. Et quod pro predictis vel aliquo predictorum super in presenti provisione contentis idest ut supra in prima provisione huius consilii continetur usque ad finem provisionis eiusdem.

Qua provisione lecta et recitata ut supra dictum est dictus dominus propositus ut supra per omnia dictum est proposuit inter dictos consiliarios supradictam provisionem et contenta in ea super qua petiit sibi per omnia pro dicto communi et suo dicta forma bonum et utile consilium impartiri. Postque illico dicto et proclamato in dicto consilio per precones communis eiusdem ut moris est quod quibus volens vadat ad consulendum super provisionem et proposita supradicta et nemine eunte et ipso proposito de voluntate consilio

et consensu officii dictorum dominorum priorum et vexilliferi proponente et partitum faciente inter consiliarios dicti consilii numero clxxxxvj presentibus in dicto consilio quod cui placet videbitur supra dictam provisionem et omnia et singula in ea constituta procedenda et admictenda esse et admicti fieri observari et executioni mandari posse et debere et firma et stabilita esse in omnibus et per omnia secundum formam dicte provisionis et contentorum in ea, et fabam nigram pro sic et quod cui contrarium vel aliud videretur det fabam albam pro non. Et ipsis fabis datis recollentes segregatis numeratis et processis per omnia secundum formam ordinamentorum dicti communis et ipsorum consiliariorum voluntatibus exquisitis ad fabas nigras et albas ut moris est repertum fuit cxxxxiiij ex ipsis consiliariis dedisse fabas nigras pro et sic secundum forman dicte provisionis obtentum firmatum et reformatum fuit non obstantibus reliquis xlij ex ipsis consiliariis repertis dedisse fabas albas in contrarium pro non.

fol 62r:

Item SEXTO Provisione suprascriptam deliberatam et factam in dicto consilio populi dicto die continentem petitionem Bernardi Mactei Gamberelli et fratrum petentium exemptionem ab extimo cum certa taxa monti que incipit cum debita reverentia exponitur vobis etc. Qua provisione lecta et recitata ut supra dictum est dictus dominus propositus ut supra per omnia dictum est proposuit inter dictos consiliarios supradictam provisionem et contenta in ea super qua petiit sibi per omnia pro dicto communi et sub dicta forma bonum utile et consilium impertiri post que illico dicto et proclamato in dicto consilio per precones communi eiusdem ut moris est quod quilibet volens vadat ad consulendam super provisionem et proposita supradicta et nemine eunte et ipso proposito de voluntate consilio et consensu offitii dictorum dominorum priorum et vexilliferi proponente et partitum faciente inter consiliarios dicti consilii numero cxliiii presentibus in dicto consilio quod cui placet et videbitur supradictam provisionem et contenta in ea procedenda et admictenda esse et admicti fieri observari et executioni mandari posse et debere firma et stabilita esse in omnibus et per omnia secundum formam dicte provisionis et contentorum in es det fabam nigram pro sic et quod cui contrarium vel aliud videbitur det fabam albam pro non. Et ipsis fabis datis recollectis segregatis numeratis et processis per omnia secundum formam ordinum dicti cominis et ipsorum consiliariorum voluntatibus exquisitis ad fabas nigras et albas ut moris est repertum fuit cxviiij ex ipsis consiliariis dedisse fabas nigras pro sic et sic secundum formam dicte provisionis obtentam firmatum et reformatum fuit non obstantibus reliquis xxv ex ipsis consiliariis repertis dedisse fabas albas in contrarium provisionis.

DOC. 11. Matriculation of Jacopo di Domenico and Matteo di Domenico in the *Arte dei Maestri di Pietra e Legname* 1399

ASF, Arte dei Maestri di Pietra e Legname, Libro 2, fol. 59v

In Dei nomine amen existentibus prudentibus viris
Rosso pieri rossi
Stefano Gherardini
Antonio bartoli malaghigna et

Jacopo francisci, consulibus artis magistrorum lapidum et lignaminis civitatis Florentie pro tempore et termino quattuor mensium inceptorum die primo mensis maij currente anno domenice incarnationis millesimo trecentesimo nonagesimo nono, Inditione septima, et finitorum die ultimo mensis augusti dicti anni. Hic est liber seu quaternus qui appellatur la matricola artis magistrorum lapidum et lignaminis civitatis comitatus et districtus Florentie continens in se matriculatos et descriptos in dicta arte et dicte artis juratos secundum formam statutorum dicte artis tempore consulum predictorum scriptus et publicatus per me Antonium quandam Michaelis Arrighi civem et notarium florentinum scribam dicte artis sub anno et inditione predictis et diebus et mensibus infrascriptis.

die xxxj maij

Jacobus dominici vocati borra popoli Sancte Marie di Settignano civitatis Florentie

die xviiij Julij

Matteus dominicj vocati borra popoli Sancte Marie di Settignano civitatis Florentie

DOC. 11a. Matriculation of Giovanni Rossellino in the *Arte dei Maestri di Pietra e Legname* 1438

ASF, Arte dei Maestri di Pietra e Legname, Libro 2, fol. 41r

In Christo nomine amen. Anno eiusdam incarnatione MCCCCXXXVII (s.C.: 1438) die primo Januarij pro quattuor mensibus proxime futuro. Existentibus

Tone Leonardi
Stasio Berardi Banchi
Laurentis Antonij pelli } Consulibus
Nicolao parentis lippi

citta Joħes Mathej delborra scarpellator in detto libº a p 486

DOC. 12. Matriculation of Tomaso Rossellino in the *Arte dei Maestri di Pietra e Legname* 1441

ASF, Arte dei Maestri di Pietra e Legname, Libro 2, fol. 95r

In Christi nomine amen anno mccccxli die primo Septembris pro quattuor mensibus pro tempore futuro. existentibus

Johanne Magistrj petri
Guarente Johannis guarenti
Andrea nofrij romoli et } Consulibus
Nicolao parentis lippi

citta Masus Mathei scarpellatore di septignano

DOC. 13. Matriculation of Antonio Rossellino in the
Arte dei Maestri di Pietra e Legname 1451

ASF, Arte dei Maestri di Pietra e Legname, Libro 2, fol. 102r

In Dei nomine amen anno dominj ab eius Incarnatione mcccclj die primo maij 1451 pro
quatuor mensibus pro tempore futuro existentibus
Juliano honofrj Romolj ⎫
Nicholao parentis lippj ⎪
⎬ Consulibus
Laurentio cionis ghibertj ⎪
Juliano Rossj petrj ⎭

citta Antonius Mathei Intaglatore sive lastraiuolus

DOC. 14. Bernardo Rossellino, on behalf of Pagno di Lapo Portigiani
and Giovanni Rossellino, requests payment for the
Tabernacle of the Baptismal Font in the Duomo, Massa
Marittima 1462

ASF, Notarile A 192 (Ser Francesco Albini, 1455–75), fol. 162r

1462
(*in the left margin*: Restitutum in publicam formam
 Procura Pagni lastraiuoli
 et Johannis Matej)

Item postea in dictis anno, indictione (10ª) et die primo mensis junij actum in populo
Sancti Stefani abbatie Florentine presentibus Ser bindo Lodovicj Cassi et Ser Matheo Pieri
Guerrucj et Ser Thomasio Ser Bartholomej Nerj de Orlandis civibus notariis florentinis
testibus etc.

Pagnus olim Lapi Pagni scultor lapidum populi Sancti Laurentij de Florentia et Johannes
olim Matei de Gambarellis scultores (*sic*) lapidum et populi Sancti Petrj Maioris de
Florentia. Et quilibet ipsorum insolidum et de per se omni modo non revocando etc.
fecerunt suum procuratorem etc. Bernardum olim Matej de Gambarellis scultorem lapi-
dum et civem florentinum presentem etc. ratificando aprobando et aceptando et con-
firmando primo et ante omnia quandam conpositionem factam jam est (*sic*) annos et ultra
per dictum Bernardum cum operarijs infrascriptis vice et nomine dictorum constituentium
etc. generaliter etc. ad agendum causandum etc. Item ad exigendum quascumque quantitates
pecuniarum quas ipsi constituentes et quilibet ipsorum habere debent vel petere possint
operarijs ecclesie chathedralj civitatis Masse districtus civitatis Senarum occasione mercedis
cuiusdam hedificj et operis facti in dicta ecclesia dicte terre Masse: videlicet in edificando et
sculpendo de (*sic*) in lapidibus marmoreis unum fontem deputatum ad sanctum baptisma
in dicta ecclesia per dictos Pagnum et Johannem seu alterum eorum jam sunt quindecim

annj vel circa. Item de exactis finiendo etc. Item ad faciendum capi et personaliter stagirj etc. Item ad intrandum in tenutam etc. Item ad petendum in solutionem etc. Item ad substituendum etc. etc. et cum relevatione oneris satisdandum etc.

DOC. 15. The Sculpture of the Facade of the Palazzo della Fraternità, Arezzo 1433–36

(From Fabriczy, *JPK*, 1900, pp. 106ff, doc. 1 and Alessandro Del Vita, "Contributi per la storia dell'arte aretina," *Rassegna d'arte*, xiii, 1913, p. 188.)

Venerdì a dì xxiiij.° d'aprile 1433. A Bernardo di Matteo da Settingnano m.ᵒ di pietra, Giovanni di Piero di Ciori da Settingnano, Ciechino di Giagio da Settingnano e Giuliano di Nanni da Settingnano deliberaro ch'e sopradetti maestri di pietra facessero il lavorio di la Fraternita. Essi promisoro (*sic*) averlo fatto per tutto il mese di ottobre prossimo che viene, chome per mano di ser Nastasgio notaio di la chasa si contiene (Arezzo, Archivio della Fraternità di S. Maria della Misericordia, *Giornale 1433–1435*, fol. 7v)

Venerdì a dì 16 ottobre 1433. In nel palazzo predetto fu deliberato per li rettori che il tempo di l'aloghasgione del lavorio di la facciata sia prorogato ai maestri per tutto novembre prossimo che viene (*ibid.*, fol. 32r)

Domenicha a dì 21 di março 1434. Item providero e hordinaro e stanziaro che Chiaromanno camarlingo predetto dià e paghi a m.ᵒ Bernardo di . . . da Settingnano fiorini dieci cioè lire 40 per parte di suo salario di fiorini 90 per salario di nostra donna (*ibid.*, fol. 51r)

Giovedì a dì 27 di maggio 1434. Item deliberaro che Chiaromanno di Grigoro camarlengo di la facciata dia e paghi all'infrascritti per le infrascritte ragioni . . . A Rosso del Ciennaroso e a Checho d'Agnolino detto Lodola per tre dì dati con due paia di buoi a trassinare le pietre per le fighure di santo Donato e santo Grighoro, in tutto l. 12 s. 10 (*ibid.*, fol. 55r)

Domenicha a dì 17 di giugno 1434. Fu deliberato che Piero di Franc.° camarlingo di la Fraternita possa e a lui sia lecito vendere tanto grano che monti fiorini cinquanta del grano di la casa, e' quali dia a paghi a Chiaromanno di Grighoro camarlingo di la facciata, i quali el detto Chiaromanno dià e paghi a Bernardo m.ᵒ predetto per parte di suo salario di fiorini novanta, i quali esso dia avere per suo salario di facitura di nostra donna . . . fior. 50 (*ibid.*, fol. 57v)

Mercoledì 30 cioè ultimo di giungno 1434. A Simo (?) provveditore predetto l. 3, 4, 8 per spese facte in vino, pane e carne, cascio e frutta per li maestri e manovali quando si tirò su nostra donna sopra la porta di detta Fraternità, e per colatione facta a miss. lo vicario e al capitulo dela pieve e del veschovado e a' trombetti che vennero a honorare dicta nostra Madre e cantare il divino uffitio e a molti altri cittadini che furono presenti (*ibid.*, fol. 58v)

A Chiaroma(n)no di grigoro chama(r)lengo de la facciata de la fraternita g(rossi) quarantadoi (quarantadue) s(oldi) di(ec)i a lui stanciati che pagas(s)e a bernardo maiestro di scharpello p(er) parte di denari (che) ave avere p(er) fattura di nostra don(n)a e

p(er) lui pagati a piero di franc(esc)o cam(arlingo) al detto bernardo a di ultimo di giugno (1434) (*Libro 37*, fol. 34v)

Venerdì a dì 16 di luglio 1434. Chiaromanno di Grighorio provveditore e camarlingo de la facciata dià e paghi a Bernardo da Settingnano m.^{ro} di scharpello per parte di suo salaro di nostra donna . . . fior. 30 (*Giornale 1433–1435*, fol. 61r)

Venerdì a dì 23 di luglio 1434. Nel palazzo dei priori nella loro audientia fu deliberato per detti rettori che Chiaromanno di Grigoro camarlingo di la facciata dià e paghi a Bernardo, Ciechino, Giuliano e Giovanni da Settingnano scarpellatori ogni resto che dovessino avere per loro salaro del lavorio di la facciata, che monta d'accordo de le parti l. 802 s. 8 (*ibid.*, fol. 61)

Domenicha a dì primo d'aghosto 1434. Giuliano di Nanni, Bernardo di Matteo, Ciechino di Giagi, Giovanni di Piero, tutti da Settingnano del piviere di Ripoli del quartiere di santo Giovanni di Firenze maestri di scharpello, confessaro avere auto da Chiaromanno di Grighoro camarlingo e provveditore di detta facciata, così in verità ebbero e ricievero in più volte e in più partite lire ottociento dieci, soldi due in fiorini, grossi e quattrini (*ibid.*, fol. 61v)

Martedì a dì ultimo d'aghosto 1434. Item alogharo a m.^{ro} Bernardo m.^{ro} de'ntaglio due fighure di santo Lorentino e Persentino che vanno in detta facciata da lato il manto di nostra donna, le quali promise fare belle, di meço rilievo secondo il disegno dato a dichiarisgione d'onni bono maestro, le quali promise dare fatte e cavate a tutte sue spese per tutto ottobre che viene; a loro promisero darli e pagarli per sua fattura fra cavatura e carratura fiorini sei a lire quattro per fiorino (*ibid.*, fol. 63r)

1435 a dì (21 di giugno).
A maiestro Bernardo di . . . da sitignano maiestro di scharpello g(rossi) 40 p(er) parte di suo salaro de le figure d(a) lui fa(t)te i(n) fraternita di s(an) donato e di s(an) grigoro a lui stanziati . . . detto di 16 daprile (*Libro 39*, fol. 34)

Venerdì a dì 22 di luglio 1435. Item feciono commessione a Michele di Conte e Marcho di Luca due del numero dei rettori in potere aloghare a m.^{ro} Bernardo m.^{ro} d'intaglio il lavorio che si deba fare overo compassi et c. che si deba fare sopra la facciata dinanzi a la casa di detta fraternita, e col concio da lato di sopra verso e fondachi vechi, non passando la somma di fiorini sessantacinque d'oro (*Stanz. e Delib. 1435*, fol. 10r)

Sabato a dì 20 d'aghosto 1435. Item dicto dì congregati detti rectori, aloghorono a m.^{ro} Bernardo di Matteo da Settingnano m.^{ro} di scharpello il lavorio, cioè uno bechatellato con compassi sono sopra la facciata a sommo a la chasa di la Fraternita, in nella forma che detto m.^{ro} Bernardo dede il disegnio, esietto (eccetto) che le teste le quali il farle e non farle rimane ala discritione di detto m.^{ro}; il qual disegnio è nella casa di detta Fraternita apresso ser Agnolo di Gratia not. di detta Fraternita. E a piè d'esso disegnio è scritto le pietre e mesure di detto lavorio per prezzo in tutto di fiorini 50 d'oro. E debba e così promette detto m.^{ro} Bernardo aver fornito eldetto lavorio infra uno anno prossimo che dia avenire oggidì cominciando; con patto che detto m.^{ro} Bernardo debba fare el detto lavorio a tutte sue spese in cavare, condurre pietre e murare e ogni altra cosa, salvochè di ferri e piombo che bisognassi per aconcime di detto lavorio come spranghe e cose simili (*ibid.*, p. 11v)

Die xx mensis augusti (1435). Item (rectores) stantiaverunt eidem Chiaromanno quod similiter det et solvat dicto Bernardo pro cavatura lapidum tempore preterito videlicet pro figuris sanctorum Donati et Gregorii l. 4 s. 13 (*Stanz. e Delib. 1430–1437*, fol. 67r)

Die veneris xxvj mensis augusti (1436). Magister Bernardus Mattei de Settingnano magister lapidum sive scalpelli sponte fecit fin(al)em quietationem de omni et toto eo et de omnibus et singulis quantitatibus pecunie et florenorum auri, quod quam seu quas dictus Bernardus petere et exigere posset a dicta Fraternitate usque in presentem diem, occasione et pretextu cujuscumque laborerii sive hedificii, quarumcumque figurarum et conci facti per dictum Bernardum (*ibid.*, fol. 67v)

DOC. 16. The Tabernacle of the Sacrament in the Badia, Florence 1436–39

ASF, Conv. soppr. 78, Libro di ricordanze segnato B

22 di settembre 1436
Alla sagrestia e per lei a Bernardo di mateo lastraiuolo fj uno d'oro di camera porto el detto per parte del tabernaculo. (fol. 42)

a di 31 d'ottobre 1436
Alla Sagrestia lire 6 s. XV per lej a Bernardo di Mateo lastraiuolo porto e' detto chontante in quattrini per parte del tabernacholo. (fol. 52v)

a di 10 di novembre 1436
Alla sagrestia lire dodici per loro a Bernardo di Mateo lastraiuolo portò chontante in quattrini per parte del tabernacholo. (fol. 54v)

martedì a di 15 di gienaio 1436 (s.C.: 1437)
Alla segrestia del monesterio lire qatro per lej a Bernardo di Mateo lastraiuolo per parte di Jº tabernacholo fa alla segrestia. (fol. 68)

venerdì a di 31 di gienaio 1437 (s.C.: 1438)
A Bernardo di Mateo lastraiuolo lire quatro; porto contante per parte del tabernacholo. (fol. 149)

lunedì a di 3 di febraio
A Bernardo di Mateo lastraiuolo lire qatro piccioli porto contante per parte del tabernacholo porto contante. (fol. 149v)

ASF, Conv. soppr. 78, 1 (Giornale B, 1435–1441)

1439 . . . a di 28 di marzo
Alla sagrestia del monastero s. 18 piccioli a un topaiuolo per una toppa fa allo sportello del sagramento. s. 18. (fol. 230v)

1439 . . . a di 29 di Marzo
Alla sagrestia lb. quatro s. 10 piccioli per loro dati a Niccolo degli Uriuoli orafo per dorare lo sportello del sagramento. lb. 4 s. 10. (fol. 231)

1439 . . . [4 aprile]
Alla sagrestia del monastero s. iiij piccioli paghò fra Quirino per gli arpioni dello sportello
del sagramento a di 4 d'aprile 1439. s. 4. (fol. 231v)

1439, venerdì adì 15 di magio
Ala sagrestia del monastero f. tre s. 19 piccioli per lei a Ngniolo di Nicholo horafo e
compagni porto contanti sono per facitura di uno sportello pel sacramento del monastero,
cioe rame e saldattura ando in detto sportello. (fol. 328)

DOC. 17. The Portal of the Sala del Concistoro in the Palazzo Pubblico, Siena 1446

(From Tysz, BR, pp. 108f, doc. 8)

Anno Domini MCCCCXXXXVI, indictione VIIII die vero XXIIII, mensis Junij. Mag-
nifici et potentes domini Priores etc. . . . atenta deliberatione Consistorij facta de reficiendo
seu fieri facendo spallerias porte Consistorij, de qua constat manu ser Johannis Benedicti
tunc notarij Consistorij, sub die 25 Februarij 1445; hinc est, quod ipsi magnifici domini . . .
locaverunt et ad faciendum dederunt magistro Bernardo Mattei de Florentia presenti, etc.
dictam portam Consistorij; faciendo eam totam de marmo carrarese; faciendum stipitos,
architraves, cornices, cardinales, et quod quodlibet de per se sit de uno pezo; ac etiam
faciendum totum politum, straforatum, pomicatum, lustratum, et bene repertum ad usum
et dictum cujuslibet boni et inteligentis magistri: cum quatuor mediis figuris virtutum
cardinalium pur di marmo carrarese: et quelibet ipsarum figurarum sit altitudinis unius
bracchij, cum armibus et aliis ornamentis, prout constat per quoddam designum factum
per eundem magistrum Bernardum; quod designum est penes Gorum Johannis de' Mas-
sainis, operarium Camere.

Quod laborerium a dictis figuris infra, ipse conductor promisit . . . esplevisse et finivisse
ad tardius usque ad festum sancte Marie Augusti proxime venturi citra, e dictas figuras
explevisse ad tardius usque ad festum Paschatis Nativitatis domini Jhesu Christi proxime
venturi citra; ac etiam promisit omnia necessaria ed oportuna ad dictum laborerium et
ponere dictum marmum omnibus suis propriis sumptibus et expensis: reservato tamen
quolibet justo impedimento, in quantum non explevisset ut supra: Pro quo laborerio et
magisterio et omnibus et singulis supradictis habere debeat, et habeat florenos . . .
(*In the margin*: Nota, quod non posui pretium, quia dictus magister non fecit debitum
suum. Ego Marianus Bartholi Sanctis notarius Consistorii, rogatus subscripsi.)
(Archivio delle riformagioni di Siena. Libro detto de' Casseri Grad: XXVII. No. 58, fol. 58v)

(From the *Libro d'entrata ed uscita* of the clerk of the Commune, Goro Massaini)
1446 Maestro Bernardo di Matejo maestro di pietra da Fiorenza, die dare lire treciento
vinti sei, soldi sette, sono per parte di lire 500 de la porta di Concistoro, la quale lui debe
fare a marmo cararese con quatro figure da capo di braccio, come apare da detta allogagione
in Concistoro di mano di ser Mariano di Bartolo, notajo di Concistoro, e apare a livro
Memoriale di me Ghoro operajo detto a fo: 65. (Siena, Biblioteca pubblica, Codice C. I, 21,
fol. 107)

DOC. 18. The Annunciation in the Museum of the Collegiata,
Empoli 1447

(From Odoardo H. Giglioli, *Empoli artistica*, Florence, 1906, pp. 160ff)

1447 Gli uomini e fratelli di detta conpagnia spirati dallo spirito santo si risolvano a fare la imagine della nuntiata elangelo di marmo per adornare laltare e areverentia de populi et per tal conto feciano per lor sindaco cioe Luigi dj lando cittadino fiorentino el quale allogo a bernardo di matteo intagliatore di pietre habitante nel populo di san anbrogio infirenze con conditione epattj che il predetto debba fare le dette dua figure di marmo bianco con quella piu belleza potessi e sapessi et come ben si conviene con alteza ciaschuna di braccia dua con fregi dorati e con sua base ben conditionate e cosi ogni rimanente et questa allocatione fu fatta adi 2 dagosto mille quattrocento quarantasette per darle finite fra quatro mesi et condutte aempoli nella detta conpagnia aogni sua spesa et con starne a juditio di lorenzo di bartoluccio fiorentino (Ghiberti) el quale le judico per belle e ben fatte eproportionate ela detta compagnia per pagamento di dette figure al detto bernardo pagorno actualmente fiorinj trentasei doro a uso corrente di firenze cioe . . . le quali figure sono al presente in detta conpagnia sul nostro altare dove di continuo concorre di molto populo dogni sesso aonorare la detta imagine della gloriosa vergine e alej raccomandandosi che pregi (*sic*) per tutti i fedeli cristiani il grande Dio che ci dia salute alanime deo gratias. (Empoli, Archivio dell'Opera di S. Andrea. *Memorie della soppressa compagnia della SS. Annunziata nella chiesa degli Agostiniani d'Empoli*, 1576, no. 4, fol. 9)

Nel 1444 fu fatta fare l'Imagine di marmo della Sant.ᵐᵃ Nunziata e per tal effetto fu da i fratelli venduto un Campo di detta Compagnia di staia tre posto a Empoli vecchio a m. Antonio di Giov. Malepa, et il prezzo di detto campo servi per pagare lo scultore che la fece, come di cio n'aparisce il ricordo fatto dal detto m. Antonio al suo Libbro di Ricordi esistente nell'opera della collegiata d'Empoli in fra le scritture di detta opera a c. 33. (Empoli, Archivio dell'Opera di S. Andrea, *Campione Beneficiale A*, fol. 133v)

DOC. 19. The Tabernacle of the Sacrament in S. Egidio (S. Maria Nuova),
Hospital of S. Maria Nuova, Florence 1450

ASF, Archivio dell'Ospedale di S. Maria Nuova, 5044: Quadernuccio di cassa 1449–1452, fol. 18v.

Bernardo di Matteo, scarpellatore, de' dare a dì XI di Febbraio 1449 (s.C.: 1450) lire venti piccioli; portò contanti, disse per parte di lavorio gli fa l. 20.
E a dì XXVIII di Febbraio l. 10 piccioli portò contanti.
E a dì IIII d'Aprile 1450 l. 8 piccioli portò contanti.
E a dì XXIIII detto l. 20 piccioli portò contanti.

E a dì VI detto l. 8 piccioli portò contanti sono per resto d'uno tabernacolo fecie per lo sacramento dallato delle donne. Messi a uscita segnato SS. c. 82 lire 66.

1450. Lorenzo di bartoluccio intagliatore de' dare a dì XXX di Luglio 1450 fiorini tre d'oro larghi, portò Vettorio di Lorenzo, contanti, per parte d'uno sportello d'uno tabernacolo da sacramento.
E de' dare a dì 19 di settembre 1450 fiorini cinque larghi, portò Vettorio suo figliuolo, contanti. (fol. 30r)

Lorenzo di Bartoluccio intagliatore de' dare a dì XXX d'ottobre 1450 fiorini due larghi portò Vettorio suo figliuolo contanti.

E de' dare a dì XXVII di Novembre 1450 fiorini tre lire tre soldi 19, portò Vettorio di Lorenzo contanti, sono pe' resto d'uno sportello di bronzo fatto al Sacramento nello Spedale delle donne.

Messi a uscita c. 67. (fol. 36r)

ASF, Archivio dell'Ospedale di S. Maria Nuova, 5063: Quaderno di Cassa 1448–1450, fol. 187.

1450. Spese minute e straordinarie . . . a dì XXII detto (aprile) lire una soldi 4 piccioli, sono per dare a portatori per recare zucchero e il tabernacolo del Corpo di Cristo dallato delle donne.

DOC. 20. The Tomb of the Beata Villana in S. Maria Novella, Florence 1451–52

ASF, Conv. soppr. 102 (S. Maria Novella di Firenze), 101, foll. 196r-v

Sia manifesto achj vedra la presente scritta chome egle certa chosa che bernardo dimatteo lastraiuolo del p̄plo di santo ambrogio. dasettignano, a tolto affare dame frate bastiano di Jacopo sindacho e prochurato del convento di Santa maria novella, una sepoltura di marmo la quale ae astare nelmuro sotto il crocifisso che e disopra al corpo della beata villana in questo modo cioè chella detta sepoltura comincj in terra uno fregio dimarmo Nero alto uno terzo Lungho braccia tre e sette ottavj. disopra aquesto una basa dimarmo biancho Luncha braccia tre e mezzo. crossa uno sesto scorniciata pulita. disopra una tavola dimarmo rosso. Lungha braccia tre e uno quarto. alta uno braccio a uno terzo recinta Ladetta tavola duna cornicciuzza morta dolce e bem pulita. E di sopra Ladetta tavola una cornice di marmo biancho, scorniciata bene conintaglj bellj crossa uno sesto. larcha uno terzo tutte le dette chose faccino una testa dichassa di sepoltura concornice di sotto e di sopra alta in tutto col fregio nero braccia due. E poj disopra alla detta chassa. Uno padiglione di marmo biancho di larchezza il difuorj di braccia quatro iscarso. alto dalla chassa in su braccia due e mezzo colla testa dellione sotto il detto padiglione la figura della beata Villana achiacere intagliata di mezzo rilievo. di lunghezza di braccia tre come sta quella che ve dipocho rilievo. E questo ae aessere dimezzo rilievo. Dipoj sotto el detto

padiglone ae aessere due angnolj dimezzo rilievo. iqualj anno atenere colluna mano il panno del padiglone e collaltra una carta cioè uno epitafio conquelle lettere che Io gli dirò intagliate e messe dj nero aolio. El detto drappo cioè il panno del padiglone vadj giu insino apresso alla basa della chassa. Eldetto drappo sia frangiato intorno isbrizzato doro. E poi dentro nel campo del padiglone di drieto brocchato doro edaltro colore Nero e brocchato di fuorj variato da quello di dentro. E tutto il detto lavorio ritornj alto con ignj suo lavorio braccia quattro emezzo. elargho come edetto disopra

Ancora il detto bernardo abbia ataglare e smurare. e murare. e amandare via i calcinaccj. e affare tutto il detto Lavorio netto aognj sua spesa doro e dognaltra cosa. ex cetto che Io abbia solo affare alzare il crocifisso quello equanto sara dj bisogno amia spesa. tanto chel detto Lavorio cisipossa porre sotto. E per le dette chose Io frate bastiano di Jacopo sopradetto dilicentia del mio priore debbo dare al detto bernardo lire ducento cinquanta di detto lavorio. El detto bernardo promette sotto la pena di fiorinj ventj darcj fatto il detto lavorio per tutto dicembre proximo cheviene

E Io frate bastiano globricho come sindacho eprocuratore i fructj del podere di marignolle che in chaso che Io nol pachasse abbia dipotere ricorre quivj. Alla quale scritta si soscriverra il detto bernardo essere contento alle dette cose disua propria mano aquesta scritta laquale Io frate bastiano o fatta di sua volonta questo dj 12 di luglo 1451. E ancora frate Guido dimichele al presente priore del convento di santa maria novella dammj licentia e dessere contento alle dette cose. E o uno disegno di sua mano come astare ildetto Lavorio il quale disegno o Io frate bastiano detto' attenere apresso ame

Io bernardo dimateio sopra detto sono contento quanto di sopra si contiene e per chiarezza di cio mi sono soscritto di mia propia mano questo di 12 di luglio 1451

Io frate guido dimichele priore al presente di s̃c̃a m̃a novella do licentia aldetto frate bastiano che faccifare eldetto lavorio e obligarsi alla detta spesa e per chiarezza dicio misono soscripto alla detta scripta dimia propria mano questo dj xij di luglo 1451

Ancora siamo rimasj dacordo difare una giunta adetto lavorio in questo modo cioe due stipitj di marmo biancho chonuno archo su amezzo tondo e scorniciato amodo darchitrave lavorato dolce glistipitj altj braccia due e mezzo larcho dirichoglio braccia due. larcho il vano dellarcho braccia quattro. larghj gli stipitj in faccia mezzo braccio. crossj uno quarto dituttto detta agiunta dognj spesa che vi va fornito fine apieno eaperfectione come detto e nellaltro e messo di colore azurro il campo. gli debbo dare lire cento. e chosi siamo rimaso dacordo e che alzare il tabernacholo del crocifisso sia a spesa del detto bernardo eper chiarezza dicio il detto bernardo sisocriverra di sua mano essere contento alla detta agiunta questo dj 27 di genaio 1451 (s.C.: 1452) E debbe avere fatto detto lavorio per di qui a pasqua di resurressio proxima che viene

E se Io frate bastiano volessj riducere in minore quantita il tabernacolo dj detto crocifisso Io labbia affare amie spese e ridotto che fusse in minore qualita. Eglj labbia affare appichare nel muro in quel modo cheglj parra che stia bene a sue spese echosj dato ispichato a sua spesa. Solo toccha ame frate bastiano apachare laspesa di ridurlo aminore qualita se mi parra. ognaltra spesa dognj minima chosa toccha al detto bernardo e compangnj.

Io bernardo dimatteio sono chontento quanto di sopra si chontiene acetto chel crocifisso nonsono tenuto apaghare neferro nepiombo nedipintura nemaiestero dilegname ma ongnj altra chosa alle mie spese E piu debbo fare una chornignia di marmo intagliata nel modo del padiglone mavadano amie spese ogj questo dj 27 di genaio 1451 annulando ongnj pena sopra scritta e salvo giusto impedimento

DOC. 21. Testament of Orlando de' Medici 1455

ASF, Notarile B 1181 (Giovanni Beltramini, 1405–56), n.p.

In dei Nomine Amen Anno domini ab eiusdem salutifera Incarnatione millesimoccccLquinto Indictione quarta et die sexta mensis decembris Actum in civitate florentie et in populo Sancte margherite de florentia et in domo habitationis infrascripti domini orlandi testatoris presentibus testibus ad infrascripta omnia et singula proprio hore infrascripti testatoris vocatis habitis et rogatis, videlicet, Domino Lutiano francisci da parma priore infrascripte abbatie, et Domino mariano petri de florentia, et Domino Zacheria Johannis da bibiena, et Domino michaele Ser Stefani de pistorio, et Domino marcello bernardi de florentia, et Domino francescho Augustini de florentia, et Domino Germano Laurentii de florentia, et Domino Juliano Nicholai de florentia, omnibus monacis profexis abbatie sancte marie de florentia, et Domino Laurentio Johannis canonico vulterrano et rectore ecclesiae sancte Johannis de Senni de mucello comitatus florentie et alijs.

(*in the left margin*: Rogatus per me Johannem Ser taddei de colle notarium florentinum sub die sexta mensis decembris 1455)

(*in the right margin*: Redditum publice piero et Johanfrancischo heredibus die xxviiii decembris 1455)

Magnificus et generosus miles dominus orlandus olim gucci demedicis de florentia sanus per dei gratiam mente sensu et intellectu: licet corpore langueris: Considerans quod nichil est certius morte, et nil incertius hora mortis suum sine scriptis numeupatuum condidit testamentum et ultimam voluntatem in hunc modum, videlicet

(*in the left margin*: Decessit die decima mensis decembris 1455 de sero)

In primis quidem animam suam recommendavit altissimo eius creatori eius quam gloriosisime matri semperque virgini marie, totique cellestie curie paradisi. Corporis vero sui sepulturam, cum de hoc seculo migrari contigerit, elegit et esse voluit in ecclesia servorum sancte marie de florentia et in cappella sancte marie magdalene quam ibidem in dicta ecclesia, dictus testator ut dixit construi fecit. Et iussit et voluit dictus testator quod infrascripti eius heredes teneantur et debeant infra unum annum proxime futurum a die mortis dicti testatoris, fecisse construi et fieri in dicta cappella sancte marie magdalene unam sepulturam marmoream prout in similibus consuevit. In qua sepultura et pro ipsius constructione expendi voluit, debonis et substantia dicti testatoris florenos auri centum. Et in casu quo predicti infrascripti eius heredes—predicta non fecerint infra dictum tempus unius anni: Eo casu reliquit et legavit arti et universitati artis cambij civitatis florentie florenos auri centumquinquaginta cum honere quod dicta ars et universitas dicte artis et seu consules dicte artis pro tempore existentes teneantur et debeant fieri facere in dicta cappella dictam sepulturam de marmore, prout in similibus consuevit. In qua et pro qua expendet et expendere teneantur et debeant pro omnibus propterea opportunis ad minus usque in quantitatem florenorum auri centum. Et voluit corpus suum interim quousque perfecta fuerit dicta sepultura, deponi ibidem inquadam cassa prout in similibus consuevit. Rogans et gravans consules dicte artis pro tempore existentes quatenus predicta fieri faciant quam primum comode fieri poterit. De predicta eorum conscientias honerando. Et circa sui coporis exequias expendi voluit quid et quantum et prout infrascriptis eius heredibus videbitur et placebit.

Item reliquit et legavit opere Sancte Reparate sive sancte marie del Fiore et nove sacrestie dicte ecclesie (*illegible*)

Item amore dei et ut deus misereatur animo dicti testatoris reliquit et legavit ecclesie et fratribus capitulo et conventui ecclesiae servorum sancte marie de florentia pro dote cappelle sancte marie magdalene quam dictus testator ut dixit construi et edificari fecit in dicta ecclesia infrascripta bona videlicet unam apotecam positam in populo sancti stefani ad pontem de florentia cum sito et intratura dicte apotece, asserens et affirmans idem testator et situm et intraturam dicte apotece, spectare et pertinere ad ipsum testatorum. Et quam apotecam dictus testator dixit habere in dicto populo sancti stefani ad pontem de florentia, cui apotece a primo via a secondo bona artis mercantorum Kallismale de florentia aiij et a iiij bona monasteri sancti mathei de arcetri infra predictos confines vel alios veriores. Cum omnibus et singulis iuribus et pertinentiis dicte apotece. Cuius apotece redditus et pensionem voluit dictus testator perpetuo de servire celebrantibus quocumque tempore in futurum divina officia in dicta cappella. Rogans dictus testator priorem et fratres dicte ecclesie, pro tempore existentes quatenus de pensione et reddito et redditibus dicte apotece faciant celebrari continuo in dicta et ad dictam cappellam missas et divina officia pro anima dicti testatoris et eius predecessorum. Ac etiam faciant et fieri faciant quolibet anno in dicta cappella festum sancti iuliani die qua celebratur dictum festum, cum cera et missis et alijs in similibus consuetis. Ac etiam teneantur continuo retinere in dicta cappella accensam unam lampadem ad honorem dei et sancte marie magdalene et sancti Juliani. Et in casu quo prior et fratres dicte ecclesie pro tempore existentes predicta non facerent, et seu inaliquo predictorum deficerent. Eo casu privavit dictam ecclesiam dicto legato dicte apotece. Et eo casu reliquit et legavit ex nunc dictam apotecam cum iuribus et pertinentiis suis dicte arti et universitati artis cambij civitatis florentie, cum honere faciendi fieri in dicta cappella dictum festum sancte iuliani quolibet anno die quo celebratur dictum festum cum cera et missis et aliis in similibus usitatis. Ac etiam teneantur dicta ars cambij in dicto casu retinere in dicta cappella accensam unam lampadem continuo ad honorem dei et sancte marie magdalene et sancti iuliani ut supra dictum est.

DOC. 22. Permission to install an arch in the Capponi Chapel, S. Spirito, Florence 1488

ASF, Conventi soppressi 122, filza 128, fol. 96r

MCCCCLXXXVIIJ

Raggunoronsi glispettabilj operaj questo di 12. disettembre Niccholo di Giovanni Chaponj e Jachopo Guiciardini Niccholo Ridolfi e Rugeri Chorbinellj eper piero di Lu[to]zzo, Francesco Nasi e per Bertoldo Chorsini, piero suo figliuolo eperloro partito stanziorono ilservito daghosto chemo(n)to Lire dugento trentuno soldi vij. Recho Ser macchario diSer andrea. E apresso perloro partito ferono chelachase dechaponj overo efigliuolj digino di nerj potesino Rompere ilmuro della loro chapella emettervi uno graticholato di brozzo overo dottone chesivedesse larcha della sepoltura dinerj.

(*in the right margin*: Sepolcro di Neri Capponi)

Index

Illustrations

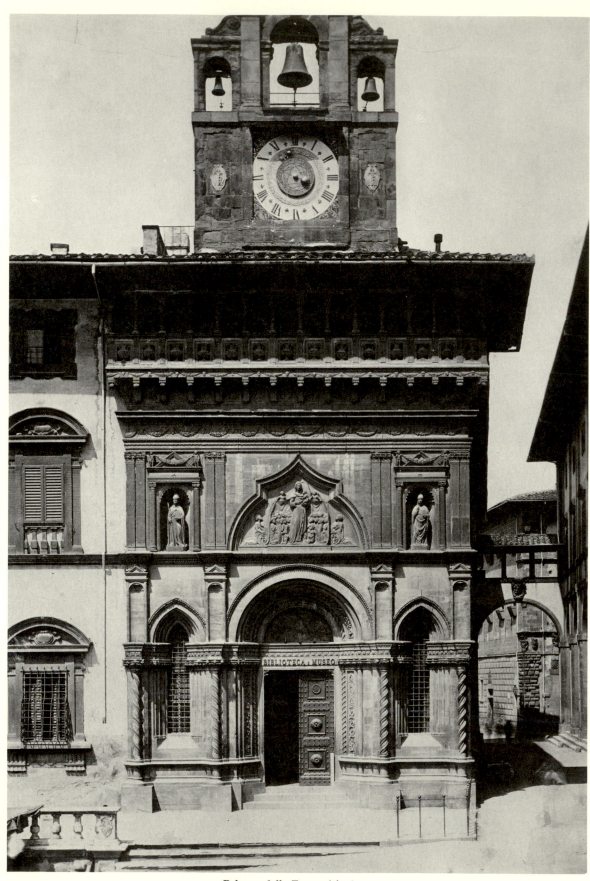

1. Palazzo della Fraternità, Arezzo

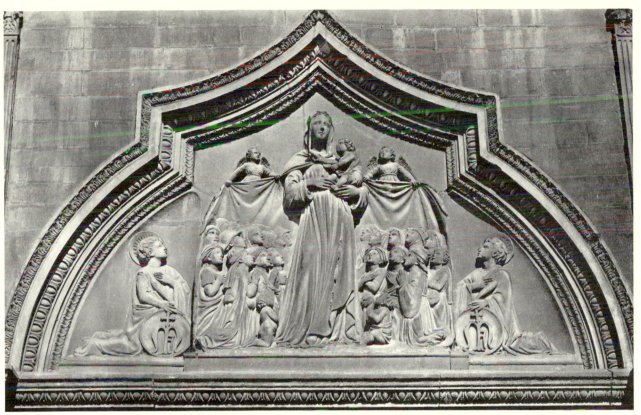

2. Bernardo Rossellino and Domenico Rossellino (?), Madonna del Manto with
SS. Lorentinus and Pergentinus, Palazzo della Fraternità, Arezzo

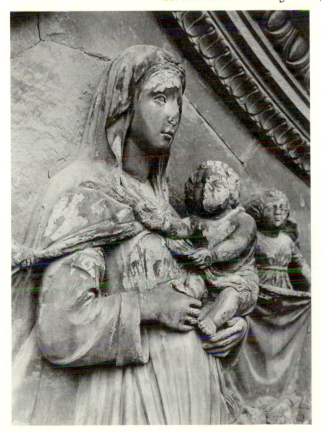 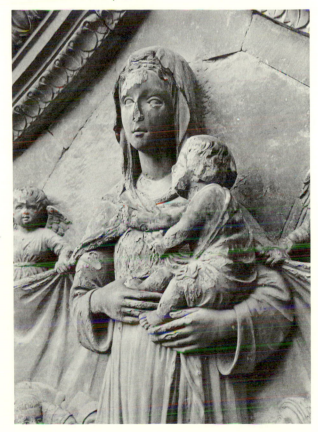

3-4. Bernardo Rossellino and Domenico Rossellino (?), details of Madonna del Manto

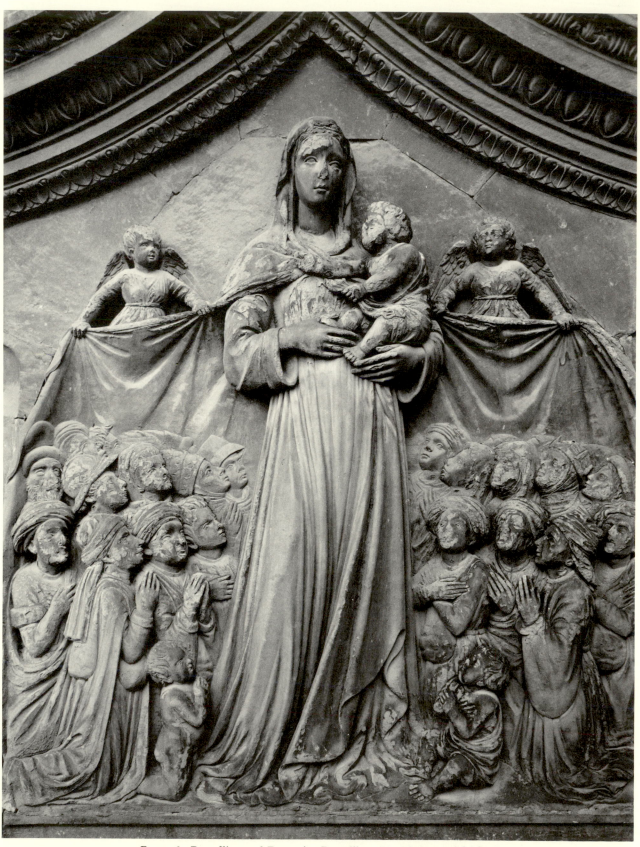

5. Bernardo Rossellino and Domenico Rossellino (?), Madonna del Manto

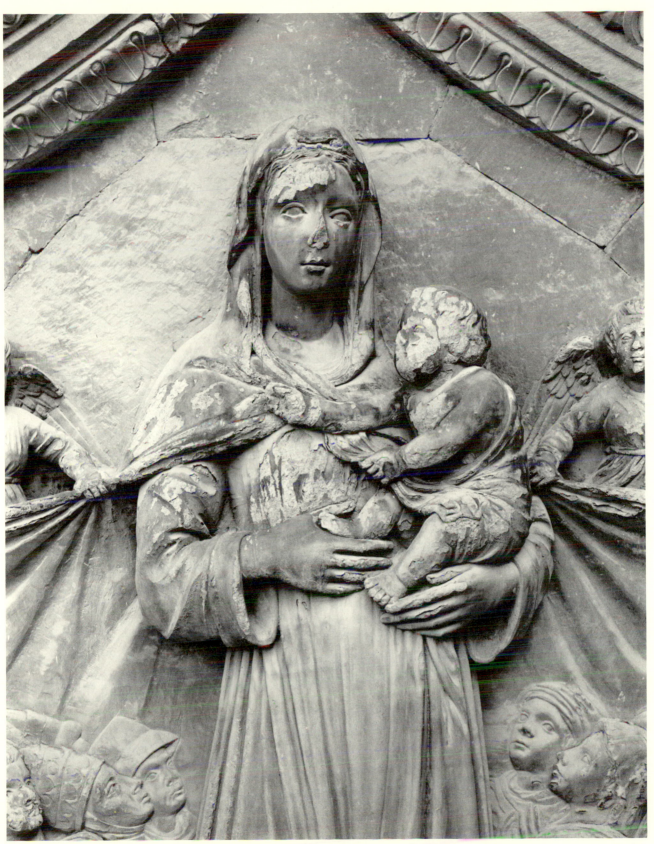

6. Bernardo Rossellino and Domenico Rossellino (?), detail of Madonna del Manto

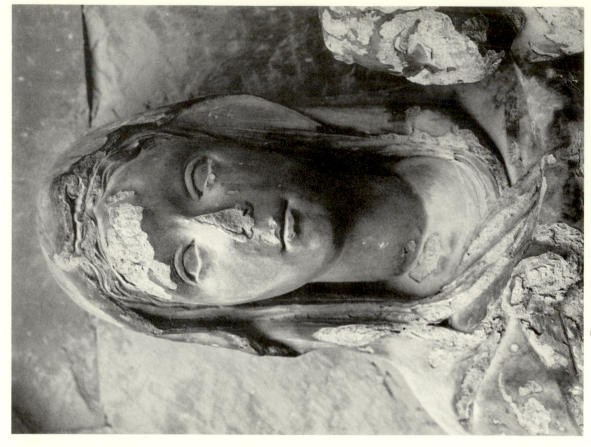

8. Bernardo Rossellino, head of Madonna del Manto

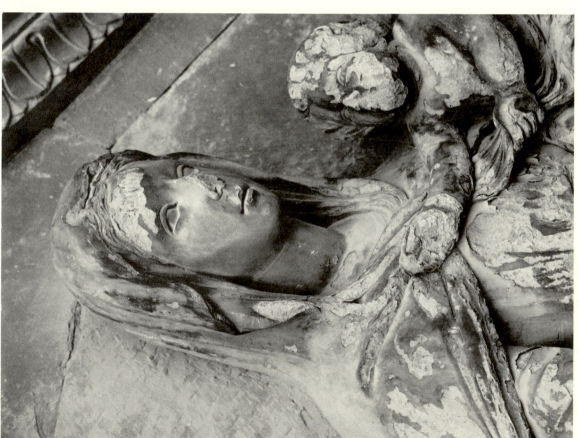

7. Bernardo Rossellino and Domenico Rossellino (?),
detail of Madonna del Manto

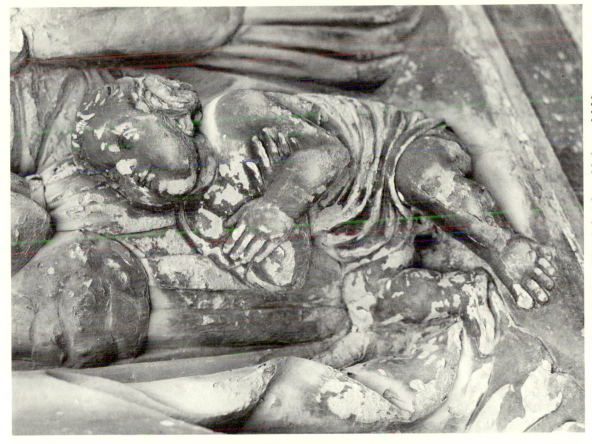

10. Bernardo Rossellino, infant from *Madonna del Manto*

9. Bernardo Rossellino and Domenico Rossellino (?),
detail of *Madonna del Manto*

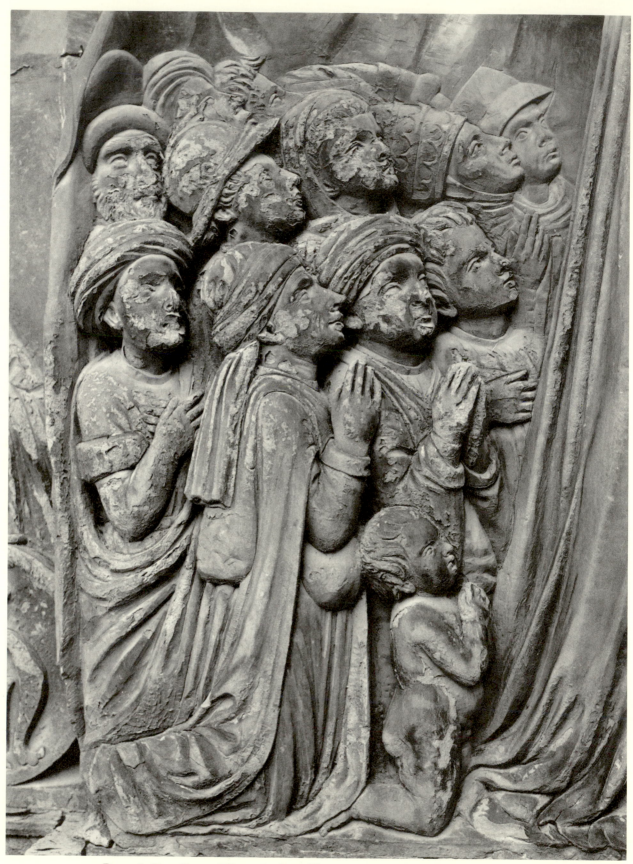

11. Bernardo Rossellino and Domenico Rossellino (?), detail of Madonna del Manto

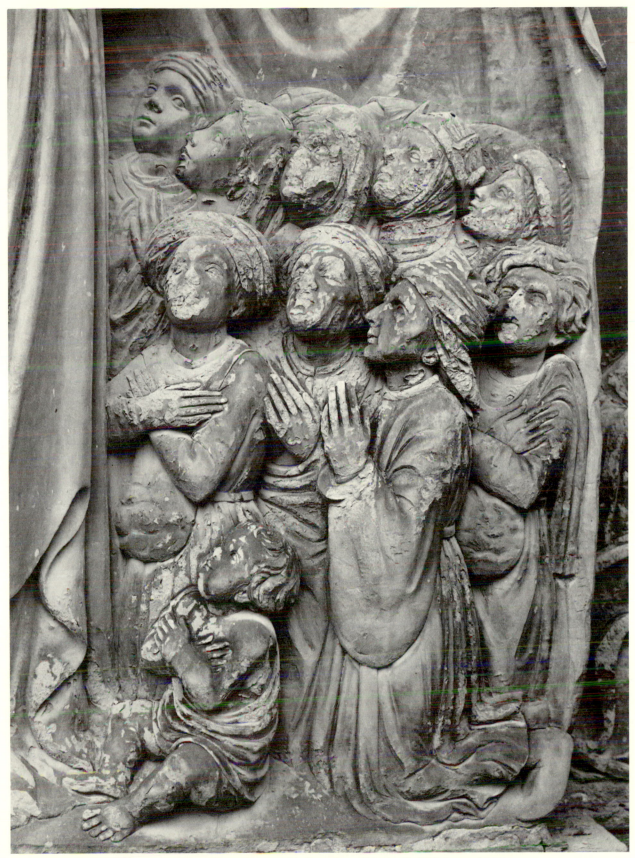

12. Bernardo Rossellino and Domenico Rossellino (?), detail of Madonna del Manto

14. Domenico Rossellino (?), right angel from *Madonna del Manto*

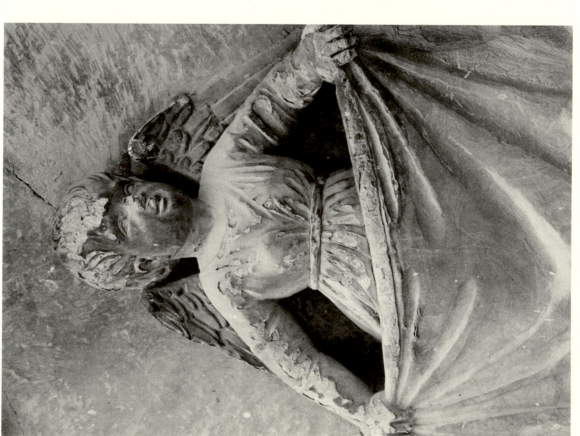

13. Bernardo Rossellino, left angel from *Madonna del Manto*

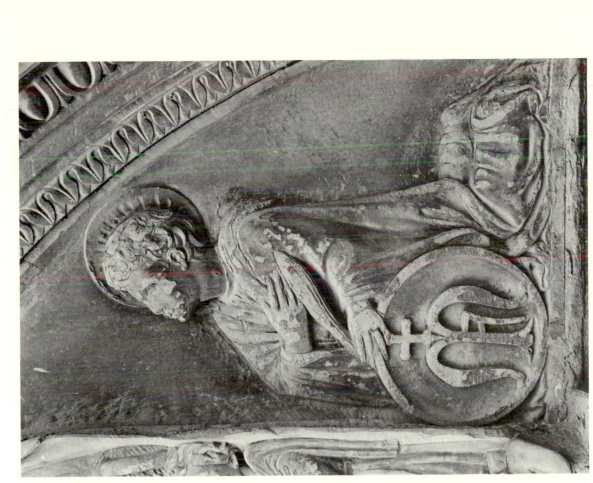

16. Bernardo Rossellino and Domenico Rossellino (?), right saint (Lorentinus or Pergentinus), Madonna del Manto

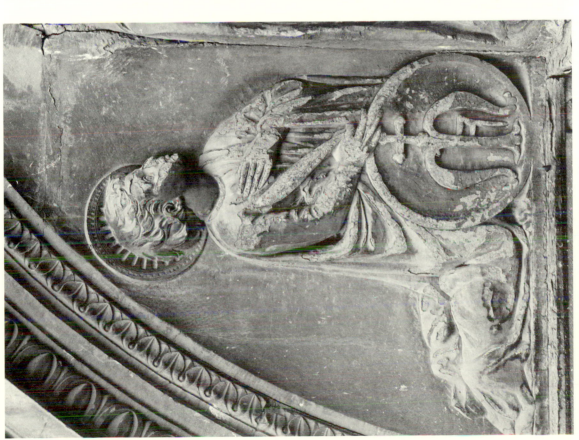

15. Domenico Rossellino (?), left saint (Lorentinus or Pergentinus), Madonna del Manto

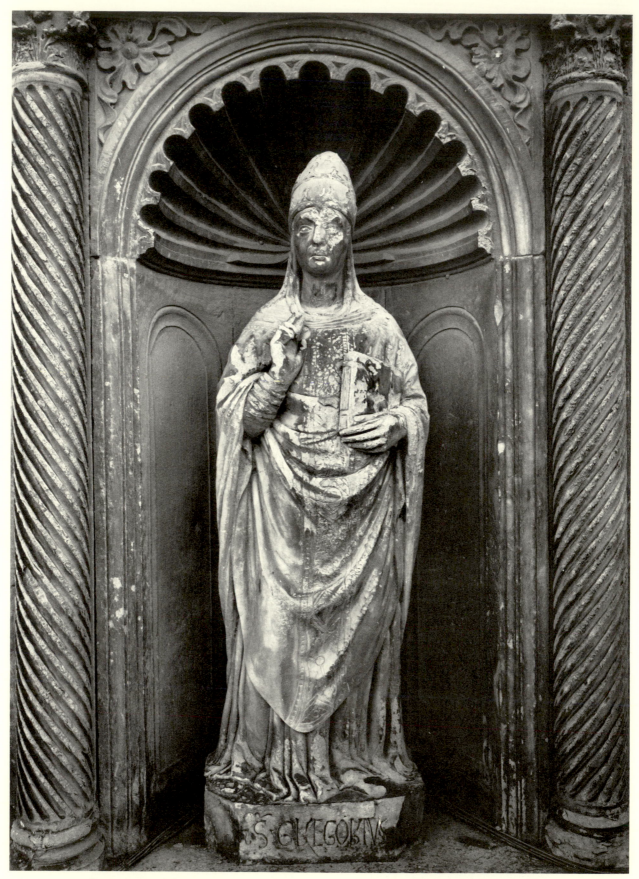

17. Bernardo Rossellino and Domenico Rossellino (?), St. Gregory, Palazzo della Fraternità, Arezzo

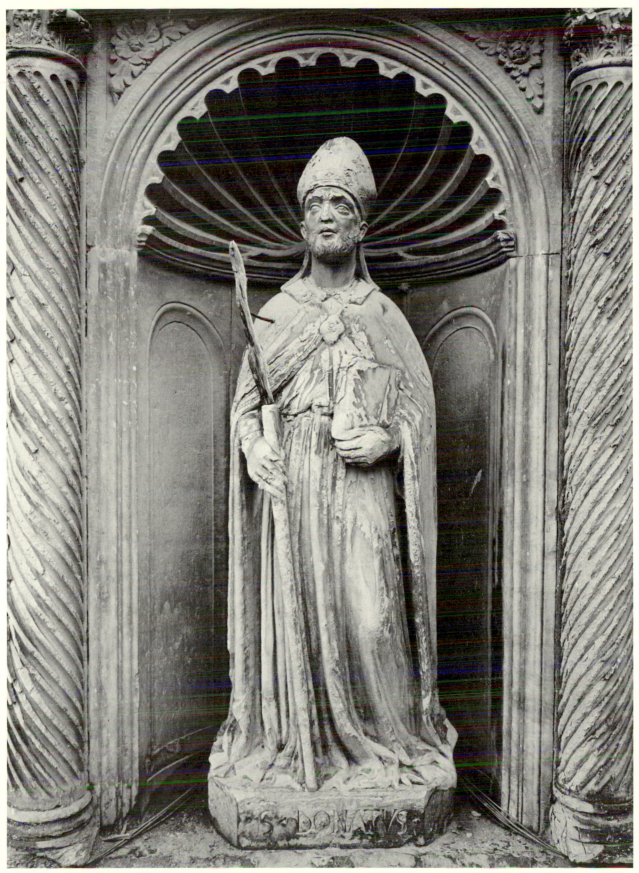

18. Bernardo Rossellino and Domenico Rossellino (?), St. Donatus, Palazzo della Fraternità, Arezzo

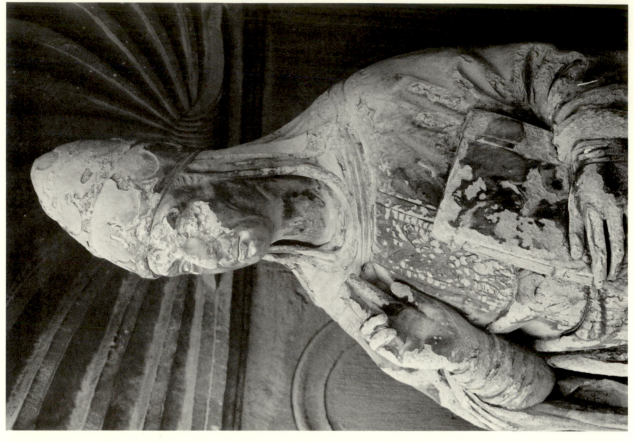

20. Bernardo Rossellino, upper part of St. Gregory

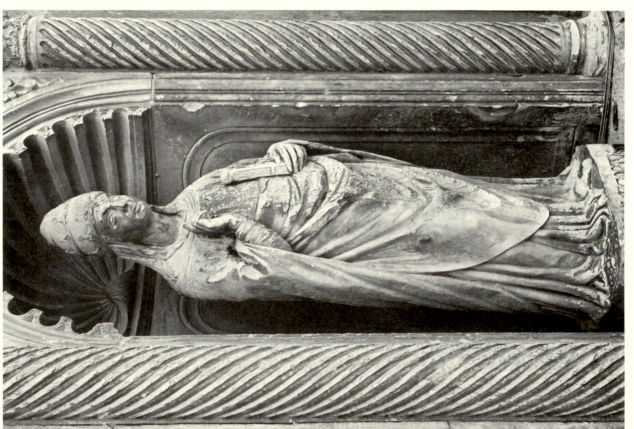

19. Bernardo Rossellino and Domenico Rossellino (?), St. Gregory

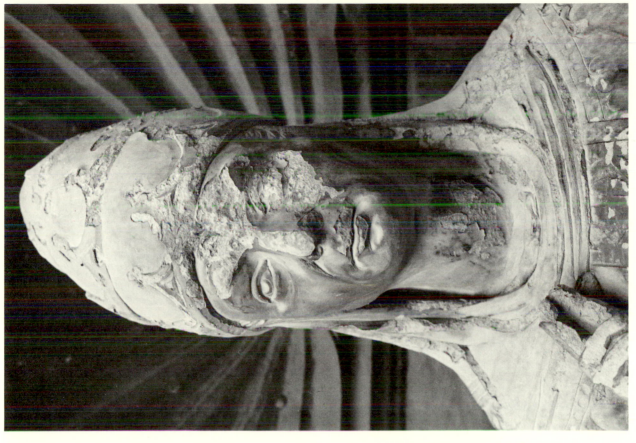

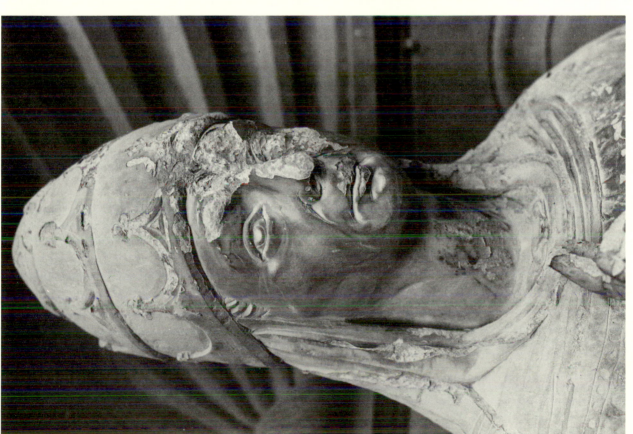

21-22. Bernardo Rossellino, head of St. Gregory

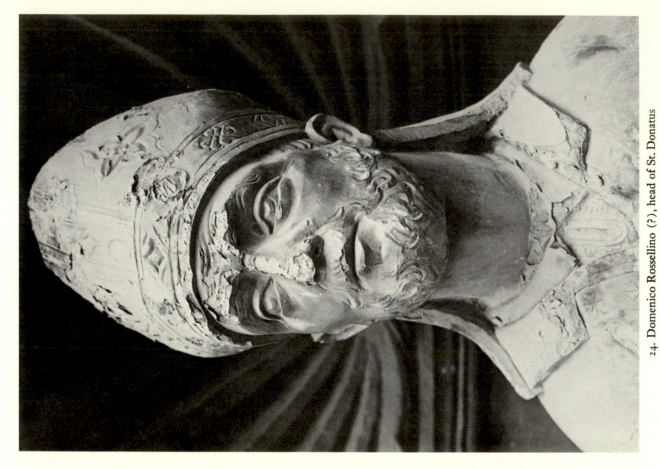

24. Domenico Rossellino (?), head of St. Donatus

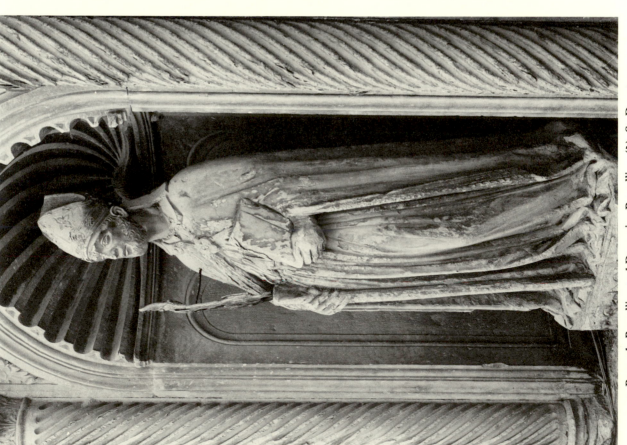

23. Bernardo Rossellino and Domenico Rossellino (?), St. Donatus

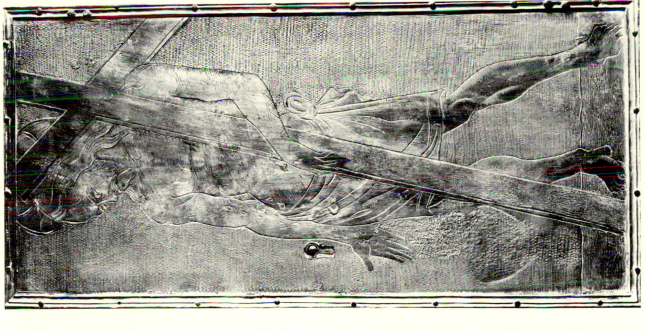

27. Agnolo di Niccolò, *Sportello*, Tabernacle of the Sacrament, Badia, Florence

25. Assistant of Bernardo Rossellino, entablature, Tabernacle of the Sacrament, Badia, Florence

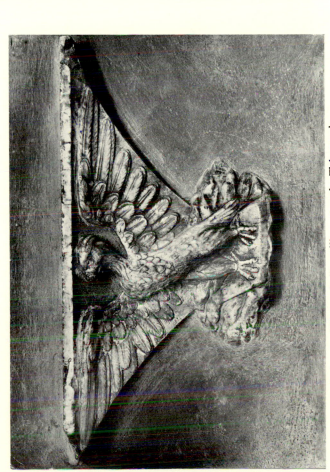

26. Assistant of Bernardo Rossellino, console, Tabernacle of the Sacrament, Badia, Florence

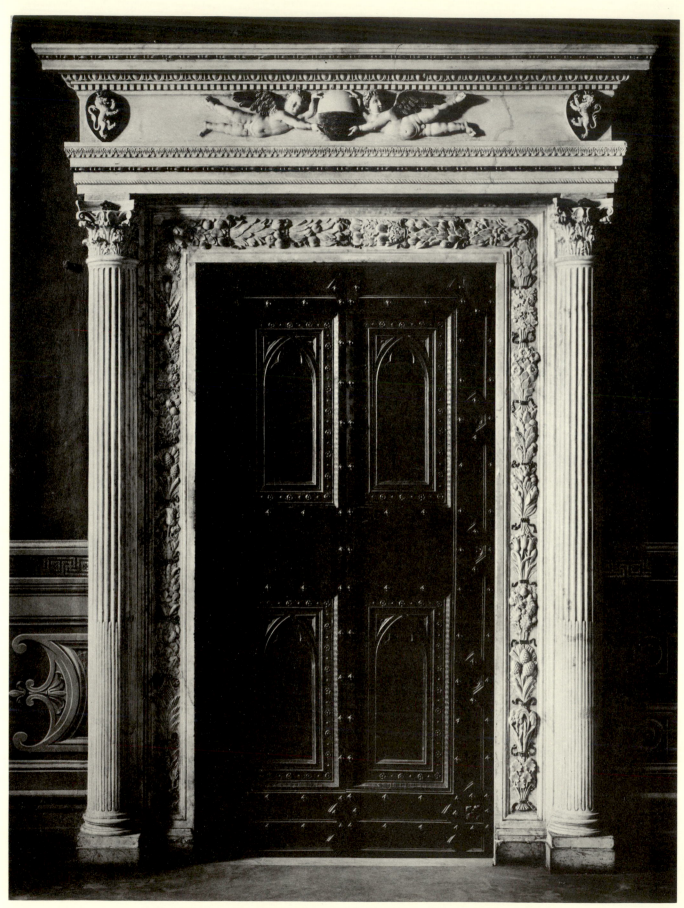

28. Bernardo Rossellino, Portal of the Sala del Concistoro, Palazzo Pubblico, Siena

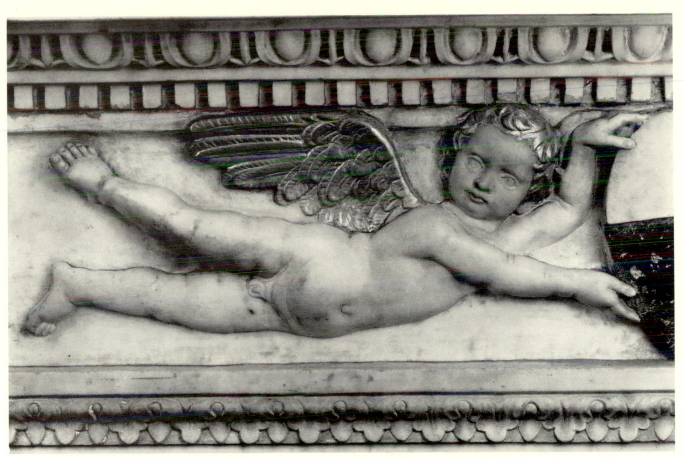

29. Bernardo Rossellino, left putto, Portal of the Sala del Concistoro

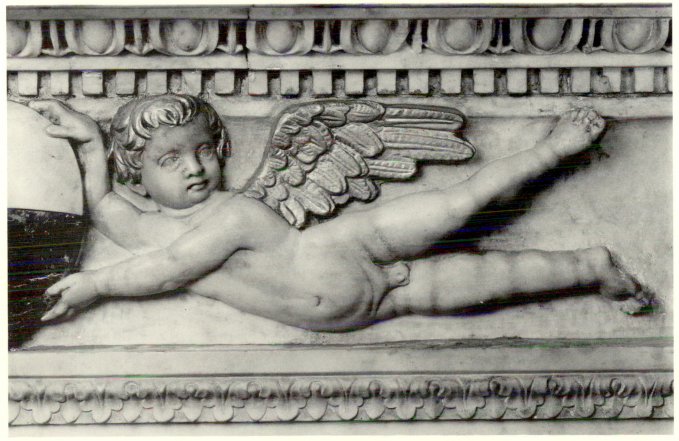

30. Bernardo Rossellino, right putto, Portal of the Sala del Concistoro

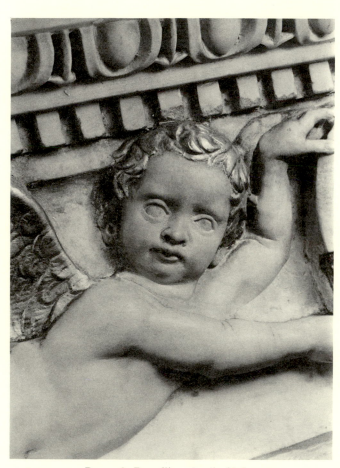

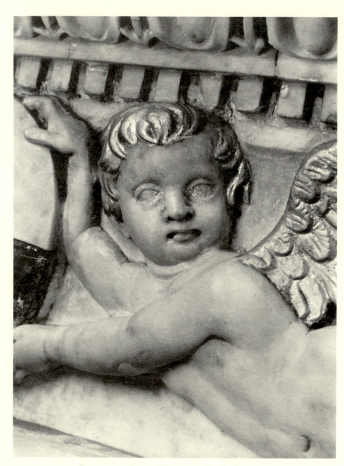

31. Bernardo Rossellino, detail of left putto,
Portal of the Sala del Concistoro

32. Bernardo Rossellino, detail of right putto,
Portal of the Sala del Concistoro

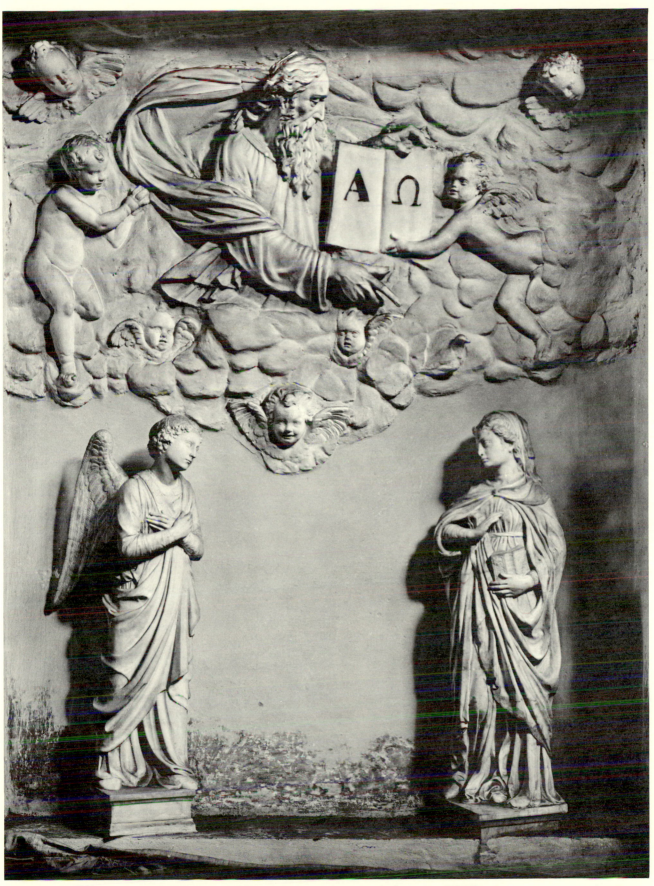

33. Bernardo Rossellino and assistants, Virgin Annunciate and Angel Gabriel,
as formerly displayed in the oratory of S. Stefano, Empoli

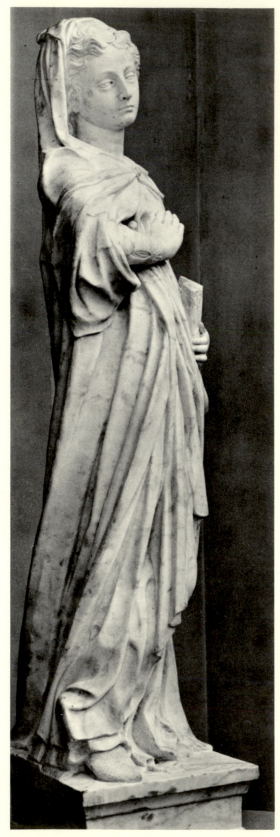
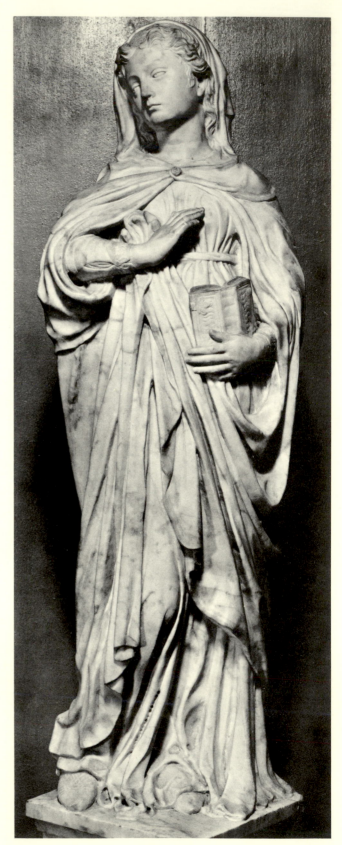

34. 35.

34-37. Bernardo Rossellino and assistant, Virgin Annunciate, Museo della Collegiata, Empoli

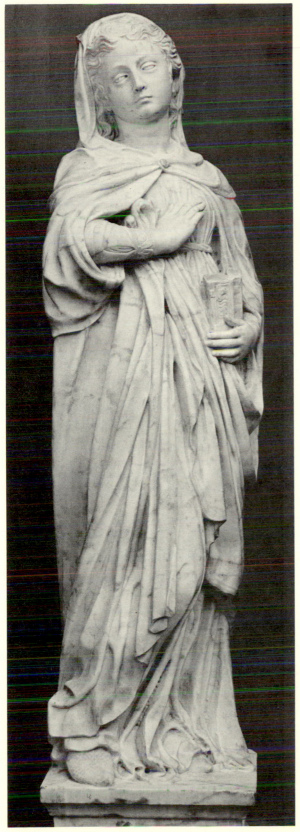

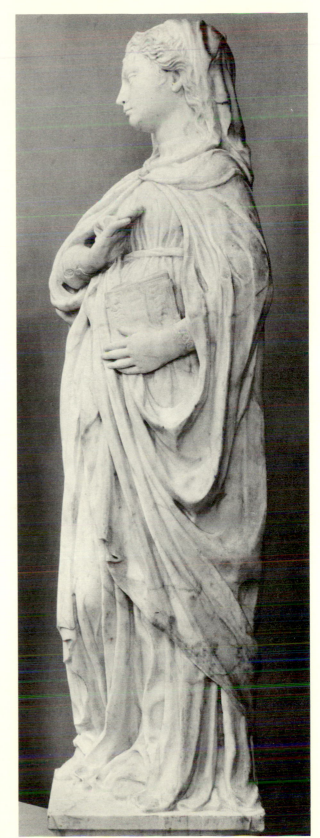

36. 37.

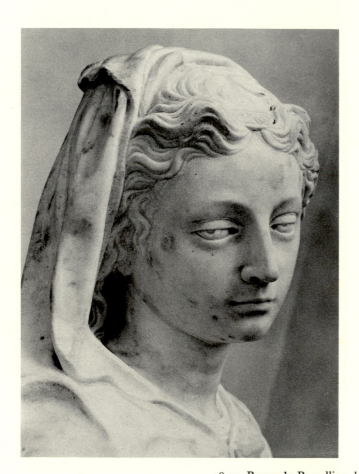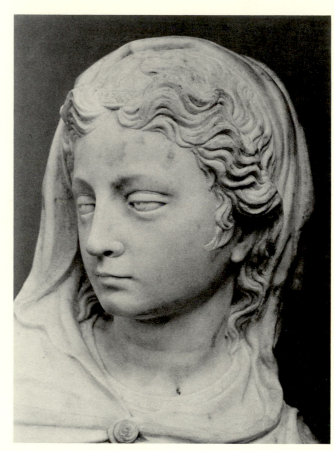

38-39. Bernardo Rossellino, head of Virgin Annunciate

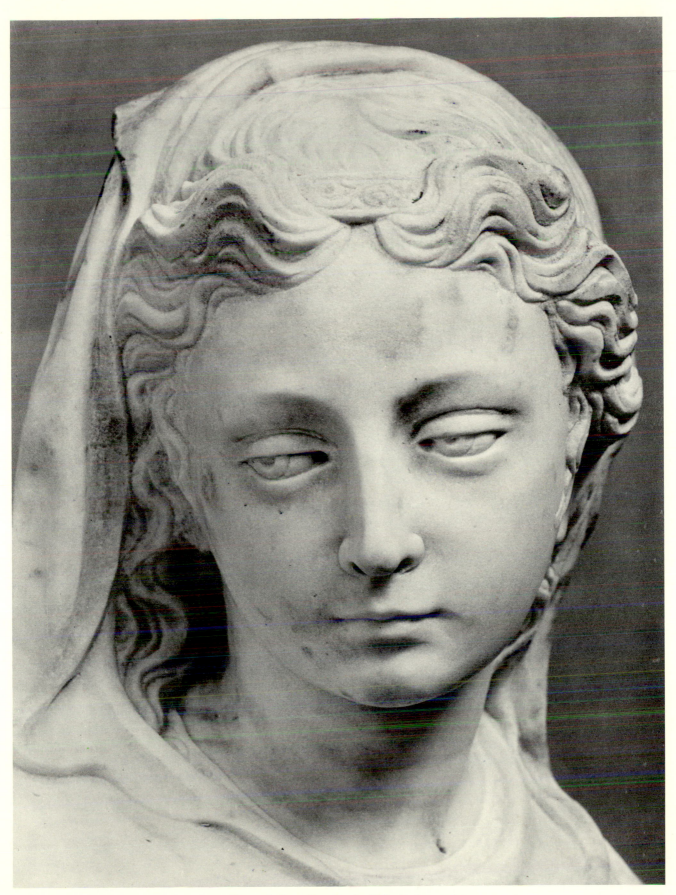

40. Bernardo Rossellino, head of Virgin Annunciate

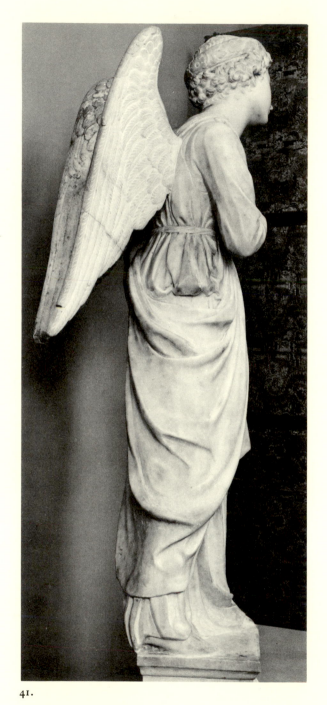

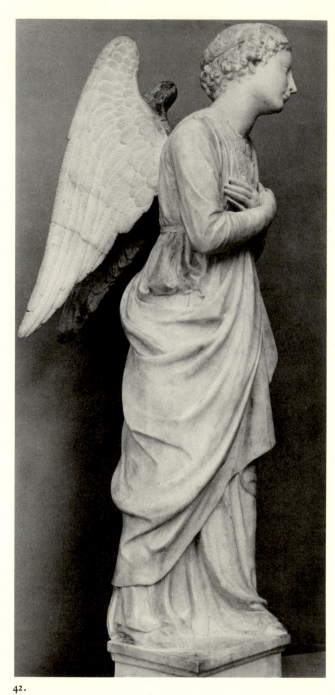

41.

42.

41-44. Bernardo Rossellino and assistant, Angel Gabriel, Museo della Collegiata, Empoli

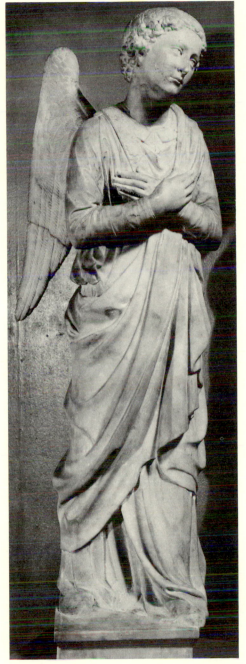

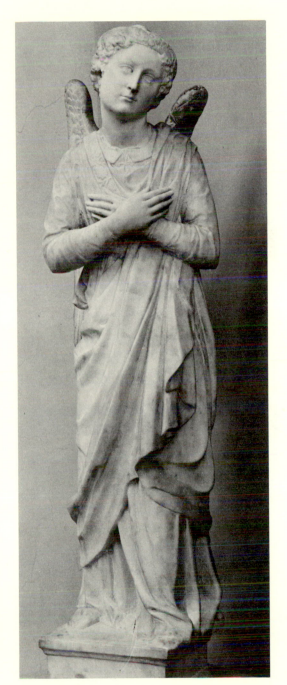

43. 44.

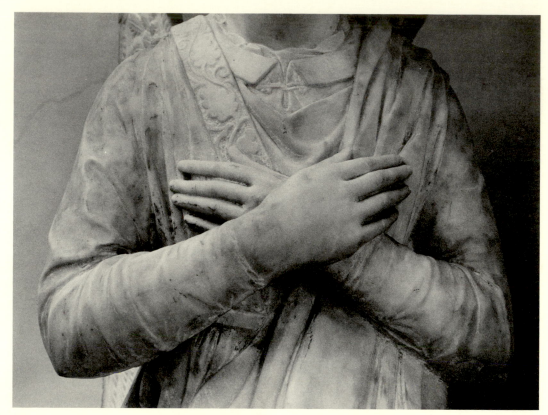

45. Bernardo Rossellino, bust of Angel Gabriel

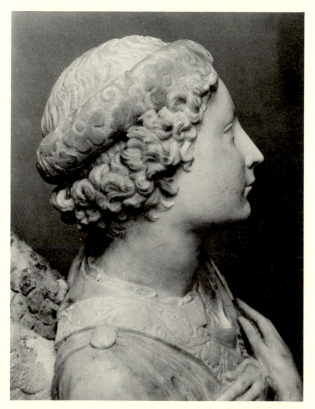
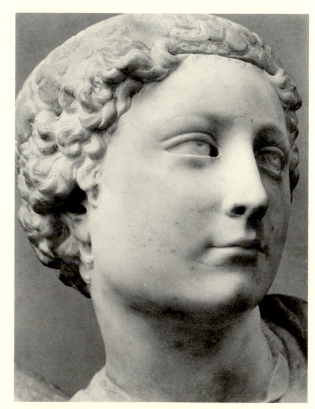

46-47. Bernardo Rossellino, head of Angel Gabriel

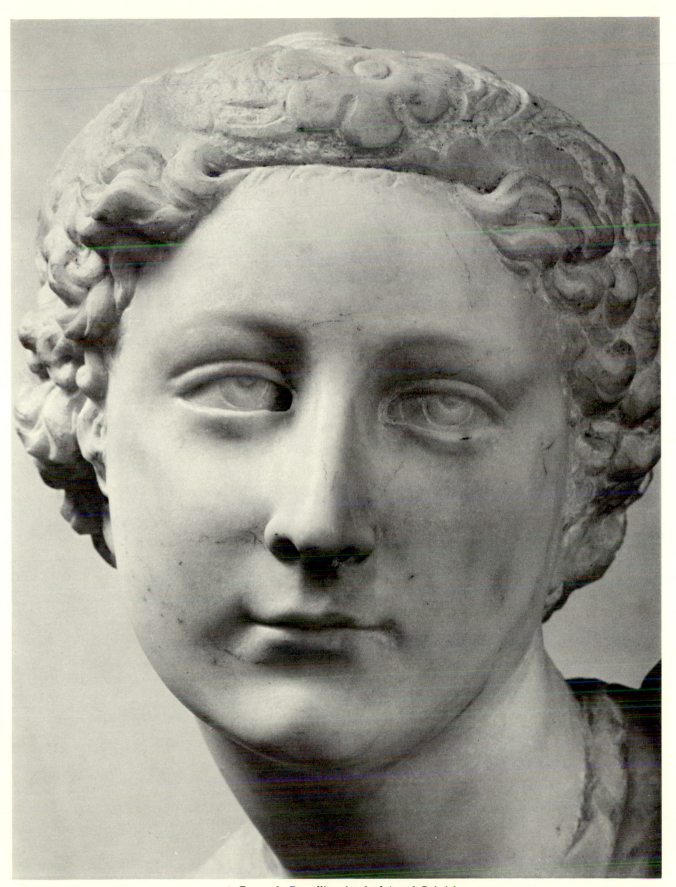

48. Bernardo Rossellino, head of Angel Gabriel

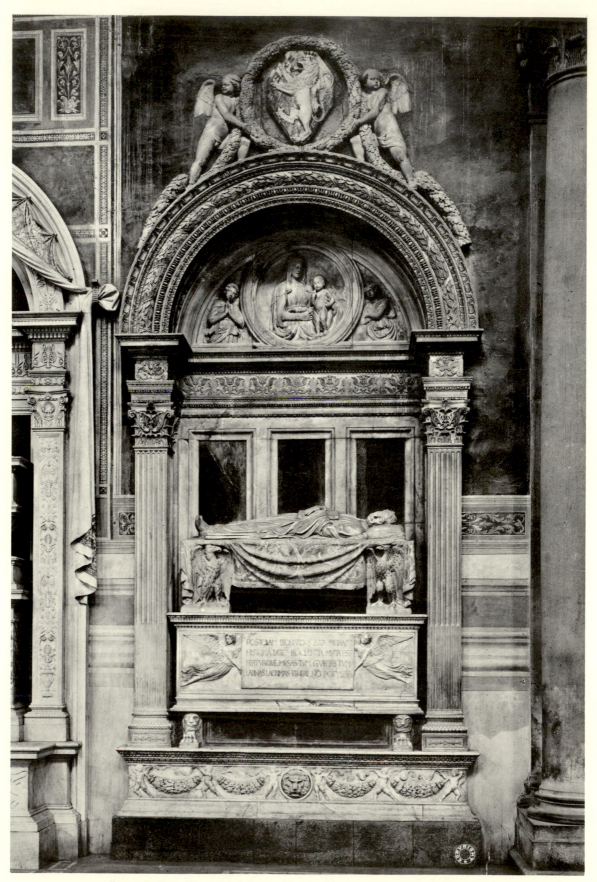

49. Bernardo Rossellino and assistants, Tomb of Leonardo Bruni, S. Croce, Florence

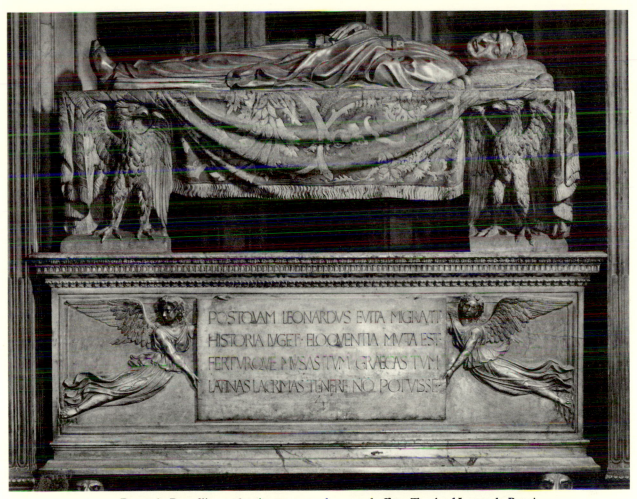

50. Bernardo Rossellino and assistants, sarcophagus and effigy, Tomb of Leonardo Bruni

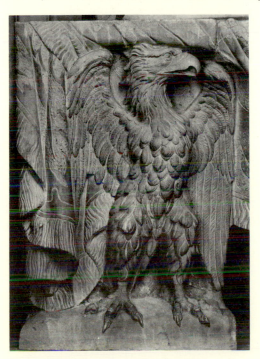

51. Assistant of Bernardo Rossellino, left eagle, Tomb of Leonardo Bruni

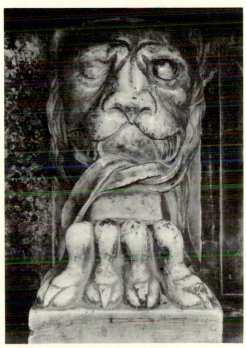

52. Assistant of Bernardo Rossellino, left support for sarcophagus, Tomb of Leonardo Bruni

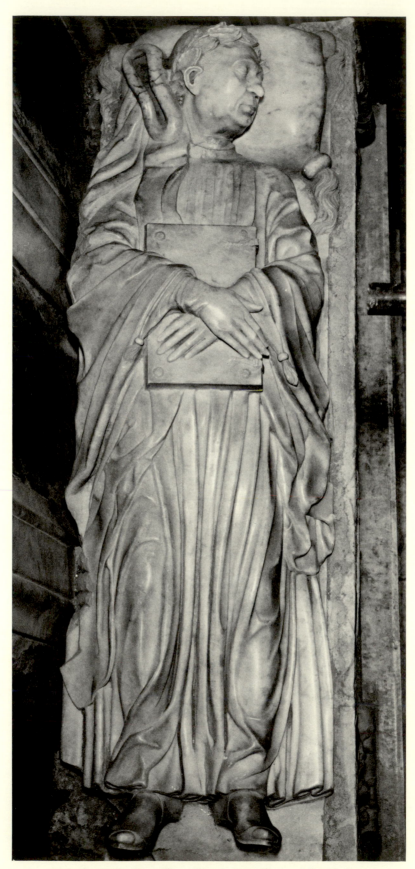

53. Bernardo Rossellino, Antonio Rossellino and Desiderio
da Settignano, effigy, Tomb of Leonardo Bruni

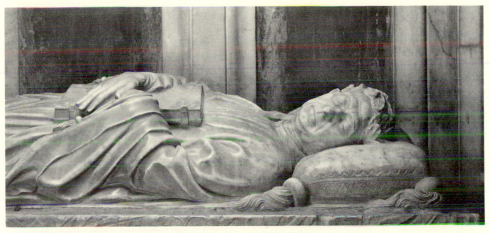

54. Bernardo Rossellino, detail of effigy, Tomb of Leonardo Bruni

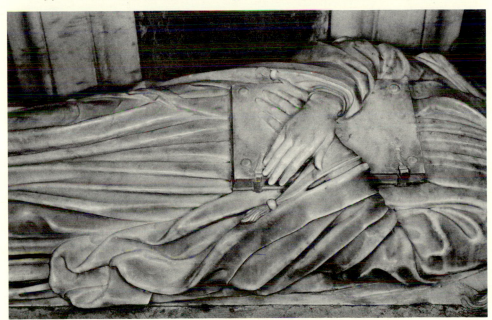

55. Bernardo Rossellino, Antonio Rossellino and Desiderio
da Settignano, detail of effigy, Tomb of Leonardo Bruni

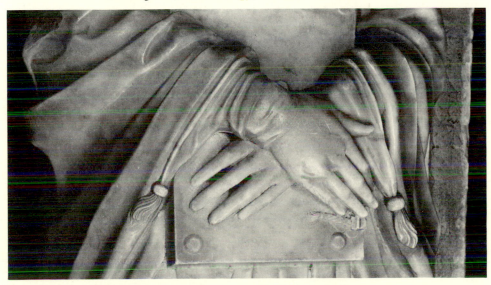

56. Bernardo Rossellino and Desiderio da Settignano,
detail of effigy, Tomb of Leonardo Bruni

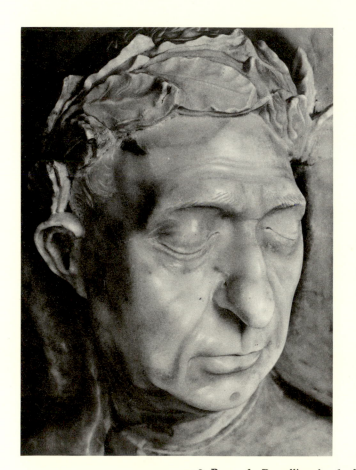 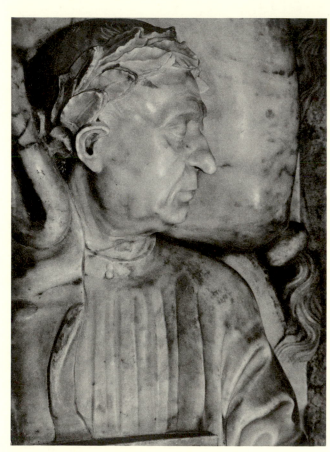

57-58. Bernardo Rossellino, head of effigy, Tomb of Leonardo Bruni

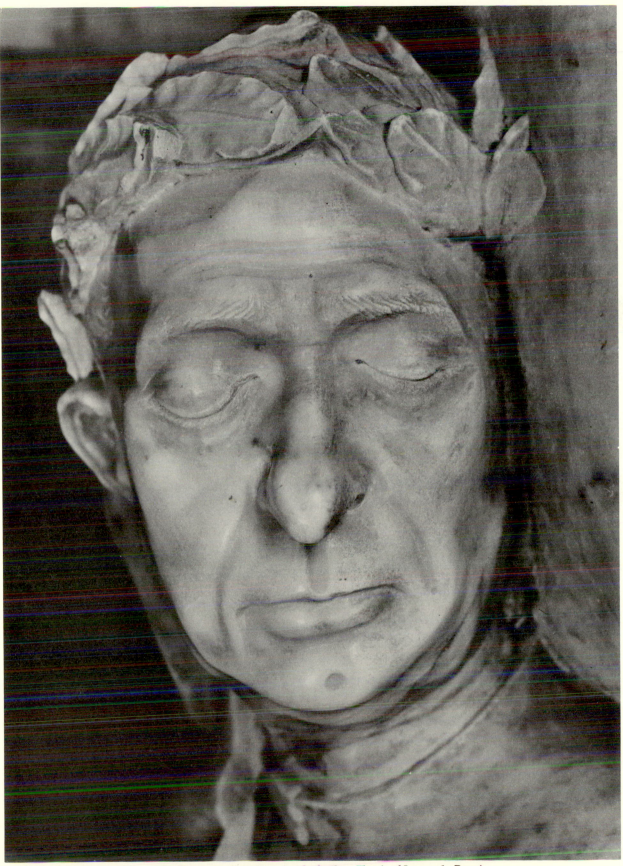

59. Bernardo Rossellino, head of effigy, Tomb of Leonardo Bruni

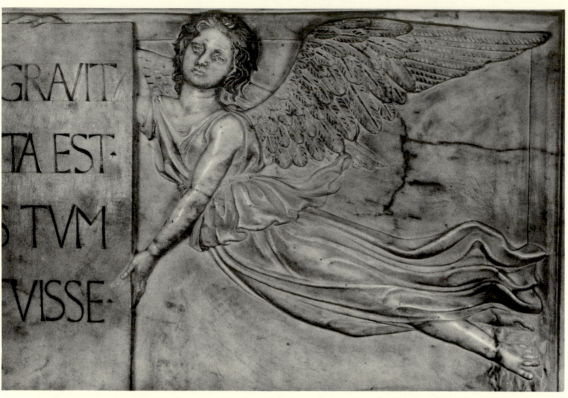

60. Bernardo Rossellino and assistant, right genius from sarcophagus, Tomb of Leonardo Bruni

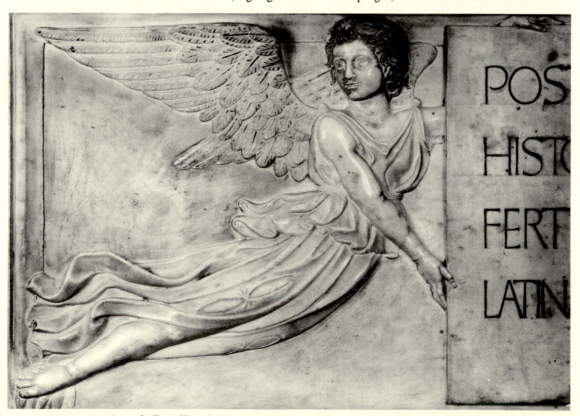

61. Antonio Rossellino, left genius from sarcophagus, Tomb of Leonardo Bruni

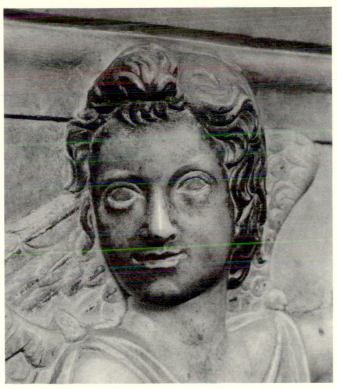

62. Antonio Rossellino, head of left genius from
sarcophagus, Tomb of Leonardo Bruni

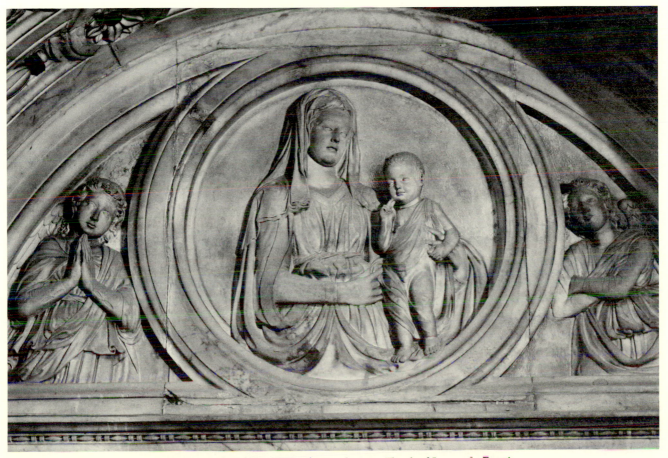

63. Bernardo Rossellino and assistants, lunette, Tomb of Leonardo Bruni

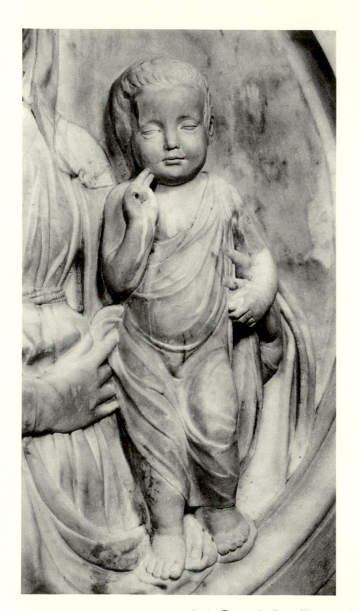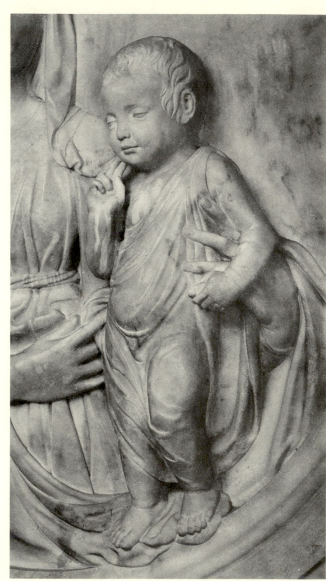

64-65. Bernardo Rossellino, Desiderio da Settignano and assistant,
Christ Child from lunette, Tomb of Leonardo Bruni

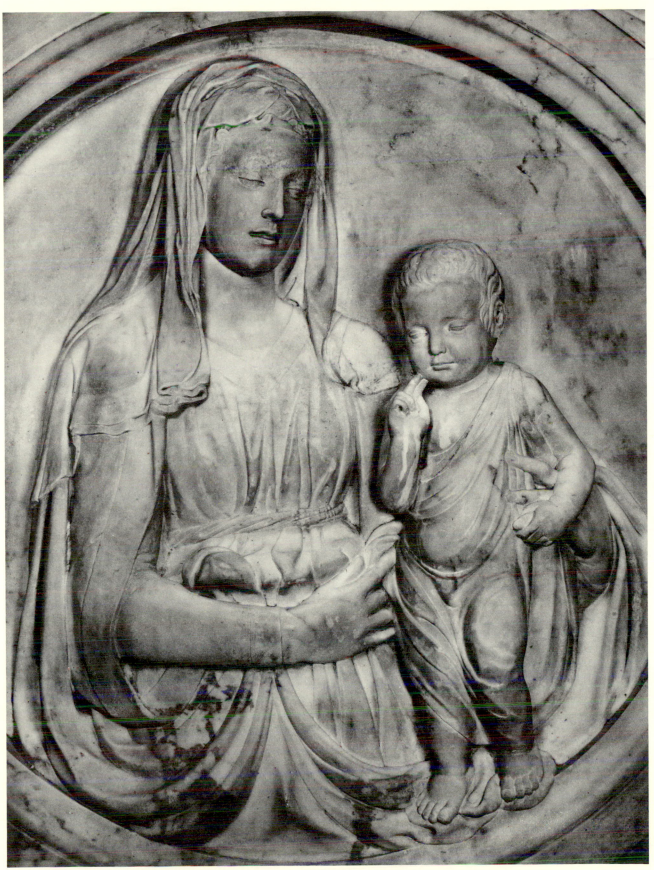

66. Bernardo Rossellino, Desiderio da Settignano and assistant, Madonna and Child
from lunette, Tomb of Leonardo Bruni

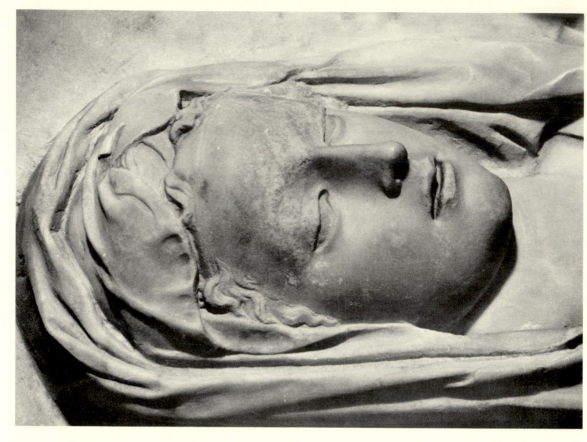

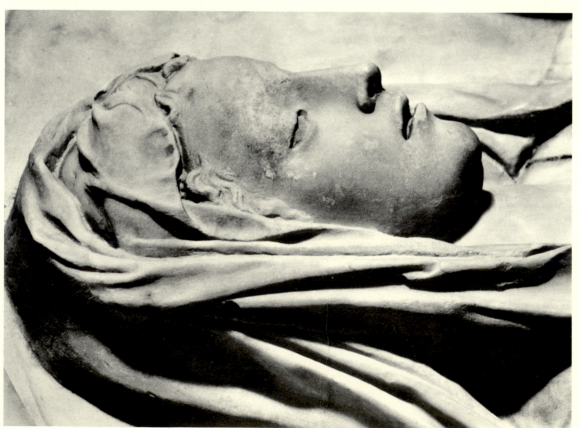

67-68. Desiderio da Settignano, head of Madonna from lunette, Tomb of Leonardo Bruni

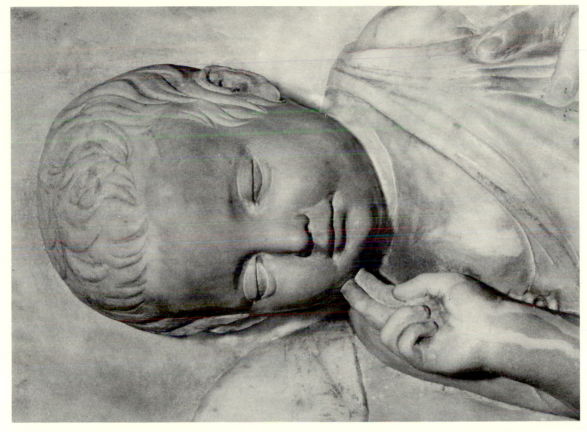

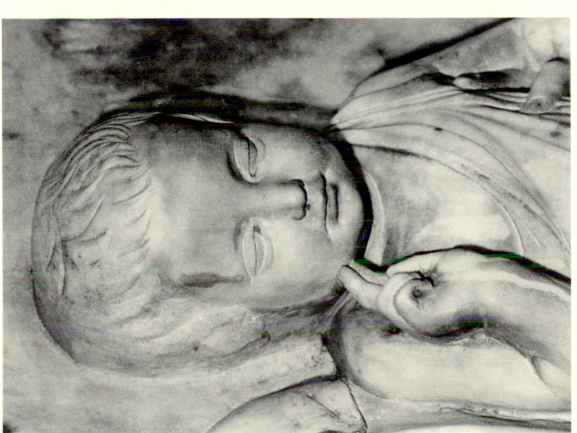

69-70. Bernardo Rossellino, head of Christ Child from lunette, Tomb of Leonardo Bruni

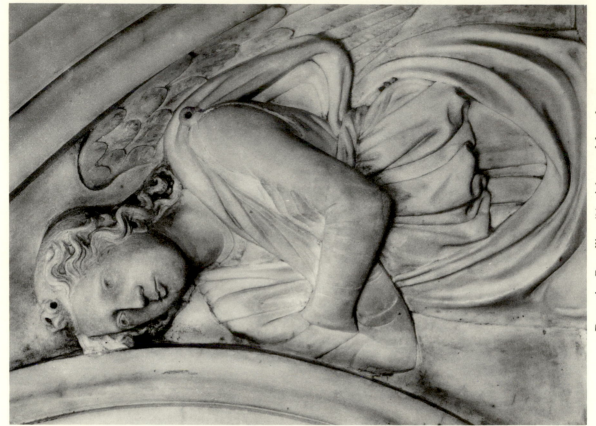

72. Domenico Rossellino (?), right angel from lunette,
Tomb of Leonardo Bruni

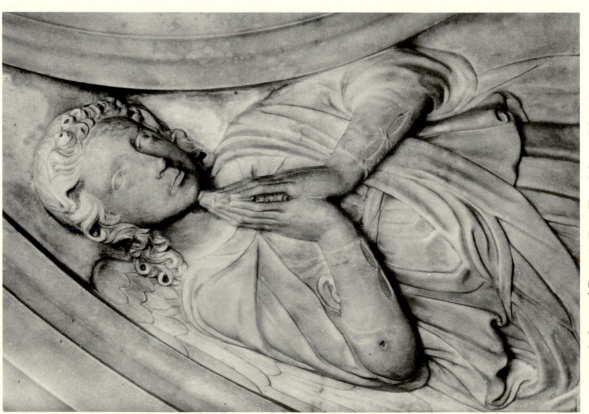

71. Assistant of Bernardo Rossellino, left angel from lunette,
Tomb of Leonardo Bruni

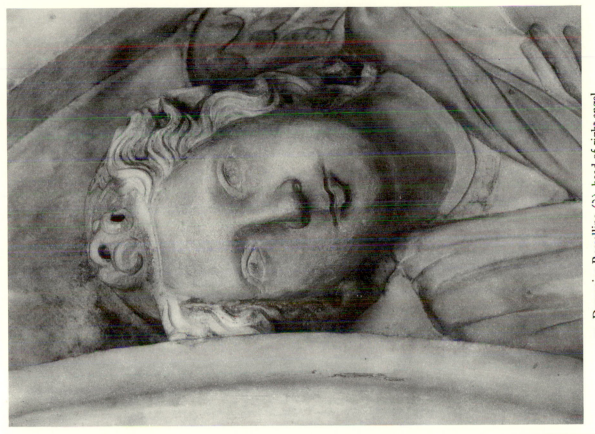

74. Domenico Rossellino (?), head of right angel
from lunette, Tomb of Leonardo Bruni

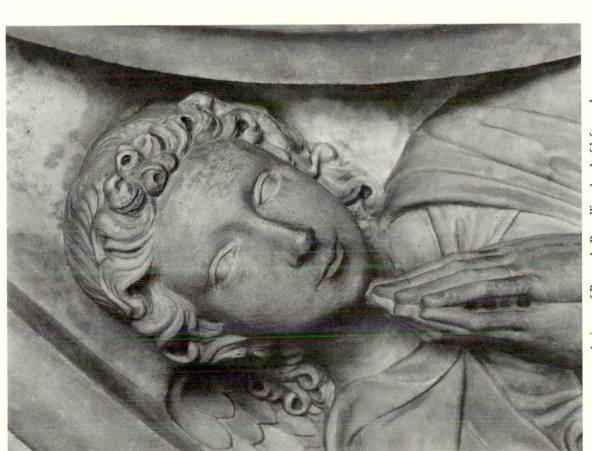

73. Assistant of Bernardo Rossellino, head of left angel
from lunette, Tomb of Leonardo Bruni

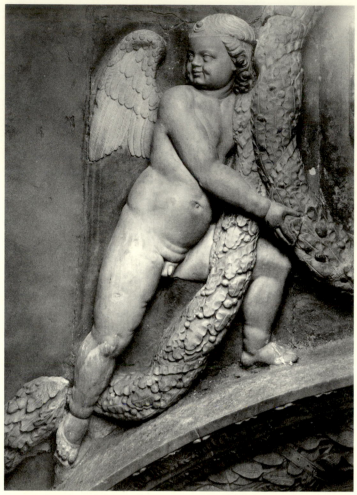

75. Buggiano, left putto from arch, Tomb of Leonardo Bruni

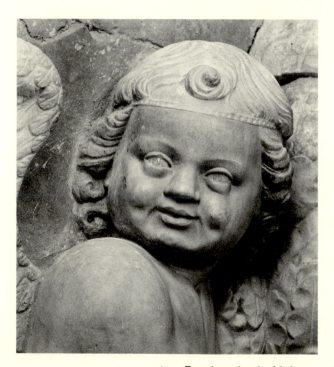 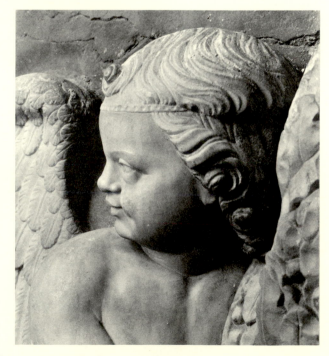

76-77. Buggiano, head of left putto from arch, Tomb of Leonardo Bruni

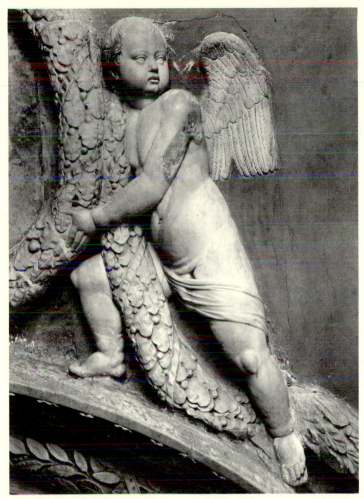

78. Buggiano, right putto from arch, Tomb of Leonardo Bruni

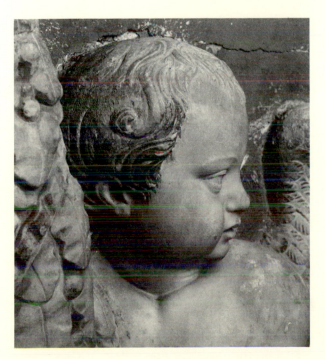 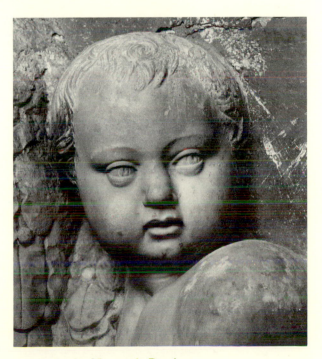

79-80. Buggiano, head of right putto from arch, Tomb of Leonardo Bruni

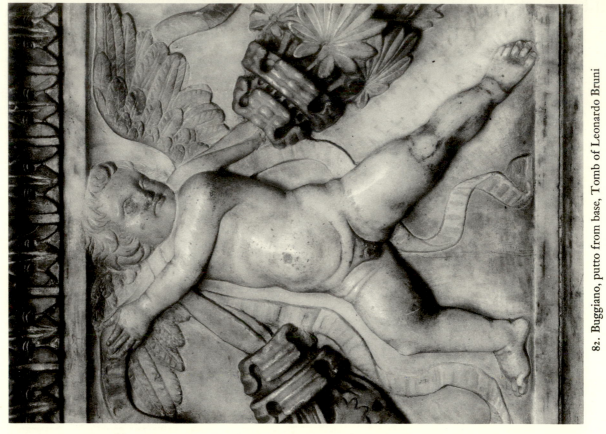

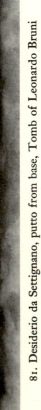

82. Buggiano, putto from base, Tomb of Leonardo Bruni

81. Desiderio da Settignano, putto from base, Tomb of Leonardo Bruni

85. Desiderio da Settignano, putto from base, Tomb of Leonardo Bruni

86. Buggiano (?), coat of arms, Tomb of Leonardo Bruni

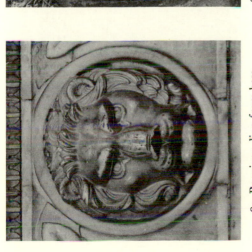

83. Buggiano, lion from base, Tomb of Leonardo Bruni

84. Desiderio da Settignano, detail of putto from base, Tomb of Leonardo Bruni

87. Assistant of Bernardo Rossellino,
putto from base, Tomb of Leonardo Bruni

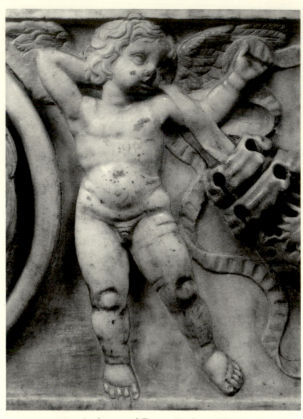

88. Assistant of Bernardo Rossellino,
putto from base, Tomb of Leonardo Bruni

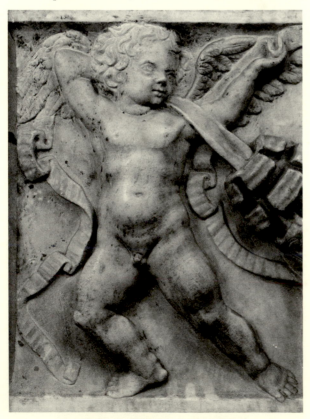

89. Assistant of Bernardo Rossellino,
putto from base, Tomb of Leonardo Bruni

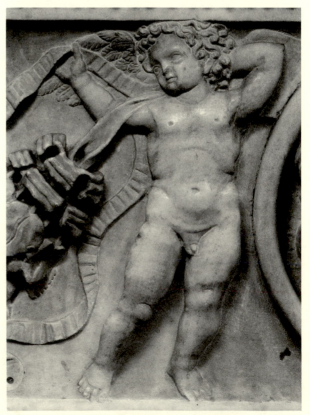

90. Assistant of Bernardo Rossellino,
putto from base, Tomb of Leonardo Bruni

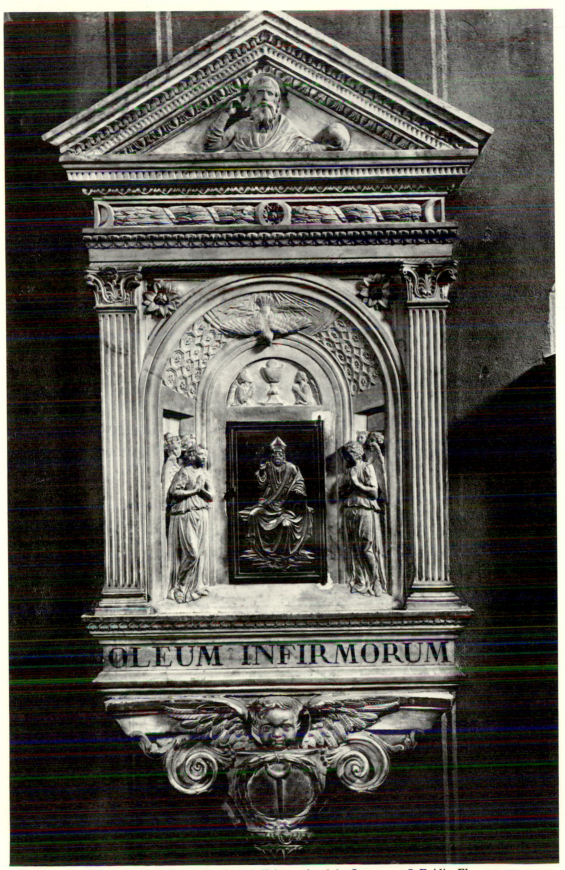

91. Bernardo Rossellino and assistants, Tabernacle of the Sacrament, S. Egidio, Florence

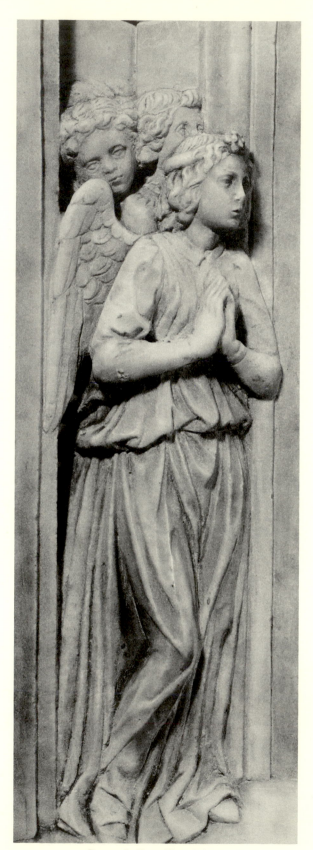

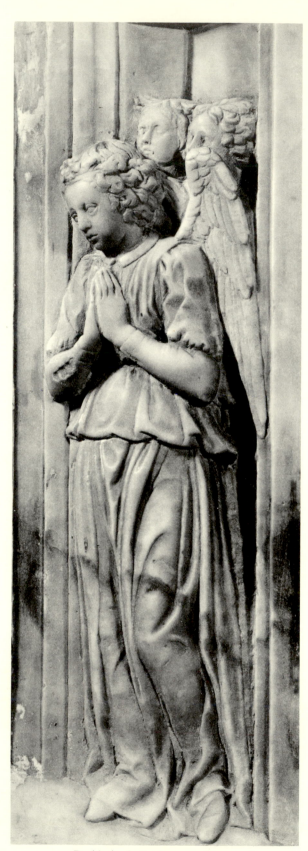

92. Bernardo Rossellino, left angel,
Tabernacle of the Sacrament

93. Desiderio da Settignano, right angel,
Tabernacle of the Sacrament

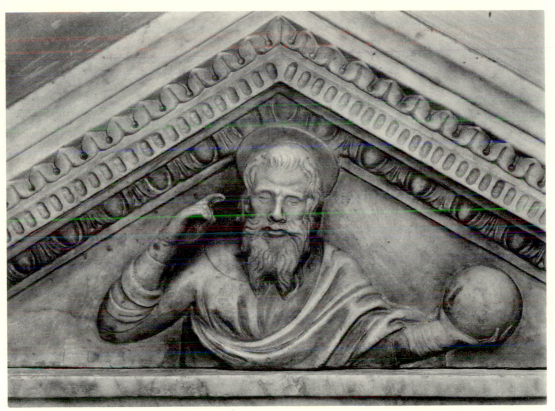

94. Assistant of Bernardo Rossellino, God the Father, Tabernacle of the Sacrament

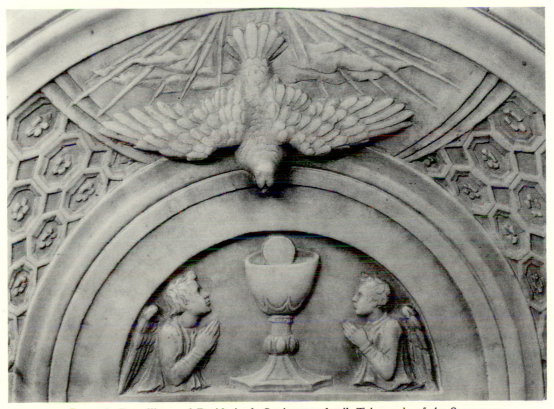

95. Bernardo Rossellino and Desiderio da Settignano, detail, Tabernacle of the Sacrament

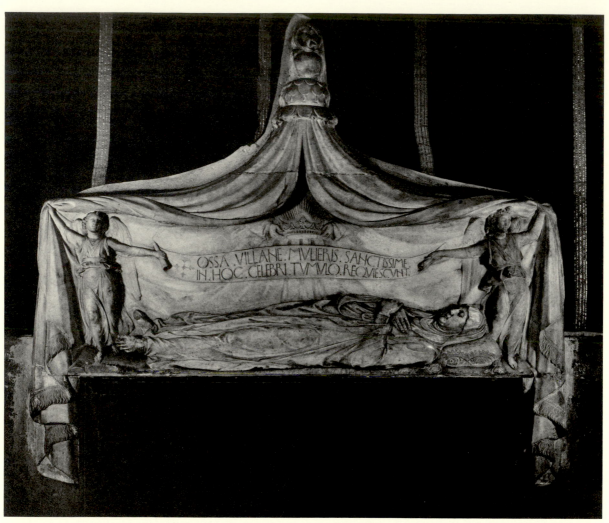

96. Bernardo Rossellino and assistants, Tomb of the Beata Villana, S. Maria Novella, Florence

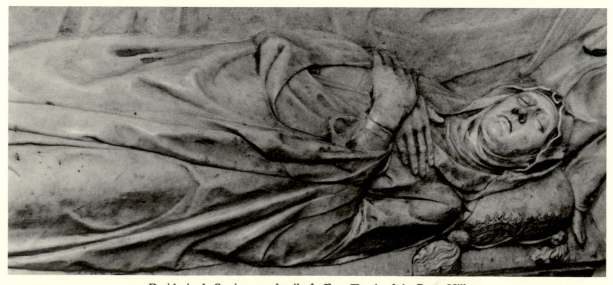

97. Desiderio da Settignano, detail of effigy, Tomb of the Beata Villana

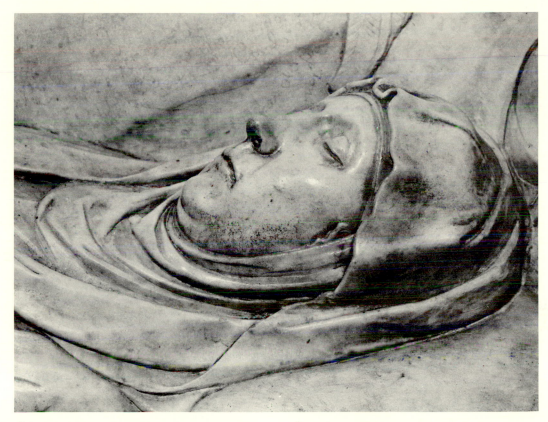

98.

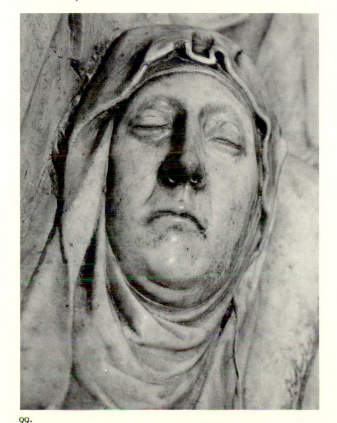

99.

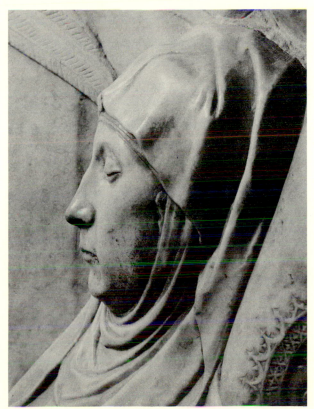

100.

98-100. Desiderio da Settignano, head of effigy, Tomb of the Beata Villana

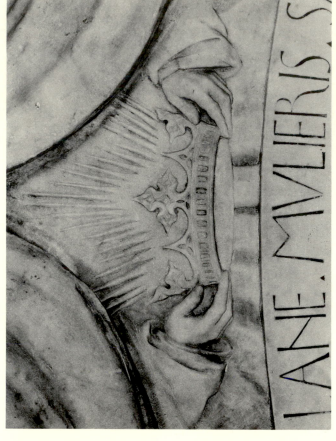

103. Desiderio da Settignano and assistant of Bernardo
Rossellino, detail, Tomb of the Beata Villana

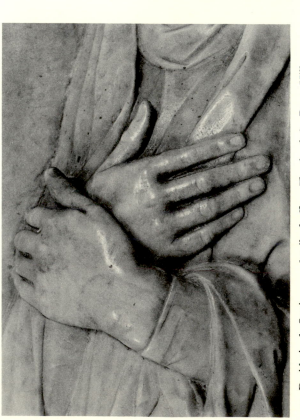

102. Desiderio da Settignano, detail of effigy, Tomb of the Beata Villana

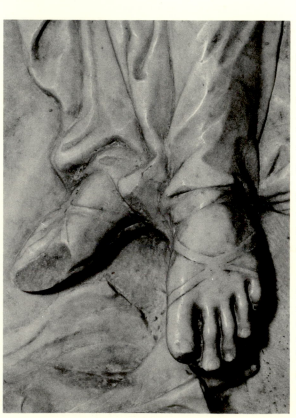

101. Desiderio da Settignano, detail of effigy, Tomb of the Beata Villana

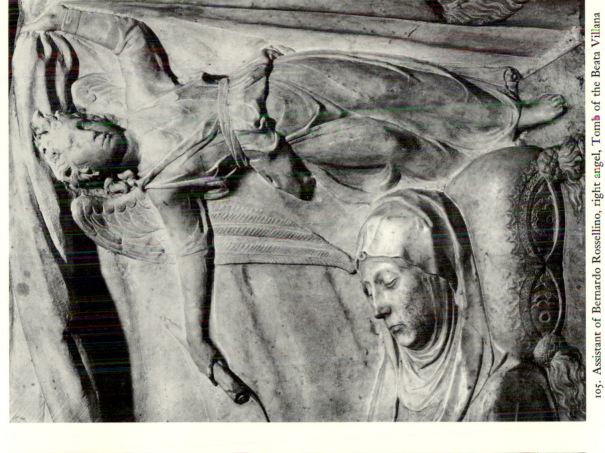

105. Assistant of Bernardo Rossellino, right angel, Tomb of the Beata Villana

104. Assistant of Bernardo Rossellino, left angel, Tomb of the Beata Villana

106. Bernardo Rossellino and assistants, Tomb of Orlando de' Medici, SS. Annunziata, Florence

107. Domenico Rossellino (?), left putto, Tomb of Orlando de' Medici

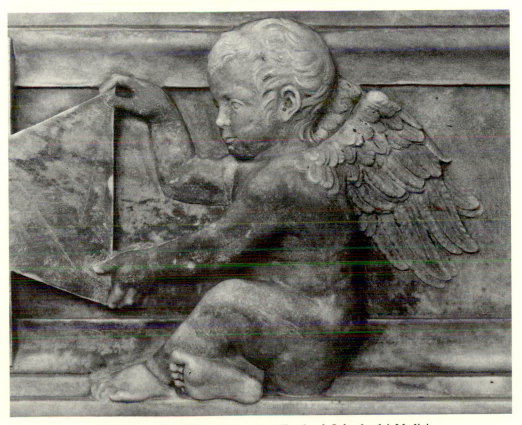

108. Antonio Rossellino, right putto, Tomb of Orlando de' Medici

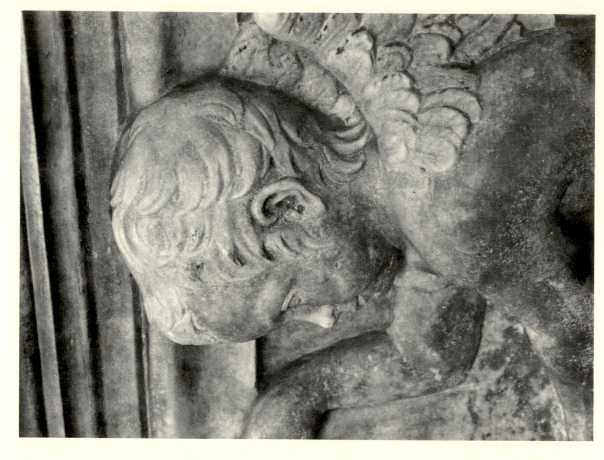

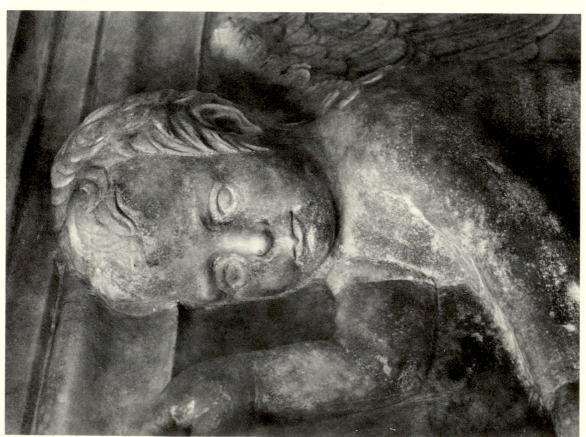

109–110. Antonio Rossellino, head of right putto, Tomb of Orlando de' Medici

112. Assistant of Bernardo Rossellino, left lion,
Tomb of Orlando de' Medici

113. Assistant of Bernardo Rossellino, right lion,
Tomb of Orlando de' Medici

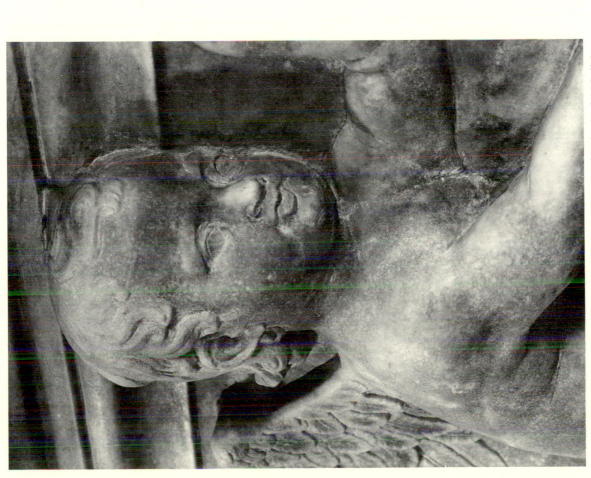

111. Domenico Rossellino (?), head of left putto, Tomb of Orlando de' Medici

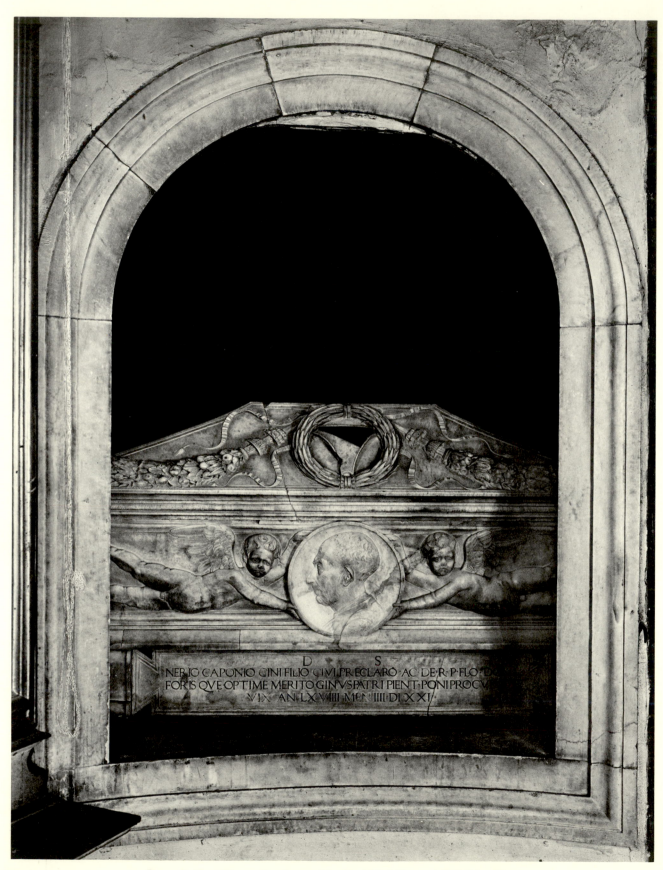

114. Bernardo Rossellino and assistants, Tomb of Neri Capponi, S. Spirito, Florence, with grill removed

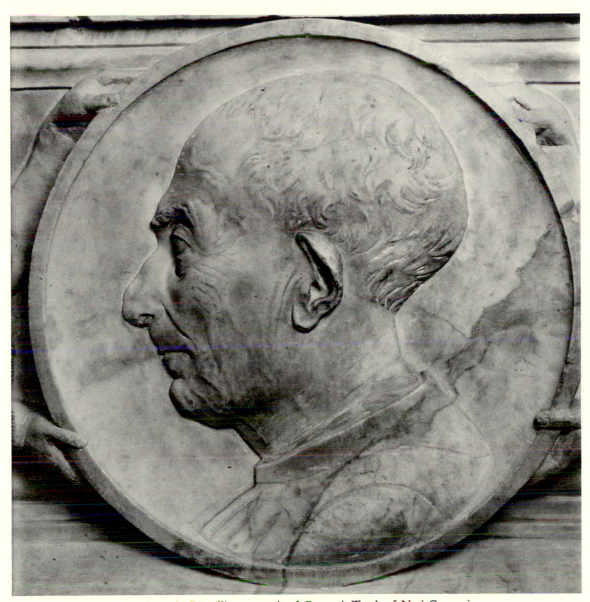

115. Antonio Rossellino, portrait of Capponi, Tomb of Neri Capponi

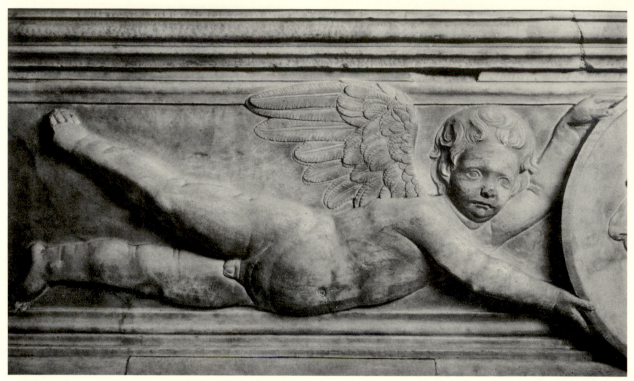

116. Assistant of Bernardo Rossellino, left putto, Tomb of Neri Capponi

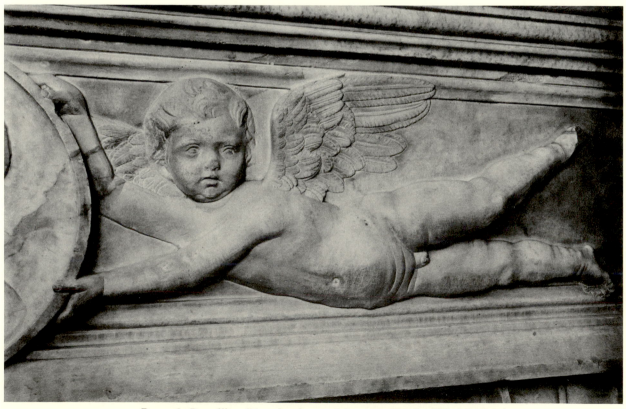

117. Bernardo Rossellino (?) and assistant, right putto, Tomb of Neri Capponi

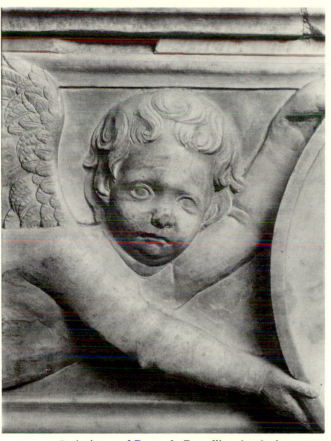

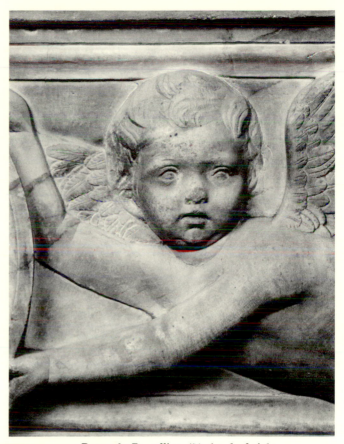

118. Assistant of Bernardo Rossellino, head of
left putto, Tomb of Neri Capponi

119. Bernardo Rossellino (?), head of right
putto, Tomb of Neri Capponi

120. Bernardo Rossellino and assistants,
Tomb of Neri Capponi

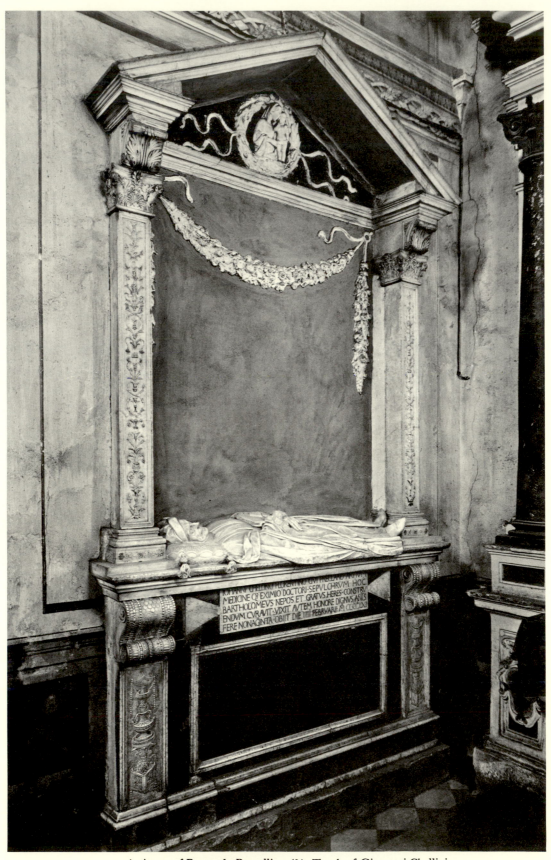

121. Assistant of Bernardo Rossellino (?), Tomb of Giovanni Chellini,
S. Domenico, S. Miniato al Tedesco

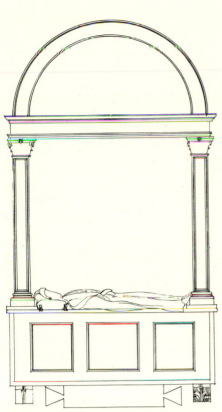

122. Reconstruction of first state,
Tomb of Giovanni Chellini

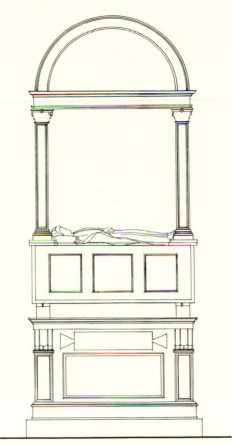

123. Reconstruction of second state,
Tomb of Giovanni Chellini

124. Detail of base, Tomb of
Giovanni Chellini

125. Assistant of Bernardo Rossellino (?),
detail, Tomb of Giovanni Chellini

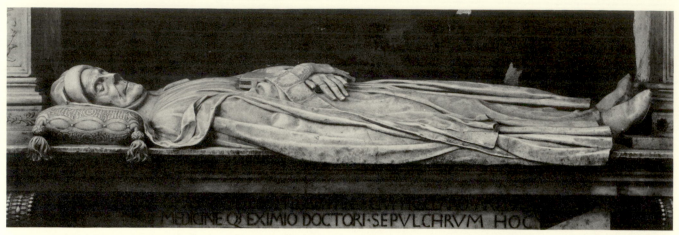

126. Assistant of Bernardo Rossellino (?), effigy, Tomb of Giovanni Chellini

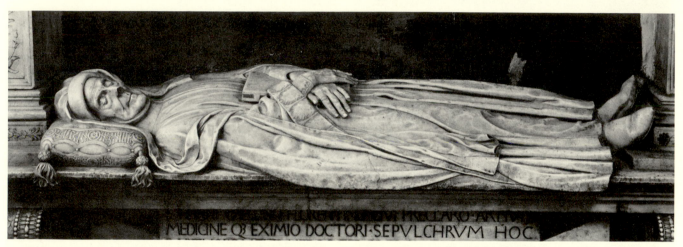

127. Assistant of Bernardo Rossellino (?), effigy, Tomb of Giovanni Chellini

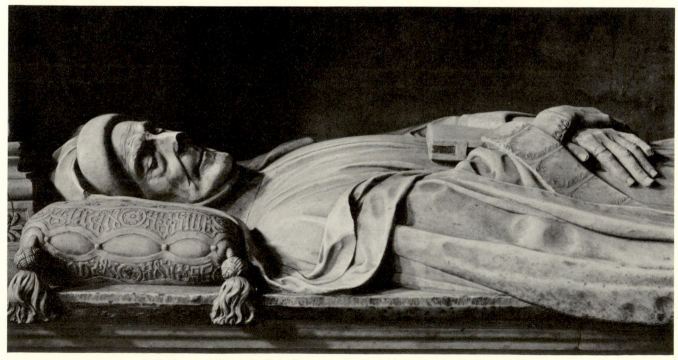

128. Assistant of Bernardo Rossellino (?), detail of effigy, Tomb of Giovanni Chellini

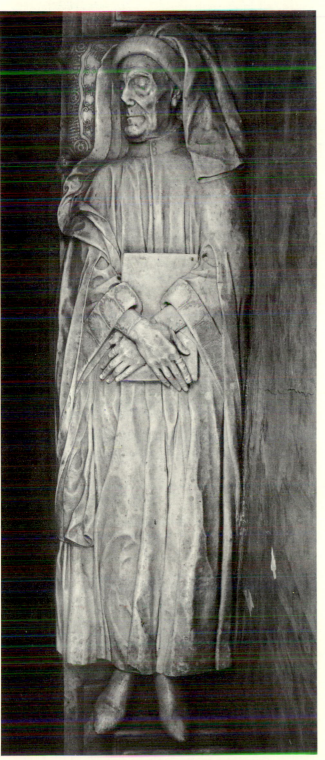

129. Assistant of Bernardo Rossellino (?),
effigy, Tomb of Giovanni Chellini

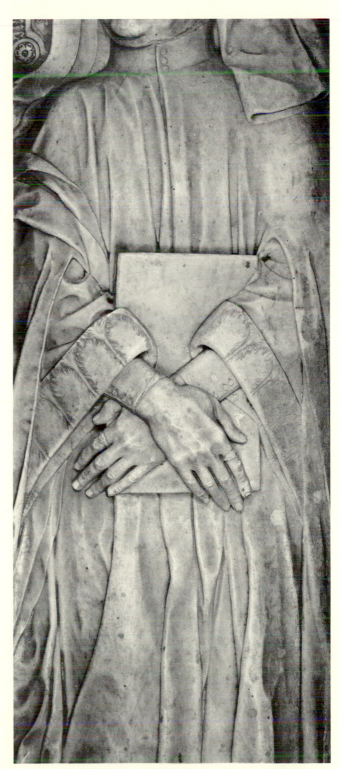

130. Assistant of Bernardo Rossellino (?), detail
of effigy, Tomb of Giovanni Chellini

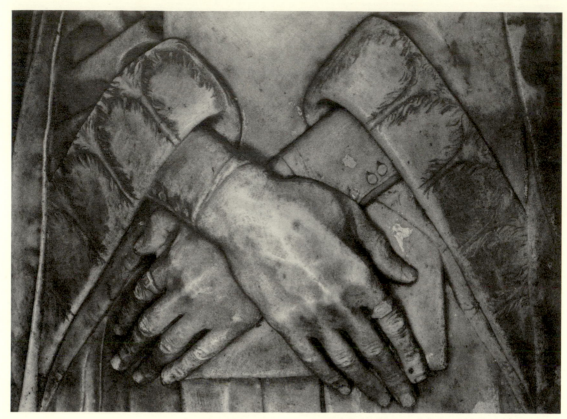

131. Assistant of Bernardo Rossellino (?), detail of effigy, Tomb of Giovanni Chellini

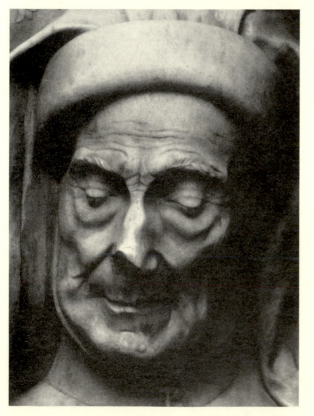 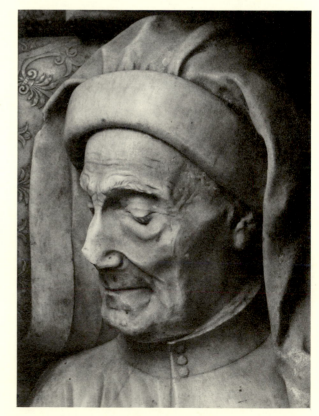

132-133. Assistant of Bernardo Rossellino (?), head of effigy, Tomb of Giovanni Chellini

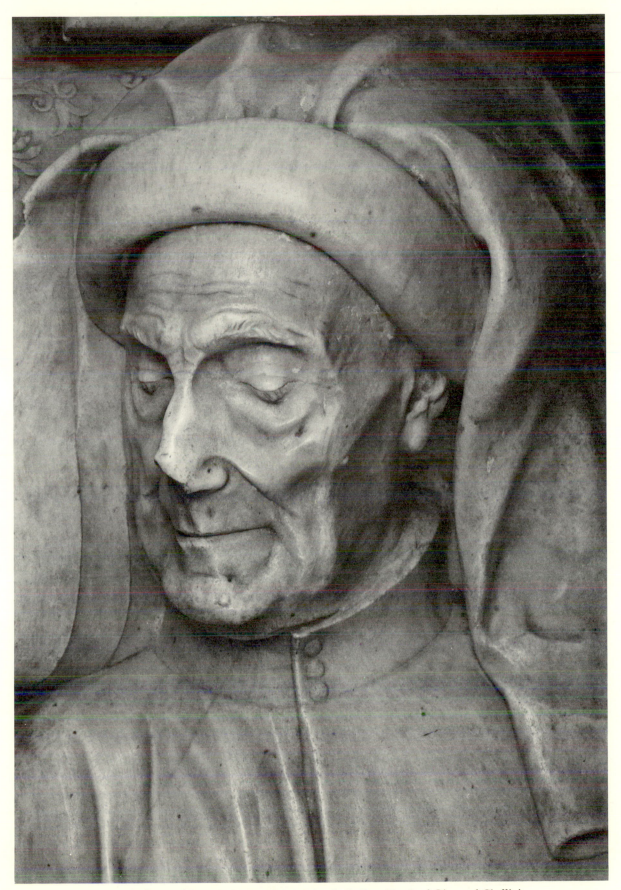

134. Assistant of Bernardo Rossellino (?), head of effigy, Tomb of Giovanni Chellini

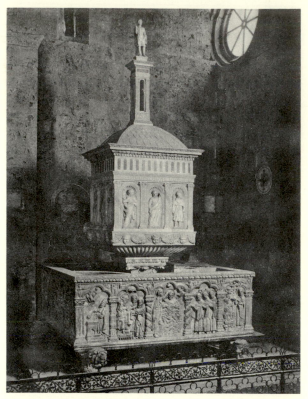

135. Baptismal Font, Duomo, Massa Marittima

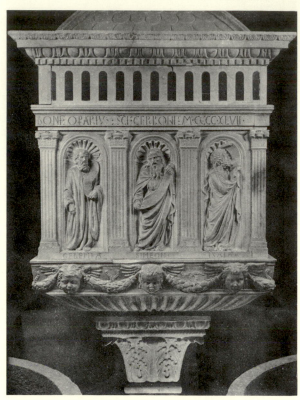

136. Giovanni Rossellino and Pagno di Lapo Portigiani, detail of tabernacle, Baptismal Font, Duomo, Massa Marittima

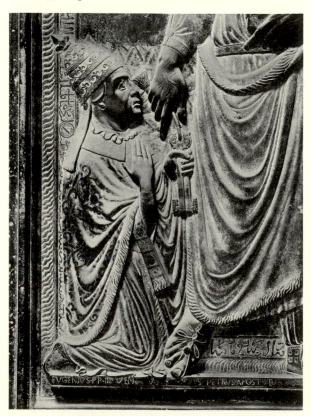

137. Filarete, portrait of Pope Eugene IV, central portal of St. Peter's, Rome

138. Lorenzo Ghiberti, Miracle of the Servant, Shrine of St. Zenobius, Duomo, Florence

139. Lorenzo Ghiberti, figure of Eve from frame, Gates of Paradise, Baptistry, Florence

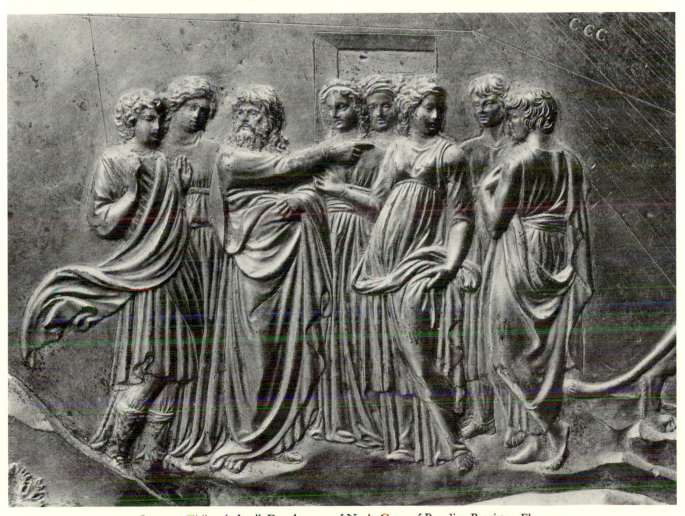

140. Lorenzo Ghiberti, detail, Drunkenness of Noah, Gates of Paradise, Baptistry, Florence

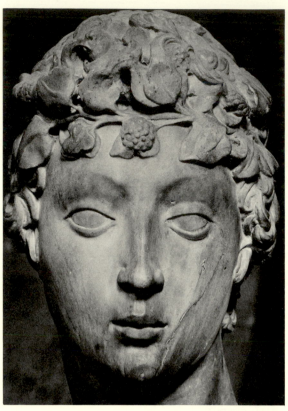

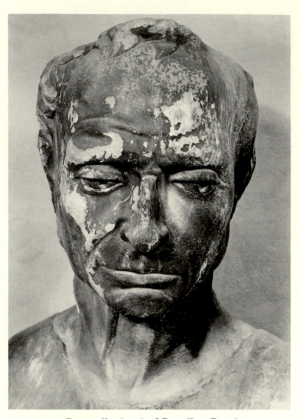

141. Donatello, head of marble David,
Museo Nazionale, Florence

142. Donatello, head of Beardless Prophet,
Museo dell'Opera del Duomo, Florence

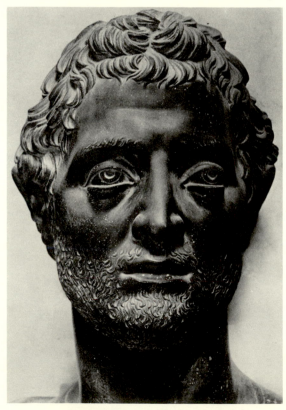

143. Nanni di Banco, head of saint, Quattro
Coronati, Or San Michele, Florence

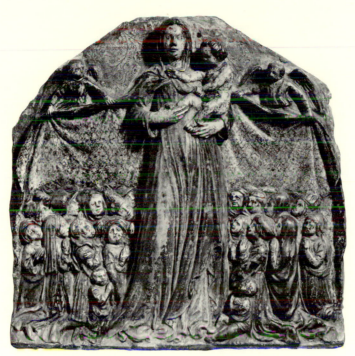

144. Tuscan, fifteenth century, Madonna
del Manto, Pinacoteca, Arezzo

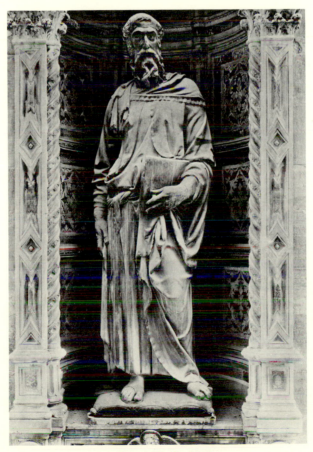

145. Donatello, St. Mark,
Or San Michele, Florence

146. Lorenzo Ghiberti, frame, North portal,
Baptistry, Florence

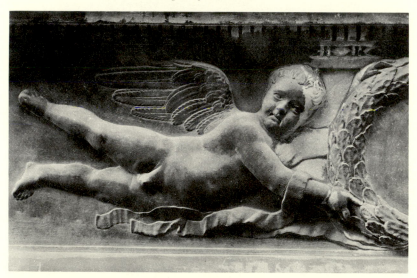

147. Donatello, left putto, Tabernacle of the Parte Guelfa,
Or San Michele, Florence

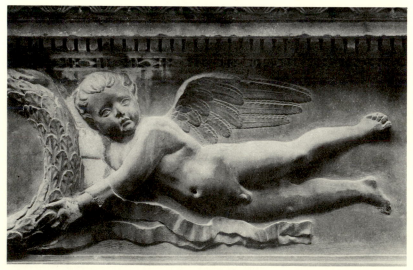

148. Donatello, right putto, Tabernacle of the Parte Guelfa,
Or San Michele, Florence

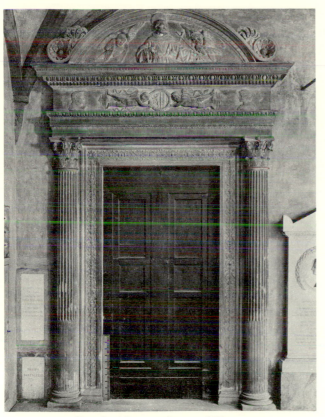

149. Portal with coat of arms of Tommaso
Spinelli, cloister, S. Croce, Florence

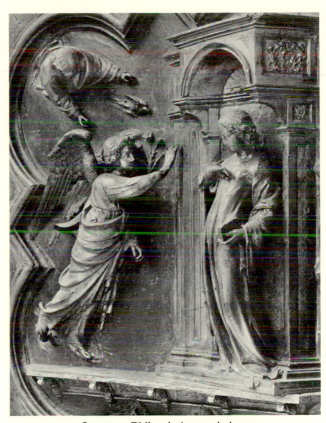

150. Lorenzo Ghiberti, Annunciation,
North portal, Baptistry, Florence

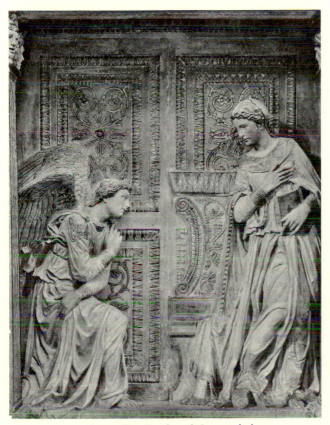

151. Donatello, Cavalcanti Annunciation,
S. Croce, Florence

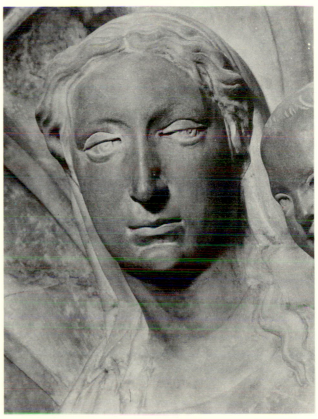

152. Michelozzo, Madonna and Child from lunette,
Tomb of Baldassare Coscia, Baptistry, Florence

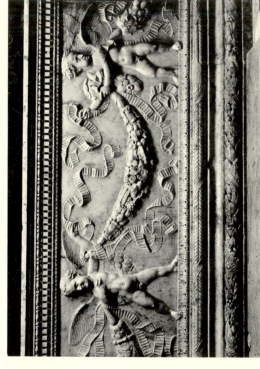

154. Michelozzo, detail of base, Tomb of Bartolommeo Aragazzi, Duomo, Montepulciano

155. Michelozzo, effigy, Tomb of Bartolommeo Aragazzi

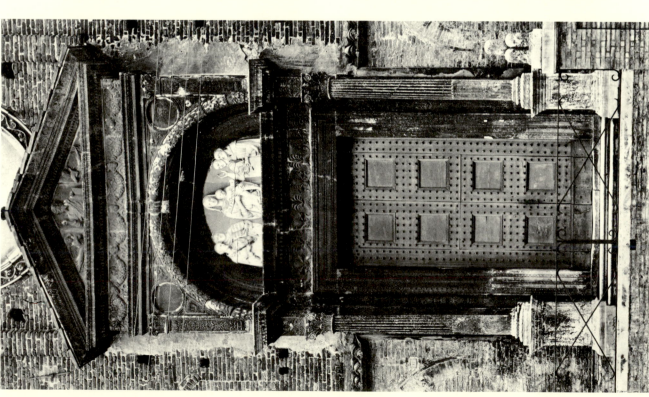

153. Maso di Bartolommeo and others, Portal, S. Domenico, Urbino

158. Michelozzo, Resurrected Christ, Tomb of Bartolommeo Aragazzi

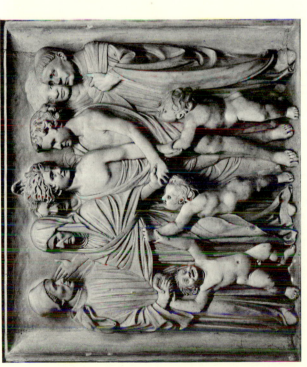

156. Michelozzo, Aragazzi Welcomed by his Family in Heaven, Tomb of Bartolommeo Aragazzi

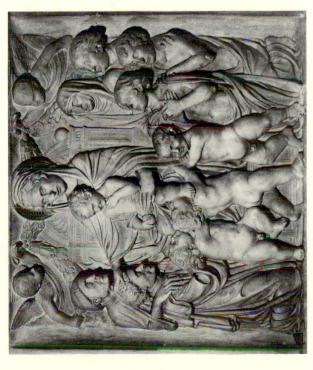

157. Michelozzo, Virgin and Child Enthroned with Members of the Aragazzi Family, Tomb of Bartolommeo Aragazzi

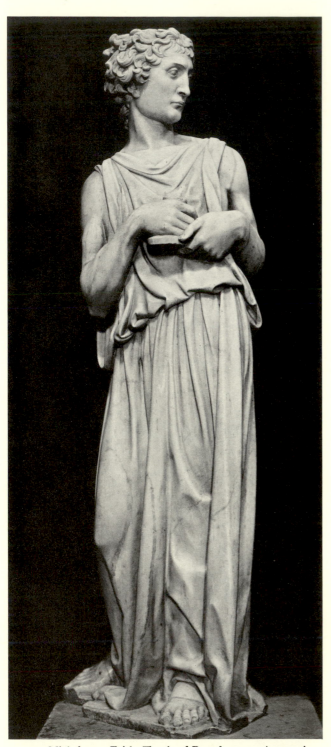

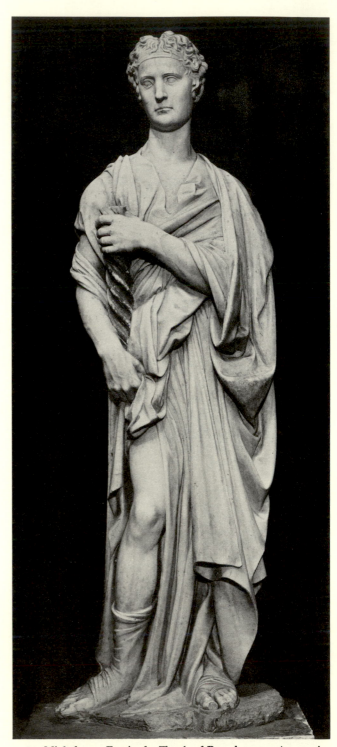

159. Michelozzo, Faith, Tomb of Bartolommeo Aragazzi 160. Michelozzo, Fortitude, Tomb of Bartolommeo Aragazzi

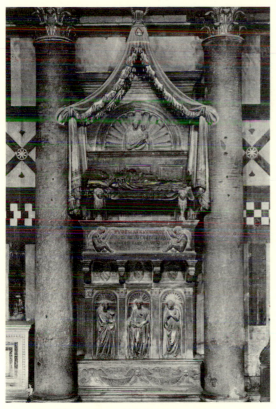

161. Donatello and Michelozzo, Tomb of
Baldassare Coscia, Baptistry, Florence

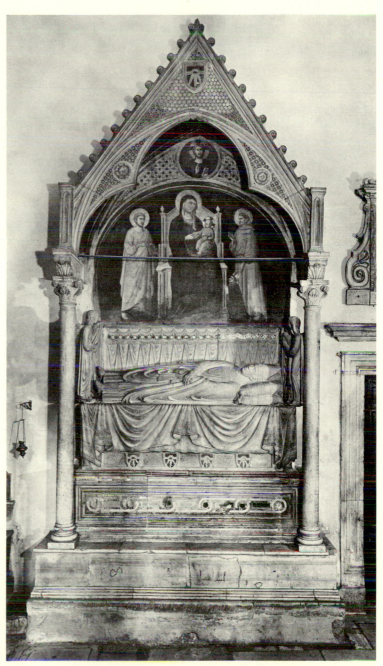

163. Giovanni di Cosma, Tomb of Cardinal Matteo
Acquasparta, S. Maria in Aracoeli, Rome

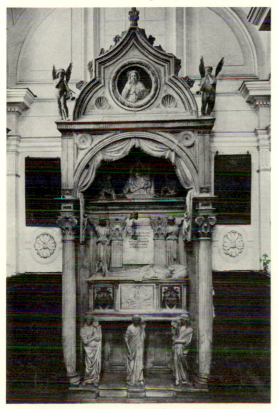

162. Donatello and Michelozzo, Tomb of
Cardinal Rainaldo Brancacci, S. Angelo
a Nilo, Naples

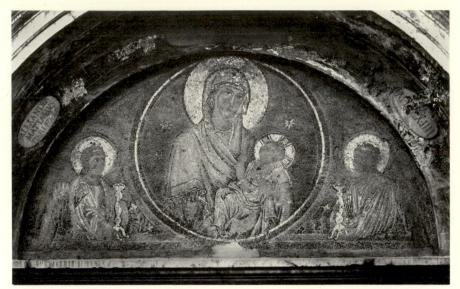

164. Roman, ca. 1300, lunette, lateral portal, S. Maria in Aracoeli, Rome

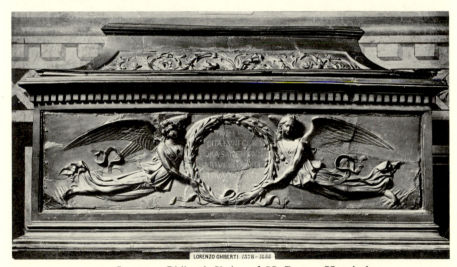

165. Lorenzo Ghiberti, Shrine of SS. Protus, Hyacinth
and Nemesius, Museo Nazionale, Florence

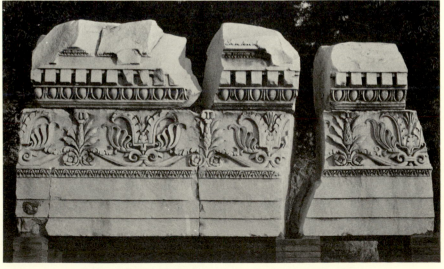

166. Entablature of the upper story, Basilica Aemilia, Rome

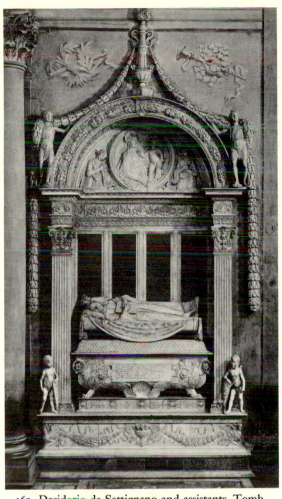

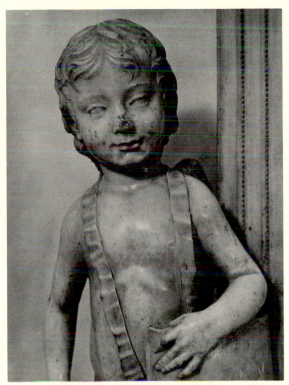

167. Desiderio da Settignano and assistants, Tomb
of Carlo Marsuppini, S. Croce, Florence

168. Desiderio da Settignano, detail of left
putto, Tomb of Carlo Marsuppini

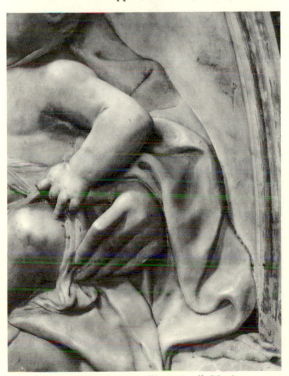

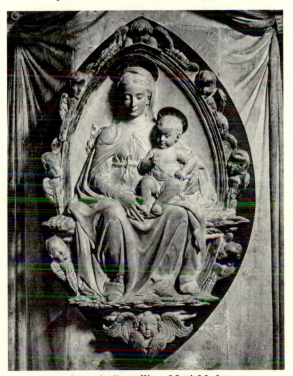

169. Antonio Rossellino, detail, Nori
Madonna, S. Croce, Florence

170. Antonio Rossellino, Nori Madonna

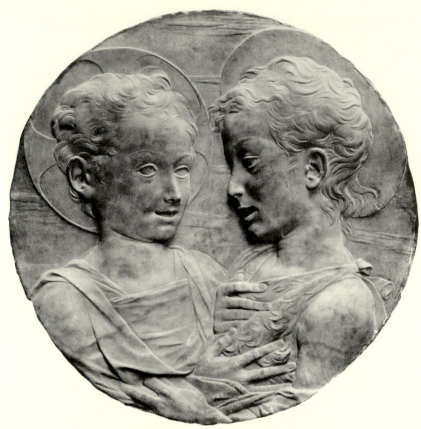

171. Desiderio da Settignano, Christ Child and
John the Baptist, Louvre, Paris

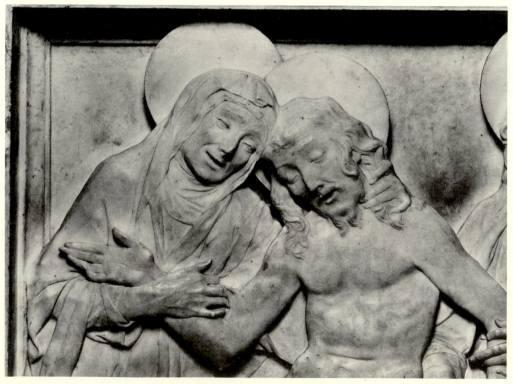

172. Desiderio da Settignano, detail of Pietà, Tabernacle
of the Sacrament, S. Lorenzo, Florence

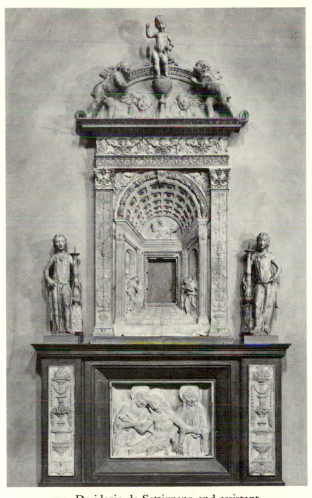

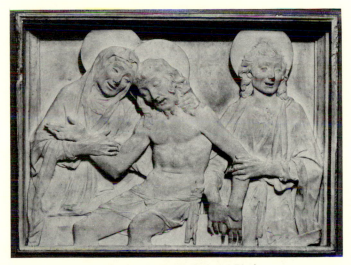

173. Desiderio da Settignano and assistant,
Tabernacle of the Sacrament

174. Desiderio da Settignano, Pietà,
Tabernacle of the Sacrament

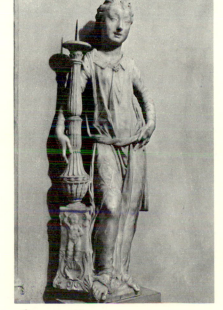

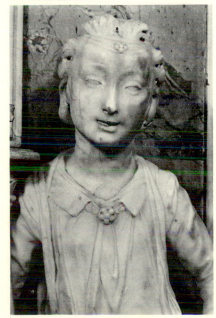

175.

176.

177.

175-177. Desiderio da Settignano, right angel, Tabernacle of the Sacrament

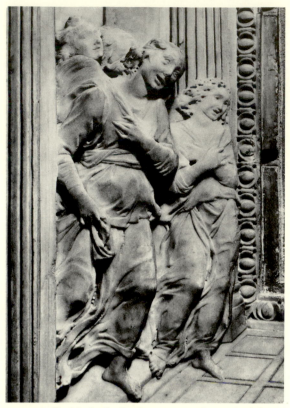

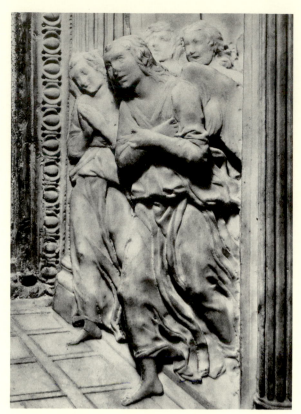

178. Desiderio da Settignano, angels to the left of the *sportello*, Tabernacle of the Sacrament

179. Desiderio da Settignano, angels to the right of the *sportello*, Tabernacle of the Sacrament

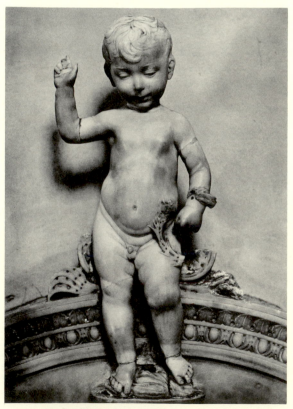

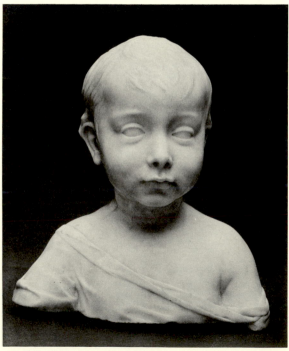

180. Desiderio da Settignano, Christ Child, Tabernacle of the Sacrament

181. Desiderio da Settignano, Bust of an Infant, Mellon Collection, National Gallery of Art, Washington, D.C.

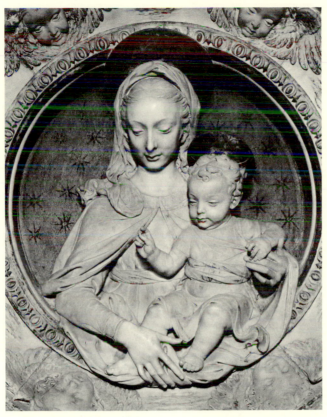

182. Antonio Rossellino, Madonna and Child, Tomb of
the Cardinal of Portugal, S. Miniato, Florence

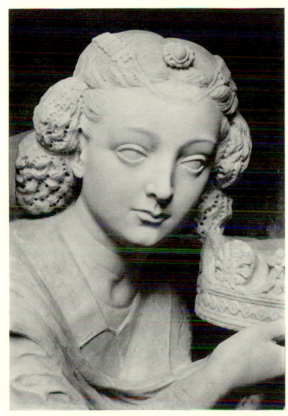

183. Assistant of Antonio Rossellino, head of left
kneeling angel, Tomb of the Cardinal of Portugal

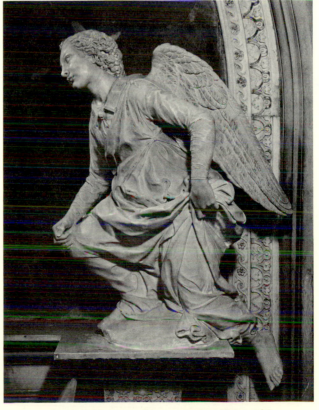

184. Antonio Rossellino, right kneeling angel,
Tomb of the Cardinal of Portugal

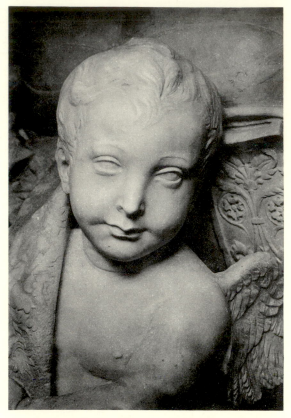

185. Antonio Rossellino, head of left putto from sarcophagus, Tomb of the Cardinal of Portugal

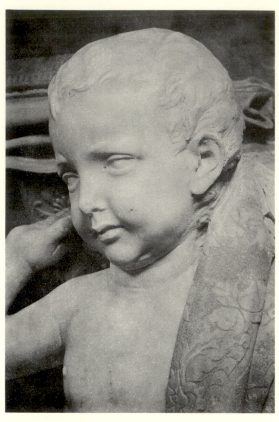

186. Antonio Rossellino, head of right putto from sarcophagus, Tomb of the Cardinal of Portugal

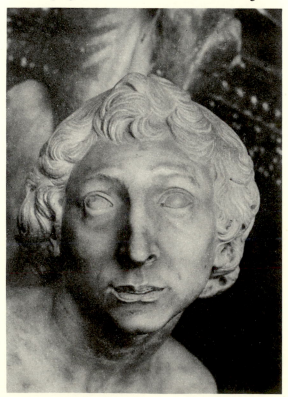

187. Antonio Rossellino, head of St. Sebastian, Museo della Collegiata, Empoli

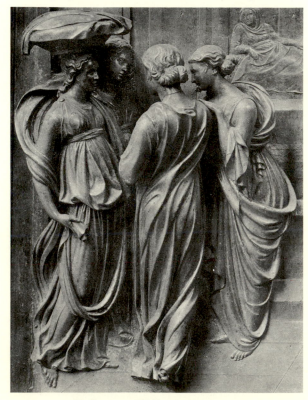

188. Lorenzo Ghiberti, detail, Story of Isaac, Gates of Paradise, Baptistry, Florence

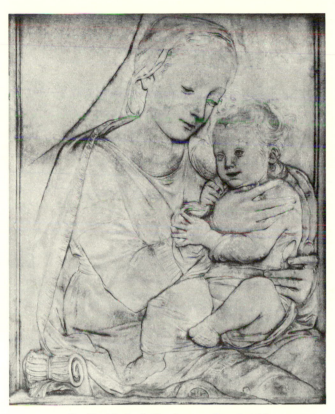

189. Desiderio da Settignano, Panciatichi
Madonna, Museo Nazionale, Florence

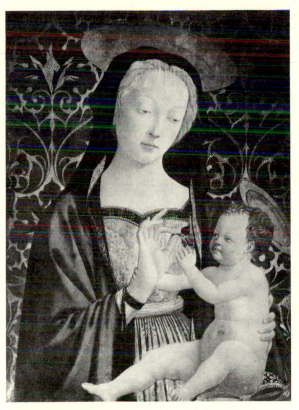

190. Domenico Veneziano, Madonna and
Child, Berenson Collection, Settignano

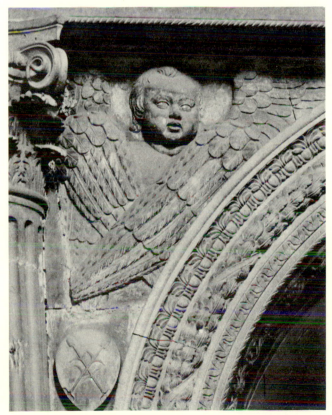

191. Buggiano, cherub from left spandrel of
entrance, Cardini Chapel, S. Francesco, Pescia

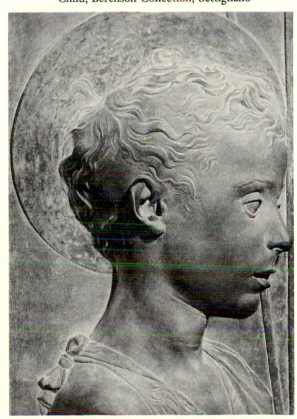

192. Desiderio da Settignano, detail of
S. Giovannino, Museo Nazionale, Florence

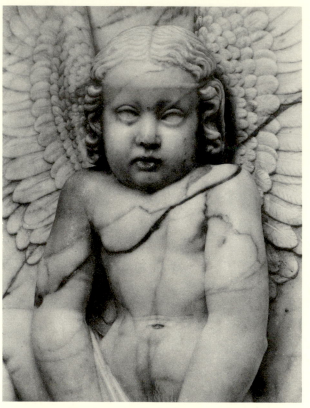

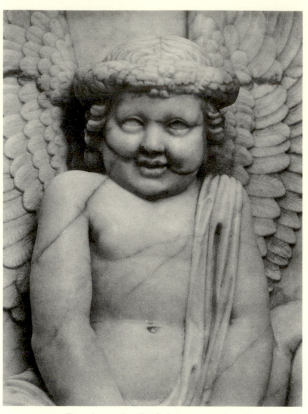

193. Buggiano, detail of left putto, Lavabo, north sacristy, Duomo, Florence

194. Buggiano, detail of right putto, Lavabo, north sacristy, Duomo, Florence

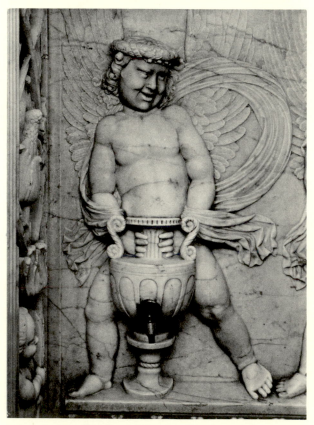

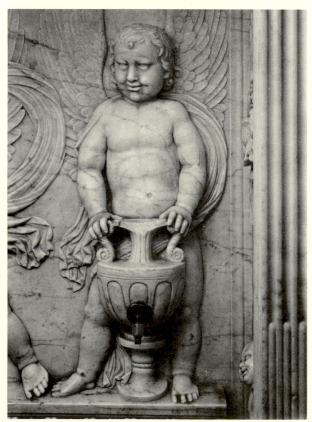

195. Buggiano, left putto, Lavabo, south sacristy, Duomo, Florence

196. Buggiano, right putto, Lavabo, south sacristy, Duomo, Florence

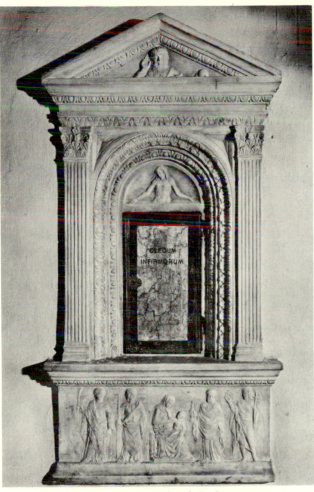

197. Buggiano, Tabernacle of the Sacrament,
S. Ambrogio, Florence

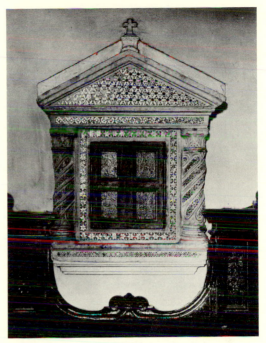

198. Cosmati school, Tabernacle of the
Sacrament, SS. Cosmas and Damian, Rome

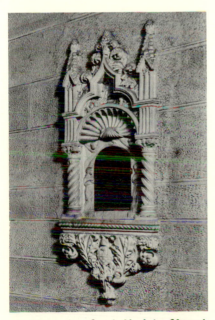

199. Florentine, first half of the fifteenth
century, Tabernacle of the Sacrament,
crypt, Duomo, Fiesole

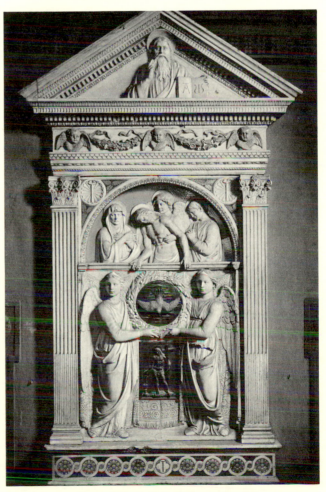

200. Luca della Robbia, Tabernacle of the
Sacrament, S. Maria, Peretola

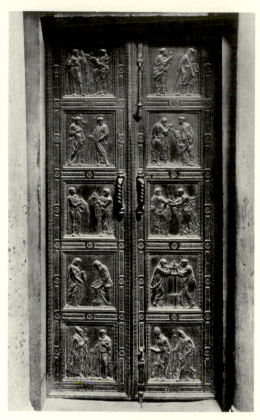

201. Donatello, right door, Old Sacristy,
S. Lorenzo, Florence

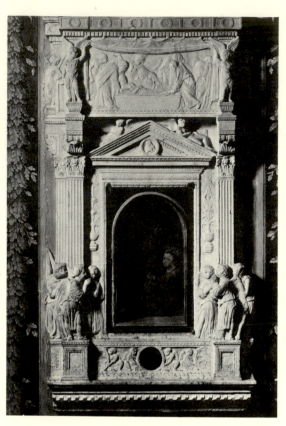

202. Donatello, Tabernacle of the Sacrament,
Sagrestia dei Beneficiati, St. Peter's, Rome

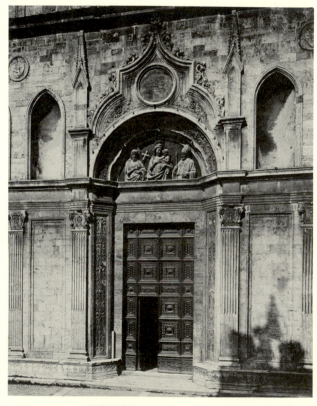

203. Michelozzo, Portal, S. Agostino,
Montepulciano

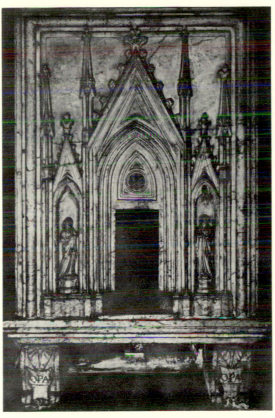

204. Sienese, shortly after 1400, Tabernacle
of the Sacrament, sacristy, Duomo, Siena

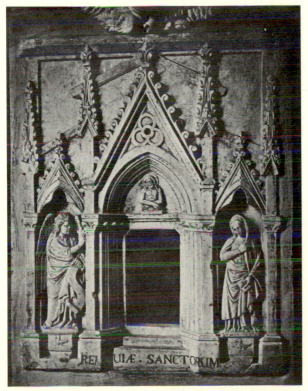

205. Sienese, fourteenth century, cast of Tabernacle of
the Sacrament, S. Eugenio, Villa di Monastero, Siena

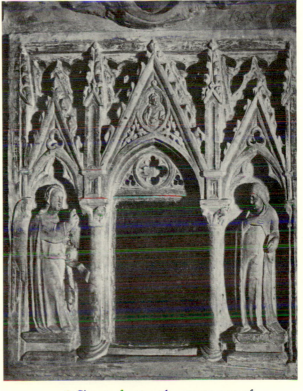

206. Sienese, fourteenth century, cast of
Tabernacle of the Sacrament, S. Eugenio
Villa di Monastero, Siena

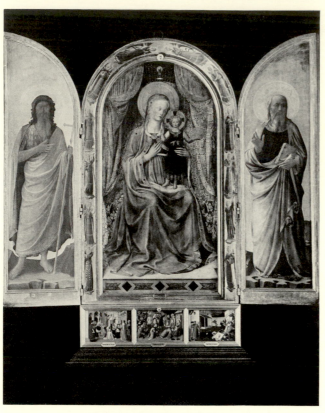

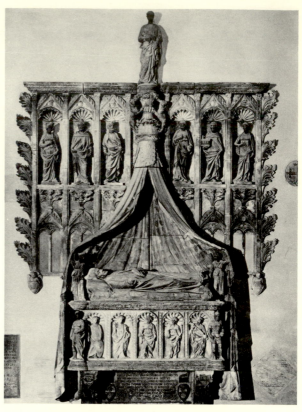

207. Fra Angelico, Linaiuoli Triptych,
Museo di S. Marco, Florence

208. Pietro Lamberti and Giovanni di Martino da
Fiesole, Tomb of Doge Tommaso Mocenigo,
SS. Giovanni e Paolo, Venice

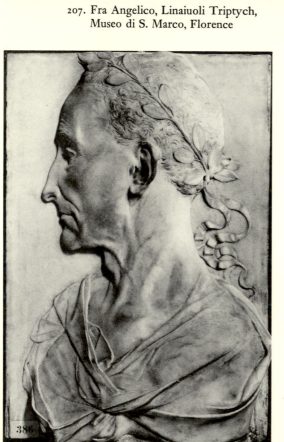

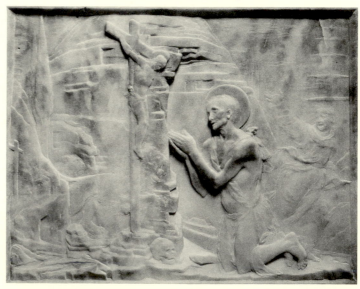

210. Desiderio da Settignano, St. Jerome in the Desert, Widener
Collection, National Gallery of Art, Washington, D.C.

209. Desiderio da Settignano, Bust of Julius
Caesar, Louvre, Paris

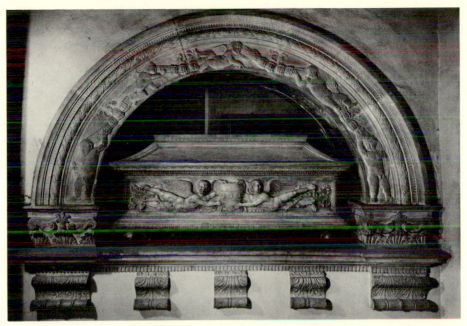

211. Pietro Lamberti, Tomb of Onofrio Strozzi,
sacristy, S. Trinita, Florence

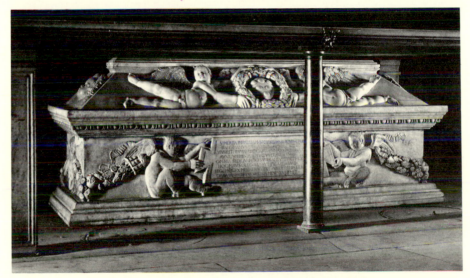

212. Buggiano, Tomb of Giovanni and Piccarda de' Medici,
Old Sacristy, S. Lorenzo, Florence

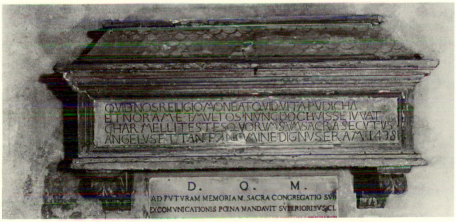

213. Florentine, ca. 1438, Tomb of Beato Angelo Mazzinghi,
S. Maria del Carmine, Florence

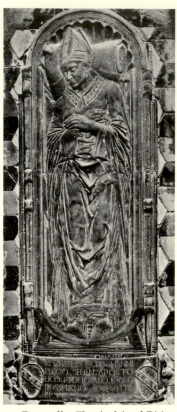

214. Donatello, Tomb slab of Bishop
Giovanni Pecci, Duomo, Siena

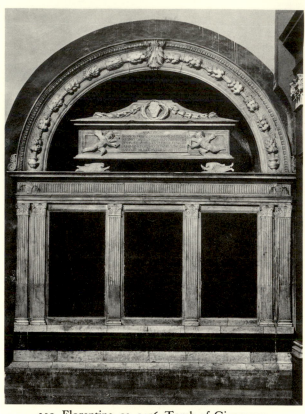

215. Florentine, ca. 1456, Tomb of Giannozzo
Pandolfini, Badia, Florence

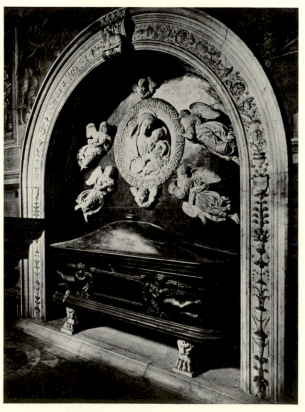

216. Benedetto da Maiano, Tomb of Filippo
Strozzi, S. Maria Novella, Florence

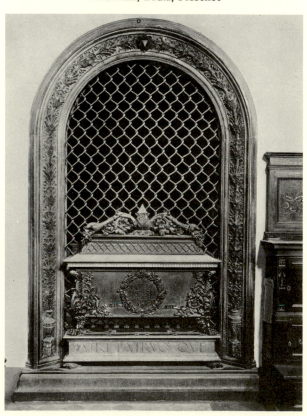

217. Andrea Verrocchio, Tomb of Giovanni and Piero
de' Medici, Old Sacristy, S. Lorenzo, Florence

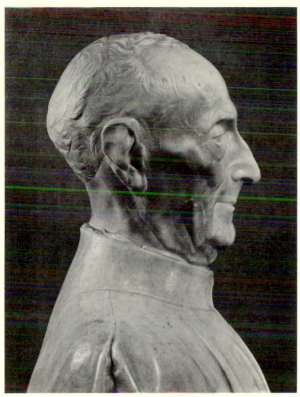

218. Antonio Rossellino, detail, Bust of
Giovanni Chellini, Victoria and Albert
Museum, London

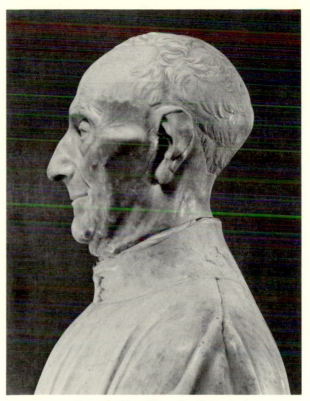

219. Antonio Rossellino, detail, Bust of
Giovanni Chellini, Victoria and Albert
Museum, London

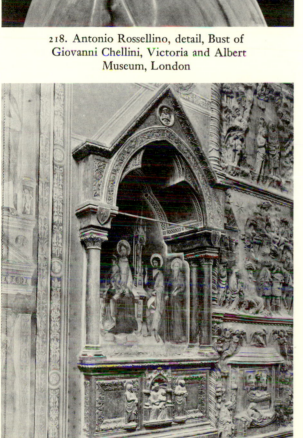

220. Veronese, late fourteenth century,
Tomb of Tommaso Pellegrini, S. Anastasia,
Verona

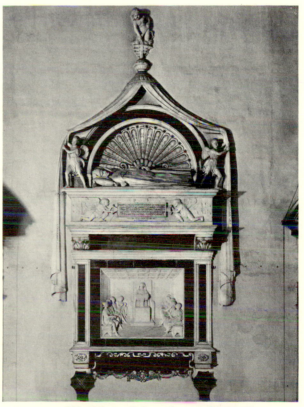

221. Workshop of Antonio and Giovanni
Rossellino, Tomb of Filippo Lazzari,
S. Domenico, Pistoia

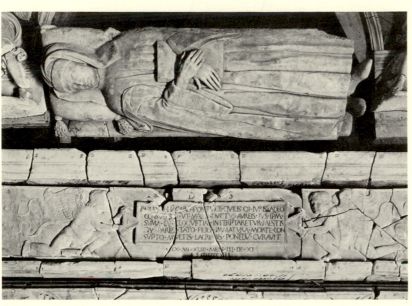

222. Workshop of Antonio and Giovanni Rossellino, effigy,
Tomb of Filippo Lazzari, S. Domenico, Pistoia

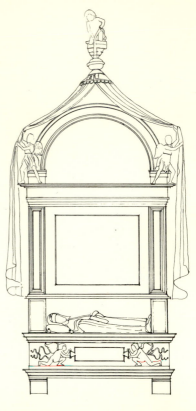

223. Reconstruction of Tomb of Filippo
Lazzari, S. Domenico, Pistoia

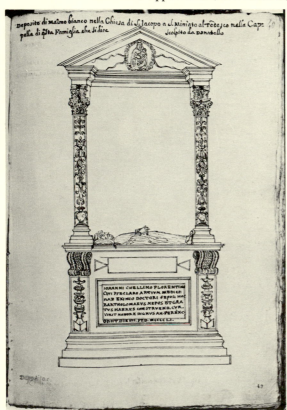

224. Tomb of Giovanni Chellini from
Giovanni di Poggio Baldovinetti, *Sepoltuario*, Florence, Biblioteca
Riccardiana, Codice Moreni 339, fol. 42r

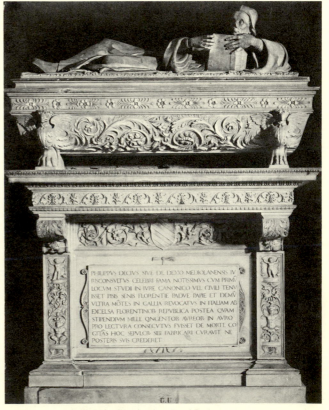

225. Stagio Stagi, Tomb of Filippo Decio,
Camposanto, Pisa